Advanced Adobe
Photoshop CS6

Chris Botello

Revealed

Advanced Adobe
PhotoshopCS6

Chris Botello

Revealed

DELMAR
CENGAGE Learning

Australia • Brazil • Japan • Korea • Mexico • Singapore • Spain • United Kingdom • United States

DELMAR
CENGAGE Learning

Advanced Adobe Photoshop CS6 Revealed
Chris Botello

Vice President, Career and Professional Editorial:
 Dave Garza

Director of Learning Solutions: Sandy Clark

Senior Acquisitions Editor: Jim Gish

Managing Editor: Larry Main

Product Manager: Nicole Calisi

Editorial Assistant: Sarah Timm

Vice President Marketing, Career and Professional:
 Jennifer Baker

Executive Marketing Manager: Deborah S. Yarnell

Associate Marketing Manager: Erin DeAngelo

Senior Production Director: Wendy Troeger

Production Manager: Andrew Crouth

Senior Content Project Manager: Kathryn B. Kucharek

Developmental Editor: Ann Fisher

Technical Editor: Tara Botelho

Director of Design: Bruce Bond

Cover Design: Riezebos Holzbaur/Tim Heraldo

Cover Photo: Riezebos Holzbaur/Andrei Pasternak

Text Designer: Liz Kingslein

Production House: Integra Software Services Pvt. Ltd.

Proofreader: Kim Kosmatka

Indexer: Alexandra Nickerson

Technology Project Manager: Jim Gilbert

Adobe® Photoshop®, Adobe® InDesign®, Adobe® Illustrator®, Adobe® Flash®, Adobe® Dreamweaver®, Adobe® Fireworks®, and Adobe® Creative Suite® are trademarks or registered trademarks of Adobe Systems, Inc. in the United States and/or other countries. Third party products, services, company names, logos, design, titles, words, or phrases within these materials may be trademarks of their respective owners.

Library of Congress Control Number: 2011945478

Hardcover edition:
ISBN-13: 978-1-133-69324-6
ISBN-10: 1-133-69324-5

Delmar
5 Maxwell Drive
Clifton Park, NY 12065-2919
USA

Cengage Learning is a leading provider of customized learning solutions with office locations around the globe, including Singapore, the United Kingdom, Australia, Mexico, Brazil, and Japan. Locate your local office at: **international.cengage.com/region**

Cengage Learning products are represented in Canada by Nelson Education, Ltd.

To learn more about Delmar, visit **www.cengage.com/delmar**

Purchase any of our products at your local college store or at our preferred online store **www.cengagebrain.com**

Notice to the Reader
Publisher does not warrant or guarantee any of the products described herein or perform any independent analysis in connection with any of the product information contained herein. Publisher does not assume, and expressly disclaims, any obligation to obtain and include information other than that provided to it by the manufacturer. The reader is expressly warned to consider and adopt all safety precautions that might be indicated by the activities described herein and to avoid all potential hazards. By following the instructions contained herein, the reader willingly assumes all risks in connection with such instructions. The publisher makes no representations or warranties of any kind, including but not limited to, the warranties of fitness for particular purpose or merchantability, nor are any such representations implied with respect to the material set forth herein, and the publisher takes no responsibility with respect to such material. The publisher shall not be liable for any special, consequential, or exemplary damages resulting, in whole or part, from the readers' use of, or reliance upon, this material.

Printed in the United States of America
1 2 3 4 5 6 7 16 15 14 13 12

Revealed Series Vision

The Revealed Series is your guide to today's hottest multimedia applications. For years, the Revealed Series has kept pace with the dynamic demands of the multimedia community, and continues to do so with the publication of 13 new titles covering the latest Adobe Creative Suite products. Each comprehensive book teaches not only the technical skills required for success in today's competitive multimedia market, but the design skills as well. From animation, to web design, to digital image-editing and interactive media skills, the Revealed Series has you covered.

We recognize the unique learning environment of the multimedia classroom, and we deliver textbooks that include:

- Comprehensive step-by-step instructions.
- In-depth explanations of the "Why" behind a skill.
- Creative projects for additional practice.
- Full-color visuals for a clear explanation of concepts.
- Comprehensive online material offering additional instruction and skills practice.
- Video tutorials for skills reinforcement as well as the presentation of additional features.
- NEW icons to highlight features that are new since the previous release of the software.

With the Revealed series, we've created books that speak directly to the multimedia and design community—one of the most rapidly growing computer fields today.

—The Revealed Series

Author's Vision

I am thrilled to be presenting you with this updated version of Advanced Photoshop. This book has always been very special to me: I love the exercises, I love the concepts and I love that readers can follow along and produce the most complex, "professional-level" Photoshop artwork. This is the book I wished for when I was learning Photoshop myself, so it makes me truly happy to be able to have created it and to share it with you.

Thank you to developmental editor Ann Fisher, technical editor Tara Botelho, and project manager Nicole Calisi. Special thanks to Jim Gish for always believing in this book.

—Chris Botello

CourseMate

A CourseMate is available to accompany *Advanced Adobe Photoshop CS6 Revealed*, which helps you make the grade!

This CourseMate includes:

- An interactive eBook, with highlighting, note taking and search capabilities
- Interactive learning tools including:
 - Chapter quizzes
 - Flashcards
 - Instructional video lessons from Total Training, the leading provider of video instruction for Adobe software. These video lessons are tightly integrated with the book, chapter by chapter and include assessment.
 - And more!

Go to login.cengagebrain.com to access these resources you have purchased.

Introduction to Advanced Adobe Photoshop CS6

Welcome to *Advanced Adobe Photoshop CS6—Revealed*. This book offers creative projects, concise instructions, and extensive coverage of advanced design and Photoshop skills, helping you to create polished, professional-looking graphics. Use this book both in the classroom and as your own reference guide.

The book is organized into 10 chapters. In these chapters you will explore many aspects of Photoshop CS6, including curves, levels, blending modes, special effects, and painting and drawing tools. You'll not only be challenged as a Photoshop CS6 user, but also as a designer working with real-world projects.

The term "advanced" will mean different things to different people. For us, "advanced" means that this book provides extensive coverage of Photoshop concepts and features that you wouldn't expect to encounter in a "beginner" class. While we do offer lessons on "basic" features like working with layers and adjustments, we then extrapolate to present more complex examples of those features in more complex scenarios.

We also provide insight into the design process. In many cases, the author of the book shares with the reader his decision making process and design choices as he develops these lessons—including mistakes he's made, surprise successes, and unexpected failures.

Finally, some lessons are just straight-out advanced, best demonstrated in Chapter 6, which is the book's centerpiece. In this chapter, readers build a complex movie poster from scratch, incorporating blending modes, photo merges, complex layer masks, and special effects.

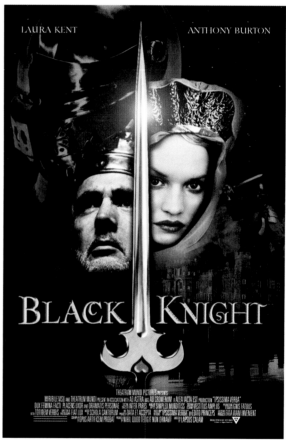

Source Adobe® Photoshop®, 2013. King: Erik Von Weber/Getty Images, Queen: Willie Maldonado/Getty Images, Small Knight: Chip Simons/Getty Images, Big Knight: Erik Von Weber/Getty Images, Castle: Pete Turner/Getty Images, Moon: StockTrek/Jupiter Images, Stars: Paul Beard/Jupiter Images, Sword: Chris Botello.

What You'll Do

A What You'll Do figure begins every lesson. This figure gives you an at-a-glance look at what you'll do in the chapter, either by showing you a page or pages from the current project or a tool you'll be using.

Comprehensive Conceptual Lessons

Within the step-by-step instructions, the author uses explanatory text and "Author's Notes" to provide conceptual instruction detailing the "how" and "why" specific skills are applied. The result is an ongoing explanation that provides insight to the author's process and design philosophy in creating the exercises in the book.

Position Images for A BACKGROUND SETTING

What You'll Do

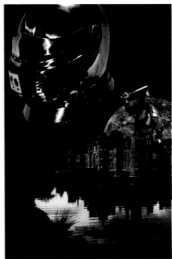

Source Adobe® Photoshop®, 2013. Small Knight: Chip Simons/Getty Images; Moon: StockTrek/Jupiter Images; Big Knight: Erik Von Weber/Getty Images; Pete Turner/Castle: Getty Images; Stars: Paul Beard/Jupiter Images

The great thing about designing movie posters is that you need to tell a story. Sometimes, when there's a really big star in the movie, all you need to do is run a picture of the star and the title. Any poster for a movie with Sandra Bullock would be a good example of this. For most titles, however, the poster needs to show more to convey some aspect of the story.

For the designer, this means that telling the story will happen in the background, usually behind a big headshot of the big movie star.

With this type of poster, the challenge for you is to design the poster as a world unto itself. It's almost as if the poster is a glimpse into the world of the movie. This means that much of your work will be focused on the background imagery of the poster—and that's usually the place you start to work.

Designing with Multiple Images

Step-by-Step Instructions

This book combines in-depth conceptual step-by-step instruction to help you produce complex, professional-level artwork in Photoshop CS6. Each set of steps guides you through a lesson where you will create, modify, or enhance an image. References to large colorful images provide visual instruction throughout the lessons. The Data Files for the steps are provided online at www.cengagebrain.com. For detailed instructions to access these files, please see page XI.

Figure 50 *Positioning the title*

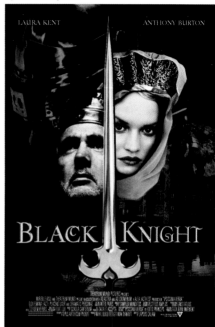

Source Adobe® Photoshop®, 2013. King: Getty Images, Queen: Getty Images, Small Knight: Getty Images, Moon: Jupiter Images, Big Knight: Getty Images, Sword: Chris Botello, Castle: Getty Images, Stars: Jupiter Images, King: Erik Von Weber, Queen: Willie Maldonado, Small Knight: Chip Simons, Moon: StockTrek, Big Knight: Erik Von Weber, Castle: Pete Turner, Sword: Chris Botello, Stars: Paul Beard

Lesson 7 Integrate Foreground Images

Position the title

1. Open Title.psd.
2. Target the **Title layer**, select all, copy, then close the file.
3. In the Black Knight Poster file, show and target the **Billing layer**.
4. Paste, then name the new layer **Title**.
5. Press **[Ctrl][T]** (Win) or ⌘ **[T]** (Mac) to scale the image.
6. Type **503** in the X text box, press **[Tab]**, type **1056** in the Y text box, then press **[Tab]**.
7. Click the **Move tool** , click **Apply**, compare your screen to Figure 50, then save.

Projects

This book contains end-of-chapter materials for additional practice and reinforcement. The Project Builders require you to apply the skills you've learned in the chapter and take them in a new direction. When you have finished the chapters in this book, you should have an impressive portfolio of the advanced work you have created using Adobe Photoshop CS6.

1. Open the three files: Pool1.psd, Pool2.psd, and Pool3.psd.
2. Assess the three images in terms of lighting, various exposures, etc.
3. Click the File menu, point to Automate, then click Merge to HDR Pro.
4. Click Browse.
5. Navigate to the drive and folder where your Chapter 9 Data Files are stored.
6. Select the three files Pool1.psd, Pool2.psd, and Pool3.psd, then click Open.
7. Click OK. Photoshop begins the process of creating the composite image.
8. If the Mode is not already set to 16 Bit, click the Mode list arrow, then choose 16 Bit.
9. Click the Preset list arrow, then sample the effects available with different presets.
10. Click the Preset list arrow, then click Photorealistic.
11. Experiment with the various sliders to produce a photorealistic result that you like.
12. Click OK to execute the HDR merge.
13. Save the resulting file as **Pool HDR Merge**.
14. Compare the composite to the three open source files.
15. Close the three open source files.
16. In the Pool HDR Merge.psd file, add any adjustment layers to produce the result you'd like.
17. Compare your results to Figure 77.
18. Save your work, then close Pool HDR Merge.psd.

Figure 77 *One result of the HDR merge*

Source Adobe® Photoshop®, 2013. Image © Scott Barnhill Photography

What Instructor Resources Are Available with This Book?

The Instructor Resources are Delmar's way of putting the resources and information needed to teach and learn effectively into your hands. All the resources are available for both Macintosh and Windows operating systems. These resources can be found online at: **http://login.cengage.com**. Once you login or create an account, search for the title under 'My Dashboard' using the ISBN. Then select the instructor companion site resources and click 'Add to my Bookshelf.'

Instructor's Manual

Available as an electronic file, the Instructor's Manual includes chapter overviews and detailed lecture topics for each chapter, with teaching tips.

Sample Syllabus

The Sample Syllabus includes a suggested syllabus for any course that uses this book.

PowerPoint Presentations

Each chapter has a corresponding PowerPoint presentation that you can use in lectures, distribute to your students, or customize to suit your course.

Data Files for Students

To complete most of the chapters in this book, your students will need Data Files which are available online. Instruct students to use the Data Files List at the end of this book. This list gives instructions on organizing files.

To access the Data Files for this book, take the following steps:

1. Open your browser and go to http://www.cengagebrain.com.
2. Type the author, title, or ISBN of this book in the Search window. (The ISBN is listed on the back cover.)
3. Click the book title in the list of search results.
4. When the book's main page is displayed, click the Access button under Free Study Tools.
5. To download Data Files, select a chapter number and then click on the Data Files tab on the left navigation bar to download the files.
6. To access additional materials, click the additional materials tab under Book Resources to download the files.

Solutions to Exercises

Solution Files are Data Files completed with comprehensive sample answers. Use these files to evaluate your students' work. Or distribute them electronically so students can verify their work. Sample solutions to lessons and end-of-chapter material are provided with the exception of some portfolio projects.

Test Bank and Test Engine

ExamView is a powerful testing software package that allows instructors to create and administer printed and computer (LANbased) exams. ExamView includes hundreds of questions that correspond to the topics covered in this text, enabling students to generate detailed study guides that include page references for further review. The computer-based and LAN-based/online testing component allows students to take exams using the EV Player, and also saves the instructor time by grading each exam automatically.

BRIEF CONTENTS

CONTENTS

CHAPTER 2: WORKING WITH LAYER STYLES

CHAPTER 3: ADJUSTING LEVELS AND HUE/SATURATION

CHAPTER 4: WORKING WITH CURVES AND ADJUSTING COLOR

CHAPTER 5: WORKING WITH TYPE AND SHAPE LAYERS

CHAPTER 6: DESIGNING WITH MULTIPLE IMAGES

CHAPTER 9: CREATING SPECIAL EFFECTS

Intended Audience

This book is designed for the experienced Photoshop user who wants to learn advanced techniques and new features in Photoshop CS6. The book presents real world assignments and takes you through the design decisions you might be faced with as you work toward your goal. By the end of the book, you'll have gained a thorough understanding of Photoshop from an advanced perspective.

Approach

The book allows you to work at your own pace through step-by-step tutorials. A concept is presented and the process is explained, followed by the actual steps. To learn the most from the book, you should adopt the following habits:

- Make sure you understand the Photoshop skill being taught in each step before you move on to the next step.
- After finishing a set of steps, ask yourself if you could do it on your own, without referring to the steps. If the answer is no, review the steps.

Icons, Buttons, and Pointers

Symbols for icons, buttons, and pointers are shown in the steps when they are used.

Windows and Macintosh

Photoshop CS6 works virtually the same on Windows and Macintosh operating systems. When there is a significant difference, the abbreviations (Win) and (Mac) are used.

The nature of working graphics requires detailed work. In Photoshop, this means that you will need to magnify areas of an image. Because monitor sizes and resolution preferences vary, be sure to set the magnification to the setting that allows you to work comfortably. The figures shown in this book are displayed at a monitor resolution of 1024 × 768.

Data Files

To complete most of the chapters in this book, your students will need Data Files which are available online. Instruct students to use the Data Files List at the end of this book. This list gives instructions on organizing files.

To access the Data Files for this book, take the following steps:

1. Open your browser and go to http://www.cengagebrain.com.
2. Type the author, title, or ISBN of this book in the Search window. (The ISBN is listed on the back cover.)
3. Click the book title in the list of search results.
4. When the book's main page is displayed, click the Access button under Free Study Tools.
5. To download Data Files, select a chapter number and then click on the Data Files tab on the left navigation bar to download the files.
6. To access additional materials, click the additional materials tab under Book Resources to download the files.

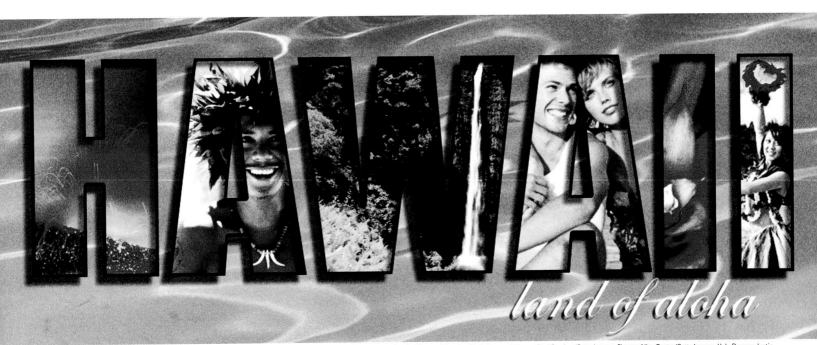

Source Adobe® Photoshop®, 2013. Man playing ukulele: Glowimages/Getty Images, Waterfall: MIXA Co. Ltd./Getty Images, Couple: Thomas Schweizer/Getty Images, Volcano: Paul Souders/Getty Images. Flower: Allan Baxter/Getty Images, Hula Dancer: Justin Horrocks/Getty Images, Water: Chris Botello.

CHAPTER 1

WORKING WITH LAYERS

CHAPTER 1

WORKING WITH LAYERS

Introduction

When you write a book titled "Advanced Photoshop," one of the main challenges throughout is how to define that which is "advanced." In our concept, the term "advanced" means taking Photoshop to the "next level." We've designed the book for users who already know how to use the program but want a thorough, in-depth understanding of the more challenging features. In addition, this is more than a how-to book; this is also a design book. We want to transcend the "tool jockey" approach of "this is what this tool does" and "this is what that tool does" to actually teach how to work with Photoshop holistically to create compelling imagery.

With that being said, you might still be surprised to see chapters devoted to features you consider basic: working with levels, working with Hue/Saturation, using the Clone Stamp tool, or working with type. Yes, levels, Hue/Saturation, the Clone Stamp tool, and type are all Photoshop features that beginners will learn somewhat early on, but in our approach, we go beyond the basic use of these features to give you an in-depth intellectual understanding of how these features work and how you can leverage that deeper knowledge to create better and more complex graphic effects.

By the end of this book, you'll be far more effective with truly advanced behaviors in Photoshop, including how to realize specific effects with blending modes, how to master adjustments to produce a desired goal, how to muster the courage to paint with the Brush tool when nothing else will work, and—perhaps most important from the design perspective—how to integrate a bunch of disparate artwork on various layers into a cohesive and singular piece of artwork.

In Chapter 1, we start our exploration of advanced Photoshop with the basics of the program: layers. In this case, though, it's a fairly complex use of layers that includes transforming, clipping, masking, adjustments and blending modes. You can think of it as a review, but we think of it as a jumping off point, a series of exercises that reinforce essential techniques on which we'll build complex structures throughout the remainder of the book.

Lock Transparent
PIXELS

What You'll Do

Image courtesy of Chris Botello. Source Adobe® Photoshop®, 2013.

Along the way, you'll create a classic type of artwork—the travel postcard with images in the letters. This is a visual concept you'll be able to use in lots of different ways for lots of different types of projects. Aloha.

Layers, layer styles, and layer masks have become such an essential component of Photoshop that it's hard to believe that the early versions of Photoshop didn't have layers. Imagine, all your work done on one single bed of pixels. Today, so much of what you do in Photoshop, you do on layers. Click the Type tool on the canvas—create a layer. Paste an image—create a layer.

This first chapter is designed as a refresher course in essential skills for working with layers, adjustment layers, layer masks, and layer styles. As you work through the chapters in this book, the layer structures and relationships are going to become quite complex, so use this exercise to hone your skills.

Lock transparent pixels

1. Open AP 1-1.psd, click the **File menu**, then click **Save As**.

2. Type **HAWAII** in the File name text box (Win) or the Save As text box (Mac), click the **Format** list arrow, click **Photoshop (*.PSD; *.PDD)** (Win) or **Photoshop** (Mac), then click **Save**.

TIP The Photoshop Format Options dialog box may open, asking if you want to maximize compatibility. You can program Photoshop to always maximize compatibility in the File Handling preferences dialog box. Click the Edit (Win) or Photoshop (Mac) menu, point to Preferences, click File Handling, click the Maximize PSD and PSB File Compatibility list arrow, click Always, then click OK.

3. Click the **Land of Aloha layer** on the Layers panel.

TIP Clicking a layer is called **targeting** a layer.

4. Press and hold [**Alt**] (Win) or [**option**] (Mac), click the **eye icon** 👁 beside the targeted layer, then compare your screen to Figure 1.

 Pressing [Alt] (Win) or [option] (Mac) while clicking the targeted layer hides all other layers. Note that the text is the only artwork on this layer. All of the other pixels on this layer are transparent, represented by the gray-and-white checkerboard pattern.

 (continued)

Figure 1 *Land of Aloha layer*

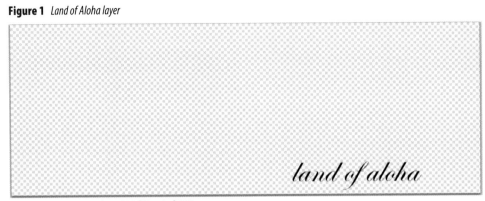

land of aloha

Image courtesy of Chris Botello. Source Adobe® Photoshop®, 2013.

Figure 2 *Layers panel*

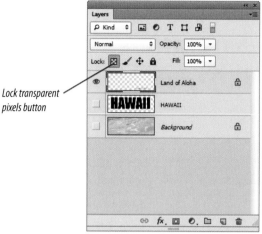

Lock transparent pixels button

Source Adobe® Photoshop®, 2013.

Figure 3 *Filling the Land of Aloha layer pixels with white*

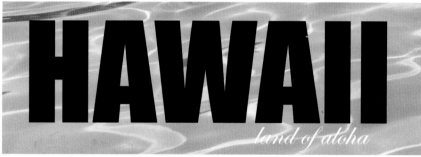

Image courtesy of Chris Botello. Source Adobe® Photoshop®, 2013.

AUTHOR'S NOTE

Make a note of the lock icon on the right side of the targeted layer. If you position your cursor over it, a tool tip will appear to explain its function—Indicates layer is partially locked. If you didn't take the time to do this—if you didn't know the name of that icon—you might reasonably think the whole layer is locked. It's not—just the transparent pixels are locked. Thus the layer is partially locked.

5. Press **[D]** to revert to default foreground and background colors.

6. Press **[X]** to switch foreground and background colors.

7. Press and hold **[Alt]** (Win) or **[option]** (Mac), then press **[Delete]** (Win) or **[delete]** (Mac).

 Pressing [Alt][Delete] (Win) or [option][delete] (Mac) fills the entire layer with the foreground color. Applying fills in this manner is much faster than using the Fill command on the Edit menu.

TIP If you use the Fill command on the Edit menu to fill an object, you'll be able to choose other fill settings, including blending modes and transparency, in the Fill dialog box.

8. Click the **Edit menu**, then click **Undo Fill Layer**.

9. Click the **Lock transparent pixels button** shown in Figure 2.

 When the Lock transparent pixels button is activated, the transparent pixels on the layer cannot be modified.

10. Press and hold **[Alt]** (Win) or **[option]** (Mac), then press **[Delete]** (Win) or **[delete]** (Mac).

 Only the black pixels are filled with the foreground color. The transparent pixels are unaffected by the white fill.

11. Press and hold **[Alt]** (Win) or **[option]** (Mac), then click the **eye icon** on the Land of Aloha layer.

 The two hidden layers become visible.

12. Compare your screen to Figure 3, then save your work.

Apply a Hue/Saturation
ADJUSTMENT LAYER

What You'll Do

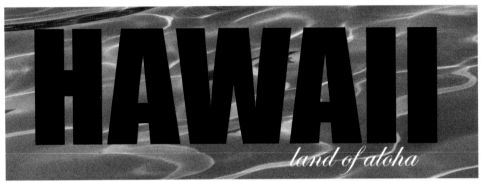

Image courtesy of Chris Botello. Source Adobe® Photoshop®, 2013.

If you're relatively new to Photoshop, you might not fully appreciate how revolutionary the introduction of adjustment layers was to the application.

Before adjustment layers, when you made an adjustment—a color correction with curves, levels, or hue saturation, for example—once you made it, you couldn't go back and modify it. You were stuck with it. There were ways to work around the issue, but that's all they were—work-arounds.

Adjustment layers offer you the ability to make an adjustment and then go back at any time and modify the adjustment. From the designer's perspective, it's the difference between being trapped with your choices and being free to experiment.

And that's not all—adjustment layers are also a record of the adjustments you've made. For example, if you're working on a new layer and want to know what color correction you made to a previous layer, all you need to do is check the adjustment layer. In the old days, you used an old-fashioned method to keep track of this information—a pencil and paper!

Figure 4 *New Layer dialog box*

New Layer

Name: Hue/Saturation 1 OK

☐ Use Previous Layer to Create Clipping Mask Cancel

Color: ☒ None ▼

Mode: Normal ▼ Opacity: 100 ▸ %

Source Adobe® Photoshop®, 2013.

Figure 5 *Modifying the hue of the water image*

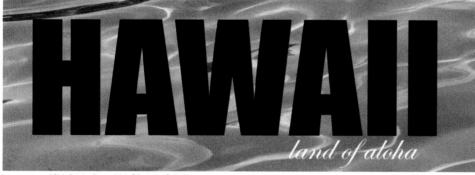

Image courtesy of Chris Botello. Source Adobe® Photoshop®, 2013.

Apply a Hue/Saturation adjustment layer

1. Target the **Background layer**.
2. Click the **Layer menu**, point to **New Adjustment Layer**, then click **Hue/Saturation**.
 The New Layer dialog box opens, as shown in Figure 4.
3. Type **Deep Blue** in the Name text box.
4. Click **OK**.
5. On the Properties panel, drag the **Hue slider** all the way to the left, so that your canvas resembles Figure 5.

(continued)

6. Click the **eye icon** 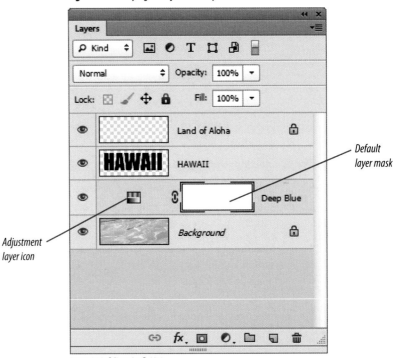 on the adjustment layer to hide it, then click again to show it.

 The adjustment layer is creating the red effect—the Background layer itself has not been modified.

7. Target the **Background layer** so that you can see the adjustment layer clearly.

 As shown in Figure 6, by default, the adjustment layer is created with a white layer mask.

8. Target the **Deep Blue adjustment layer**.

9. On the Properties panel, drag the **Hue slider** to +155.

10. Drag the **Saturation slider** to + 28.

11. Compare your screen to Figure 7.

12. Save your work.

Figure 6 *Identifying an adjustment layer*

Default
layer mask

Adjustment
layer icon

Source Adobe® Photoshop®, 2013.

Figure 7 *Viewing a different hue adjustment*

land of aloha

Image courtesy of Chris Botello. Source Adobe® Photoshop®, 2013.

Working with Layers

Work with a LAYER MASK

What You'll Do

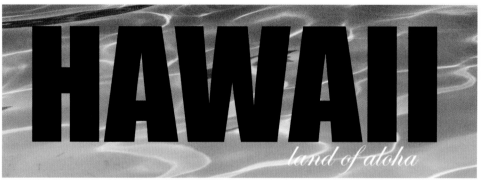

Image courtesy of Chris Botello. Source Adobe® Photoshop®, 2013.

Think about this for a moment: In the early versions of Photoshop, layers didn't exist. That's right—no layers. You had one flat canvas to work with, and if you layered one image over another, when you deselected, the two images became one.

The introduction of layers opened up a whole new realm of possibilities of what you could

create with Photoshop. And with layers came layer masks. Layer masks are essential to working with layers; they allow you to choose which areas of the layer are visible and which areas are not visible.

The layer mask interface is very straightforward: paint black in the areas that you do not want to show. Another great thing about

layer masks is that they are always available to be modified. In other words, you can paint white over the areas that you painted black, and those areas will show again.

But layer masks are not just black and white. Gray is neither white nor black; it's somewhere in between. Areas that you paint with gray in a layer mask are neither visible nor invisible—they're somewhere in between. Therein lies the power of gray in conjunction with layer masks: the ability to create semi-transparency for images on layers.

Work with a layer mask

1. Click the **Layers panel menu button** ▾≡, click **Panel Options**, click the **largest thumbnail icon** in the Thumbnail Size section, then click **OK**.

 The adjustment layer icon changes from the half-black/half-white circle to the Hue/Saturation adjustment icon.

2. Click the **layer mask thumbnail** on the Deep Blue adjustment layer to verify that it is targeted.

3. Press [**D**], press [**X**], fill the layer mask with the black foreground color, then compare your Layers panel to Figure 8.

 The effect of the adjustment layer—the red water—disappears on the canvas. Wherever black appears in the layer mask, the adjustment layer is no longer visible.

 (continued)

Figure 8 *Layer mask filled with black*

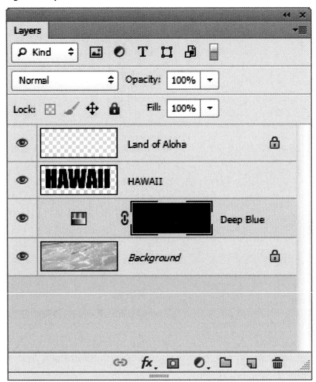

Source Adobe® Photoshop®, 2013.

Figure 9 *Using a layer mask to gradate the effect of an adjustment layer*

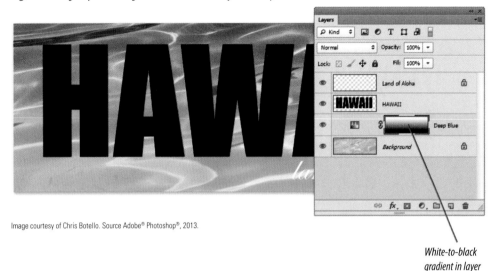

Image courtesy of Chris Botello. Source Adobe® Photoshop®, 2013.

White-to-black gradient in layer mask

Figure 10 *Modifying an adjustment layer*

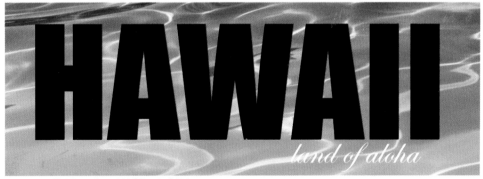

Image courtesy of Chris Botello. Source Adobe® Photoshop®, 2013.

4. Press **[Ctrl][I]** (Win) or ⌘ **[I]** (Mac) to invert the black mask to a white mask.

 The adjustment layer effect is restored. Wherever white appears in the layer mask, the adjustment layer is visible.

5. Press **[X]** to switch the foreground and background colors so that white is the foreground color and black is the background color.

6. Click the **Gradient tool** 📷, then click the **Linear Gradient button** 📷 on the Options bar at the top of the window, if necessary.

7. Position your cursor at the top center of the image, click and drag straight down, then release at the bottom of the image.

 A gradient appears in the layer mask and the adjustment layer effect fades down the artwork as shown in Figure 9.

8. Click the **Hue/Saturation adjustment icon** 📷 on the Deep Blue layer, then on the Properties panel, drag the **Hue Slider** to +34.

9. Compare your canvas to Figure 10.

 This is the real power of adjustment layers: you can always go back and tweak the adjustment. The effect is now a deep dark blue fading down to the original lighter blue.

10. Save your work.

Use One Layer
TO MASK ANOTHER LAYER

What You'll Do

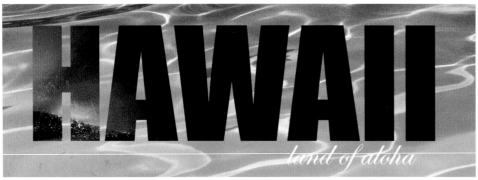

Source Adobe® Photoshop®, 2013. Volcano: Paul Souders/Getty Images, Water: Chris Botello.

Masking effects have enjoyed a long and illustrious career in the graphic arts. Long before the advent of computer graphics, masking had staked its territory as a popular and beloved design effect: think of those 50's postcards that had great beach photos inside the word FLORIDA! Come to think of it, if you can get your hands on some of those old postcards, please do. They are a great example of classic effects that were done in the days before digital.

Today, of course, they can be done in Photoshop. Actually, they can be done many different ways in Photoshop, and these next few lessons are going to examine those methods closely.

Masking is a great effect for you to have in your designer's bag of tricks. Working on a project that incorporates multiple masking techniques and complex interrelationships between artwork on layers is one of the best ways to investigate the many powerful options available in the Layers panel.

Figure 11 *Preparing to clip the Volcano layer*

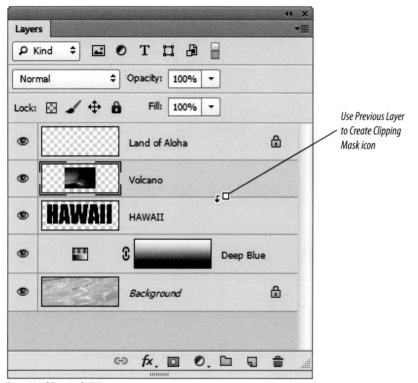

Use Previous Layer to Create Clipping Mask icon

Source Adobe® Photoshop®, 2013.

AUTHOR'S NOTE

When you set the view percentage for a document so that you can see the entire canvas, anything you paste into the document will be centered on the canvas. Though this doesn't sound like such a big deal, knowing this can come in very handy, especially when you are aligning pasted images or trying to center images on the canvas.

Use one layer to mask another layer

1. Open Volcano.psd from your Data Files folder, select all, copy, then close the file.

 TIP Try doing Step 1 using four keyboard commands: [Ctrl][0], [Ctrl][A], [Ctrl][C], [Ctrl][W] (Win) or ⌘ [0], ⌘ [A], ⌘ [C], ⌘ [W] (Mac).

2. Zoom in or out so that you are viewing the canvas at 50%.

 You should be able to see the entire canvas.

3. Target the **HAWAII layer**.

4. Click the **Edit menu**, then click **Paste**.

 The Volcano.psd image is pasted on its own layer immediately above the targeted layer. When you paste in Photoshop, the contents are pasted on their own layer, always above the targeted layer.

5. Name the new layer **Volcano**.

6. Press and hold **[Alt]** (Win) or **[option]** (Mac), then position the mouse pointer between the Volcano and HAWAII layers on the Layers panel so that you see the pointer shown in Figure 11.

7. Click the line between the two layers.

 The volcano image is masked—or "clipped"—by the pixels on the layer below it—the HAWAII layer. The volcano image is visible only where there are pixels on the HAWAII layer. Where the HAWAII layer is transparent, the volcano image is not visible.

 TIP Note that the Volcano layer now has the bent arrow icon which represents the Use Previous Layer to Create Clipping Mask option is activated.

(continued)

8. Press **[Ctrl][T]** (Win) or ⌘ **[T]** (Mac), then scale the volcano image 125%.

9. Click the **Move tool** , then move the graphic so the volcano is positioned in the letter H as shown in Figure 12.

TIP Use the arrow keys to move the image in small increments. Each time you press an arrow, the image moves one pixel in that direction. Press and hold [Shift] when you press an arrow, and the image will move 10 pixels in that direction.

10. Save your work.

Figure 12 *Positioning the volcano image*

Source Adobe® Photoshop®, 2013. Volcano: Paul Souders/Getty Images, Water: Chris Botello.

Working with Layers

Mask a Layer with the
PASTE INTO COMMAND

What You'll Do

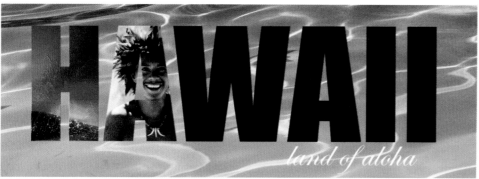

Source Adobe® Photoshop®, 2013. Man playing ukulele: Glowimages/Getty Images, Volcano: Paul Souders/Getty Images, Water: Chris Botello.

Paste is probably one of the first commands you learned when you sat down at a computer for the first time. First copy, then paste. Paste Into is not quite so common.

Paste Into is a cool and effective way of masking a graphic—in some ways, it's more effective than some of the more popular methods that you probably use. Paste Into is inextricably linked to layer masks, and it's this important relationship that we'll explore in this lesson.

Mask a layer with the Paste Into command

1. Open Ukulele.psd, select all, copy, then close the file.

2. Target the **HAWAII layer**.

3. Press and hold [**Ctrl**] (Win) or ⌘ (Mac), then click the **HAWAII layer thumbnail**.

 As shown in Figure 13, all of the pixels on the HAWAII layer are selected.

 TIP Pressing and holding [Ctrl] (Win) or ⌘ (Mac), then clicking a layer thumbnail loads a selection of all the pixels on the layer. If the layer has transparent areas, as this layer does, the transparent areas will not be selected.

4. Click the **Rectangular Marquee tool** 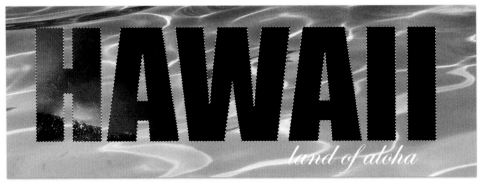, press and hold [**Alt**] (Win) or [**option**] (Mac), then drag a box around the letter H only.

 The letter H is deselected.

 TIP Pressing and holding [Alt] (Win) or [option] (Mac) when creating a selection removes the selection from the currently selected area.

 (continued)

Figure 13 *All pixels on the HAWAII layer are selected*

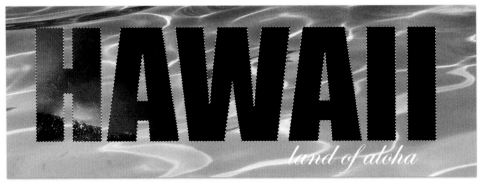

Source Adobe® Photoshop®, 2013. Volcano: Paul Souders/Getty Images, Water: Chris Botello.

Figure 14 *Positioning the ukulele graphic*

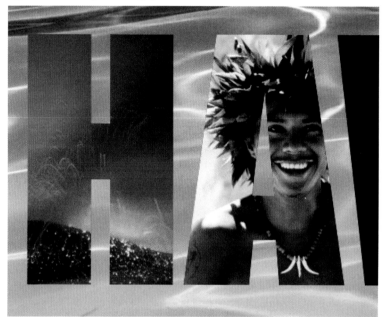

Source Adobe® Photoshop®, 2013. Man playing ukulele: Glowimages/Getty Images, Volcano: Paul Souders/Getty Images, Water: Chris Botello.

5. Click the **Polygonal Lasso tool** , then verify that the Feather value in the Options bar is set to **0 px**.

6. Press and hold **[Alt]** (Win) or **[option]** (Mac), then draw a box around the letters WAII.

 The letters are deselected. Only the letter A is selected.

7. Target the **Volcano layer**, click the **Edit menu**, point to **Paste Special**, then click **Paste Into**.

 The ukulele image is pasted on a new layer above the Volcano layer. The new layer is created automatically with a layer mask that represents the selection that was pasted into—a white A on a black background.

8. Name the new layer **Ukulele**, press and hold **[Alt]** (Win) or **[option]** (Mac), then click the **layer mask thumbnail** to view the mask.

TIP Pressing and holding [Alt] (Win) or [option] (Mac) when clicking a layer mask thumbnail displays the layer mask on the canvas.

9. Click the **Ukulele thumbnail** to view the image again, then rotate and position the image so the man's eyes are level, as shown in Figure 14.

 Be sure to note that when you execute the Paste Into command, by default, the artwork is not locked to the layer mask. This means that the artwork can be moved independently from the layer mask. In this example, regardless of how you move the image, it will be visible only within the letter A, which will remain stationary.

10. Save your work.

Use a Single Layer to
MASK MULTIPLE LAYERS

What You'll Do

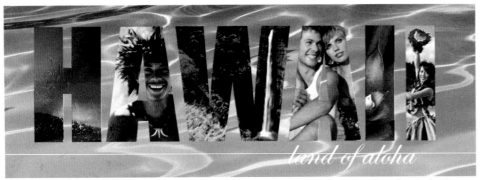

Source Adobe® Photoshop®, 2013. Man playing ukulele: Glowimages/Getty Images, Waterfall: MIXA Co. Ltd./Getty Images, Couple: Thomas Schweizer/Getty Images, Volcano: Paul Souders/Getty Images. Flower: Allan Baxter/Getty Images, Hula Dancer: Justin Horrocks/Getty Images, Water: Chris Botello.

Things get really interesting in the Layers panel when multiple layers all "clip" into a single layer that plays the role of the mask. That single layer can be used to mask multiple images placed on multiple layers; you don't need to use multiple masks to achieve the effect.

As you work through this lesson, keep in mind the complex tasks that the Layers panel handles with such ease.

Working with Layers

Figure 15 *Viewing the new and automatically clipped layer*

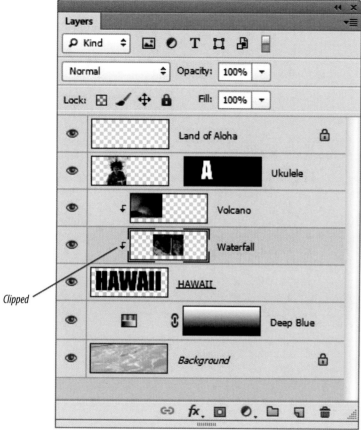

Source Adobe® Photoshop®, 2013.

Use a single layer to mask multiple layers

1. Open Waterfall.psd, select all, copy, then close the file.

2. Target the **HAWAII layer**.

3. Click the **Edit menu**, then click **Paste**.

 As shown in Figure 15, the new layer is automatically "clipped" by the HAWAII layer because it was pasted *beneath* the Volcano layer, which was already being "clipped." Note the bent arrow icon on the new layer.

4. Name the layer **Waterfall**.

 The waterfall image is partially obscured by the volcano image, which is on the layer above it. However, no part of the ukulele graphic obscures the waterfall image.

 (continued)

5. Drag the **Waterfall layer** above the Volcano layer.

 The waterfall image is no longer obscured. The Waterfall layer remains clipped into the HAWAII layer.

6. Reposition the waterfall image as shown in Figure 16.

(continued)

Figure 16 *Reordering clipped layers in the Layers panel*

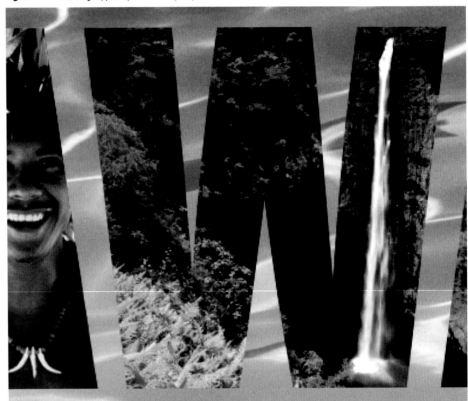

Source Adobe® Photoshop®, 2013. Man playing ukulele: Glowimages/Getty Images, Waterfall: MIXA Co. Ltd./Getty Images, Water: Chris Botello.

Working with Layers

Figure 17 *Preparing to clip a layer*

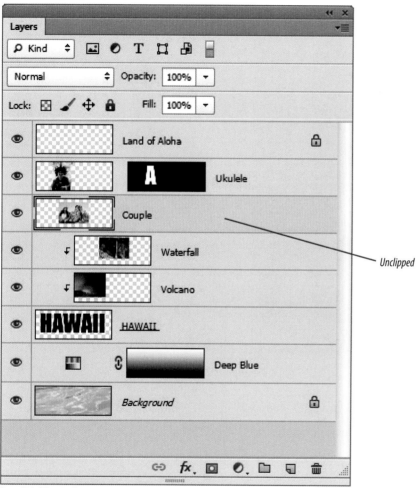

Unclipped

Source Adobe® Photoshop®, 2013.

7. Open Couple.psd, select all, copy, then close the file.

8. Verify that the Waterfall layer is targeted, apply the Paste command, then name the layer **Couple**.

 The couple image is not automatically clipped, as shown in Figure 17.

9. Press and hold [**Alt**] (Win) or [**option**] (Mac), then position the cursor on the Layers panel over the line between the Couple and Waterfall layers so that you see the "clip" icon.

10. Click between the two layers.

 The couple image is clipped into the mask. The couple image is being masked by the HAWAII layer, *not* the Waterfall layer. When you have a series of clipped layers—as you do here—it is the bottommost layer that clips the layers above it.

 (continued)

11. Position the couple in the letter A as shown in Figure 18.

 This position is a good example of a design challenge. In this type of illustration, the images are the fill for the type. If the image is too complex or too busy, it will draw your eye away from the main word. In this case, the blue sky above their heads, the many intertwining limbs, the sand below their legs, the white soda can—all of these elements make for a very busy interior for the letter A.

12. Resize and position the couple artwork as shown in Figure 19.

 At this larger size, many of the extraneous elements of the image are clipped out. What remains is a bit more abstract, because the couple is cropped so closely by the letter A. Note, however, that we still see him holding her hand, a nice touch in the image that you wouldn't want to lose.

(continued)

Figure 18 *Positioning the couple image*

Source Adobe® Photoshop®, 2013. Couple: Thomas Schweizer/Getty Images, Water: Chris Botello.

Figure 19 *Couple image resized*

Source Adobe® Photoshop®, 2013. Couple: Thomas Schweizer/Getty Images, Water: Chris Botello.

Working with Layers

Figure 20 *Masking the couple image where it overlaps the W*

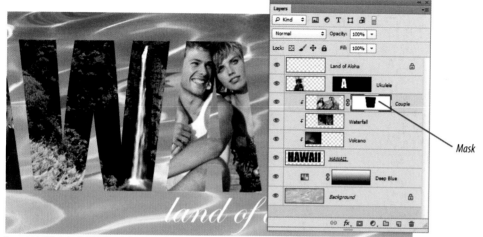

Mask

13. With the Couple layer still targeted, click the **Add layer mask button** on the Layers panel.

14. Click the **Polygonal Lasso tool** , then make a selection around the letter W.

15. Fill the selection with black.

 As shown in Figure 20, the selection is filled with black in the mask, and the couple image is no longer visible in the letter W.

 (continued)

16. Save your work.

17. Using the same method, clip and mask the Flower.psd image into the first letter I, then clip and mask the Hula.psd image into the second letter I.

 Figure 21 shows one of many possibilities.

18. Save your work.

Figure 21 *Flower and hula clipped, sized, and positioned*

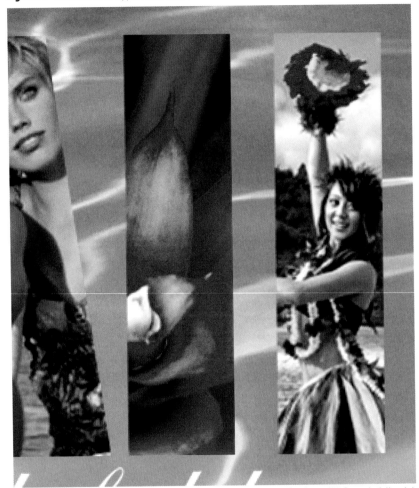

Source Adobe® Photoshop®, 2013. Couple: Thomas Schweizer/Getty Images, Flower: Allan Baxter/Getty Images, Hula Dancer: Justin Horrocks/Getty Images, Water: Chris Botello.

Add a Stroke
LAYER STYLE

What You'll Do

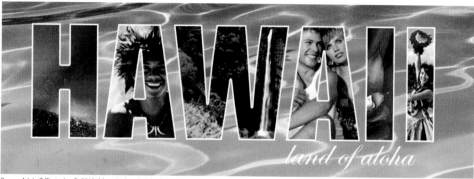

Source Adobe® Photoshop®, 2013. Man playing ukulele: Glowimages/Getty Images, Waterfall: MIXA Co. Ltd./Getty Images, Couple: Thomas Schweizer/Getty Images, Volcano: Paul Souders/Getty Images, Flower: Allan Baxter/Getty Images, Hula Dancer: Justin Horrocks/Getty Images, Water: Chris Botello.

As a designer, it is worth your time to think about and experiment with strokes. They can be very effective, or they can be trite and predictable. What makes the difference? A stroke works when the art calls for it—it's that simple.

At this point, all six images have been placed into the title and have been masked so that none interferes with any other. As a designer, this is the point where you'd want to take a moment to assess the art and decide how it can be improved to achieve a finished look.

The first thing to note is that the letterforms seem a bit bare. They simply butt up against the water image in the background. To remedy this, you will apply a stroke to the letterforms.

Add a stroke layer style

1. Target the **HAWAII layer**, click the **Layer menu**, point to **Layer Style**, then click **Stroke**.

 The Layer Style dialog box opens, and the Stroke settings become available.

 TIP Double-click a layer (to the right of the layer name) to open the Layer Style dialog box.

2. Verify that the **Preview check box** is checked, then click the **Set color of stroke box** as shown in Figure 22 to open the Color Picker (Stroke Color) dialog box.

 (continued)

Figure 22 *Layer Style dialog box*

Set color of stroke box

Source Adobe® Photoshop®, 2013.

Figure 23 *The Stroke style applied*

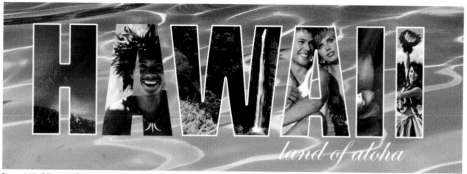

Source Adobe® Photoshop®, 2013. Man playing ukulele: Glowimages/Getty Images, Waterfall: MIXA Co. Ltd./Getty Images, Couple: Thomas Schweizer/ Getty Images, Volcano: Paul Souders/Getty Images, Flower: Allan Baxter/Getty Images, Hula Dancer: Justin Horrocks/Getty Images, Water: Chris Botello.

Figure 24 *Clipping the ukulele image to apply the Stroke style*

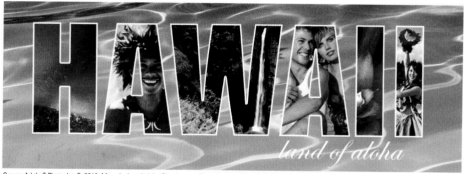

Source Adobe® Photoshop®, 2013. Man playing ukulele: Glowimages/Getty Images, Waterfall: MIXA Co. Ltd./Getty Images, Couple: Thomas Schweizer/ Getty Images, Volcano: Paul Souders/Getty Images, Flower: Allan Baxter/Getty Images, Hula Dancer: Justin Horrocks/Getty Images, Water: Chris Botello.

AUTHOR'S NOTE

It is important that you understand that you are applying the stroke to the HAWAII layer. The stroke appears *over* the five images that have been "clipped" into the HAWAII layer, even though they are above the HAWAII layer. When an image is clipped into a given layer, the image takes on the layer styles applied to that layer. However, the stroke does *not* appear in the letter A because the Family layer is above the HAWAII layer and is not clipped. This is another example of how the choices you make when building an illustration will affect choices you make later on down the line.

3. Type **255** in the R, G, and B text boxes, then click **OK**.

4. Click the **Position** list arrow, then click **Inside**.

5. Drag the **Size slider** to 4 px, click **OK**, then compare your canvas to Figure 23.

 Note that an Effects layer and a Stroke layer now appear in sublayers beneath the HAWAII layer.

TIP Layer styles are listed as sublayers within the layer to which they are applied.

6. Note that the ukulele artwork in the first letter A is not stroked. Only the layers that are clipped into the HAWAII layer are stroked.

7. Clip the Ukulele layer into the layers beneath it, then compare your canvas to Figure 24.

8. Save your work.

Lesson 7 Add a Stroke Layer Style

Apply and Edit Multiple
LAYER STYLES

What You'll Do

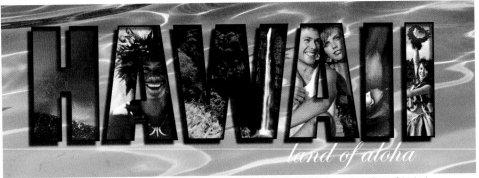

Source Adobe® Photoshop®, 2013. Man playing ukulele: Glowimages/Getty Images, Waterfall: MIXA Co. Ltd./Getty Images, Couple: Thomas Schweizer/Getty Images, Volcano: Paul Souders/Getty Images, Flower: Allan Baxter/Getty Images, Hula Dancer: Justin Horrocks/Getty Images, Water: Chris Botello.

As a designer, you should keep the word "flat" in the back of your mind whenever you assess your work at a given stage. Flat is usually not a good thing.

The HAWAII art at this stage is flat. Note that even with the multiple images, the masking and the stroke, the overall effect remains stubbornly two dimensional. We want the HAWAII art to "pop"—to jump off the page.

A drop shadow is a classic solution for adding the illusion of depth to an illustration. In this lesson, you are going to add a drop shadow to create the effect that the word HAWAII is floating above the water in the background.

Figure 25 *Drop Shadow settings in the Layer Style dialog box*

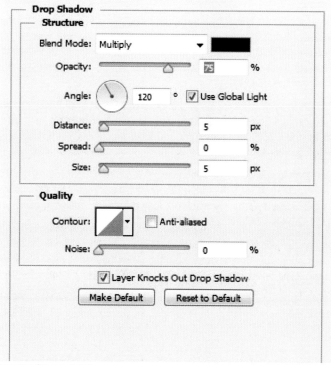

Source Adobe® Photoshop®, 2013.

Add a Drop Shadow layer style

1. With the **HAWAII layer** still targeted, click the **Add a layer style button** fx on the Layers panel, then click **Drop Shadow**.

 Note on your screen that the Drop Shadow check box is automatically checked on the left side of the dialog box. This is because you chose Drop Shadow from the list. The Stroke check box is also checked because you previously added a Stroke style, and it is still active. Drop Shadow settings are shown in Figure 25.

 (continued)

Drop Shadow Settings

The following four settings for drop shadows aren't necessarily self-explanatory, so use the definitions below to better understand your options.

Angle Determines the lighting angle at which the effect is applied to the layer

Distance Specifies the offset distance for the shadow—how far it is away from the artwork

Spread Determines the size of the shadow effect before the edge blurs

Size Controls the size of the blur at the edge of the effect

2. Drag the **Distance slider** to 16 px.

 The Distance slider determines the offset of the shadow—how far it is positioned from the object.

3. Drag the **Angle slider** counterclockwise so that the text box reads 45.

4. Drag the **Size slider** to 5 px.

 Along with the size of the shadow, the Size slider determines the softness of the shadow.

5. Click the **Set color of shadow** button to open the Color Picker (Drop Shadow Color) dialog box.

6. Type **13R/8G/57B** to choose a dark blue color, then click **OK**.

(continued)

About the Use Global Light option

Many layer styles produce their effects by adjusting the brightness and contrast of the artwork they're applied to. The effect is often created with a "light source," meaning that the artwork appears to be brightened from a certain direction. For example, if you apply a Bevel and Emboss layer style to chiseled text and set the light source to light the artwork from the right, you will create shadows and darker areas on the left side of the artwork.

When you apply multiple layer styles to a single piece of artwork, the Use Global Light option comes into play. This option exists as a simple solution to help you maintain a consistent light source for multiple layer styles. With the Use Global Light option checked, all of your layer styles will create their individual effects using "light" from the same direction.

Consistency is great when you want it, and if you want a consistent light source, the Use Global Light feature is a great option. But don't think that you must have a consistent light source. Sometimes different layer styles applied to the same artwork look even more interesting when they strike the artwork from different angles or light sources.

You can turn off the Use Global Light option and manually set the angle and the altitude of the light source. Don't forget about the Altitude option: it often yields interesting results with different values. Always remember to experiment.

Working with Layers

Figure 26 *Viewing the drop shadow*

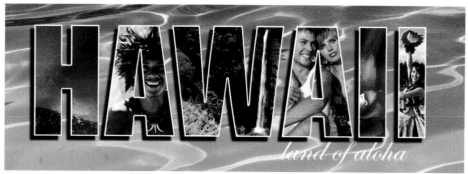

Source Adobe® Photoshop®, 2013. Man playing ukulele: Glowimages/Getty Images, Waterfall: MIXA Co. Ltd./Getty Images, Couple: Thomas Schweizer/ Getty Images, Volcano: Paul Souders/Getty Images, Flower: Allan Baxter/Getty Images, Hula Dancer: Justin Horrocks/Getty Images, Water: Chris Botello.

Figure 27 *Viewing edits to the layer styles*

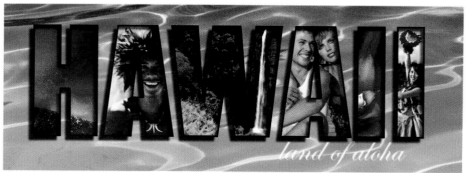

Source Adobe® Photoshop®, 2013. Man playing ukulele: Glowimages/Getty Images, Waterfall: MIXA Co. Ltd./Getty Images, Couple: Thomas Schweizer/ Getty Images, Volcano: Paul Souders/Getty Images, Flower: Allan Baxter/Getty Images, Hula Dancer: Justin Horrocks/Getty Images, Water: Chris Botello.

AUTHOR'S NOTE

From a design perspective there's a lot to look at as the result of these three simple changes. First, note how the black stroke is so much better for the illustration than the white stroke. The black stroke delineates the letterforms, but it does so without calling attention to itself. Compare that to the white stroke, which practically screamed, "Hey, look at me! I'm a white stroke!" Note too how the black stroke is a segue to the dark drop shadow behind it. The reduction of the opacity of the shadow from 85% to 70% creates a more consistent transparency effect with the 50% opacity of the inner shadow.

7. Drag the **Opacity slider** to 85, click **OK**, then compare your work to Figure 26.

 Take some time to note how the drop shadow adds a sense of depth to the illustration. Note how the images in the letterforms appear more vibrant in contrast to the dark shadow behind them.

8. Save your work.

9. Target the **HAWAII layer**, then double-click the **Stroke effect** listed beneath the HAWAII layer on the Layers panel.

 The Layer Style dialog box opens showing the Stroke settings you applied earlier.

10. Change the stroke color to black, then click **OK**.

11. Click **Drop Shadow** in the list on the left side of the dialog box.

 The Layer Style dialog box changes to show the Drop Shadow settings you applied earlier.

TIP Be sure to click the Drop Shadow name itself, not the check box beside it.

12. Drag the **Opacity slider** to 70%.

13. Click **Inner Shadow** in the list on the left side of the dialog box.

14. Drag the **Distance slider** to 17 px, drag the **Opacity slider** to 50%, click **OK**, then compare your canvas to Figure 27.

 An Inner Shadow effect layer now appears on the Layers panel between Drop Shadow and Stroke.

TIP Layer styles are listed in alphabetical order, regardless of the order in which they are applied.

15. Save your work.

Copy Layer Styles
BETWEEN LAYERS

What You'll Do

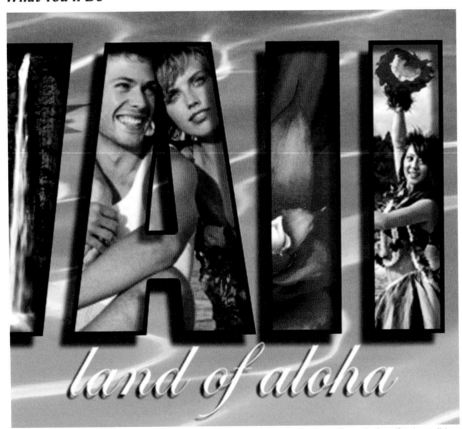

Source Adobe® Photoshop®, 2013. Waterfall: MIXA Co. Ltd./Getty Images, Couple: Thomas Schweizer/Getty Images, Flower: Allan Baxter/Getty Images, Hula Dancer: Justin Horrocks/Getty Images, Water: Chris Botello.

We've spent much time up to this point discussing how adjustment layers and layer styles are so powerful because they can be modified at any time. We also have discussed how they remain in the Layers panel as a record of the adjustments and styles that you've applied to the image.

This lesson brings these two great features together. Layer styles can be copied between layers. This allows you to create a specific style only once and then use it multiple times in the document.

The ability to modify layer styles becomes very important when duplicating layer styles. Duplicating a layer style is a quick and effective method for applying the same style to multiple layers. However, the specific style settings for one layer may or may not work for the artwork on other layers. No problem. With layer styles, you can simply adjust the style to fit the new artwork.

Figure 28 *Results of copying the layer style*

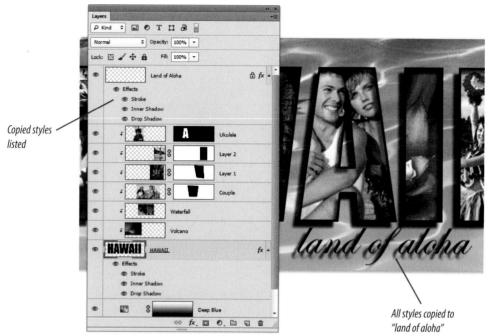

Copied styles listed

All styles copied to "land of aloha"

Source Adobe® Photoshop®, 2013. Man playing ukulele: Glowimages/Getty Images, Waterfall: MIXA Co. Ltd./Getty Images, Couple: Thomas Schweizer/Getty Images, Volcano: Paul Souders/Getty Images, Flower: Allan Baxter/Getty Images, Hula Dancer: Justin Horrocks/Getty Images, Water: Chris Botello.

Copy styles between layers

1. Verify that you can see all the layers on the Layers panel.

2. Note the three layer styles listed beneath the HAWAII layer, then note the layer effects icon at the right side of the HAWAII layer.

 TIP The layer effects icon represents all the styles applied to the layer.

3. Press and hold **[Alt]** (Win) or **[option]** (Mac), then drag the **layer effects icon** up to the Land of Aloha layer, releasing when you see a black rectangle around the layer.

4. Compare your artwork to Figure 28.

 The three layer styles are copied from the Hawaii layer to the Land of Aloha layer. The Land of Aloha type appears black because the black stroke is so wide that it fills the letters.

 (continued)

5. Target the **Land of Aloha layer**, click the **Layer menu**, point to **Layer Style**, then click **Scale Effects**.

6. Type **30** in the Scale Layer Effects dialog box, then click **OK**.

7. Hide the Stroke and Inner Shadow effects on the Land of Aloha layer, then compare your canvas to Figure 29.

8. Save your work.

Figure 29 *Copied layer style*

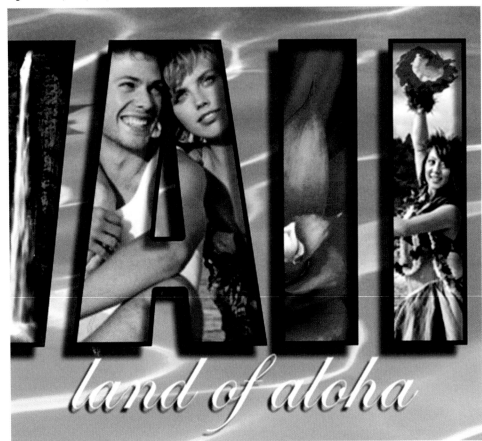

Source Adobe® Photoshop®, 2013. Waterfall: MIXA Co. Ltd./Getty Images, Couple: Thomas Schweizer/Getty Images, Flower: Allan Baxter/Getty Images, Hula Dancer: Justin Horrocks/Getty Images, Water: Chris Botello.

Apply a Blending
MODE

What You'll Do

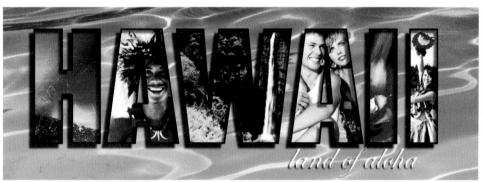

Source Adobe® Photoshop®, 2013. Man playing ukulele: Glowimages/Getty Images, Waterfall: MIXA Co. Ltd./Getty Images, Couple: Thomas Schweizer/Getty Images, Volcano: Paul Souders/Getty Images, Flower: Allan Baxter/Getty Images, Hula Dancer: Justin Horrocks/Getty Images, Water: Chris Botello.

 In this lesson, you will use a Hue/Saturation adjustment layer to apply an Overlay blending mode to the artwork.

Blending modes are in some ways the most "advanced" features in Photoshop, but only from the intellectual perspective. To apply a blending mode couldn't be easier: click the blending mode menu on the Layers panel, then choose a blending mode. What's more challenging is getting familiar with what each blending mode does. Some of them, like Multiply or Screen, are easy to understand. Others, like Hard Light or Color Burn are less predictable.

What's even more challenging is learning how to use blending modes to achieve a "look" that you have in your mind, the right look for the imagery you're trying to create. That comes only with experience and a willingness to try to develop some level of intellectual understanding of each blending mode and how and why it does what it does.

In this lesson, you'll apply one of the more essential blending modes, Overlay, to improve the overall effect and finish the artwork.

Use the Overlay blending mode to add vibrancy to artwork

1. Target the **Ukulele layer** in the Layers panel.

2. Click the **Create new fill or adjustment layer button** on the Layers panel, then click **Hue/Saturation**.

 An unclipped Hue/Saturation adjustment layer is added above the Ukulele layer. Note that the adjustment layer itself has no effect on the image; adjustment layers only affect an image when actual adjustments are made.

3. Clip the Hue/Saturation adjustment layer into the layers beneath it.

 The Hue/Saturation adjustment layer can now only affect the images clipped into the HAWAII type.

4. Click the **blending mode menu** on the Layers panel, click **Overlay**, then compare your screen to Figure 30.

 One of the basic functions of the Overlay blending mode is that it always increases contrast. Thus, dark areas of an image get darker, bright areas of an image get lighter, and the color becomes more intense or saturated.

5. On the Properties panel, drag the **Lightness slider** to +40. Because you used a Hue/Saturation adjustment layer to apply the Overlay blending mode, you have the controls in the Hue/Saturation adjustment layer at your disposal to modify how the blending mode affects the artwork.

 TIP If the Properties panel is not open, double-click the Hue/Saturation icon on the Ukulele layer to open it.

 (continued)

Figure 30 *Viewing the Overlay blending mode effect*

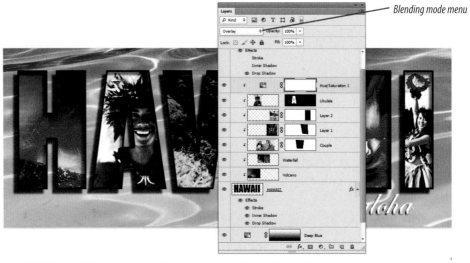

Blending mode menu

Source Adobe® Photoshop®, 2013. Man playing ukulele: Glowimages/Getty Images, Waterfall: MIXA Co. Ltd./Getty Images, Couple: Thomas Schweizer/Getty Images, Volcano: Paul Souders/Getty Images, Flower: Allan Baxter/Getty Images, Hula Dancer: Justin Horrocks/Getty Images, Water: Chris Botello.

Figure 31 *The final artwork*

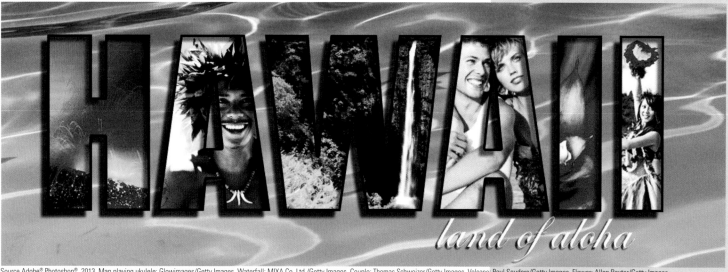

Source Adobe® Photoshop®, 2013. Man playing ukulele: Glowimages/Getty Images, Waterfall: MIXA Co. Ltd./Getty Images, Couple: Thomas Schweizer/Getty Images, Volcano: Paul Souders/Getty Images, Flower: Allan Baxter/Getty Images, Hula Dancer: Justin Horrocks/Getty Images, Water: Chris Botello.

6. Drag the **Saturation slider** to +29.

7. Hide and show the Hue/Saturation adjustment layer and examine how the Overlay blending mode has affected this image.

 Taking the time to hide and show blending mode layers is essential to train your eye to become familiar with and recognize the effects of various blending modes.

8. Verify that the Hue/Saturation adjustment layer is showing.

9. Press **[F]** on your keypad twice or until the artwork is positioned against a black background.

10. Compare your artwork to Figure 31.

11. Press **[F]** again to return to Standard Screen Mode, save your work, then close Hawaii.psd.

Transform with a
PUPPET WARP

What You'll Do

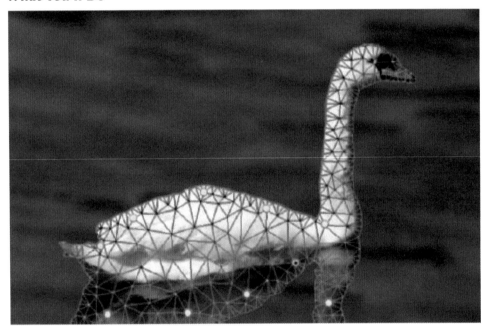

© 2013 Cengage Learning. Source Adobe® Photoshop®, 2013.

Like the Scale and Rotate commands, Puppet Warp is a transform command that allows you to modify targeted artwork. The Puppet Warp command creates a mesh over targeted artwork. You interact with that mesh to specify areas that you want to transform and areas that you want to remain unaffected. This is what makes Puppet Warp so revolutionary: you can protect some areas while radically transforming others.

You can use the Puppet Warp for subtle transformations, like reshaping clothing or hair, and you can use it for dramatic transformations, like moving a subject's arms and legs. You could make a cat's tail bend in the opposite direction, or you could reshape a pencil into a question mark.

The Puppet Warp will be very useful when you are creating complex montages—like the Black Knight poster in Chapter 6. Once you've positioned images the way you want them, you can use the Puppet Warp to make slight or even dramatic changes so the images work together exactly as you want them to.

Working with Layers

Figure 32 *Adding push pins*

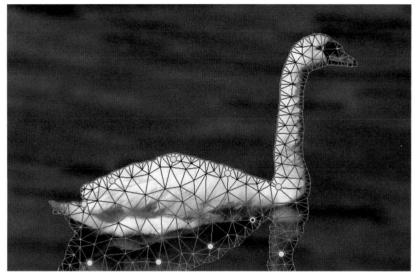

© 2013 Cengage Learning. Source Adobe® Photoshop®, 2013.

Use the Puppet Warp command

1. Open AP 1-2.psd, then save it as **Puppet Warp**.

 Note that the swan artwork is on its own layer.

2. Target the **Swan layer**, click the **Edit menu**, then click **Puppet Warp**.

 A mesh appears covering the entire contents of the layer, and the cursor changes to the Add Push Pin pointer.

 TIP Verify that the Show Mesh check box is checked on the Options bar to view the mesh.

3. Using Figure 32 as a guide, click the areas of the mesh to add push pins.

 These areas will remain unaffected if you transform other areas of the mesh.

 (continued)

4. Click the **push pin** at the base of the head, as shown in Figure 33.

5. Float over the push pin at the base of the head so that your cursor changes to an arrow, then click and drag to move the head and neck as shown in Figure 34.

(continued)

Figure 33 *Adding a push pin at the base of the head*

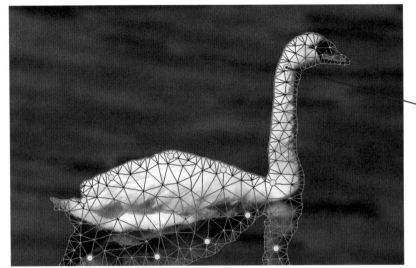

New push pin

© 2013 Cengage Learning. Source Adobe® Photoshop®, 2013.

Figure 34 *Moving the head and neck to the right*

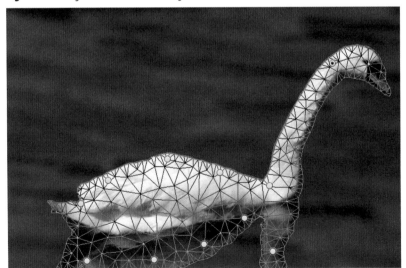

© 2013 Cengage Learning. Source Adobe® Photoshop®, 2013.

Working with Layers

Figure 35 *Pulling the neck back from a new push pin*

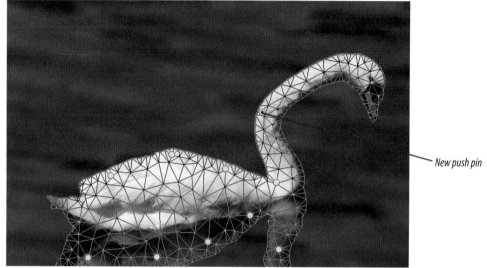

— New push pin

© 2013 Cengage Learning. Source Adobe® Photoshop®, 2013.

6. Click the **push pin** near the center of the neck, then move the neck to the left as shown in Figure 35.

(continued)

7. Click and drag the pin you created at the base of the head to reshape the image as shown in Figure 36.

8. Click to add a pin on the swan's eye, then drag the head straight down to create an elegant arc at the top of the neck.

(continued)

Figure 36 *Moving the head to the left*

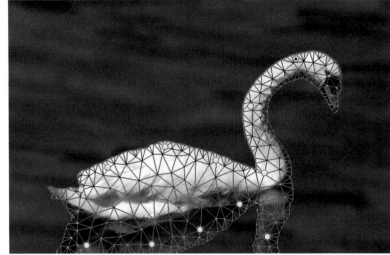

© 2013 Cengage Learning. Source Adobe® Photoshop®, 2013.

The Puppet Warp Settings

The exercise in this lesson represents a practical application of the Puppet Warp command: enhancing the appeal of an image with a complex transformation. As you have certainly figured out, the Puppet Warp can also be used for wild special effects. Imagine tying a knot in a pencil or bending a spoon to the shape of the letter U—that's totally doable with the Puppet Warp command.

The list below will familiarize you with some additional settings on the Options bar and techniques you can experiment with when using the Puppet Warp command:

The **Mode** setting determines the elasticity of the mesh.

The **Density** setting determines the spacing of mesh points—how closely you can position them. The more points you add increases precision but also demands more processing from your computer.

The **Expansion** setting expands or contracts the outer edge of the mesh. Use this setting when the choice for whether or not to warp the edge is a factor in the transformation.

Deselect the **Show Mesh** check box to show only the pins, not the mesh itself.

Click a pin to select it. Press Delete to remove a selected pin. Click the Remove All Pins button on the Options bar to clear all pins from the mesh.

Figure 37 *Warped swan*

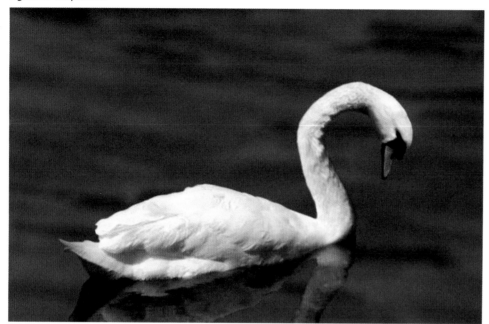

© 2013 Cengage Learning. Source Adobe® Photoshop®, 2013.

9. Press **[Ctrl][H]** (Win) or ⌘ **[H]** (Mac) repeatedly to hide and show the mesh.

 When you hide the mesh, the push pins remain visible.

TIP To hide and show the mesh, you can also check and uncheck the Show Mesh check box on the Options bar.

10. Click and drag the **single push pin** in the reflection of the neck left to mirror the change to the swan's neck.

11. Click the **Move tool** , click **Apply**, then compare your result to Figure 37.

12. Save your work, then close Puppet Warp.psd.

1. Open AP 1-3.psd, then save it as **Hawaii Noise**.
2. Target the Hue/Saturation 1 layer, then click the Create a new layer button on the Layers panel.
3. Name the new layer **Noise**.
4. Click the Edit menu, then click Fill.
5. Enter the settings shown in Figure 38, then click OK.
6. Change the blending mode on the Noise layer to Overlay.

Figure 38 *Fill settings*

Source Adobe® Photoshop®, 2013.

Working with Layers

7. Set the blending mode back to Normal.
8. Click the Filter menu, point to Noise, then click Add Noise.
9. Enter the settings shown in Figure 39, then click OK.

Figure 39 *Add Noise settings*

Source Adobe® Photoshop®, 2013.

10. Change the blending mode on the Noise layer to Overlay, then compare your artwork to Figure 40.
11. Save your work, then close Hawaii Noise.psd.

Figure 40 *Completed Project Builder 1*

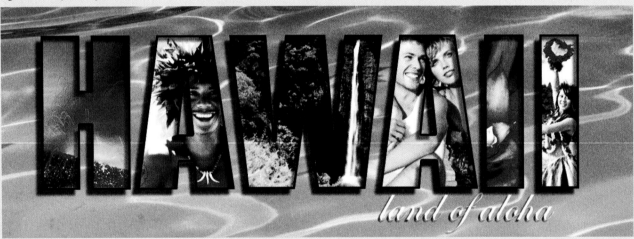

Source: Adobe® Photoshop®, 2013. Man playing ukulele: Glowimages/Getty Images, Waterfall: MIXA Co. Ltd./Getty Images, Couple: Thomas Schweizer/Getty Images, Volcano: Paul Souders/Getty Images, Flower: Allan Baxter/Getty Images, Hula Dancer: Justin Horrocks/Getty Images, Water: Chris Botello.

1. Open AP 1-4.psd, then save it as **Puppet Pencil**.
2. Target the Pencil layer, click the Edit menu, then click Puppet Warp.
3. Add a pin in the yellow paint at the top of the pencil.
4. Add a second pin in the yellow paint at the bottom of the pencil.
5. Add a third pin in the center of the yellow paint.
6. Drag the top point clockwise to the right to warp the pencil.
7. Add a pin in the eraser and a pin at the point then warp the pencil to resemble Figure 41.
8. Save your work, then close Puppet Pencil.psd.

Figure 41 *Completed Project Builder 2*

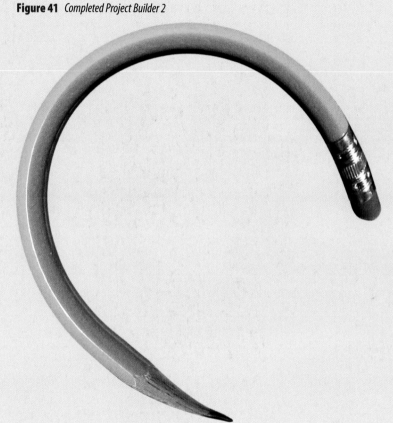

© 2013 Cengage Learning. Source Adobe® Photoshop®, 2013.

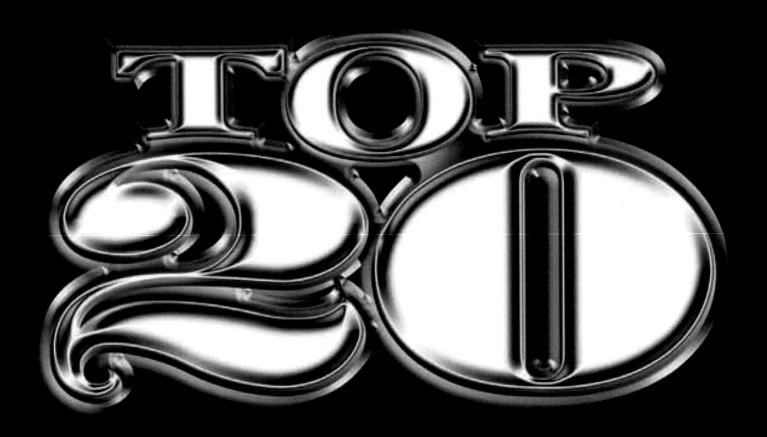

CHAPTER 2

WORKING WITH
LAYER STYLES

1. Copy and paste from Illustrator to Photoshop.

2. Export layers from Illustrator to Photoshop.

3. Create a Chisel Hard Emboss layer style.

4. Create a Stamp Visible layer.

5. Create a Smooth Emboss layer style.

6. Create and apply a Gradient Overlay layer style.

7. Create a Pillow Emboss layer style.

8. Create a chrome effect without using layer styles.

9. Duplicate a chrome effect with saved curves.

Copy and Paste from
ILLUSTRATOR TO PHOTOSHOP

What You'll Do

Image courtesy of Chris Botello. Source Adobe® Photoshop®, 2013.

Adobe Illustrator is an articulate and powerful software package, but many professional designers are so Photoshop-oriented that they completely ignore Illustrator. They tell themselves that Photoshop can do everything that Illustrator can do—but that's not true.

Illustrator offers many smart and sophisticated options for working with paths and typography. Incorporate Illustrator into your skills set, and you'll soon find that you're producing typography and graphics that are more interesting and sophisticated than what most other designers are coming up with using just Photoshop. That's a sweet edge to have in the competitive world of graphic design.

Figure 1 *Pasting an Illustrator path as pixels in Photoshop*

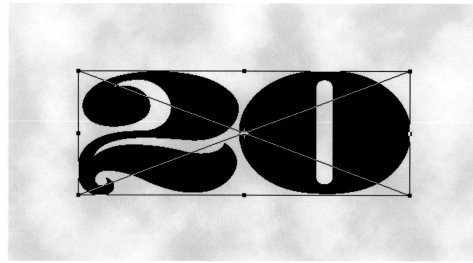

Image courtesy of Chris Botello. Source Adobe® Photoshop®, 2013.

Copy and Paste from Illustrator to Photoshop

1. Open AI 2-1.ai in Illustrator, click **Edit** (Win) or **Illustrator** (Mac) on the Menu bar, point to **Preferences**, then click **File Handling & Clipboard**.
2. In the Clipboard on Quit section, verify that the PDF and the AICB (no transparency support) check boxes are both checked and that only the Preserve Paths option button is selected, then click **OK**.

 See the Author's Note on this page.
3. Click the **Selection tool**, select the two numbers, then copy them.
4. Switch to Photoshop, open PS 2-2.psd in Photoshop, then save it as **Paste from Illustrator**.
5. Display the Layers panel, if necessary.
6. Click the **Edit menu**, then click **Paste**.

 The Paste dialog box appears, offering you four options for pasting. We will explore the Pixels, Path, and Shape Layer options in this chapter.
7. Click the **Pixels option button**, then click **OK**.

 As shown in Figure 1, the artwork is pasted in a bounding box, which can be resized, rotated, and so on.

 (continued)

8. Click the **Move tool** 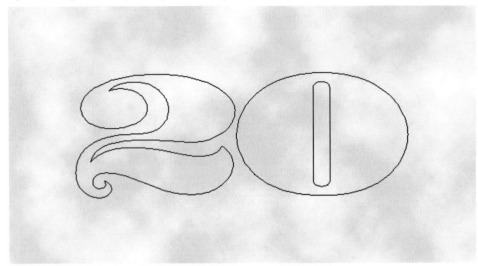, then click **Place**.

 When you paste as pixels, the result of the paste is a bitmap graphic, which is pasted as a new layer. No vector information is pasted with the graphic.

9. Delete the new layer.

10. Click the **Edit** menu, click **Paste**, click the **Path option button**, then click **OK**.

 As shown in Figure 2, the path from Illustrator is pasted; a new layer is not created.

11. Click the **Window menu**, click **Paths**, then note that the path was pasted as a new Work Path in the Paths panel.

12. Click below the Work Path on the Paths panel to turn the Work Path off.

 The path disappears.

13. Change the foreground color to any red swatch on the Swatches panel.

 (continued)

Figure 2 *Pasting an Illustrator path as a path in Photoshop*

Image courtesy of Chris Botello. Source Adobe® Photoshop®, 2013.

Working with Layer Styles

Figure 3 *Pasting an Illustrator path as a shape layer in Photoshop*

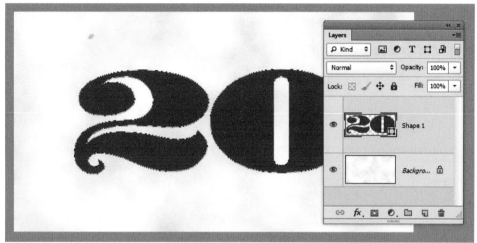

Image courtesy of Chris Botello. Source Adobe® Photoshop®, 2013.

14. Paste again, click the **Shape Layer option button**, then click **OK**.

 As shown in Figure 3, the artwork is pasted as a shape layer and uses the foreground color as its fill.

 Shape layers are vector graphics positioned on layers in a Photoshop document. As vectors, they can be scaled and otherwise transformed without any loss in quality. This makes shape layers ideal for handling paths from Illustrator.

15. Save your work, close AI 2-1.ai, then close Paste from Illustrator.psd.

Export Layers from
ILLUSTRATOR TO PHOTOSHOP

What You'll Do

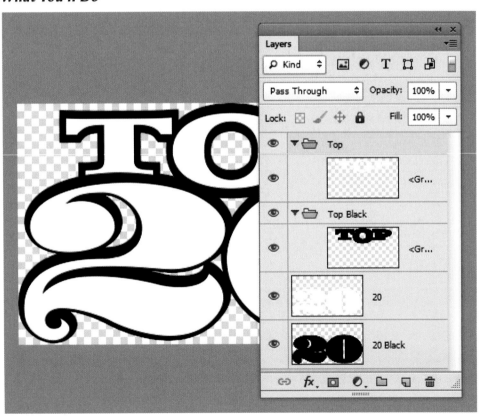

Image courtesy of Chris Botello. Source Adobe® Photoshop®, 2013.

Photoshop and Illustrator are remarkably compatible. Incorporating the power of Illustrator into your Photoshop skills set expands your overall skills set as a designer exponentially. When you are as fluent in Illustrator as you are in Photoshop, you'll find that much of the artwork you want to create in Photoshop is best started in Illustrator, with all of its great drawing tools and precise typographical abilities.

With each upgrade, Adobe has strived to make Photoshop and Illustrator more and more compatible. One of the best features of that compatibility is the ability to export layered artwork from Illustrator to Photoshop while maintaining the layer structure created in Illustrator.

Figure 4 *Export dialog box*

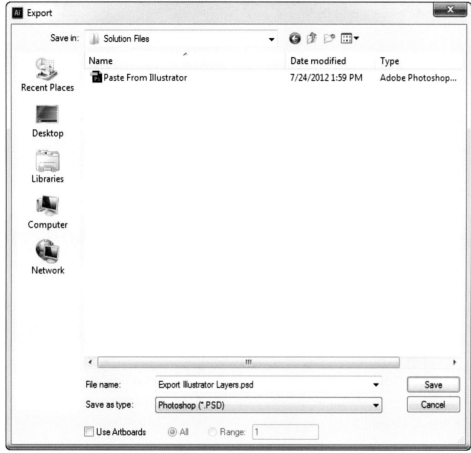

Source Adobe® Photoshop®, 2013.

Export layers from Illustrator to Photoshop

1. Open AI 2-3.ai in Adobe Illustrator, then save it as **Export Illustrator Layers**.

 TIP When saving, click OK to accept the default settings in the Illustrator Options dialog box.

2. Display the Layers panel, click the **Selection tool** then pull the individual pieces of the illustration apart, keeping an eye on the Layers panel.

3. Click the **File menu**, click **Revert**, then click **Revert** in the dialog box that follows.

4. Click the **File menu**, then click **Export**.

5. Click the **Save as type list arrow** (Win) or the **Format list arrow** (Mac) in the Export dialog box, then click **Photoshop (*.PSD)** (Win) or **Photoshop (psd)** (Mac), as shown in Figure 4.

 TIP Note that the file to be exported is automatically named with the .psd extension: Export Illustrator Layers.psd.

6. Click **Save** (Win) or **Export** (Mac).

 The Photoshop Export Options dialog box opens.

7. Click the **Color Model list arrow**, click **RGB**, click the **Resolution list arrow**, then click **High (300 ppi)**.

 With this export, you are creating a Photoshop file. The choices you made in this step determine the color model of the file—RGB—and the resolution of the file—300 ppi.

 (continued)

Lesson 2 Export Layers from Illustrator to Photoshop

ADVANCED PHOTOSHOP 2-7

8. In the Options section, click the **Write Layers option button**, click the **Maximum Editability check box**, then verify that the Anti-aliasing setting is Type Optimized (Hinted) so that your dialog box resembles Figure 5.

 With these choices, you have specified that you want to save or "write" the layers from the Illustrator file to the Photoshop file and that you want the artwork to be anti-aliased in the Photoshop file.

9. Click **OK**, then close the Illustrator document.

(continued)

Figure 5 *Photoshop Export Options dialog box*

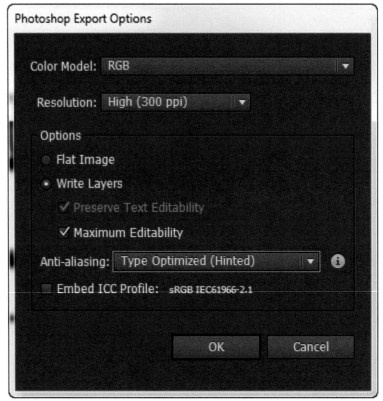

Source Adobe® Photoshop®, 2013.

Working with Layer Styles

Figure 6 *Illustrator artwork and layers exported to Photoshop*

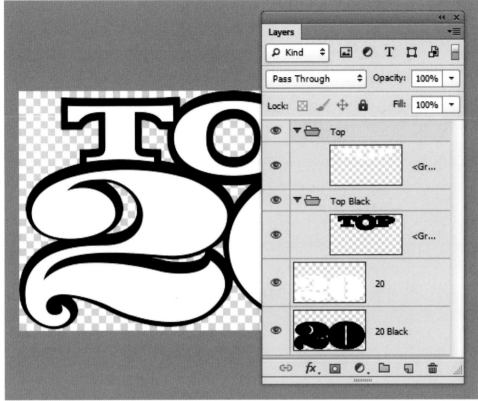

Image courtesy of Chris Botello. Source Adobe® Photoshop®, 2013.

10. Switch to Photoshop, then open Export Illustrator Layers.psd.

11. Notice that the layers from Illustrator—including their layer names—were exported into the Photoshop Layers panel, as shown in Figure 6.

12. Close Export Illustrator Layers.psd.

Create a Chisel Hard
EMBOSS LAYER STYLE

What You'll Do

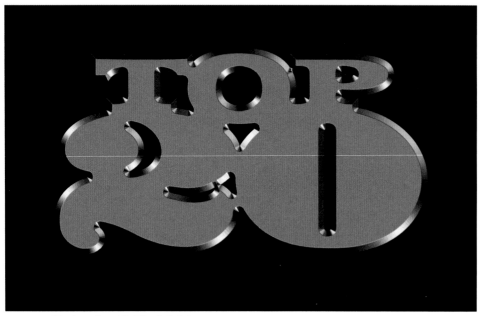

Image courtesy of Chris Botello. Source Adobe® Photoshop®, 2013.

Chisel Hard Emboss, the first of many layer styles you'll experiment and work with in this chapter, creates a dramatic, three-dimensional effect. A chisel is hardly a gentle tool, and this layer style delivers exactly what its name implies: A chiseled effect with a hard edge. Chisel Hard Emboss, a subset of the Bevel and Emboss layer style, is a very useful layer style, one that you will use often, especially when you want to create metallic effects.

Once you've specified settings for a layer style, you can make those settings the default for that type of layer style. This can be enormously useful for saving time from entering the same settings over and over, and it helps you to be sure that your work is consistent.

Creating default layer styles

Once you've specified settings for a layer style, Photoshop allows you to make those settings the default for that type of layer style. This can be enormously useful for saving time from entering the same settings over and over, and it helps you to be sure that your work is consistent. For example, let's say you design a monthly newsletter for a client, and in that newsletter all the photos have a drop shadow. You could save the settings for the drop shadow - the size, distance, spread, opacity, and so on, as a default that you can use every month when designing the piece. You can save default settings for every layer style so, theoretically, you could have a default Bevel & Emboss, a default Inner Shadow, a default Outer Glow, etc. Once you've entered settings, simply click the Make Default button in the Layer Style dialog box. Click the Reset to Default button to restore the original Photoshop defaults for the style.

Create a Chisel Hard Emboss layer style

1. Open PS 2-4.psd, then save it as **Top 20**.

 This file was generated from the same Illustrator layers that you worked with in the previous lessons. The canvas was expanded, and the artwork for Top and 20 has been merged as the 20 Back layer.

2. Verify that you are viewing the document at 50%.

3. Hide the Text layer and the 20 layer, then target the **20 Back layer**.

4. Click the **Layer menu**, point to **Layer Style**, then click **Bevel & Emboss**.

5. Verify that the **Preview check box** is checked, then move the dialog box so that you can see as much of the artwork as possible.

6. Verify that Style is set to **Inner Bevel** in the Structure section.

7. Click the **Technique list arrow**, then click **Chisel Hard**.

8. Drag the **Depth slider** to **100%**.

9. Experiment by dragging the **Size slider**, then set it to **29**.

(continued)

10. Type **42** in the Angle text box.

 The angle determines the angle that the light source strikes the artwork.

11. Type **30** in the Altitude text box.

 The Use Global Light check box should be checked.

12. Click the **Gloss Contour list arrow**, then click **Ring** (the second thumbnail in the second row).

 Gloss contours are preset curves—just like the curves you use to color correct an image—that dramatically affect the contrast and the appearance of the layer effect. Explore the other contours, but be sure to return to Ring.

13. Click the **Anti-aliased check box**, and note the effect on the artwork.

14. For a dramatic effect, increase the contrast by dragging the **Highlight Mode Opacity slider** to **95%**.

15. Click the **Contour check box** directly beneath the Bevel & Emboss check box in the Styles section on the left.

 Like a gloss contour, the Contour check box applies a preset curve.

16. Compare your Layer Style dialog box to Figure 7.

17. Click **OK**, then compare your canvas to Figure 8.

18. Save your work.

Figure 7 *Bevel & Emboss settings in the Layer Style dialog box*

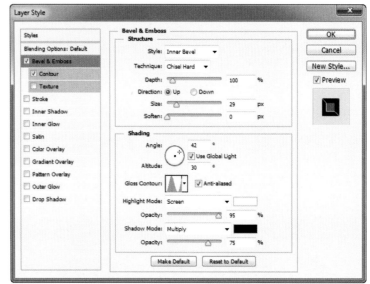

Source Adobe® Photoshop®, 2013.

Figure 8 *Effect of applying the Chisel Hard Inner Bevel layer style*

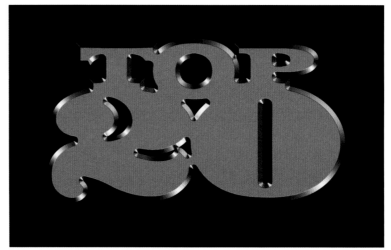

Image courtesy of Chris Botello. Source Adobe® Photoshop®, 2013.

Working with Layer Styles

Figure 9 *Saving settings as a default*

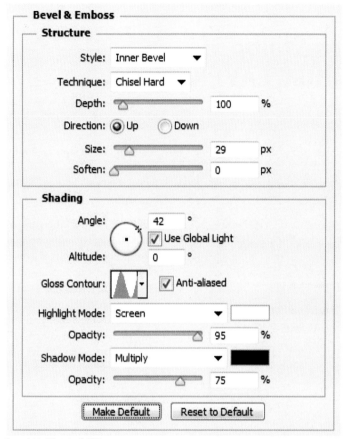

Source Adobe® Photoshop®, 2013.

Make a default layer style

1. Double-click the **Bevel & Emboss layer style** on the Layers panel.

 The dialog box opens showing the settings you entered.

2. Click the **Make Default button**, shown in Figure 9.

 No visible action occurs—for example, you're not offered the option to name the default. However, whenever you apply a Bevel & Emboss layer style in the future, these settings will automatically appear as the default. See the Author's Note on page 11.

3. Click **OK**.

4. Save your work.

Create a Stamp
VISIBLE LAYER

What You'll Do

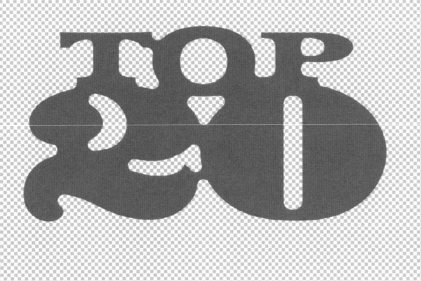

Image courtesy of Chris Botello. Source Adobe® Photoshop®, 2013.

A stamp visible layer copies the entire canvas in its current visual status, then creates a new layer with the artwork flattened onto one layer.

When you're working with complex layered art, a stamp visible layer can be very effective for putting all of your artwork onto one layer so you can manipulate the artwork as a single piece of art. Note the word "visible" in the term Stamp Visible. When you create a stamp visible layer, the entire canvas is copied. Thus, only the visible artwork will be included in the new layer. Artwork on hidden layers will not be "stamped."

Working with Layer Styles

Figure 10 *Using the Stamp Visible command*

Source Adobe® Photoshop®, 2013.

Create a stamp visible layer

1. Verify that the **20 Back layer** is targeted on the Layers panel and that the Bevel & Emboss layer style is showing.

2. Press [**Shift**][**Alt**][**Ctrl**][**E**] (Win) or [**Shift**] [**option**] ⌘ [**E**] (Mac).

 This keyboard sequence is called Stamp Visible. As shown in Figure 10, it takes a picture of the document in its current visible state and copies it into a new layer above the targeted layer.

3. Hide all the other layers except the new layer.

4. Click the **Magic Wand tool** [icon], set the Tolerance to **0**, then verify that the **Anti-alias** and **Contiguous** options are activated.

 (continued)

5. Click to select the gray fill area.

Your selection should resemble Figure 11. Note that we needed to create the stamp visible layer to select this area. In the layered artwork, this area is created by the Bevel & Emboss layer style; thus it is a virtual area. Only when flattened is it selectable with the Magic Wand tool.

(continued)

Figure 11 *Selecting the gray fill area*

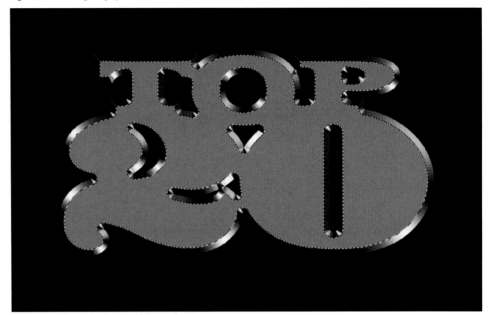

Image courtesy of Chris Botello. Source Adobe® Photoshop®, 2013.

Working with Layer Styles

Figure 12 *Gray fill area isolated*

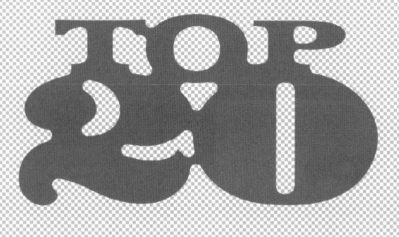

Image courtesy of Chris Botello. Source Adobe® Photoshop®, 2013.

6. Click the **Select menu**, then click **Inverse**.
7. Press [**Delete**] to delete the selected pixels.
8. Deselect, then compare your canvas to Figure 12.
9. Save your work.

Create a Smooth
EMBOSS LAYER STYLE

What You'll Do

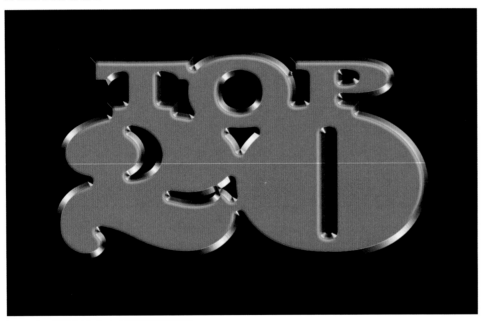

Image courtesy of Chris Botello. Source Adobe® Photoshop®, 2013.

In the early days of computer graphics, naysayers dismissed computer-generated art as automated and monotonous. Their criticism was that all you do is take some artwork, apply a filter, and what you get is what you get. Of course, that is an extremely limited view of computer graphics. What it overlooks is that computer graphic design is not about "applying a filter"—anybody can do that. Computer graphic design is about knowing all the utilities that you have at your disposal and, even more challenging, knowing how and when to use those tools to create an image that you have in your imagination. This lesson will provide you with a great example of using two different layer styles—each from the same dialog box—and making them work in tandem to create unique artwork.

Figure 13 *Settings for the smooth emboss*

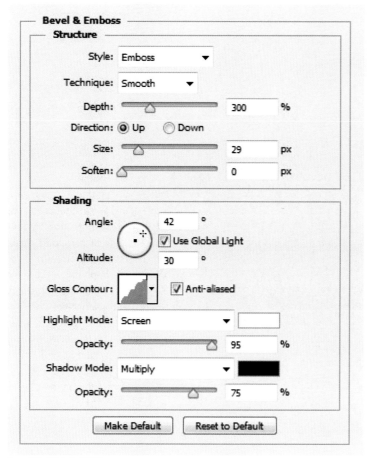

Source Adobe® Photoshop®, 2013.

Create a Smooth Emboss layer style

1. Show the Layer 1 and 20 Back layers, then rename the 20 Back layer **Chisel Hard Emboss**.

2. Rename Layer 2 **Smooth Emboss**, then verify that it is the targeted layer.

3. Create a Bevel & Emboss layer style.

 The Layer Style dialog box opens with the default Bevel & Emboss settings.

4. Set the Style to **Emboss**, set the Technique to **Smooth**, then set the Depth to **300**.

5. Drag the **Size slider** to **29**.

6. Click the **Gloss Contour list arrow**, then click **Rounded Steps**, the fifth icon in the second row.

7. Click the **Anti-aliased check box**.

TIP For the exercises in this chapter, and usually for all the gloss contours you apply in your own work, activate the Anti-aliased option.

8. Compare your settings to Figure 13, then click **OK**.

(continued)

9. Hide the Chisel Hard Emboss layer so that you can see the Smooth Emboss layer on its own.

As shown in Figure 14, the Smooth Emboss effect is dramatically different from the Chisel Hard Emboss effect. Both feature a bevelled edge, but where the Chisel Hard Emboss features a hard, shiny edge, the Smooth Emboss presents a much softer edge—thus the term Smooth Emboss.

(continued)

Figure 14 *Smooth Emboss effect on its own*

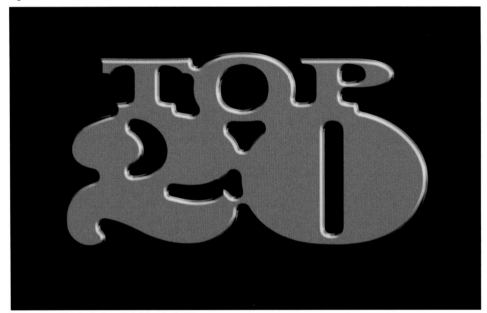

Image courtesy of Chris Botello. Source Adobe® Photoshop®, 2013.

Working with Layer Styles

Figure 15 *Two layer styles creating one effect*

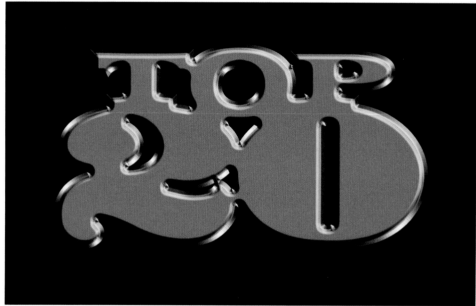

Image courtesy of Chris Botello. Source Adobe® Photoshop®, 2013.

10. Show both embossed layers, then compare your canvas to Figure 15.

Lesson 5 Create a Smooth Emboss Layer Style

ADVANCED PHOTOSHOP 2-21

Create and Apply a
GRADIENT OVERLAY LAYER STYLE

What You'll Do

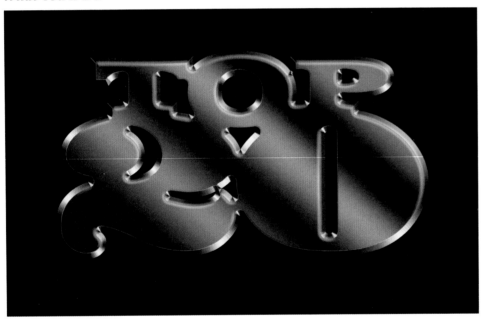

Image courtesy of Chris Botello. Source Adobe® Photoshop®, 2013.

In most illustrations in which gradients are utilized, the gradient is often an element that calls attention to itself. By its very nature, it has movement—the shift from one color to other colors—and that movement is often noticeable. In this lesson, you're going to use a gradient overlay for a subtle effect: to enrich the Smooth Emboss effect you created in the previous lesson. You'll see how the gradient overlay adds complexity to the layer style effect and how it contributes to the metallic effects that are the key to this illustration. But there's a little twist. As you go through the later lessons in this chapter, you'll see that the gradient overlay will be covered mostly by other elements. In the final version of the illustration, it will be interesting for you to note the very subtle role that this gradient overlay ultimately plays.

Figure 16 *Specifications for the gradient*

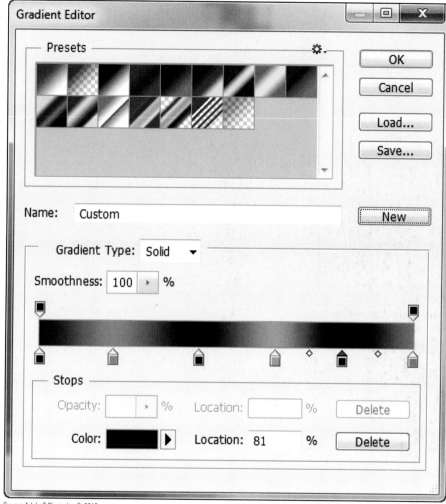

Source Adobe® Photoshop®, 2013.

Create and apply a Gradient Overlay layer style

1. Double-click the **Effects sublayer** under the Smooth Emboss layer.

2. Click the words **Gradient Overlay** in the Styles section on the left.

 A default black and white gradient is applied to the Smooth Emboss layer style.

3. Click the **black and white gradient** in the Gradient section.

4. Double-click the **first color stop**, type **41** in the R, G, and B text boxes in the Color Picker dialog box, then click **OK**.

5. Double-click the **second color stop**, type **140** in the R, G, and B text boxes, then click **OK**.

6. Click the bottom edge of the **gradient ramp** anywhere between the two color stops to add a third color stop.

7. Drag the **new color stop** left until the Location text box value is **20**.

8. Double-click the **new color stop**, type **150** in the R, G, and B text boxes, then click **OK**.

9. Click the bottom edge of the gradient ramp to the right of the new color stop to add a fourth, then drag it until the Location text box value is **43**.

10. Double-click the **new color stop**, type **36** in the R, G, and B text boxes, then click **OK**.

11. Click the bottom edge of the gradient ramp to the right of the new color stop to add a fifth, then drag it until the Location text box value is **63**.

(continued)

12. Double-click the **new color stop**, type **190** in the R text box, **164** in the G and B text boxes, then click **OK**.

 This color stop has a slightly pink color cast.

13. Click to the right of the new color stop to add a sixth, then drag it until the Location text box value is **81**.

14. Double-click the **new color stop**, type **14** in the R, G, and B text boxes, then click **OK**.

 Your Gradient Editor dialog box should resemble Figure 16 on the previous page.

15. Type **Smooth Emboss Overlay** in the Name text box, then click **New**.

 The new gradient appears as a thumbnail in the Presets section.

16. Click **OK** to close the Gradient Editor dialog box.

 The new gradient appears in the Gradient section and is applied to the Smooth Emboss layer style.

17. Click **OK** to close the Layer Style dialog box, then compare your artwork to Figure 17.

 A new sublayer named Gradient Overlay appears beneath Bevel & Emboss in the Smooth Emboss layer.

 (continued)

Figure 17 *Gradient overlay applied*

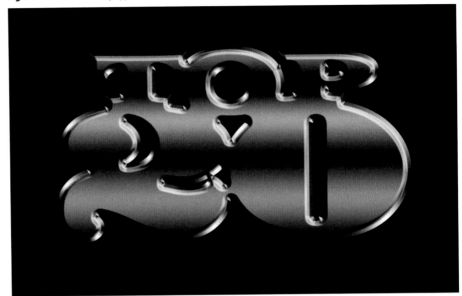

Image courtesy of Chris Botello. Source Adobe® Photoshop®, 2013.

Working with Layer Styles

Figure 18 *Gradient overlay scaled and applied on an angle*

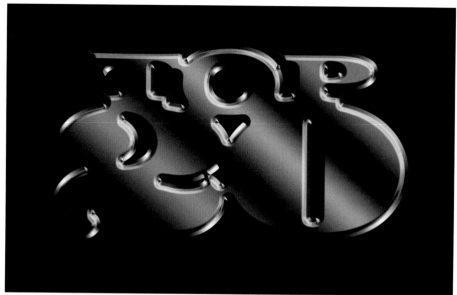

Image courtesy of Chris Botello. Source Adobe® Photoshop®, 2013.

18. Double-click the **Gradient Overlay sublayer** to edit it in the Layer Style dialog box.

19. Type **51** in the Angle text box.

20. Experiment with the Scale slider.

21. Drag the **Scale slider** to **92**, click **OK,** then compare your artwork to Figure 18.

 The often-overlooked Scale slider reduces or enlarges the gradient overlay within the layer style and can be useful for positioning the gradient in a way that is just right for the illustration.

Create a Pillow Emboss
LAYER STYLE

What You'll Do

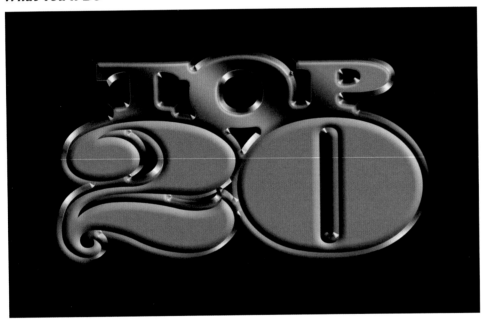

Image courtesy of Chris Botello. Source Adobe® Photoshop®, 2013.

This lesson demonstrates how exporting layers from Illustrator really pays off. You're going to apply yet another layer style, but this time, you will apply it to a foreground component created in Illustrator for this illustration. Keep an eye out for how the layer style adds an entirely new dimension to the artwork, and keep in mind that the basis for the effect was the foreground and background components that were exported from Illustrator.

This lesson also introduces the Pillow Emboss layer style, a multi-faceted layer style that can be used to add soft-edged dimension to artwork. Look for a unique component to the layer style—a glow outside of the object once the style is applied. A fundamental part of working with layers involves duplicating layers and layer styles and adjustment layers between layers. You are going to do it over and over and over again.

Figure 19 *Settings for the Pillow Emboss effect*

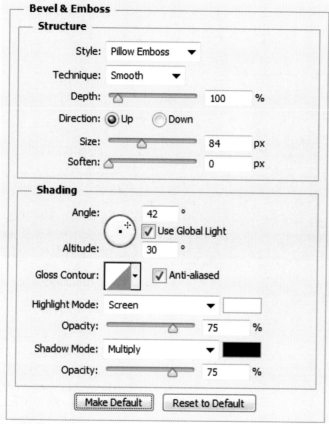

Source Adobe® Photoshop®, 2013.

Create a Pillow Emboss layer style

1. Show the layer named **20**, then change its name to **Pillow Emboss**.

2. Click the **Layer menu**, point to **Layer Style**, then click **Color Overlay**.

3. Click the **red swatch**, type **132** in the R, G, and B text boxes, then click **OK**.

4. Click the words **Bevel & Emboss** in the Styles section.

5. Click the **Style list arrow**, then click **Pillow Emboss**.

6. Set the Technique to **Smooth**, then set the Depth to **100%**.

7. Experiment with the Size slider to get a good sense of what the Pillow Emboss effect does.

8. Drag the **Size slider** to **84**.

9. Verify that all of the settings in the Shading section are the same as those shown in Figure 19.

(continued)

10. Click **OK**, then compare your artwork to Figure 20.

The Pillow Emboss layer style can be applied with a hard or a soft edge. In this case, it's a soft, rounded edge like its name, a pillow.

(continued)

Figure 20 *Results of the Pillow Emboss effect*

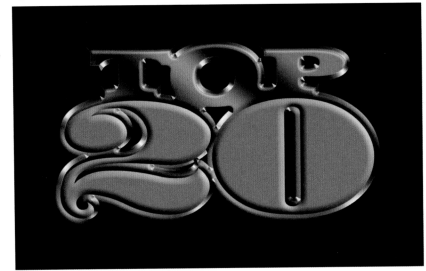

Image courtesy of Chris Botello. Source Adobe® Photoshop®, 2013.

Working with Layer Styles

Figure 21 *Viewing the Pillow Emboss layer style only*

Image courtesy of Chris Botello. Source Adobe® Photoshop®, 2013.

Figure 22 *Illustration with the top text embossed*

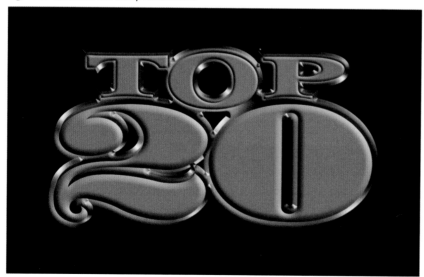

Image courtesy of Chris Botello. Source Adobe® Photoshop®, 2013.

11. Hide the Smooth Emboss and Chisel Hard Emboss layers to see the Pillow Emboss effect against the black background, then compare your canvas to Figure 21.

Note the glow created by the layer style outside the objects. Note too how that affects the artwork behind the pillow embossed objects when all layers are showing.

12. Show the Smooth Emboss and Chisel Hard Emboss layers, then save your work.

Copy layer styles between layers

1. Show the **Text layer**, change its name to **Text Pillow**, then save your work.

2. Press and hold **[Alt]** (Win) or **[option]** (Mac), then drag the **Effects sublayer** in the Pillow Emboss layer group to the Text Pillow layer.

Dragging the Effects sublayer copies *all* the layer styles to the new destination. You can also copy individual styles between layers.

TIP The Size setting on the Pillow Emboss layer style that you copied is too large for the Text Pillow artwork.

3. Double-click the **Bevel & Emboss layer style** in the Text Pillow layer.

4. Drag the **Size slider** to **34**, click **OK**, then compare your artwork to Figure 22.

5. Save your work.

Create a Chrome Effect
WITHOUT USING LAYER STYLES

What You'll Do

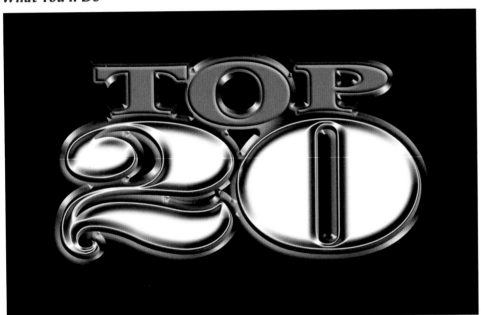

Image courtesy of Chris Botello. Source Adobe® Photoshop®, 2013.

They say that you can't teach an old dog new tricks. That may be true. But remember, it is often the case that the old dog remembers the old tricks that the new dog was never around to have seen in the first place. In so many ways, that is true of Photoshop. With each upgrade, Photoshop has become so much more sophisticated. It has been designed to anticipate effects that designers want, like embosses, bevels, overlays, and contour effects, and it provides settings and sliders that are preset to deliver the goods. That makes for a great application, one in which you can create spectacular effects quickly and easily.

But if you've been around long enough, you remember the days when there were no layer styles. Heck, you remember when there were no layers! Back then, the effects that you wanted to create didn't come prepackaged with the software. You had to figure out how to create effects by combining such basic utilities as filters, selections, channels, and curves. The result is that you had to think harder and work longer. And some of the effects that you could create the old-fashioned way were so complex and unique that no dialog box could possibly duplicate them. That's the case with the chrome effect you will create in this lesson. It's an old recipe, handed down and traded around for years. So if you're a new dog, follow along while the old dog teaches you an old trick.

Working with Layer Styles

Figure 23 *Artwork filled with black*

Image courtesy of Chris Botello. Source Adobe® Photoshop®, 2013.

Figure 24 *Selection saved as a channel*

Image courtesy of Chris Botello. Source Adobe® Photoshop®, 2013.

Lesson 8 Create a Chrome Effect without Using Layer Styles

Save a selection

1. Target the **Pillow Emboss l...** the **Create a new layer butt...** Layers panel.

 The Pillow Emboss layer is duplica...

2. Change the name of the duplicate layer to **Chrome 20**, then drag it to the top of the Layers panel.

3. Drag the **Layer effects icon** *fx* on the Chrome 20 layer to the **Delete layer icon** 🗑 on the Layers panel to delete all the layer styles from the Chrome 20 layer.

4. Press [**D**] to access default colors on the Tools panel, then click the **Lock transparent pixels button** ⊠ on the Layers panel.

5. Fill the artwork with black, then click the selected **Lock transparent pixels button** ⊠ to deactivate it.

6. Hide all the other layers, then compare your canvas to Figure 23.

7. Press and hold [**Ctrl**] (Win) or ⌘ (Mac), then click the **layer thumbnail** on the Chrome 20 layer to load a selection of the artwork.

8. Click the **Select menu**, click **Save Selection**, then type **Original 20** in the Name text box.

9. Click **OK**, show the Channels panel, then click the name **Original 20** on the Channels panel to view the new channel.

 Your screen should resemble Figure 24. The white areas of the channel represent the pixels that were selected when the selection was saved; conversely, the black areas represent those that were not selected.

(continued)

...ick the **RGB channel** on the Channels panel, then save your work.

Use the Emboss filter

1. Verify that the **Chrome 20 layer** is targeted and the artwork is still selected.

2. Click the **Select menu**, point to **Modify**, then click **Feather**.

3. Type **18** in the Feather Radius text box, then click **OK**.

4. Display the Color panel, click the **Color panel menu button** , then click **Grayscale Slider**.

5. Drag the **slider** to **33%**, so that the foreground color is light gray as shown in Figure 25.

6. Click the **Edit menu**, then click **Stroke**.

7. Click the **Inside option button**, type **24** in the Width text box, click **OK**, then compare your work to Figure 26.

 With this method, the stroke plays a major role in the final effect. Keep an eye on this gray stroke throughout this lesson.

8. Click the **Select menu**, then click **Load Selection**.

9. Click the **Channel list arrow**, click **Original 20**, then click **OK**.

 The original selection replaces the feathered selection.

10. Click the **Filter menu**, point to **Stylize**, then click **Emboss**.

(continued)

Figure 25 *Choosing a light gray swatch on the Color panel*

Source Adobe® Photoshop®, 2013.

Figure 26 *Viewing the stroke*

Image courtesy of Chris Botello. Source Adobe® Photoshop®, 2013.

Working with Layer Styles

Figure 27 *Result of the Emboss filter*

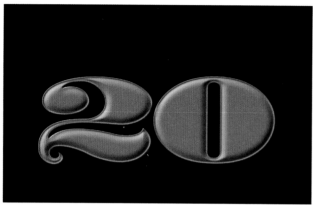

Image courtesy of Chris Botello. Source Adobe® Photoshop®, 2013.

11. Type **135** in the Angle text box, type **13** in the Height text box, type **160** in the Amount text box, then click **OK**.
12. Select the inverse, then delete the selection.

 You are doing this to remove the glow that was created outside the shape when you applied the stroke to the feathered edge.
13. Deselect all, show **Layer 1** on the Layers panel, then compare your artwork to Figure 27.
14. Show all the layers.

Apply a Curves adjustment layer

1. Verify that the **Chrome 20 layer** is targeted.
2. Click the **Layer menu**, point to **New Adjustment Layer**, then click **Curves**.
3. Type **Emboss Curves** in the Name text box, click the **Use Previous Layer to Create Clipping Mask check box**, then click **OK**.

 The Properties panel opens showing the default Curves adjustment.
4. On the Properties panel, drag the **white handle** at the lower-left corner straight up to the upper-left corner, so that your Properties panel resembles Figure 28.

 Note the Input/Output values at the lower-left area of the dialog box. The Input value of the white handle that you moved was 0 (black). Now its Output value is 255 (white). Every point on the horizontal line between the two points is at the top of the dialog box. This means that all the points on the line have a value of 255—they are all white.

 (continued)

Figure 28 *Modifying the curve to make all pixels on the layer white*

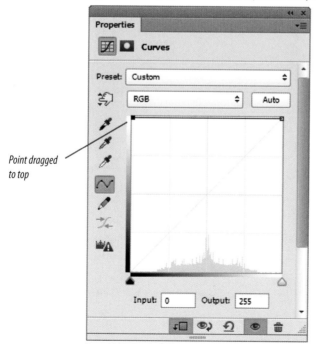

Point dragged
to top

Source Adobe® Photoshop®, 2013.

Lesson 8 Create a Chrome Effect without Using Layer Styles

5. Position your cursor over the horizontal line so that a + sign appears, then moving left to right, click to add three new points, as shown in Figure 29.

Modify curves to create a Chrome effect

1. On the Properties panel, drag the **second point** down to the position shown in Figure 30.

TIP After you select a point, you can simply enter the Input/Output values shown in Figure 30 to reposition it.

(continued)

Figure 29 *Adding points to the curve*

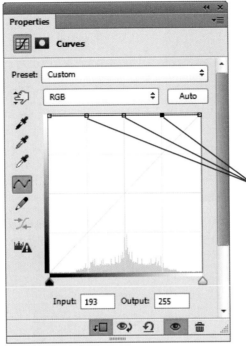

Three points

Source Adobe® Photoshop®, 2013.

Figure 30 *Changing the location of the second point on the curve*

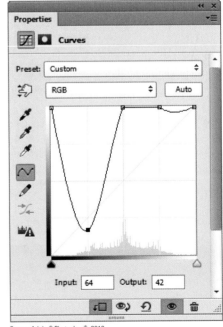

Source Adobe® Photoshop®, 2013.

Working with Layer Styles

Figure 31 *Changing the location of the fourth point*

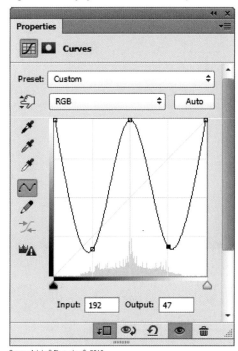

Source Adobe® Photoshop®, 2013.

Figure 32 *Repositioning the far-right point*

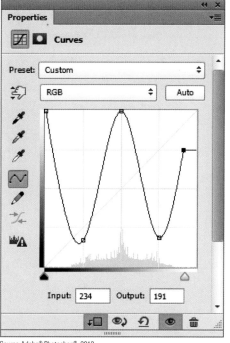

Source Adobe® Photoshop®, 2013.

2. Drag the **fourth point** down to the position shown in Figure 31.

3. Relocate the far-right point to different locations and note how the Chrome effect becomes more intense.

4. Position the far-right point as shown in Figure 32.

5. Click the **Properties panel menu button** ▾☰ click **Save Curves Preset**, then save the curve as **Chrome**.

 When you save a curve, it is automatically saved in the Preset menu on the Properties panel.

 (continued)

6. Click **Save**, then compare your work to Figure 33.

7. Hide and show the Curves adjustment.

 The curves modification achieves a great effect. The only problem is that very harsh highlights can be seen at the edges of the artwork. Zoom in on them to get an idea of why they're creating an unappealing effect.

8. Target the **Chrome 20 layer** on the Layers panel, then load the **Original 20 selection** that you saved.

9. Click the **Select menu**, point to **Modify**, then click **Contract**.

10. Type **7** in the Contract By text box, then click **OK**.

11. Click the **Add layer mask button** on the Layers panel.

12. Compare your artwork to Figure 34.

 Note the big difference that little move made. This is a great example of how you become a better Photoshop designer. Don't just accept what you get. Look for what works and find what doesn't work. When you do, come up with a quick smart solution to get what doesn't work out of there.

 (continued)

Figure 33 *Result of the Curves modifications*

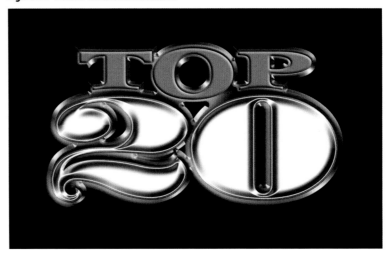

Image courtesy of Chris Botello. Source Adobe® Photoshop®, 2013.

Figure 34 *Artwork after removing unwanted edge effects*

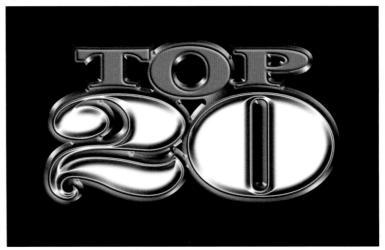

Image courtesy of Chris Botello. Source Adobe® Photoshop®, 2013.

Working with Layer Styles

Figure 35 *Offsetting the Chrome 20 layer*

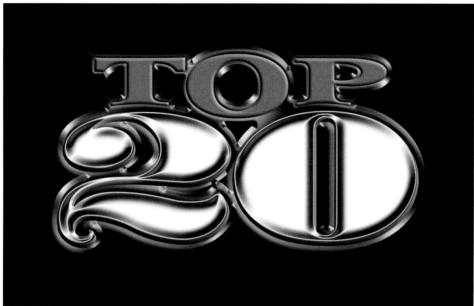

Image courtesy of Chris Botello. Source Adobe® Photoshop®, 2013.

13. Hide and show the **Chrome 20 layer** to see its relationship with the Pillow Emboss effect beneath it.

 Because the Chrome 20 artwork is directly above the Pillow Emboss effect, it pretty much obscures the entire Pillow Emboss effect.

14. Verify that the **Chrome 20 layer** is still targeted, click the **Move tool** ⊕, then click ↑ 12 times.

15. Compare your artwork to Figure 35, then save your work.

Duplicate a Chrome
EFFECT WITH SAVED CURVES

What You'll Do

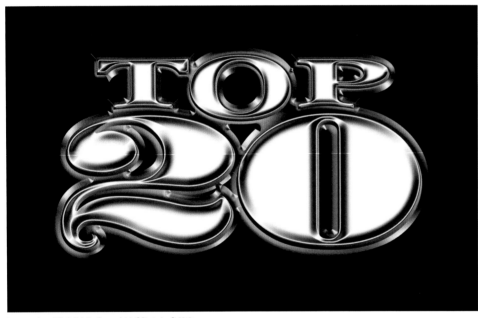

Image courtesy of Chris Botello. Source Adobe® Photoshop®, 2013.

In the previous chapter, you created a chrome effect using a Curves adjustment layer rather than the Bevel & Emboss layer style. When you created that adjustment layer, you saved the curves data as an .acv file. In this lesson, you want to apply that same curve data to the text at the top of the illustration. Rather than duplicate the adjustment layer, you will load the curves data. You can also use this lesson as a second chance to review creating the Chrome effect from the previous lesson.

Working with Layer Styles

Figure 36 *Applying a feathered stroke to the artwork*

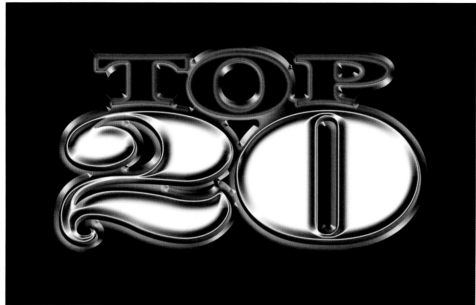

Image courtesy of Chris Botello. Source Adobe® Photoshop®, 2013.

Apply the Emboss filter

1. Duplicate the Text Pillow layer, then change its name to **Chrome Text**.
2. Delete the effects.
3. Press [**D**] to access the default colors on the Tools panel, then click the **Lock transparent pixels button** ▨ on the Layers panel.
4. Fill the artwork with black, then click the selected **Lock transparent pixels button** ▨ to deactivate it.
5. Press and hold [**Ctrl**] (Win) or ⌘ (Mac), then click the **layer thumbnail** on the Chrome Text layer to load a selection of the artwork.
6. Save the selection as **Original TOP**.
7. Click the **Select menu**, point to **Modify**, then click **Feather**.
8. Type **9** in the Feather Radius text box, then click **OK**.
9. Click the **Color panel menu button** ▼≣ then verify that **Grayscale Slider** is checked.
10. Drag the **slider** to **30%**.
11. Click the **Edit menu**, then click **Stroke**.
12. Choose the **Inside option button**, type **12** in the Width text box, then click **OK**.
13. Deselect, then compare your artwork to Figure 36.
14. Load the **Original TOP** selection.
15. Click the **Filter menu**, point to **Stylize**, then click **Emboss**.

(continued)

16. Type **135** in the Angle text box, type **6** in the Height text box, then type **160** in the Amount text box.

17. Click **OK**, then deselect all.

Your artwork should resemble Figure 37.

18. Save your work.

Load saved curves

1. Press and hold [**Alt**] (Win) or [**option**] (Mac), click the **Create new fill or adjustment layer button** 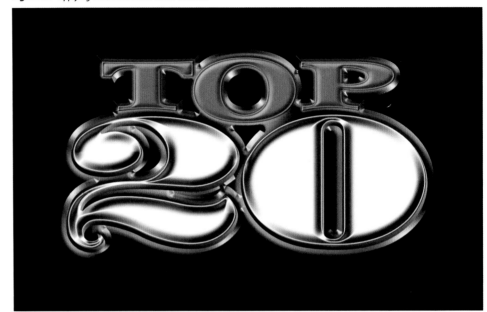, then click **Curves**.

2. Type **Emboss Curves** in the Name text box, click the **Use Previous Layer to Create Clipping Mask check box**, then click **OK**.

3. Click the **Preset list arrow** on the Properties panel, then click **Chrome**.

4. Target the **Chrome Text layer** on the Layers panel, then load the **Original TOP** selection.

5. Zoom in on the letter **T** so that you are viewing it at 100%.

6. Click the **Select menu**, point to **Modify**, then click **Contract**.

7. Type **4** in the Contract By text box, then click **OK**.

8. Click the **Add layer mask button** on the Layers panel.

9. Deselect all.

10. Click the **Move tool**, then move the artwork straight up 10 pixels.

TIP Pressing and holding [Shift] while pressing an arrow key moves a selection 10 pixels in the direction of the arrow you pressed.

(continued)

Figure 37 *Applying the Emboss filter to the artwork*

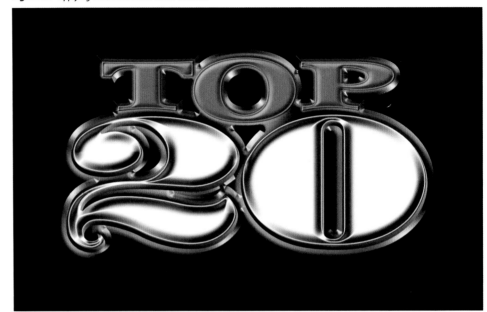

Image courtesy of Chris Botello. Source Adobe® Photoshop®, 2013.

Working with Layer Styles

Figure 38 *Final artwork*

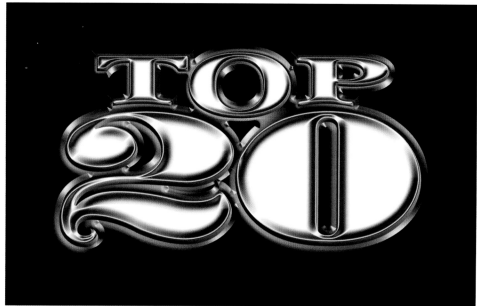

Image courtesy of Chris Botello. Source Adobe® Photoshop®, 2013.

11. Hide the rulers, if necessary.

12. Click the **View menu**, point to **Screen Mode**, then click **Full Screen Mode**.

 Your canvas is positioned within a black screen and the panels are hidden.

 TIP Press [F] or [Esc] to toggle between Full Screen Mode and Standard Screen Mode.

13. Compare your artwork to Figure 38.

14. Save your work, then close Top 20.psd.

1. Open AP 2-5.psd, then save it as **Pink Lady**.
2. Create a new layer above the Background layer, then name it **Back Tray**.
3. Press and hold [Ctrl] (Win) or ⌘ (Mac), then click the Layer thumbnail to load the selection of the Lady layer.
4. Press and hold [Shift] [Ctrl] (Win) or [Shift] ⌘ (Mac), then click the Layer thumbnail to load and add the selection of the Luck layer so that you have a selection of both layers.
5. Target the Back Tray layer.
6. Click the Select menu, point to Modify, then click Expand.
7. Type **18** in the Expand By dialog box, then click OK.
8. Click the Edit menu, then click Fill.
9. Click the Use list arrow, choose 50% Gray, verify that the Opacity is set to 100%, then click OK.
10. Deselect all.
11. Create a Bevel & Emboss layer style.
12. Set the Style to Inner Bevel, set the Technique to Chisel Hard, set the Depth to 100, then set the Size to 10 pixels.
13. Click the Use Global Light check box, then set the Angle to 120.
14. Change the Gloss Contour to Gaussian, verify that the Anti-aliased check box is not checked, then click OK.
15. Target the Lady layer, then add a Bevel & Emboss layer style.
16. Set the Style to Pillow Emboss, set the Technique to Smooth, set the Depth to 100, then set the Size to 29 pixels.
17. Verify that the Use Global Light check box is checked and that the Angle is set to 120.
18. Verify that the Gloss Contour is set to Linear, then click OK.
19. Target the Luck layer, then add a Bevel & Emboss layer style.
20. Set the Style to Pillow Emboss, set the Technique to Chisel Hard, set the Depth to 100, then set the Size to 10 pixels.
21. Verify that the Use Global Light check box is checked and that the Angle is set to 120.
22. Set the Gloss Contour to Cove-Deep, then click OK.
23. Compare your artwork to Figure 39, save your work, then close Pink Lady.psd.

Figure 39 *Completed Project Builder 1*

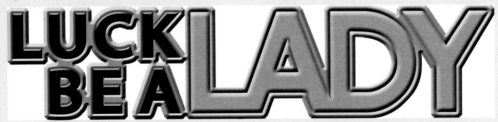

Image courtesy of Chris Botello. Source Adobe® Photoshop®, 2013.

1. Open AP 2-6.psd, then save it as **Luck Be A Lady**. (*Hint*: The typeface is Bellevue.)
2. Target the Pink layer, then add a Bevel & Emboss layer style.
3. Set the Style to Inner Bevel, set the Technique to Chisel Hard, set the Depth to 100, then set the Size to 32 pixels.
4. Verify that the Use Global Light check box is checked and that the Angle is set to 120.
5. Set the Gloss Contour to Ring.
6. Drag the Shadow Mode Opacity slider to 50%, then click OK.
7. Target the Black layer, then add a Bevel & Emboss layer style.
8. Set the Style to Outer Bevel, set the Technique to Chisel Hard, set the Depth to 161, then set the Size to 10 pixels.
9. Verify that the Use Global Light check box is checked and that the Angle is set to 120.
10. Verify that the Gloss Contour is set to Linear, then click OK.
11. Compare your artwork to Figure 40.
12. Save your work, then close Luck Be A Lady.psd.

Figure 40 *Completed Project Builder 2*

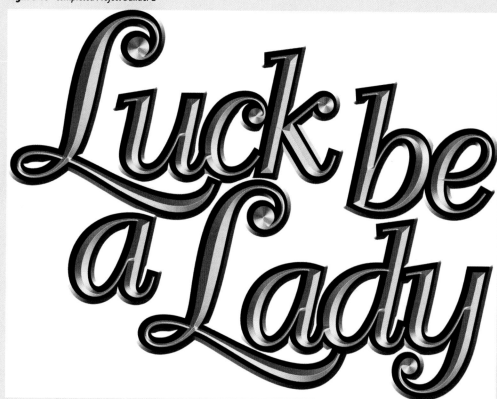

Image courtesy of Chris Botello. Source Adobe® Photoshop®, 2013.

blue

CHAPTER 3 ADJUSTING LEVELS AND HUE/SATURATION

1. Analyze a grayscale image.
2. Adjust levels.
3. Explore the Hue/Saturation adjustment.
4. Adjust hue, saturation, and lightness.

Analyze a
GRAYSCALE IMAGE

What You'll Do

Source Adobe® Photoshop®, 2013. KL Services/Getty Images

In this chapter, we're going to look at Photoshop on its most basic level: the pixel. In Photoshop, everything you do can be reduced to two basic actions: changing the color of pixels or changing the location of pixels. It's a rather stunning statement, if you think about it: everything that this powerful piece of software does all comes down to two basic actions.

In these exercises, you're going to focus on the color of pixels and what it means to modify that color. You're also going to look at how a pixel gets its color in the first place. Understanding Photoshop at its most basic level is the best preparation for learning and executing the complex color adjustments and corrections that you will encounter throughout the remainder of this book.

Remember: It's all about the pixel.

Adjusting Levels and Hue/Saturation

Figure 1 *Info panel*

Sample the pixels in a grayscale image

1. Open AP 3-1.psd, click the **File menu**, then click **Save As**.

2. Type **Levels of Gray** in the File name text box (Win) or Save As text box (Mac), verify that Photoshop (*.PSD; *.PDD) shows in the Format text box, then click **Save**.

3. Click the **Image menu**, point to **Mode**, then note that **Grayscale** is checked.

 This image is in Grayscale mode.

4. Click the **Window menu**, then click **Info** to show the Info panel.

5. Minimize other panels that may be open so that you are only using the Info panel and the Tools panel.

6. Click the **Info panel menu button**, then click **Panel Options**.

7. Click the **Mode list arrow** for the First Color Readout, then click **RGB Color**.

8. Click the **Mode list arrow** for the Second Color Readout, click **HSB Color**, then click **OK** so that your Info panel resembles Figure 1.

TIP Clicking the eyedropper buttons on the Info panel is another method for choosing the desired color mode.

9. Zoom in to 1600%, then scroll around with the **Hand tool**.

(continued)

10. Click the **Eyedropper tool** on the Tools panel then float it over the pixels.

 As you move the pointer the Info panel displays the values of the pixels in the RGB and HSB modes simultaneously.

11. Position the pointer over a single pixel, then note its grayscale value on the Info panel.

 In a grayscale image, a pixel can be one of 256 colors, from 0-255. See the Author's Note below.

12. Zoom out so that you are viewing the image at 100%.

13. Float the pointer over the top black rectangle on the left, as shown in Figure 2, then note the grayscale values on the Info panel.

 TIP Designers and printing professionals refer to dark areas in an image—such as the top two squares in Figure 2—as *shadows*.

14. Float the pointer over the bottom white rectangle.

 TIP Designers and printing professionals refer to light areas in an image—such as the bottom two squares in Figure 2—as *highlights*.

15. Float the pointer over the middle gray rectangle.

 128 is the middle value in the grayscale ramp.

 TIP Designers and printing professionals refer to middle values in an image as *midtones*.

 (continued)

Figure 2 *Sampling pixels*

Source Adobe® Photoshop®, 2013. KL Services/Getty Images

AUTHOR'S NOTE

A pixel is always one color, regardless of what color mode you are in. In the Info panel, the RGB Color mode identifies a pixel's grayscale value. In a grayscale image, a pixel can be one of 256 colors, from 0–255. Black pixels have a grayscale value of 0. White pixels have a grayscale value of 255. All other pixels fall somewhere in between.

Figure 3 *Sampling the darkest area of the gradient*

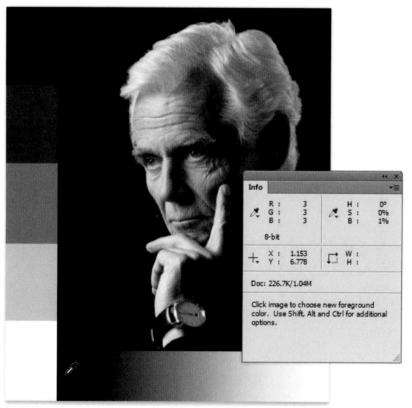

Source Adobe® Photoshop®, 2013. KL Services/Getty Images

16. Float the pointer over the light gray rectangle above the white rectangle.

 192 is the grayscale value between 128 and 255.

17. Float the pointer over the dark gray rectangle below the black rectangle.

 64 is the grayscale value between 0 and 128.

18. Position the pointer to the far left of the gradient below the image of the man, as shown in Figure 3, then note the grayscale value on the Info panel.

19. Try to find the black pixels in the gradient— the pixels with a value of 0.

20. Slowly move the pointer to the right, across the gradient, and note the grayscale values on the Info panel.

 The starting and ending colors for this gradient were black and white, respectively.

21. Explore the image to identify various grayscale values. Can you find pixels with a value of 0 in the dark sweater? Can you find pixels with a value close to 255 in the man's hair? Identify which areas of the image are the midtones.

Modify the levels of gray in a grayscale image

1. Click the **Select menu**, click **Load Selection**, click the **Channel list arrow**, click **Man and Gradient**, then click **OK**.

2. Click the **Image menu**, point to **Adjustments**, then click **Posterize**.

3. Verify that the **Preview check box** is checked, type **8** in the Levels text box, don't click **OK**, then compare your artwork to Figure 4.

 Be sure you understand that the file is still in Grayscale mode and 256 shades are still *available* for every pixel. The posterization effect is forcing each pixel to be one of only eight shades of gray, despite what's available.

 With only eight shades of gray, there aren't enough grays to create the effect of a smooth transition from the shadow areas of the image to the highlight areas.

4. Float the pointer from left to right across the gradient at the bottom while noting the grayscale values on the Info panel.

TIP The RGB section of the Info panel now shows two numbers separated by a forward slash for each value. The values to the left of the slash represent pixel values before posterizing, and the values on the right represent what the pixel values will be if you execute the posterize effect.

(continued)

Figure 4 *Posterizing to eight levels*

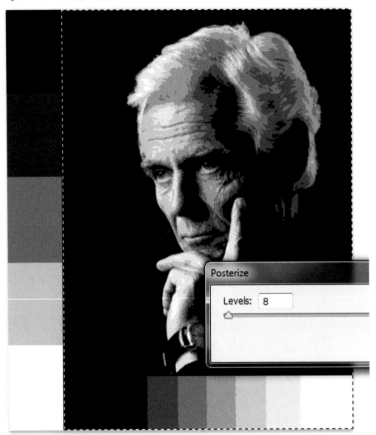

Source Adobe® Photoshop®, 2013. KL Services/Getty Images

AUTHOR'S **NOTE**

Posterizing an image is very popular—you've probably seen it many times. Now you have a better understanding of how it actually works. Some dazzling Photoshop effects are the result of relatively simple algorithms. Getting an intellectual grasp on how Photoshop is doing what it's doing is the first step to mastering this application.

Figure 5 *Posterizing to 24 levels*

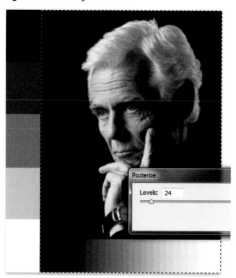

Figure 6 *Posterizing to four levels*

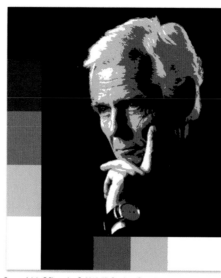

5. Type **24** in the Levels text box, then compare your artwork to Figure 5.

 With only 24 shades of gray, the image is surprisingly normal looking. At a quick glance, it would be difficult to notice anything amiss in the man's face or in his hands. This is because these areas do not demand the effect of a smooth and graduated transition from light to dark. However, note that the shadow areas on the side of the man's face are posterized.

 Now look at the tones in the sweater: the posterize effect is immediately apparent and is mirrored in the gradient at the bottom of the canvas.

6. Type **64** in the Levels text box.

 At 64 levels, the posterize effect (often called *stair-stepping* because you can see the step from one gray level to another) is hardly visible. However, note the gradient at the bottom. The stair-stepping is still visible.

7. Type **255** in the Levels text box.

 At 255 levels, the image is realistic because enough grays are being used to transition from shadows to highlight. That concept is reflected in the gradient's smooth transition from black to white.

8. Type **4** in the Levels text box, click **OK**, then compare your artwork to Figure 6.

 See the Author's Note on this page.

9. Deselect all, save your work, then close Levels of Gray.psd.

AUTHOR'S NOTE

Before reading any further, try to state out loud how the posterize effect works. At 4 levels, why does this image appear the way it does?

Here's what happened: The Posterize effect identified all the pixels whose value was from 0-63 and said, "You guys are 64 different shades of dark gray, but now I only have four grays to work with. So you guys are all black, grayscale value 0. And 64-128? You're all dark gray—value 107. And 129-192? Now you're all light gray—value 187. And the rest of you, 193-255, you're all 255." Getting an intellectual grasp on how Photoshop does what it does is very empowering.

Adjust LEVELS

What You'll Do

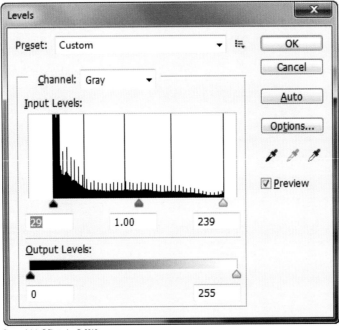

Source Adobe® Photoshop®, 2013.

Now that you have a thorough understanding of grayscale and that every pixel in a grayscale image has a single value attached to it, you are ready to manipulate those values using the Levels dialog box.

The Levels dialog box is a great place to analyze the tonal range of your file, from shadows to highlights. Quite literally, every pixel in the image is displayed using a diagram based on grayscale values.

While you can use levels to adjust the color of an image, the Levels dialog box is best used to specify the basic tonal range of the image: the shadow point, the highlight point, and the midpoint.

Figure 7 *Levels dialog box*

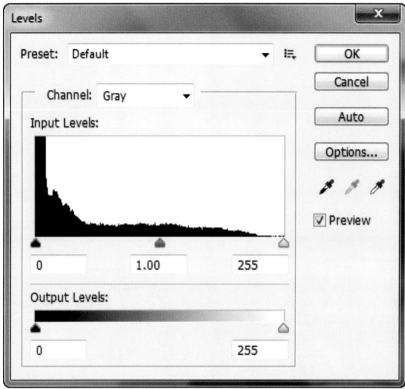

Source Adobe® Photoshop®, 2013.

Explore the Levels dialog box

1. Open AP 3-2.psd, then save it as **Levels Intro**.
2. Load the selection named **Man Alone**.
3. Click the **Image menu**, point to **Adjustments**, then click **Levels**.

 When you make a selection then open the Levels dialog box using the Image/Adjustments command, the histogram represents only the area of an image that is selected.

TIP Be sure to read the Author's Note on this page about histograms.

(continued)

AUTHOR'S NOTE

As shown in Figure 7, the most striking component of the Levels dialog box is the histogram. The *histogram* is a visual reference of every pixel in the selection—in this case, the selection of the man. Here's a good analogy for understanding the histogram: Imagine that the histogram has 256 slots, one for each of the 256 available colors in the grayscale image. The slot for the 0-value pixels is on the left, and the slot for the 255-value pixels is on the right. Imagine that there are a total of 1000 pixels in the image with a grayscale value of 64. Using a black marble to represent each pixel, imagine that you drop 1000 marbles into the 64 slot on the slider. Next, imagine that the image contains 1500 pixels with a grayscale value of 72, and you drop 1500 black marbles into the 72 slot. Imagine that you do this for each of the 256 colors in the image. Your result would be the histogram—exactly what you see in the Levels dialog box. The height of the histogram, from left to right, shows the relative number of pixels that the file—or in this case, the selected pixels—has in each of the 256 grayscale values.

4. Verify that the **Preview check box** is checked, then view the Levels dialog box beside the image, as shown in Figure 8.

 Figure 8 is an approximate representation of the histogram's relation to areas of the image. The dark pixels in the image are represented by the yellow area in the histogram. The far fewer light pixels are represented by red. And the majority of the image is composed of midrange pixels, represented by blue. (Note that this is just an illustration - your dialog box won't show red, yellow, and blue.)

5. Click **Cancel**.

6. Click the **Image menu**, point to **Adjustments**, then click **Posterize**.

7. Type **4** in the Levels text box, click **OK**, then float your pointer over the selection to sample the four grayscale values that now compose the image.

 The image is composed of pixels that have grayscale values of 0, 85, 107, or 255.

8. Press **[Ctrl][L]** (Win) or ⌘ **[L]** (Mac) to open the Levels dialog box, then compare it to Figure 9.

 The histogram precisely reflects the change in the selection, with pixels represented only at the 0, 85, 107, and 255 points on the Levels slider. To extend the previous analogy, all of the "marbles" now fall into one of four "slots." Note that, proportionately, there are many more pixels falling into the zero slot than the other three combined, and note how that fact is apparent in the posterized image.

9. Click **OK**, then revert the file.

Figure 8 *Approximate representation of the histogram's relation to areas of the image*

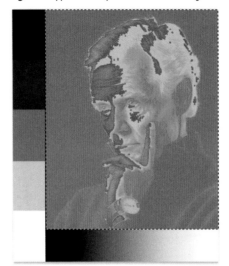

Source Adobe® Photoshop®, 2013. KL Services/Getty Images

Figure 9 *Levels dialog box showing only four gray values*

Source Adobe® Photoshop®, 2013. KL Services/Getty Images

Adjusting Levels and Hue/Saturation

Figure 10 *Positioning the Info panel*

Figure 11 *Positioning the Levels dialog box*

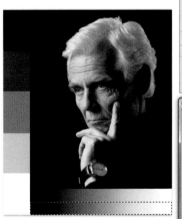

Analyze fundamental moves in the Levels dialog box

1. Load the saved selection named Half Gradient, then verify that your Info panel is positioned as shown in Figure 10.

2. Open the Levels dialog box, then position it as shown in Figure 11.

 The histogram describing the gradient is pretty much what you'd expect: a relatively even dispersion of pixels across the levels ramp. Note that not one area—from shadows to midtones to highlights—dominates the histogram.

3. Click **Cancel**.

4. Click the **Select menu**, then click **Load Selection**.

5. Click the **Channel list arrow**, click **Man Alone**, click **Add to Selection**, then click **OK**.

6. Open the Levels dialog box.

 The histogram has changed because it now represents the pixels in the two selections.

7. Note the three triangles at the base of the Levels slider.

 The black triangle on the left represents all black pixels in the selection—those with a grayscale value of 0. The white triangle on the right represents all white pixels in the image—those with a grayscale value of 255. The gray triangle in the middle represents the middle value of all the selected pixels.

 (continued)

8. Press **[Ctrl][H]** (Win) or ⌘ **[H]** (Mac) to hide the selection edges.

9. Drag the **white triangle** to the left until the third Input text box reads **128**, then compare your screen to Figure 12.

 All of the pixels in the selection that were originally 128—middle gray—are now 255. Therefore, any pixel that was originally 128 or higher is now white. Note that the gray triangle moved with the white triangle, and the transition of black pixels to white pixels now happens in a much shortened range. Compare the bottom half of the gradient to the top half that was not affected by the move. The shortened transition from black to white then the "blow out" to white in the right half is analogous to what is happening to the image of the man above.

TIP See the Author's Note at the bottom of this page.

10. Float the pointer over the image, then note in the Info panel the before/after grayscale values.

(continued)

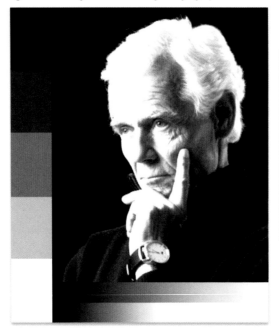

Figure 12 *Viewing the result of moving the highlight point*

Source Adobe® Photoshop®, 2013. KL Services/Getty Images

Figure 13 *Viewing the result of moving the shadow point*

Source Adobe® Photoshop®, 2013. KL Services/Getty Images

Figure 14 *Viewing the result of moving the midpoint to the left*

Source Adobe® Photoshop®, 2013. KL Services/Getty Images

11. Press and hold [**Alt**] (Win) or [**option**] (Mac) so that the Cancel button changes to Reset, then click **Reset**.

12. Drag the **black triangle** to the right until the first Input text box reads **128**, then compare your screen to Figure 13.

 This step has the exact opposite effect on the selection. The pixels that were originally 0–128 are all now 0. The transition from black to white now occurs in the pixels that were originally 129–255. This is illustrated in the gradient: the left half is entirely black, and the right half now transitions from black to white.

13. Press and hold [**Alt**] (Win) or [**option**] (Mac) so that the Cancel button changes to Reset, then click **Reset**.

14. Drag the **gray triangle** left until the middle Input text box reads **1.92**, then compare your screen to Figure 14.

 The effect on the image is far less drastic, but just as specific. Looking at the histogram, note how many more pixels are now positioned between the midpoint value—the gray triangle—and the white triangle. In other words, a much greater percentage of pixels now fall in the upper half of the grayscale. Note how the image of the man was substantially brightened. In the gradient, note how short the range is from shadow to midpoint, while the midpoint to highlight point has been lengthened.

 (continued)

TIP Moving the gray midpoint triangle to the left brightens the middle range of a selection.

15. Drag the **gray triangle** right until the middle Input text box reads **0.64**, then compare your screen to Figure 15.

 Looking at the histogram, note how many more pixels are now positioned between the midpoint value and the black triangle. More of the image now falls in the darker half of the grayscale. Note how the image of the man was substantially darkened. In the gradient, note how long the range is from shadow to midpoint, while the midpoint to highlight point has been shortened.

TIP Moving the gray midpoint triangle to the right darkens the middle range of a selection.

16. Click **OK**, then undo and redo repeatedly to decide whether or not you like the image better with the darkened midtones.

17. Save your work, then close Levels Intro.psd.

Use levels to set the shadow point and the highlight point

1. Open AP 3-3.psd, then save it as **Shadow & Highlight Points**.

2. Open the Levels dialog box, compare your histogram to Figure 16, then float around the image to sample the darkest and lightest pixels anywhere on the canvas.

 This file has been manipulated to show an example of "weak" shadow and highlight points.

(continued)

Figure 15 *Viewing the result of moving the midpoint to the right*

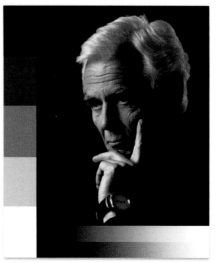

Source Adobe® Photoshop®, 2013. KL Services/Getty Images

Figure 16 *Viewing a histogram with "weak" shadow and highlight points*

Source Adobe® Photoshop®, 2013. Getty Images

Figure 17 *Sampling the lightest areas of the image*

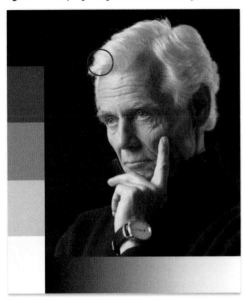

Source Adobe® Photoshop®, 2013. KL Services/Getty Images

Figure 18 *Moving the highlight point*

Source Adobe® Photoshop®, 2013.

Weak shadow points occur when dark areas of an image are composed of pixels whose grayscale values aren't dark enough. Conversely, weak highlight points occur when light areas of the image aren't light enough.

To create an image with a dynamic range from highlight to shadow, you want the pixels in the image to utilize the entire grayscale. However, as often happens with digital images from less sophisticated cameras, the blacks aren't black enough and the whites aren't white enough.

If you look at the histogram, you can clearly see that although the entire range is being utilized, no pixels are at the low end and the high end of the grayscale. This is reflected in the image as well. If you sample shadows in the man's sweater, or at the left side of the gradient, or the dark rectangle in the upper-left corner, you would want to find pixels whose grayscale values range from 0–10. However, you'll note that the grayscale values in these areas are much higher.

On the other side of the grayscale, the areas that should be 250 or higher are hovering somewhere in the 230 range. Because of weak highlight and shadow points, the image appears flat and lacks contrast.

3. Float your pointer in the lightest area of the image—the man's hair—as shown in Figure 17.

4. Look for the lightest pixel you can find.

 The lightest pixels are between 231–239, meaning 16 brighter levels aren't being used.

5. In the Levels dialog box, drag the **white triangle** left until the far-right Input text box reads **239**, as shown in Figure 18.

(continued)

6. Position your pointer over the far-right end of the gradient to verify that the lightest pixel has been brightened to **255**.

7. Float your pointer in the darkest area of the image—in the man's sweater—looking for the darkest pixel you can find.

 The darkest pixel to find is grayscale value 42.

TIP Because you have modified the highlight point, the Info panel now shows before and after values when you sample the image. Note only the before values when you sample.

8. In the Levels dialog box, drag the **black triangle** right until the far-left Input text box reads **29**, as shown in Figure 19.

(continued)

Figure 19 *Moving the shadow point*

Source Adobe® Photoshop®, 2013.

Adjusting Levels and Hue/Saturation

Figure 20 *Comparing before and after examples of the image*

Source Adobe® Photoshop®, 2013. KL Services/Getty Images

9. Click **OK**, then undo and redo the change to see the dramatic change to the image, as shown in Figure 20.

TIP Throughout this book, when you are asked to undo and redo to see a change, always end by redoing the change—in other words, when you are done viewing, be sure that the change has been executed.

10. Save your work.

Adjust levels in specific areas

1. Float the pointer over the five squares on the left.

 The Levels adjustments made so far have resulted in the squares' grayscale values being almost exactly what they should be. Black is 0, white is 255, and the middle square is either 128 or very close to it.

2. Take a moment to assess the man's face.

 The face overall is flat. The shadows are weak, the highlights are also weak, and the whole face is too light. The face is the most important part of this image, yet it lacks contrast and therefore is less interesting.

 (continued)

3. Click the **Create new fill or adjustment layer button** 🔘 on the Layers panel, then click **Levels**.

 The Properties panel opens with the Levels settings.

4. On the Properties panel, drag the **gray midpoint triangle** to the right until the midpoint Input text box reads **0.80**, as shown in Figure 21.

 The whole image darkens, which is a good move for the face. But the face is still flat and lacks contrast. We could manipulate the shadow and highlights in this Levels adjustment, but instead, we'll add a second adjustment so we can see how the midpoint adjustment works in concert with the next adjustment.

5. Click the **Create new fill or adjustment layer button** 🔘 on the Layers panel, then click **Levels**.

 A second Levels adjustment layer is added to the Layers panel.

6. Drag the **white highlight triangle** left until the highlight on the forehead "blows out" to white.

 We dragged the white triangle to 221.

7. Drag the **black shadow triangle** right until the shadows on the face deepen in a way that you find satisfactory.

 We dragged our black triangle to 10, as shown in Figure 22. Note that the front of the face now has interesting contrast, but the side of the face to the right of his finger has become too black. Also, the highlights in his hair and on his finger have "blown out" to white.

 (continued)

Figure 21 *"Opening" the midtones*

Source Adobe® Photoshop®, 2013. KL Services/Getty Images

Figure 22 *Moving the highlight point*

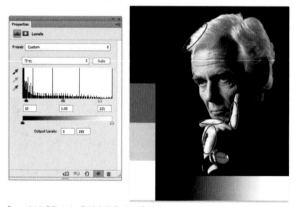

Source Adobe® Photoshop®, 2013. KL Services/Getty Images

AUTHOR'S NOTE

Whereas setting shadow and highlight points is often based on pixel data in the image, lightening or darkening midtones is usually a very subjective choice. An image that looks just fine to one designer may need brightening in the eyes of another designer, whereas a third designer might find the image too light already. In the case of this image, where the overall tone of the face fell on the lighter side, darkening the midtones to improve contrast was arguably the right move.

Figure 23 *Masking the brightened hand*

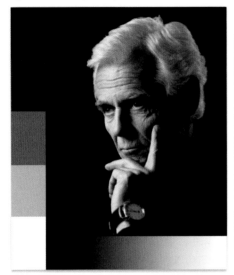

Source Adobe® Photoshop®, 2013. KL Services/Getty Images

Figure 24 *Viewing the final adjusted image*

Source Adobe® Photoshop®, 2013. KL Services/Getty Images

8. Press **[Ctrl][I]** (Win) or ⌘ **[I]** (Mac).

 The mask on the second Levels adjustment is inverted, and the adjustment is no longer visible.

9. Click the **Brush tool** , then choose a large brush with **0%** Hardness.

10. Set the Opacity on the Brush tool to **20%**.

11. Choose a white foreground color, then paint over the man's face to make the adjustment gradually more visible in just that area of the image.

12. Compare your results to Figure 23.

13. Hide and show the adjustment to see its affect on the image.

14. Hide and show the first adjustment to see the effect the midtone adjustment had on the final artwork.

 Figure 24 shows the original image with no adjustments and the final image.

15. Save your work, then close Shadow & Highlight Points.psd.

Explore The
HUE/SATURATION ADJUSTMENT

What You'll Do

Source Adobe® Photoshop®, 2013. George Doyle/Getty Images

The Hue/Saturation adjustment is a powerful Photoshop utility, one that you'll use over and over again. With it, you can saturate or desaturate an image, convert an image to black and white, and dramatically alter the hue of selected pixels. That's what you'll do in this lesson. You'll make a number of saturation and hue manipulations, and study the effect they have on an image.

Figure 25 *Viewing modified hues*

Source Adobe® Photoshop®, 2013. George Doyle/Getty Images

Figure 26 *Comparing before/after for all hues*

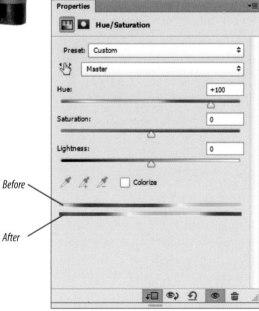

Before

After

Source Adobe® Photoshop®, 2013.

Manipulate hue

1. Open AP 3-4.psd, then save it as **Crayons**.
2. Verify that the Info panel is visible.
3. Target the **Right Crayons layer**.
4. Create a Hue/Saturation adjustment layer clipped into the Right Crayons layer.
5. On the Properties panel, drag the **Hue slider** to the right so that its value reads **100**, or simply type **100** in the Hue text box, then compare your artwork to Figure 25.

 The Hue value—for every pixel in the image— has been moved 100 degrees on the color wheel.
6. Sample different pixels in the image, and note the before-and-after change in the Hue value.

 For every pixel you click, the new value will be the old value plus 100.
7. Note the two rainbow gradients on the Properties panel as shown in Figure 26.

 The top rainbow gradient represents the original color wheel, and the bottom gradient represents the color wheel as it is being modified.
8. Compare the red area at the center of the top gradient to the same location in the bottom gradient.

 With the shift in hue, the areas of the image that were originally red are now green. The two gradients in the Properties panel are useful for predicting the results of modifying the Hue slider.

(continued)

9. Click the **Toggle layer visibility button** on the Properties panel repeatedly to compare the red crayon in the original image to its modified version.

 As shown in Figure 27, the red crayon is now green.

10. Compare different areas of the before-and-after rectangles to the before-and-after views of the image.

11. Drag the **Hue slider** to **-100**.

 Though the hues in the Color Picker are shown from 0 to 359, the Hue/Saturation slider moves in two directions, positive and negative. Starting with 0 degrees, 0 thru 180 represents a counterclockwise movement on the color wheel. 0 thru -180 represents a clockwise movement on the wheel.

12. Click the **Reset to adjustment defaults button** on the Properties panel, then target the **Right Crayons layer** on the Layers panel.

Figure 27 *Comparing before/after hues*

Source Adobe® Photoshop®, 2013. George Doyle/Getty Images

Adjusting Levels and Hue/Saturation

Figure 28 *Viewing the colorized image*

Source Adobe® Photoshop®, 2013. George Doyle/Getty Images

Colorize an image

1. Display the Swatches panel, then click the **RGB Green swatch** near the upper-left corner of the Swatches panel.

2. Click the **Set foreground color button** on the Tools panel.

3. Write down the Hue, Saturation, and Brightness values of the color.

 The values of this color are 120H/100S/100B.

4. Click **Cancel**.

5. Click the **Hue/Saturation adjustment** on the Layers panel, click the **Colorize check box** on the Properties panel, then compare your screen to Figure 28.

 When you click the Colorize check box, all of the pixels in the image take on the Hue value of the foreground color.

6. Move the pointer over the modified pixels and note the before-and-after H values on the Info panel.

 The Hue value for every pixel in the modified image is 120. The only thing that differentiates the pixels is their saturation and lightness values.

7. Note the change to the bottom rainbow gradient on the Properties panel.

 Once colorized, every hue on the color wheel becomes the same hue—in this case Hue 120. This is identical to what has happened to every pixel in the modified image.

 (continued)

8. Drag the **Hue slider** back and forth from left to right.

By moving the Hue slider, you can colorize the image with any of the 360 hues in the color wheel.

TIP Note that, once colorized, the Hue slider specifies hues from 0 through 360 rather than 0 through 180 and 0 through -180. This is a bit misleading, because 0–360 is actually a total of 361 hues. However, 0 and 360 represent the same location on the color wheel, and therefore the same hue.

9. Drag the **Hue slider** to **120**.

Manipulate saturation

1. Drag the **Saturation slider** to **50**, then compare your artwork to Figure 29.

The green hue is intensified.

2. Drag the **Saturation slider** to **75**.

The green hue is further intensified.

3. Drag the **Hue slider** left and right to see the other hues at this saturation.

4. Click the **Reset to adjustment defaults button** 🔄 on the Properties panel.

5. Drag the **Saturation slider** to **50**, then compare your image to Figure 30.

All the various hues are intensified. Note, however, that the gray crayon on the right hardly changes. This is because it originally had a low saturation value and the Saturation slider therefore has minimal impact. In other words, it's hard to increase saturation in a pixel that has little or no saturation to begin with.

(continued)

Figure 29 *Increasing the saturation of the colorized image*

Source Adobe® Photoshop®, 2013. George Doyle/Getty Images

Figure 30 *Increasing saturation*

Source Adobe® Photoshop®, 2013. George Doyle/Getty Images

AUTHOR'S NOTE

Note that, regardless of how you drag the Hue and Saturation sliders, the crayons always look like crayons. The darker crayons always stay darker than the lighter crayons. This is because you are not modifying the lightness values of the pixels. The lightness value defines the image—from shadow to highlight. So long as the overall lightness is maintained, the "reality" of the image will not change.

Adjusting Levels and Hue/Saturation

Figure 31 *Reducing saturation*

Original *Saturated*

Source Adobe® Photoshop®, 2013. George Doyle/Getty Images

Figure 32 *Desaturating the image completely*

Original *Completely desaturated*

Source Adobe® Photoshop®, 2013. George Doyle/Getty Images

6. Move your pointer over the modified image, and note the before-and-after values on the Info panel.

 Modifying saturation also affects the H and L values. The impact on the H values is minimal. However, an increase in saturation usually requires an increase in lightness.

TIP Note that the Properties panel refers to "Lightness" while the Info panel refers to "HSB." This text refers generally to Hue, Saturation, Brightness (HSB).

7. Drag the **Saturation slider** to **-50**, then compare your image to Figure 31.

 With this decrease in saturation, the color is muted and not vibrant.

8. Drag the **Saturation slider** to **-100**, then compare your image to Figure 32.

 With no saturation, every pixel is and can only be a shade of gray.

9. Save your work, then close Crayons.psd.

Adjust Hue, Saturation,
AND LIGHTNESS

What You'll Do

Source Adobe® Photoshop®, 2013. Barbara Penovar/Jupiter Images/Getty Images

In many projects, you will adjust and manipulate HSL to produce a variety of color effects. For example, if you were designing a catalog for a clothing company, they may supply you with a photograph of a green sweater then tell you that they want you to use the photo to also show a red and a blue sweater. Achieving a realistic result when modifying HSL is always interesting and sometimes tricky. Lesson 4 focuses on that challenge. You will be given the task of modifying the color of an article of clothing, and your goal will be to manipulate HSL so that the modification is so realistic that nobody would notice that you've been up to your tricks.

Figure 33 *Increasing the saturation of the sweater*

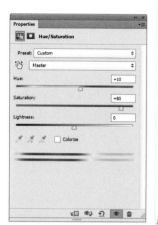

Figure 34 *Making the sweater black*

Lesson 4 Adjust Hue, Saturation, and Lightness

Adjust HSL in dark areas

1. Open AP 3-5.psd, then save it as **Sweater**.

2. Show the Navy Blue adjustment layer, then double-click the **layer thumbnail** to open the Properties panel panel.

3. Drag the **Hue slider** back and forth to see the sweater as different hues.

 Regardless of what hue you set, the color of the sweater looks realistic. When you are working with darker images, it's easier to modify the hue and keep the image looking real. This is because, by definition, a darker image has broad shadow areas that clearly define the shape of the image. Note, however, that no matter where you drag the Hue slider, the color of the sweater remains drab.

4. Drag the **Saturation slider** to +80, drag the **Hue slider** back and forth, then compare your artwork to Figure 33.

 With a high saturation adjustment, the hues in the sweater are brighter yet the image remains realistic. Note that the sweater is so vivid that the woman's face, unaltered from the original, is wan and colorless in comparison.

5. Press and hold [**Alt**] (Win) or [**option**] (Mac), drag the **layer mask thumbnail** from the Navy Blue adjustment layer on top of the layer mask thumbnail on the Black layer, then click **Yes** when asked if you want to replace it.

6. Hide the Navy Blue adjustment layer, show the Black adjustment layer, then view the Properties panel.

7. Set the Saturation value to **–100**, set the Lightness value to **–40**, then compare your result to Figure 34.

(continued)

8. Hide and show the adjustment.

 Generally speaking, you can use the Lightness slider to darken parts of an image and keep the result looking realistic.

9. Drag the **Lightness slider** all the way to the left.

 Compare your screen to Figure 35.

 Undo and redo to see the difference between the two blacks. In our first black sweater, we maintained a range of tone with areas that were darker than others, such as the folds in the sleeves and under the arm. Compare that to the all-black sweater. This is a great example of how you always want to maintain detail and a range of tone in the dark areas of a realistic image, even an image that is supposed to register as black.

10. Replace the layer mask on the Red adjustment layer with the layer mask from the Black adjustment layer.

11. Hide the Black adjustment layer, show the Red adjustment layer, then view the Properties panel.

12. Modifying only the Hue and Saturation sliders, experiment with different values and try to make the sweater the most vivid red that you can while maintaining realism.

13. Drag the **Hue slider** to **−80**, drag the Saturation slider to **+90**, then compare your result to Figure 36.

 (continued)

Figure 35 *Filling the sweater with black*

Source Adobe® Photoshop®, 2013. Barbara Penovar/Jupiter Images/Getty Images

Figure 36 *Making the sweater red*

Source Adobe® Photoshop®, 2013. Barbara Penovar/Jupiter Images/Getty Images

Adjusting Levels and Hue/Saturation

Figure 37 *Increasing lightness in the Hue/Saturation adjustment*

Source Adobe® Photoshop®, 2013. Barbara Penovar/Jupiter Images/Getty Images

Figure 38 *A brighter and more vivid red created with a Levels adjustment*

Source Adobe® Photoshop®, 2013. Barbara Penovar/Jupiter Images/Getty Images

This is as bright and vivid a red sweater as you'll be able to create while maintaining realism. If you push the saturation value past 90, the highlights on the shoulders get hot and start to pop, creating an unrealistic effect. It's a good red, but what if you wanted a really bright red, like a fire engine red?

14. Drag the **Lightness slider** to **+20**, then compare your result to Figure 37.

 The increase in lightness detracts from the color of the image and makes it look unrealistic. See the Author's Note below.

15. Drag the **Lightness slider** back to **0**.

16. Add a new Levels adjustment, then drag the **white highlight triangle** to **185**, drag the **midpoint left** to **2.00**, then drag the **black shadow point** right to **11**.

17. Copy the mask to the Levels adjustment layer, then compare your result to Figure 38.

 This is an extreme adjustment, but it works. The sweater is a much brighter red, though the image is breaking up a bit.

18. Save your work, then close Sweater.psd.

AUTHOR'S NOTE

This is an important footnote to this entire chapter. The Lightness slider in the Hue/Saturation adjustment is not intended to be used to brighten or darken an image. It was not designed for that purpose. Photoshop has a number of other adjustments that brighten and darken an image using far more sophisticated algorithms. As you saw in this lesson, the Lightness slider was not at all a good choice for brightening the image. On the other hand, you can use it to darken an image; for example, it did a good job modifying the sweater to black. Nevertheless, Levels, Curves, and/or Brightness/Contrast adjustments are the correct method.

1. Open AP 3–6 psd, then save it as **Color Woman**.
2. Posterize the image to six levels.
3. Select all the black areas, then fill them with a different color.
4. Select all the white areas, then fill them with a different color.
5. Fill each of the other four levels with four different colors so that each level is all one color.
6. Use the Paint Bucket tool to add other colors to the artwork.
7. Compare your artwork to Figure 39.
8. Save your work, then close Color Woman.psd.

Figure 39 *Completed Project Builder 1*

Source Adobe® Photoshop®, 2013. Barbara Penovar/Jupiter Images/Getty Images

1. Open AP 3-7.psd, then save it as **Green Drink**. (*Hint*: The goal in this exercise is to change the color of various areas of the image that involve the intersection of hard and soft edges, requiring you to use different degrees of hardness on the brush you mask with.)
2. Create a new Hue/Saturation adjustment layer, drag the Hue to +154, then drag the Saturation to +35.
3. Press [Ctrl][I] (Win) or ⌘ [I] (Mac) to invert the layer mask and make it black.
4. Use a soft-edge brush and paint with white to change the color of the girl's shirt on either side of the glass and behind the glass.
5. Use a harder-edged brush to change the color of the straw.
6. Compare your finished artwork to Figure 40.
7. Save your work, then close Green Drink.psd.

Figure 40 *Completed Project Builder 2*

Source Adobe® Photoshop®, 2013. Stockbyte/Jupiter Images/Getty Images

Adjusting Levels and Hue/Saturation

CHAPTER 4 WORKING WITH CURVES AND
ADJUSTING COLOR

1. Explore the Curves adjustment.
2. Adjust curves in a grayscale image.
3. Analyze color channels.
4. Adjust color with curves.

Explore the Curves
ADJUSTMENT

What You'll Do

Source Adobe® Photoshop®, 2013.

The Curves adjustment is a color manipulation utility in Photoshop, like the Levels dialog box or the Brightness/Contrast slider. What makes the Curves adjustment different is that it is the most comprehensive and most powerful option for manipulating color, and that power is based on the precision that it offers. With curves, you have up to 14 different points throughout an image's tonal range to adjust, and you can quite literally target a specific grayscale value. You can also make very precise adjustments to specific color channels.

When you get to the point that you're working with curves, you're working with some of the central and most powerful concepts in Photoshop. As with most skills, it's all about experience. With time, practice, and experience, you develop a reliable sense of how to work with curves to achieve a desired effect. Sometimes that desired effect will be a basic adjustment: improving contrast, brightening or darkening an image, or tweaking the overall color. For those adjustments, you'll find that you can rely on standard curve adjustments to do the trick.

At other times, you'll be using curves to achieve unique and less specific challenges, and that's when curves will really test you. Simply put, there will be some color changes you'll want to make that won't be achieved with a standard curve. For these, you'll need to experiment and work your way toward your goal.

This chapter is an in-depth exploration of the Curves adjustment. If you're self-taught with curves, these lessons offer a number of insights into how the Curves adjustment works that you likely haven't taught yourself.

If you're new to working with curves, use these lessons as an opportunity to build a strong foundation for working with them, starting with a clear understanding of how the adjustment works.

This chapter also provides an analysis of the RGB and CMYK color spaces and how they relate to Photoshop's color adjustment tools like Curves, Color Balance, and Selective Color. Exploring them, you'll strengthen your approach and your understanding of how to achieve your color adjustment goals.

Figure 1 *Curves Display Options dialog box*

Source Adobe® Photoshop®, 2013.

Explore the Curves adjustment

1. Open AP 4-1.psd, then save it as **Sunset Swans**.

 We're beginning with a grayscale image for an important reason: a grayscale image has a single channel. Pixels in a grayscale image can be one, and only one, of 256 shades of gray. Using a basic grayscale image allows you to make adjustments with curves and really understand what's happening to the image.

2. Verify that the Info panel is showing and has at least one color readout set to RGB.

3. Create a Curves adjustment layer, then detach the Properties panel from the panels dock.

4. Resize the Properties panel enough so that you can see the Input and Output settings.

5. Click the Properties panel menu button ▼≣ , click **Curves Display Options**, choose the settings shown in Figure 1, then click **OK**.

 See the Author's Note on this page about the Curves Display Options dialog box.

6. Note the histogram in the Curves adjustment.

TIP The histogram is explained in detail in Chapter 3.

7. Note the white and black triangle sliders beneath the histogram.

 The triangle sliders—and how they relate to the histogram—are the component of the Curves adjustment that functions most like the Levels adjustment. The concept is the same: moving the black slider adjusts the black point and moving the white slider adjusts the white point.

 (continued)

8. Note the black to white blend along the bottom and along the left side of the grid, as identified in Figure 2.

 The blends (or "ramps") have no practical function and don't change as a result of any changes you make to the curve. Their function is simply to represent the movement of shadow to highlight. In other words, the bottom blend shows you that the tonal range moves from shadow to highlight (black to white) as you move from left to right in the grid. The side vertical blend shows that the tonal range moves from black to white as you move from bottom to top in the grid.

9. Move the mouse pointer over the grid so that your cursor turns into a crosshair, position the crosshair in the center of the grid so that the Input and Output text boxes both read 128, then click to add a point.

10. Compare your Properties panel to Figure 3.

 Think of the Input and Output text boxes as being the Before and After representation of any changes you make to the curve. Because you've made no changes to the curve up to this point, the Input/Output values for the point you clicked—and every other point on the curve—are the same.

 (continued)

Figure 2 *Curves adjustment*

Output ramp from black to white

Output ramp from black to white

Input ramp from black to white

Source Adobe® Photoshop®, 2013.

Figure 3 *Adding a point to the curve*

New point

Source Adobe® Photoshop®, 2013.

Working with Curves and Adjusting Color

Figure 4 *Changing the curve*

Intersection line represents starting position

Source Adobe® Photoshop®, 2013.

Input and Output values of selected point

11. Drag the **point** straight up so that the Input/Output text boxes match Figure 4.

 This move and its result convey—in a simple and basic way—what the Curves adjustment is all about. We've altered the tonal range of the image. Pixels that had a grayscale value of 128 now have a value of 160. Therefore, those pixels are lighter by 32 shades of gray. But it's not only those specific pixels that have changed; the entire image has been brightened, and the curve is a visual representation of that change. Note how it deviates from the light gray intersection line. Pixels in the middle range of the grayscale are most affected by the move, with the adjustment tapering off in equal measure at the brightest highlights and darkest shadows.

12. Move the mouse pointer over the curve and note the changes to the Input/Output text boxes.

 As you drag, you'll see that the Output values are higher than the Input values. They have all been brightened, but the increase is not as dramatic as it is in the midrange of the curve.

13. Drag the **point** on the curve to different areas of the grid and note the effect on the image.

 When you drag the curve below the intersection line, the image is darkened.

 (continued)

14. Type **95** in the Input text box, then type **70** in the Output text box.

As shown in Figure 5, the image darkens. You can select any point on the curve and enter specific Input and Output values.

Figure 5 *Entering specific Input and Output values*

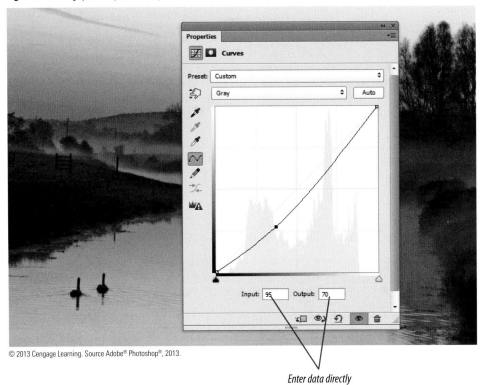

Enter data directly

Figure 6 *Adding and relocating a second point on the curve*

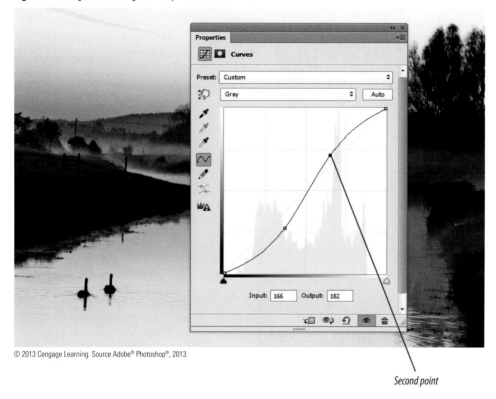

© 2013 Cengage Learning. Source Adobe® Photoshop®, 2013.

Second point

15. Click anywhere on the curve to the right of the middle point to add a second point.

16. Drag the **second point** above the diagonal, as shown in Figure 6.

 The first point doesn't move when you drag the second point.

17. Click and drag the **second point** straight up to remove it from the curve.

18. Save your work, then close Sunset Swans.psd.

Adjust Curves in a GRAYSCALE IMAGE

What You'll Do

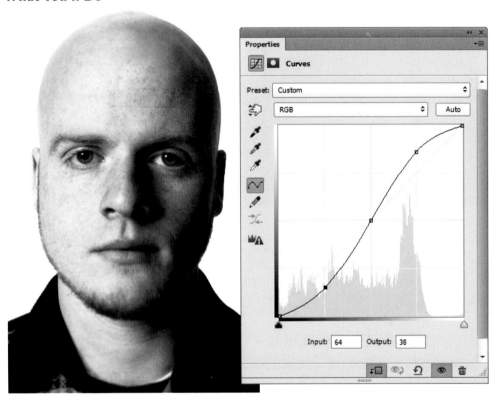

© 2013 Photodisc/Getty Images. Source Adobe® Photoshop®, 2013.

When it comes to adjusting color, the Curves adjustment is the most sophisticated utility that Photoshop has to offer. Quite literally, you can use a curve to manipulate a specific level of gray in an image—it's that precise.

Mastering the Curves adjustment is one of the great challenges in Photoshop for retouchers and color technicians. It's an art, it's a craft, and it's a technical challenge as well.

As a designer, you don't need to master every aspect of curves and color retouching. But you do need to work with curves and to understand the central concepts of how they control the color and the tonal range of the image.

Working with Curves and Adjusting Color

Figure 7 *Inverting the image*

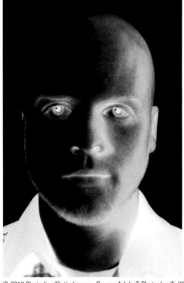

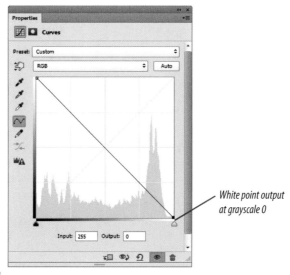

White point output
at grayscale 0

AUTHOR'S NOTE

If you've walked through the color department of a design firm, advertising agency, or offset printer, you've probably seen men and women in a dark room staring intently at images on their monitors.

These are the people who are responsible for the color quality of a job; these are the people who make sure that the client's million-dollar print campaign looks great when it's printed. These people—scanners, retouchers, and color specialists—spend much of their well-paid days working with curves.

You could invest years learning about curves and still not know everything there is to know, so you can be sure you're not going to learn everything about curves in the next five lessons. But you can study basic curve adjustments and learn skills that you can use in a real world design project.

Invert an image using curves

1. Open AP 4-2.psd, then save it as **Analyze Curves**.
2. Verify that the **Original layer** on the Layers panel is targeted and is the only visible layer.
3. Click the **Image menu**, point to **Adjustments**, then click **Invert**.

 How does the Invert command work? Before moving forward, take a few moments to imagine creating this effect with curves. What would the curve look like?
4. Undo the last step.
5. Create a Curves adjustment layer.
6. Drag the **black point** from the lower-left corner up to the upper-left corner.

 The 0 Input value of the black point changes to an Output value of 255. Because the entire curve now sits at the very top of the grid, every pixel now has an Output value of 255. Thus, the entire image is white.
7. Drag the **white point** to the lower-right corner so that your image and the Properties panel resemble Figure 7.

 The curve is now inverted. The black point has changed from 0 to 255 and is now white. The white point has changed from 255 to 0 and is now black. All the points in between are also inverted. In other words, pixels that were in the bottom half are now in the top half and vice-versa.

(continued)

8. Position your pointer over the curve, then click to add a point in the location shown in Figure 8.

Nothing changes—we added a point only for the sake of sampling the change to the curve. Pixel 191—originally the midpoint between 128 and 255—will be output as 64, its inverse on the grayscale and the midpoint between 0 and 128. In other words, a light gray pixel is inverted and becomes a dark gray pixel.

(continued)

Figure 8 *Viewing the change to pixel 191*

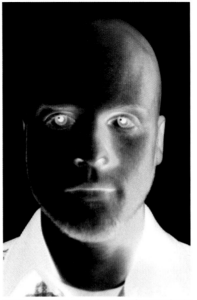

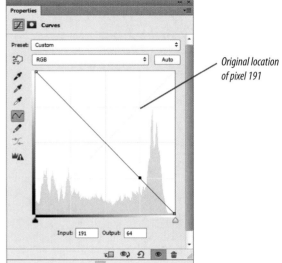

Original location of pixel 191

© 2013 Photodisc/Getty Images. Source Adobe® Photoshop®, 2013.

Working with Curves and Adjusting Color

Figure 9 *Viewing the change to pixel 64*

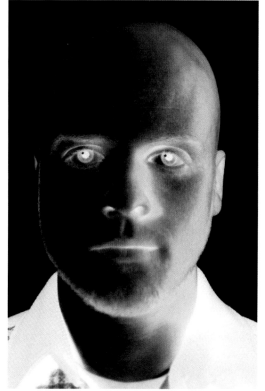

© 2013 Photodisc/Getty Images. Source Adobe® Photoshop®, 2013.

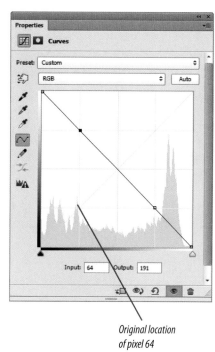

*Original location
of pixel 64*

9. Position your pointer over the curve, then click to add a point in the location shown in Figure 9.

 Pixels with an Input value of 64 will be output as their inverse: 191.

10. Add a point at the very center of the curve.

 Pixel 128 is the middle gray pixel—128 is the median point between 0 and 255. The curve has not changed location at the 128 point on the grid. All the other pixels have swapped values with their counterparts on the other side of the midpoint. 129 is 127. 130 is 126. 131 is 125, and so on.

11. Hide the Curves adjustment layer, then save your work.

Relocate the black point, the white point, and the midpoint

1. Target and show only the **Weak Highlights and Shadows layer**.

 As shown in Figure 10, the image on this layer has been manipulated to have weak shadow and highlight points—the darkest pixels need to be darker, and the lightest pixels need to be lighter.

2. Move the mouse pointer around over the image and use the Info panel to find the lightest grayscale value.

 The light background contains the lightest pixels—those with a grayscale value of 235. This means that there are 20 lighter pixels available on the grayscale that this image is not using.

3. Move the mouse pointer over the image and try to find the darkest grayscale value.

 The darkest pixels are in the shadows underneath the man's collar—those with a grayscale value of 26. This means that there are 26 darker pixels available on the grayscale that this image is not using.

 (continued)

Figure 10 *Assessing the tonal range of the image*

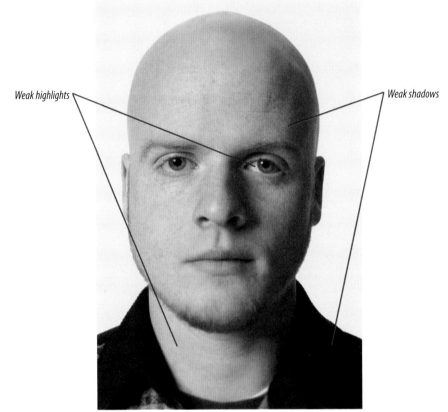

Weak highlights

Weak shadows

© 2013 Photodisc/Getty Images. Source Adobe® Photoshop®, 2013.

AUTHOR'S NOTE

When sampling for highlights, don't sample the white circles that usually appear in the center of a subject's eyes, as they do in this image. These highlights are created from a reflection of the camera's flash. In other words, they are artificial, and therefore shouldn't be used as part of your sample when adjusting highlights. Printers and retouchers refer to these highlights as *spectral* highlights.

Working with Curves and Adjusting Color

Figure 11 *Relocating the black point*

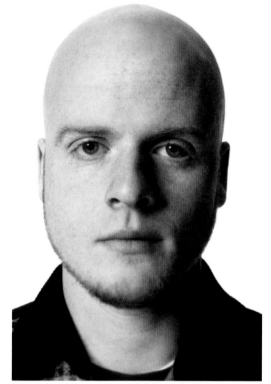

© 2013 Photodisc/Getty Images. Source Adobe® Photoshop®, 2013.

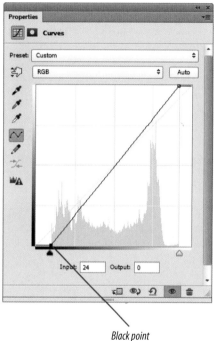

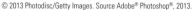
Black point

4. Create a clipped Curves adjustment layer named **Improve Highlight/Shadow Points**.

5. Drag the **highlight point** straight to the left, so that your Input/Output values read **235/255**, respectively.

 With this move, the lightest pixels in the original image—235—will be output as the lightest value on the grayscale—255. But remember the big point with curves: wherever the curve moves, all of the pixels on the curve change. Look carefully at the curve—at no point is it in the same location as it was originally. At every point, it is slightly above its original location. Note that the black point is the only point on the curve that didn't change. You cannot change the black point by moving the white point.

6. Drag the **black point** to the right, so that your Input/Output values are the same as those in Figure 11.

 With this move, the pixels that were originally 26 are now 0. Note the change to the curve. In the lower-left quadrant, the curve is below its original location—the dark half got darker. In the upper-right quadrant, the curve is above its original location—the lighter half got lighter. This, by definition is an increase in contrast.

(continued)

Lesson 2 Adjust Curves in a Grayscale Image

7. Click to add a point anywhere on the curve, then move the point to the center so that your Input/Output is 128/128.

TIP If you like, you may enter numbers directly into the Input and Output text boxes.

8. Drag the **midpoint** straight up so that your panel resembles Figure 12.

 The image is brightened overall. It is brightened the most at the middle point.

 (continued)

Figure 12 *Brightening the midtones*

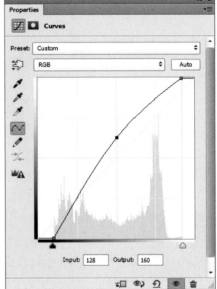

© 2013 Photodisc/Getty Images. Source Adobe® Photoshop®, 2013.

Working with Curves and Adjusting Color

Figure 13 *Darkening the midtones*

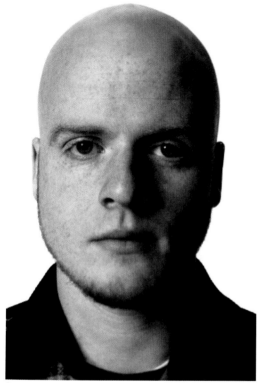

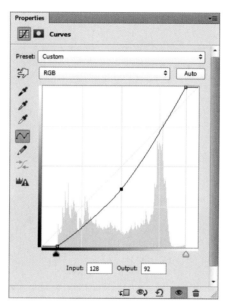

9. Drag the **midpoint** straight down so that your panel resembles Figure 13.

 The image is darkened overall.

10. Remove the midpoint by dragging it out of the Properties panel.

11. Save your work.

Improve contrast with curves

1. Show and target only the **Poor Contrast layer**.

2. Move the mouse pointer over the image and try to find the lightest grayscale value and the darkest grayscale value.

 The image on this layer has been manipulated to have poor contrast in the dark gray to light gray range. Don't confuse this with the black point and the white point. In this image, the black and white points are set properly. The darkest pixels are in the single-digit area of the grayscale, and the lightest pixels are 250 or over. The poor contrast is in the range between the dark grays (grayscale value 64) and the light grays (grayscale value 191).

 (continued)

3. Use the Eyedropper tool 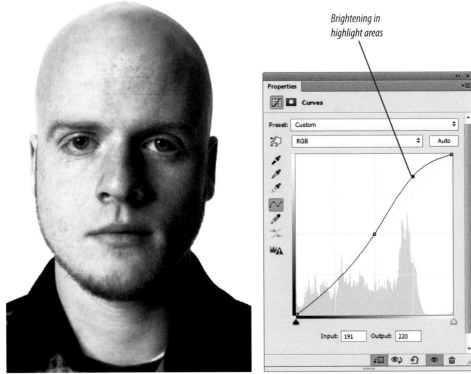 and the Info panel to sample the pixels on the man's cheek, screen left.

The pixels on the light side of the face are in the 165–195 range. Note that the histogram in the far-right quadrant of the grid—the highlights—shows that almost no pixels in the image have those values. The white pixels in the background are all 255 and therefore represented at the white point. But the light grays in the image—on the screen-left side of the man's face and neck, for example—all fall in the middle-right quadrant. This makes sense, because our sampling of the screen-left side of the man's face showed pixels in the range of 165–195. Those pixels should be in highlight range: 191–255. In other words, what should be the highlight in the image are instead middle-range grays.

4. Create a new clipped Curves adjustment layer named **Improve Contrast**.

5. Click the curve to add a point at **128/128**.

6. Click the curve to add a point at **191/191**.

Grayscale 191 is commonly recognized as the central area of the highlights in an image, because 191 is exactly between 128 and 255.

7. Drag the **191 point** straight up so that your Input/Output values are **191/220**, then compare your screen to Figure 14.

Note the curve from the midpoint of the grid to the white point. With this move, every pixel in the "upper half" of the grayscale has been brightened, and the curve is farthest away from the intersection line at the top end of the curve. Note too that the bottom half of the curve has darkened slightly.

(continued)

Figure 14 *Brightening the highlights*

Brightening in highlight areas

© 2013 Photodisc/Getty Images. Source Adobe® Photoshop®, 2013.

AUTHOR'S NOTE

Don't get your terms mixed up. *Highlights* are light gray areas of the image. The *highlight point*—or *white point*—is the whitest area of the image. *Shadows* are the dark gray areas of the image. The *shadow point*—or *black point*—is the blackest area of the image. This is all lingo, and none of it is official. The design and print worlds are replete with lingo, jargon, and catchphrases. It's important that you develop your own set of terminology that you can use to clearly identify specific areas of an image. Consider using the following five terms: *black point*, *shadows*, *midtones*, *highlights*, and *white point*.

Working with Curves and Adjusting Color

Figure 15 *Brightening the highlights too much*

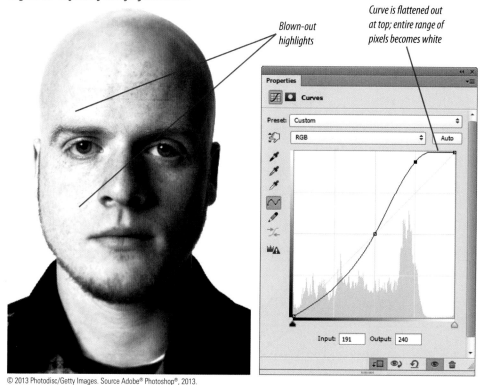

Blown-out highlights

Curve is flattened out at top; entire range of pixels becomes white

© 2013 Photodisc/Getty Images. Source Adobe® Photoshop®, 2013.

8. Click the **Toggle layer visibility button** 👁 on the Properties panel to hide the change to the image, then click 👁 to show the change to the image.

Try to relate the changes in the image to the changes in the curve. Note that light areas on the face screen-left have been changed dramatically, while the face screen-right and the dark shirt collar change only slightly. Note too that the face screen-left is lightened, but those pixels are not white.

9. Drag the **point** even higher to change the Output value to **240**, then compare your screen to Figure 15.

Figure 15 shows an example of "blown out" highlights. Note that patches of the face screen-left are all white and no longer show any detail. This is reflected at the very top of the curve, where it has flattened out. A whole range of pixels have been "blown out" to white.

10. Undo the move.

(continued)

11. Use the **Eyedropper tool** 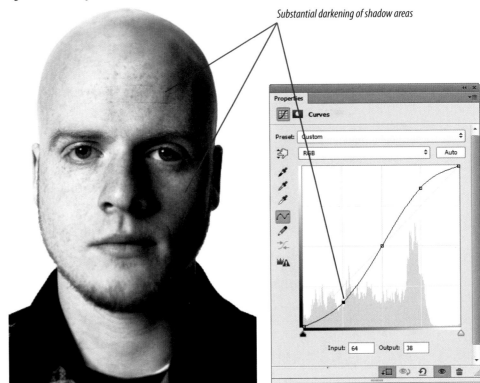 on the Tools panel to sample the shadows on the collar.

 The pixels in the collar are where they should be on the curve: at the low end, but not at the black point. However, the shadow areas on the face screen-right still seem weak and could be darkened to increase the tonal range of the face from highlight to shadow.

12. Add a new point to the curve at Input **64** and Output **38**, then compare your screen to Figure 16.

13. Hide and show the layer to see the change to the shadow areas.

 This was a dramatic move in the right direction. The face is the most important part of the image, and it now has "shape" and a satisfying range from highlight to shadow. Note the "S" shape of the curve and remember it. An "S" curve always represents an increase in contrast.

14. Save your work.

Figure 16 *Darkening the shadows*

Substantial darkening of shadow areas

© 2013 Photodisc/Getty Images. Source Adobe® Photoshop®, 2013.

Working with Curves and Adjusting Color

Figure 17 *Posterize effect made with the Posterize command*

Draw a Posterize curve

1. Show and target only the **Posterize Command layer**.

 First, you will posterize the image using the menu command.

2. Click the **Image menu**, point to **Adjustments**, then click **Posterize**.

3. Verify that the Levels slider is set to **4**, then click **OK**.

 Your screen should resemble Figure 17. Why does the posterized image appear the way it does? Because all the pixels from 0–63 are now black. The pixels from 64–127 are now dark gray. The pixels from 128–190 are light gray, and the pixels from 191–255 are now white. So here's the question: If you were to duplicate this effect using the Curves adjustment, what would you do? What would the adjustment look like? Take some time to think about it before moving on. Sketch it out on a piece of paper. Apply everything you've learned about grayscale and how the Curves adjustment functions. Test yourself. How would you do it?

4. Show and target the **Posterize Curve layer**.

 (continued)

5. Create a new clipped Curves adjustment layer named **Posterize**.

Before we begin, a quick disclaimer: it's extremely unlikely that you would ever use curves to posterize an image. Why would you when the Posterize command does such a quick and effective job? We're creating a posterize effect with the Curves adjustment 1) to drive home the central concepts of manipulating curves, 2) to show you a seldom used function in the Properties panel (the pencil), and 3) because this is a great illustration of how what you might think of as only a menu command is actually related to curves and can be duplicated with curves. Keep these three points in mind as you proceed.

6. Click the **pencil tool** in the Properties panel, then click where the black point normally would be. This would be the 0 Output and 0 Input point.

7. Press and hold [**Shift**], then click the **Input 63/ Output 0 point** on the grid.

As shown in Figure 18, all pixels input from 0–63 are now 0.

(continued)

Figure 18 *Using the pencil*

© 2013 Photodisc/Getty Images. Source Adobe® Photoshop®, 2013.

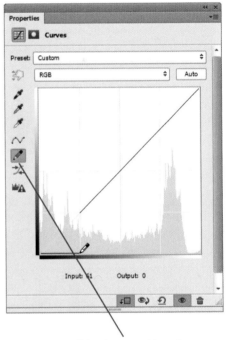

Click to draw curve with pencil

Working with Curves and Adjusting Color

Figure 19 *Posterize effect created in the Properties panel*

8. Release [Shift], then click the **64/64 point** on the grid.

9. Press and hold [**Shift**], then click the **128/64 point** on the grid.

 All pixels from 64–128 are now 64.

10. Release [Shift], then click the **129/191 point** on the grid.

11. Press and hold [**Shift**], then click the **191/191 point** on the grid.

 All the pixels from 129–191 are now 191.

12. Release [Shift], then click the **192/255 point** on the grid.

13. Press and hold [**Shift**], then click the **white point (255/255)**.

14. Compare your screen to Figure 19.

15. Save your work, then close Analyze Curves.psd.

Analyze Color
CHANNELS

What You'll Do

Source Adobe® Photoshop®, 2013.

One of the best methods for building color adjustment skills is to first develop a solid understanding of the basic concept of each color channel. All color images on your monitor are composed of the three primary colors of light: red, green, and blue. Thus, for a color image, Photoshop provides you three color channels: red, green, and blue. Working together, the three channels produce all of the color you see in the image.

Earlier in this chapter—and in the previous chapter—we analyzed and adjusted a grayscale image, which had a single channel. Thus, every pixel could be one and only one of 256 shades of gray. The concept is the same for RGB color files with one very big difference: an RGB file has three channels, and each of those channels has a grayscale range of 0–255. Thus, every pixel in an RGB file can be one of 256 shades of red and one of 256 shades of green and one of 256 shades of blue. For example, a pixel's color might be 50R/220G/145B.

With 256 shades available per pixel and per channel, the number of colors available is 256 x 256 x 256. This means that, in an RGB file, each pixel can be one of more than 16 million colors. But remember, even though it has three color components, R, G & B, each pixel is only one color, and that one color is the result of the combination of the three primary colors.

Working with Curves and Adjusting Color

Figure 20 *The Red channel in black and red*

Brightest areas represent pixels in the image with highest red component ———

Darkest areas represent pixels in the image with lowest red component ———

© 2013 Cengage Learning. Source Adobe® Photoshop®, 2013.

Figure 21 *The Red channel in black and while*

Darkest pixels brightened; red component increased ———

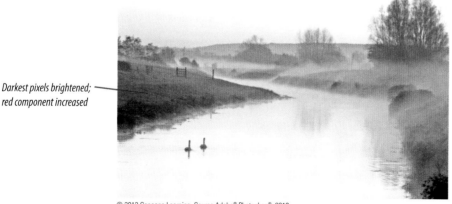

© 2013 Cengage Learning. Source Adobe® Photoshop®, 2013.

Understand grayscale in a channel

1. Open AP 4-3.psd, then save it as **Analyze Channels**.

2. Click the **Edit menu** (Win) or **Photoshop menu** (Mac), point to **Preferences**, then click **Interface**.

3. Click the **Show Channels in Color check box**, if necessary, then click **OK**.

4. Verify that the **Sunset layer** is targeted, then open the Channels panel.

5. Click the **Red channel thumbnail** to see only the red channel, then compare it to Figure 20.

 Channels are often called "channel masks," and it's helpful to think of them that way. In a channel, dark areas represent less color and light areas represent more color. In Figure 20, there's a lot of red in the pixels that make up the sky, but very little red in the dark foliage along the river.

6. Return to the Preferences/Interface dialog box, remove the check mark in the Show Channels in Color check box, then click **OK**.

7. Compare your Red channel to Figure 21.

 Nothing changed. Photoshop is now displaying the channel as 256 shades of gray (black to white) as opposed to 256 shades of red (black to red). Now, the white areas represent the areas of the image where red will be most prevalent.

8. Click the **RGB channel thumbnail**, then verify that the Info panel is showing and that at least one of the color readouts is set to RGB.

(continued)

9. Move the mouse pointer over the sky and note the readout in the Info panel.

In an RGB file, every pixel has one red value (from 0–255), one green value (from 0–255), and one blue value (from 0–255). Because the sky area of the image was white in the Red channel, you can expect that the pixels that make up the sky all have a Red readout that is high on the grayscale: over 240.

10. Move the mouse pointer over the dark foliage on the left side of the image, and note the readout information for the Red channel in the Info panel.

The Red readouts will be low, some of them under 30, because these are the darkest areas of the image.

11. Target the **Curves 1 adjustment layer**, click the **Channel list arrow (RGB)** on the Properties panel, then click **Red**.

This menu in the Properties panel allows you to modify each channel individually (Red, Green or Blue) or modify the composite RGB curve, which affects all three channels.

12. Drag the **black point** to the location shown in Figure 22, then compare the change in your image to Figure 23.

The image now has a red color cast because the Red component has been increased dramatically.

(continued)

Figure 22 *Increasing the red component in all pixels*

Red channel targeted

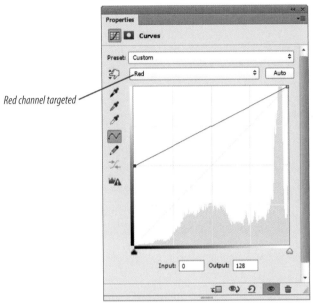

Source Adobe® Photoshop®, 2013.

Figure 23 *Color change in the composite image*

Red component increased in all pixels

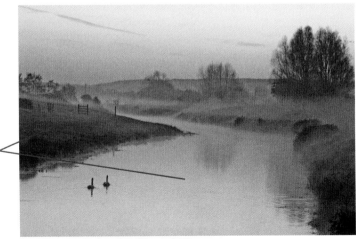

© 2013 Cengage Learning. Source Adobe® Photoshop®, 2013.

Working with Curves and Adjusting Color

Figure 24 *Red channel brightened*

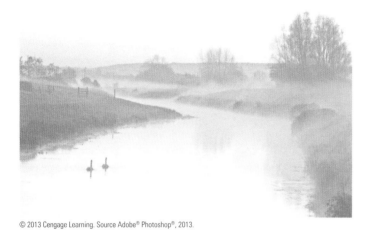

Figure 25 *The composite of the Red and Green channels*

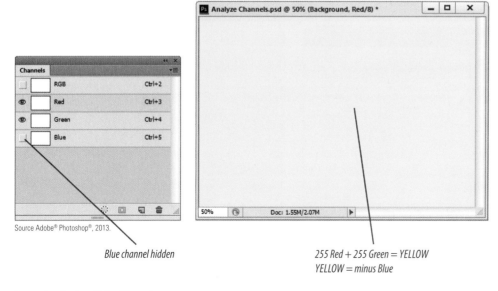

Blue channel hidden

255 Red + 255 Green = YELLOW
YELLOW = minus Blue

13. Click the **Red channel thumbnail** on the Channels panel, then compare your Red channel to Figure 24.

 The entire channel is brightened considerably and the shadow areas are all a medium gray.

14. Revert the file.

Viewing two of three channels

1. Verify that only the Background layer is visible.

 All of the pixels on the canvas are white.

2. On the Channels panel, click the **Blue channel thumbnail**, the **Green channel thumbnail**, then the **Red channel thumbnail**.

 All three of the channels are white. A white pixel in an RGB image has an RGB value of 255R/255G/255B.

3. Verify that the **Red channel** is targeted and that it is the only visible channel, then make the Green channel visible.

 As shown in Figure 25, 255R/255G/0B produces yellow pixels. To put it in other words, Red + Green = Yellow. Or, you can also say Yellow = "Minus Blue." If you want an image to be more yellow, or to be "warmer," you know that those pixels will have higher grayscale values in the red and green components relative to the blue component.

 To put it in different terms, if you want an image to be more yellow, reduce the blue component. If that's not enough, increase the red and green components.

 (continued)

4. Show just the Red and Blue channels.

As shown in Figure 26, 255R/0G/255B produces magenta pixels. Red + Blue = Magenta, or Magenta = "Minus Green." Like yellow, magenta is one of the process ink colors. When you're adjusting color in an RGB image, if you want the image to be more red, increase the red, but if you want it to be more magenta, reduce the green component.

5. Show just the Green and Blue channels.

As shown in Figure 27, 0R/255G/255B produces cyan pixels. Green + Blue = Cyan, or Cyan = "Minus Red."

6. Click the **RGB channel thumbnail**, make the Sunset layer visible, then target the **Sunset layer**.

(continued)

Figure 26 *The composite of the Red and Blue channels*

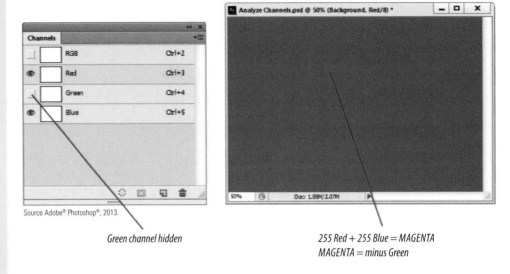

Source Adobe® Photoshop®, 2013.

Green channel hidden

255 Red + 255 Blue = MAGENTA
MAGENTA = minus Green

Figure 27 *The composite of the Green and Blue channels*

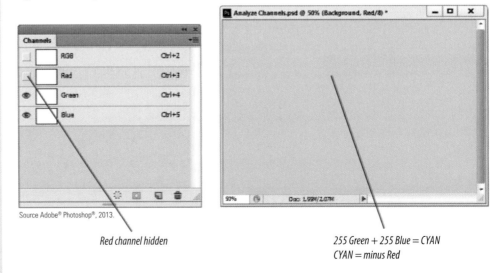

Source Adobe® Photoshop®, 2013.

Red channel hidden

255 Green + 255 Blue = CYAN
CYAN = minus Red

Working with Curves and Adjusting Color

Figure 28 *Info panel with RGB and CMYK readouts*

Source Adobe® Photoshop®, 2013.

7. Verify that the readouts in the Info panel are set to RGB and CMYK, as shown in Figure 28.

8. Show and target the Curves 1 adjustment layer.

 The Sunset image is one that is not color specific. Compared to an image of someone's face, in which the fleshtone color is either correct or incorrect, the color in this image could work with many different variations. Presently, the overall tone is a warm orange.

9. On the Properties panel, click the **RGB menu**, click **Blue**, then add a point to the curve at **Input 128/Output 180**.

 Overall, the image becomes more blue. Note that the Blue histogram shows no pixels in the far-right quadrant of the grid. That's because the lightest pixels in the image—those in the sky—have blue components that are lower than grayscale 191.

 (continued)

10. Remove the point from the Blue curve, then repeat the same steps to add a point at **Input 128/Output 180** to the Green curve.

The image becomes more green.

11. Remove the point from the Green curve, then repeat the same steps for the Red curve.

As shown in Figure 29, the image becomes more red.

12. Remove the point from the Red curve, click the same menu, then click **Green**.

(continued)

Figure 29 *Increasing the Red component*

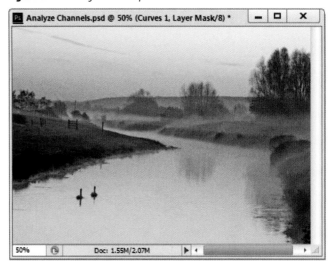

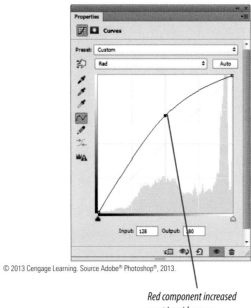

© 2013 Cengage Learning. Source Adobe® Photoshop®, 2013.

Red component increased most in mid-range

Working with Curves and Adjusting Color

Figure 30 *Decreasing the Green component*

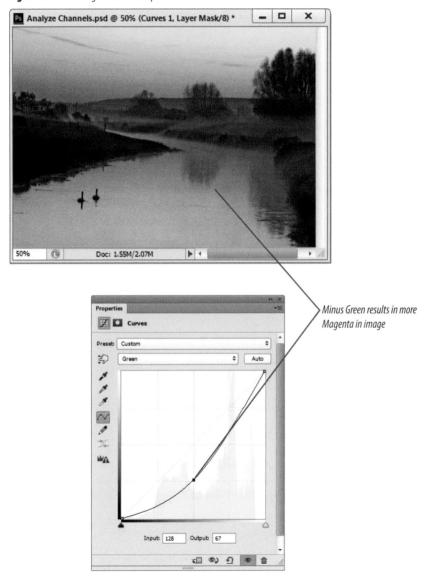

Minus Green results in more Magenta in image

© 2013 Cengage Learning. Source Adobe® Photoshop®, 2013.

13. Reduce the Green overall as shown in Figure 30, then position the Eyedropper tool 🖊 over the image as shown in the figure.

 The image becomes noticeably more magenta—more purplish—with the reduction of green. It's more reddish, but not in the same way as Figure 29. The Info panel shows a before and after readout. Note that in the RGB readout, only the Green value has changed.

TIP The CMYK readout in the Info panel shows that the Magenta ink component would be increased by nearly 20 percent if this image were printed with the 4-Color printing process.

14. Remove the point from the Green curve, apply the same move to the Blue curve, then position the Eyedropper tool over the image to see the before/after readouts.

 The image becomes noticeably more yellow with the reduction of blue.

TIP The CMYK readout in the Info panel shows that the Yellow ink component would be increased if this image were printed with the 4-Color printing process.

(continued)

15. Remove the point from the Blue curve, apply the same move to the Red curve, then move the Eyedropper tool over the image to see the before and after readouts.

The image becomes noticeably more cyan with the reduction of red.

TIP The CMYK readout in the Info panel shows that the Magenta ink component would be increased if this image were printed with the 4-Color printing process.

16. Delete the Curves 1 adjustment layer.

17. Create a Color Balance adjustment layer above the Sunset layer.

18. Note the two ends of each of the three sliders.

As shown in Figure 31, the Color Balance adjustment is a visual representation of this entire discussion. The more you move away from Red, you move closer to Cyan. Magenta is opposite Green. Yellow is opposite blue.

(continued)

Figure 31 *Color Balance adjustment*

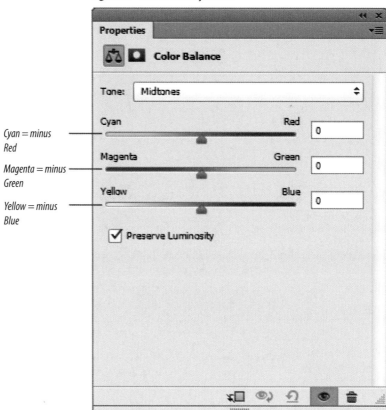

Cyan = minus Red

Magenta = minus Green

Yellow = minus Blue

Source Adobe® Photoshop®, 2013.

Figure 32 *Moving the color balance away from Green and towards Magenta*

Increase in magenta cast overall

© 2013 Cengage Learning. Source Adobe® Photoshop®, 2013.

19. Drag the **middle slider** left so that the middle text box reads **-80**.

 The result, shown in Figure 32, is the same as the move you made in Step 13 when you reduced the green component. Each slider manipulates one of the three color channels. This is a great illustration of why curves are the most sophisticated color manipulation utility. The Color Balance adjustment allows you to adjust midtones (the middle of the curve), shadows (the lower end of the curve), and highlights (the upper end of the curve). Compare that to curves, where you can manipulate any point on the entire curve and add multiple points to the curve for a far more complex adjustment.

20. Experiment with moving the other sliders on the panel.

21. Save your work, then close Analyze Channels.psd.

Adjust Color
WITH CURVES

What You'll Do

© 2013 Cengage Learning. Source Adobe® Photoshop®, 2013.

When it comes to adjusting color, one of the first moves you should make isn't about adjusting color, at least not specifically. Before you even begin to consider the overall color balance, you first need to analyze the overall tonal range of the image. Think of it this way: if there's poor contrast, if the shadows are weak, if the white point is too dark, or if the midrange of the image is too dark or too light, trying to make color adjustments is futile. You must address the tonal range first, verify that the shadows and highlights are strong, verify that there's good contrast—that the image has "snap." Once this has been achieved, you're ready to make smart and effective color adjustments.

Don't confuse the two, but keep in mind that adjusting the tonal range is adjusting color. When an image has poor contrast or weak shadows or dim highlights, those factors have a direct influence over the color throughout the image. When you correct those problems, you'll be amazed at how those moves alone can dramatically improve color. Dull, muddy color suddenly becomes vivid and vibrant.

Generally speaking, adjusting color means changing the relationship between the Red, Green, and Blue channels, whether that adjustment is overall or "local." You might decrease the Red component in a fleshtone, for example, or increase the Blue component for a more vivid sky.

Still speaking in general terms, adjusting the tonal range of an image is something you do in the RGB composite channel. The RGB channel shows one curve that is the composite—or the combination—of the three color channels. Changes that you make to the RGB curve affect all the channels equally. For example, if you adjust the RGB curve to brighten the midrange of the image, that adjustment brightens the Red, Green, and Blue channels by the same measure.

Finally, it helps to consider some useful terminology. When working in the RGB composite channel, the adjustments you make fall into the categories of brightening the image, darkening the image, increasing or "bumping" the contrast, "opening" shadows for more detail, improving the black and white points, and maintaining highlights so that they don't "pop" or get "blown out" to pure white. Note that none of these terms refers to a specific color channel. These are changes that you make to the composite image.

You can make all of these changes to individual channels, but it helps if you don't think of adjustments to individual color channels as "brightening" or "darkening." It's much clearer to think in terms of "increasing" or "decreasing" the specific color. So, rather than think, "I need to brighten the reds in the sky," I'd say, "I need to increase the red in the sky." In another case, I might say, "The shadows look a little yellowish; there's not enough blue in the shadows."

These are not hard and fast rules, and you'll find all kinds of jargon when it comes to correcting curves. The takeaway point is this: the lighter the pixels in a color channel—the closer they are to grayscale 255—the greater the component of that color in the pixel. The darker the pixels in a color channel—the closer they are to grayscale 0—the lesser the component of that color in the pixel.

Remove a color cast in a landscape image

1. Open AP 4-4.psd, then save it as **Outback**.
2. On the Info panel, verify that the first readout is set to **RGB** and the second readout is set to **CMYK**.
3. Assess the overall appearance of the image in terms of color.

 With landscapes, it's seldom the case that the color is "wrong," as it might be with a fleshtone or a commercial product. As shown in Figure 33, this image clearly has a yellow cast overall and the foliage that would naturally be green is closer to yellow and orange. However, the image is set at sunset, which would justify that palette.

4. Sample different areas of the image with the **Eyedropper tool** .

 Though I never color adjust an image in terms of CMYK, I do use the CMYK readouts in the Info panel as an indication of the color balance of the image. In the case of this image, the yellow readout in the Info panel is substantially higher than the other readouts, and that's an indication of a direction to follow.

5. Create a new Curves adjustment layer.
6. Add a point to the Blue curve at **Input 128/ Output 150**.

 I decided to counter the overall yellow cast by increasing the blue. It is now clear that there's an overall red cast to the image. This makes sense, because yellow is made with the Red and Green channels. The yellow cast appears to have been the result of too little blue and too much red.

 (continued)

Figure 33 *Assessing the image*

Yellow – red color cast overall in foliage

Working with Curves and Adjusting Color

Figure 34 *The original image and the image after the adjustment*

Lesson 4 Adjust Color with Curves

7. Add a point to the Red curve, then experiment by moving the point to various locations beneath the intersection line.

 Experimenting this way is a smart solution for adjusting color. Different reductions of red will result in different qualities of green for the foliage in the image.

8. Drag the new point on the Red curve to **Input 147/Output 100**.

9. Hide and show the Curves adjustment layer to see the change.

 As shown in Figure 34, the change is dramatic and the original image did indeed have a heavy red/yellow cast throughout. One measure of why this move was an improvement is the increase in detail overall. Note how the mountains in the background are more differentiated from the midground. Note how the fencepost is more prominent, and how the red patches of sunlight on the ground in the foreground are so much more pronounced against the green foliage. Finally, note how the plants in the foreground now show so much more color variation and detail.

10. Assess the overall appearance of the image in terms of color.

 When you make a color adjustment that improves an image dramatically, it's easy to jump to the conclusion that your work is done, because the image looks so much better. Instead, after every move, stop and assess the image. In this case, the improvement is

 (continued)

dramatic, but the overall color tone of the image is cold. The greens are cold—like the color of evergreen trees. This makes me think that I might have gone too far with the increase of the blue component overall.

11. Click the **Channel menu** on the Properties panel, click **RGB**, then compare your adjustment to Figure 35.

 The grid shows the adjustment that you made to the red channel and the blue channel.

12. Switch back to the Blue channel, then experiment with reducing the Blue channel by various degrees.

13. Decrease the Blue channel to **Input 128/ Output 139**.

 Though it was a small move, it improved the greens and warmed up the image overall.

14. Return to the RGB composite channel.

 Whenever I adjust color and am satisfied, I always take a moment to experiment with adjusting the contrast.

15. Click the **Properties panel menu button** ▦, then click **Curves Display Options**.

16. Remove the check mark in the Channel Overlays check box so that you can see the RGB composite curve better, click **OK**, then re-create the curve shown in Figure 36.

 (continued)

Figure 35 *The RGB composite grid showing adjustments made to the Red and Blue channels*

RGB composite curve is black

Source Adobe® Photoshop®, 2013.

Figure 36 *Increasing contrast overall*

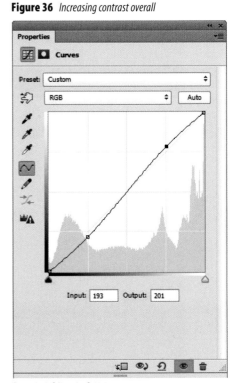

Source Adobe® Photoshop®, 2013.

Working with Curves and Adjusting Color

Figure 37 *A before and after view of the original and all the adjustment*

Lesson 4 Adjust Color with Curves

17. Hide and show the adjustment layer to see all the changes, then compare your final image to Figure 37.

18. Save your work, then close Outback.psd.

Adjust color in a fleshtone and make local color adjustments

1. Open AP 4-5.psd, then save it as **Red Scarf**.

2. Assess the appearance of the image.

 There's a white hot spot over the woman's shoulder where the pixels are all white, but it's not too distracting. At first glance, the image looks good in terms of color balance, but the colors are all very cold. There's a sense of drabness; the red scarf is not vibrant and the face seems a bit lifeless.

3. Click the **Eyedropper tool** 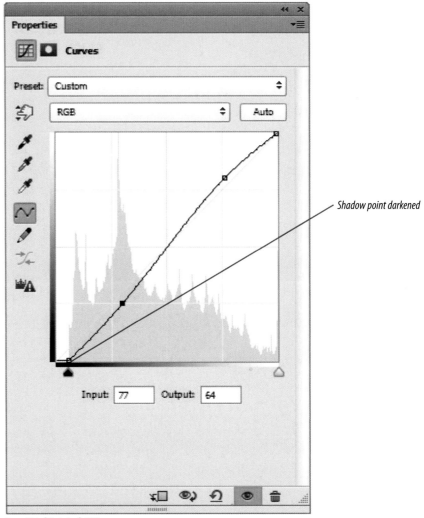, then sample the shadow areas in the scarf and neck area.

 The shadow areas have grayscale readings in the 20s, which indicates weak shadows and offers some explanation for the overall drabness.

4. Create a new Curves adjustment layer.

 The histogram shows no pixels at the far-left edge, which confirms that the shadows in the image are weak.

5. Drag the **black point** to the right so that its Input/Output values are 14/0.

6. Click to add a point to the curve, then set its Input/Output values to 195/205.

7. Click to add another point to the curve, set its Input/Output values to 77/64, then compare your curve to Figure 38.

 This curve represents significant change. The black point has been darkened—which darkened the entire image—and the "S" curve increased contrast.

 (continued)

Figure 38 *Darkening the shadow point and increasing contrast*

Shadow point darkened

Source Adobe® Photoshop®, 2013.

Working with Curves and Adjusting Color

Figure 39 *Before and after view of the adjustment*

Before

After
© 2013 Cengage Learning. Source Adobe® Photoshop®, 2013.

8. Hide and show the Curves adjustment layer to see the changes.

 This is a good illustration of how adjusting black and white points and adjusting contrast is also a color adjustment. As shown in Figure 39, along with the dramatically improved contrast, the adjusted image shows a palette of colors that is far more vibrant. However, the bump in contrast has blown out the highlights on the jacket, screen-right.

9. Click the **Brush tool** , then mask the adjustment layer completely over the jacket screen-right.

 As you can see in the before image in Figure 39, the highlights in this area of the jacket were already blown out. Photoshop can't "fix" blown out highlights—you can't adjust detail in an area that has no detail to begin with—but you don't want to increase the problem when adjusting other areas of the image. The contrast bump made the hot spot on screen-left larger and brighter.

 (continued)

10. Create a new Curves adjustment layer above the first adjustment layer.

 The fleshtone still looks cold and "ruddy," so I want to experiment with some color shifts. Rather than go back to the first adjustment layer, I'd prefer to leave it alone and use a new curve for this adjustment.

11. Target the **Blue channel,** add a point to the Blue curve, then set the Input/Output values to **166/150**.

12. Hide and show the second adjustment layer to see the changes.

13. Mask the adjustment layer so that it doesn't affect the irises and the jacket.

 As shown in Figure 40, the decrease in blue adds a sense of warmth to the fleshtone, the scarf, and the background. I masked the adjustment from the irises to preserve the ice-blue color and the cold whites. I masked the adjustment from the jacket to maintain the neutral gray and not create a color bias by making the jacket yellowish.

14. Create a third Curves adjustment layer, add a new point to each channel, then adjust the curves so that the Input/Output values are as follows: **Red 126/137**; **Green 128/120**; **Blue 133/113**.

(continued)

Figure 40 *"Warming" the flesh tone*

Before

After

© 2013 Cengage Learning. Source Adobe® Photoshop®, 2013.

Working with Curves and Adjusting Color

Figure 41 *Before and after view of all the adjustments*

Before

After

© 2013 Cengage Learning. Source Adobe® Photoshop®, 2013.

15. Press [**Ctrl**][**I**] (Win) or ⌘ [**I**] (Mac).

 The layer mask on the new adjustment layer is inverted from default white to black. The entire adjustment is entirely masked.

16. Paint white with a soft brush so that the adjustment affects only the scarf.

 The red of the scarf becomes more vivid.

TIP When you make adjustments to just specific areas of an image, those are called "local" adjustments, as opposed to "global"—overall—adjustments.

17. Set the Opacity on the Brush tool to **30%**, then gradually "paint in" red highlights to brighten the hair and make its color more vivid.

18. Select the three adjustment layers on the Layers panel, then press [**Ctrl**][**G**] (Win) or ⌘ [**G**] (Mac).

 The three adjustments are grouped into a single group folder.

19. Hide and show the group folder to see the sum total of adjustments to the image.

20. Compare your result to Figure 41.

21. Save your work, then close Red Scarf.psd.

Adjust color in a water image

1. Open AP 4-6.psd, then save it as **Sailboat**.

2. Click the **Eyedropper tool** 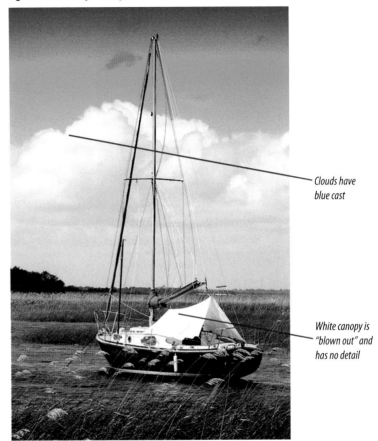, then sample the white sail of the boat.

 From a photography standpoint, this isn't a great photo because the entire white canopy has been blown out to white. As shown in Figure 42, there's no detail in the canopy to work with. It's just a field of white.

3. Sample the back end of the boat.

 The pixels at the back of the boat are 0/0/0—pure black. These two samples tell us that we don't want to move the white point or black point. There's already too much pure white in the image, and the overall contrast looks good.

4. Sample other areas of the image.

 This image is a good example of a common occurrence with a water image: an overall blue cast. Think of how much blue there is in the image. There's a big blue sky over an expanse of blue water. The boat itself is blue, and there's a bright blue sail cover to boot. In addition, there's a substantial amount of green grass, and blue is a big component of that green. It's often the case with a sunny water image that the photographer or the camera or both will overcompensate to capture all that blue, and that will result in a blue cast to the image. As you sample the image, you'll see in the CMYK readout in the Info panel that Cyan dominates almost every pixel in the image. The clouds are also a big hint: they're not white—they're pale blue.

 (continued)

Figure 42 *Assessing the image*

Clouds have blue cast

White canopy is "blown out" and has no detail

© 2013 Cengage Learning. Source Adobe® Photoshop®, 2013.

Working with Curves and Adjusting Color

Figure 43 *Moving the white point in the Red channel*

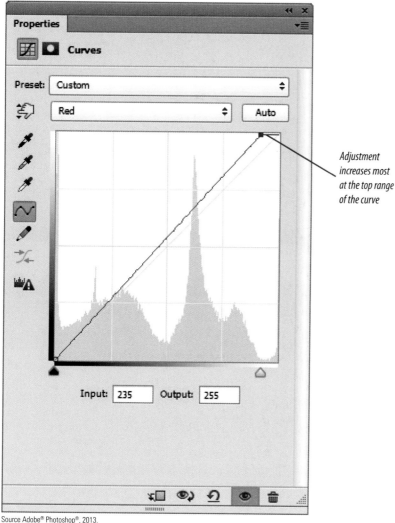

Adjustment
increases most
at the top range
of the curve

Source Adobe® Photoshop®, 2013.

5. Create a new Curves adjustment layer, then experiment with reducing the Blue component to various degrees.

 Reducing the blue a little bit improves the image, but doesn't completely remove the color cast. Reducing the blue significantly is no help at all—it just creates a weird green/yellow cast. When adjusting one channel isn't enough, that's usually a good hint that an adjustment of another channel is needed.

6. Change the Blue channel curve's Input/Output values to **130/107**, then sample different areas of the image.

 The blue reduction made a subtle improvement, but the clouds alone show that the blue cast remains strong overall. Where to go from here? The hint is in the CMYK readout in the Info panel, which shows that Cyan continues to dominate the entire image. Since you know that Cyan is created from subtracting Red, that tells you that adding Red will decrease the Cyan cast.

7. Move the Red channel's white point as shown in Figure 43, so that its Input/Output values are **235/255**.

 (continued)

8. See Figure 44.

Figure 44 shows the original image and the adjusted image. The Red adjustment was a big move, and clearly a move in the right direction. The Red move needed to be dramatic, because Cyan was so dominant in the original image it required a big Red move as a counter. So we moved the white point because we wanted the adjustment to have a major impact on the upper half of the curve. With this method, Red is increased in the midtones and increased even more dramatically in the highlights. Had we increased Red from the midpoint, the effect would taper off in the highlight range, and the Cyan cast would have remained in the clouds.

9. Hide/show the adjustment layer to see the before/after result.

In the adjusted image, the green of the grass, the gold/tan of the reeds, and the pink and white glow of the clouds shows how far off the original image was. The important take-away point from this lesson is that what we read initially as a Blue cast was actually a Cyan cast. Thus, reducing the Blue channel wasn't enough to fix the problem. The key was increasing the Red channel substantially to counter the Cyan cast.

10. Save your work, then close Sailboat.psd.

Figure 44 *The original and final images*

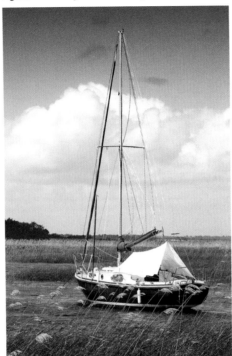 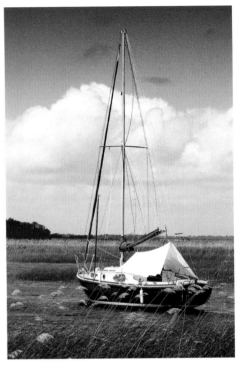

Before
© 2013 Cengage Learning. Source Adobe® Photoshop®, 2013.

After

Working with Curves and Adjusting Color

Figure 45 *Assessing the image*

© 2013 Cengage Learning. Source Adobe® Photoshop®, 2013.

Adjust color in a poor quality image

1. Open AP 4-7.psd, then save it as **Old Car**.

2. Assess the photographic quality of the image.

 As shown in Figure 45, this image clearly has big problems. Before we even address the color problems, note that the photo itself is poorly shot. The buildings in the background are overlit and blown out. The subject of the image—the car—is in the foreground, and the entire foreground is in shadow. This means that no matter what adjustments we make, the background and the buildings will be the brightest and most prominent components of this image.

3. Assess the color quality of the image.

 This image has big color problems too. The whole thing is purple. Based on what we learned in this chapter, we want to now check to see if that purple is too much Red, too much Magenta, too much Blue, or too much Cyan.

4. Position the **Eyedropper tool** over the street pavement in the foreground.

 Keep in mind the sailboat from the previous set of steps when you sample this image. Unlike with the sailboat, the Info panel shows that Cyan is not dominant in the CMYK readout. Instead, Yellow is weak. That's a hint that there's too much Blue, because Yellow is created in RGB by subtracting Blue. In the RGB readout, note that Blue is dominant almost throughout the image. This image has a Blue cast, not a Cyan cast.

 (continued)

5. Move the pointer over the deep shadow under the side of the car, as shown in Figure 46.

Dark shadows are always reliable areas of an image to sample, because they should be neutral. A neutral dark shadow should show the three RGB channels as lower numbers with all of them close in value. 12R/12G/12B would be a very satisfactory neutral dark shadow. In this case, the readout on the shadow is 1R/0G/20B!

6. Create a new Curves adjustment layer.

First we must address the overall brightness of the image. The blown out background means that the highlights can't be brightened. However, the foreground and most important part of the image is in shadow, so it is best to keep the shadow areas as bright as possible to show detail in the car.

7. Add a point to the curve, then set its Input/Output values to **57/68**.

The shadow areas of the image are brightened.

(continued)

Figure 46 *Sampling the shadows*

© 2013 Cengage Learning. Source Adobe® Photoshop®, 2013.

Working with Curves and Adjusting Color

Figure 47 *Before and after view of the blue reduction*

8. Add another point to the curve, then set its Input/Output values to **215/215**.

 Adding this point insures that no pixels higher than 215 will be brightened.

9. Switch to the Blue channel, add a point to the Blue curve, then set its Input/Output values to **101/63**.

10. Hide and show the new adjustment layer to see the change.

 As shown in Figure 47, the foreground is brightened slightly and the image appears far more balanced in color.

11. Sample the dark shadow at the side of the car.

 Blue is still very dominant in the dark shadow, which tells you that the reduction of blue didn't have enough impact on the lower end of the Blue curve.

(continued)

12. Move the black point on the Blue curve to the right so that its Input/Output values are **13/0**, as shown in Figure 48.

13. Sample the change in the same shadow areas. The Blue value has been reduced.

14. Evaluate the image.

 At this point, there aren't any more global changes you can make with curves to make the red of the car more vivid. Increasing Red and reducing Green would do the trick but would create a color cast everywhere else in the image. In that case, you'd need to create a complex layer mask to affect only the red of the car.

15. Create a new Selective Color adjustment layer, then verify that the Colors option is set to Reds and that the Relative option button is selected on the Properties panel.

16. Drag the **Cyan slider** to **-90**, then drag the **Magenta slider** to **+20**, as shown in Figure 49.

(continued)

Figure 48 *Darkening the black point in the Blue channel*

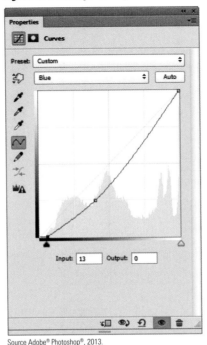

Source Adobe® Photoshop®, 2013.

Figure 49 *Selective Color adjustment*

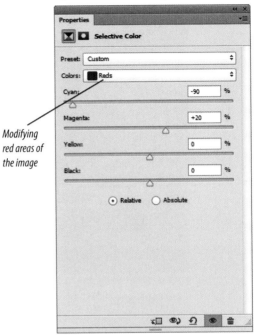

Modifying red areas of the image

Source Adobe® Photoshop®, 2013.

Relative and Absolute Options for Selective Color

The Selective Color adjustment is a unique and powerful color adjustment utility. It has all the power of the Color Balance adjustment taken to the ultimate extreme by allowing you to make adjustments based on specific colors. You can make the Reds more Red, or the Greens less Blue. Don't overlook the Neutrals, Blacks, and Whites either—correcting them in the Selective Color Adjustments panel is a smart way to remove a color cast from an image.

The Selective Color adjustment has two options: Relative and Absolute. Neither changes the basic behavior of the adjustment; each affects only the degree to which the changes you make affect the image.

The Relative option changes the amount of Cyan, Magenta, Yellow, or Black you adjust based on a percentage of what's already there. For example, if a pixel were 50% Magenta and you dragged the Magenta slider to 20%, the Magenta in the value would increase by 10 to 60% (20% of 50% is 10). Thus, the sliders work relative to the percentages already there.

The Absolute option is more straightforward. Using the same example, the Magenta value would increase to 70% (50% + 20% = 70%).

As you can see, both options move you in the same direction. You might prefer the Absolute option because it's easier to understand the change you're making, but the Relative option affects the image more gradually.

Working with Curves and Adjusting Color

Figure 50 *Before and after view all the adjustments*

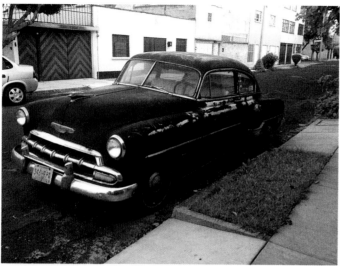

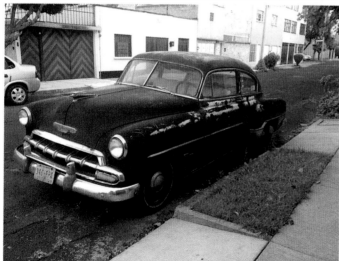

© 2013 Cengage Learning. Source Adobe® Photoshop®, 2013.

17. Click the **Colors list arrow**, choose **Neutrals**, drag the **Magenta slider** to **-6**, then drag the **Yellow slider** to **+10**.

18. Create a new Hue/Saturation adjustment layer.

19. Click the **Master** list arrow, then click **Reds**.

20. Increase the Saturation to **+15**.

21. Hide and show the Hue/Saturation adjustment layer.

 The improvement is noticeable. Given that the car is in shadows, this red is reasonably bright and vivid; a hot, vivid red would not be realistic in these lighting conditions. In the sunshine, yes. In the shade, no.

22. Create a layer group for the three adjustment layers, then hide and show the layer group to see the overall changes.

 As shown in Figure 50, the image is dramatically improved from the original. Note how the green grass is now green. Also, note how the pavement in the street is now a neutral gray—which is what it's supposed to be. Neutral areas are always good indicators of whether or not an image has a color cast.

23. Save your work, then close Old Car.psd.

1. Open AP 4-8.psd, then save it as **Curves Review**.
2. Show the Top Right layer, target it, then zoom in so that you are viewing the image at 50%.
3. Use the Eyedropper tool to find the brightest pixel in the image, then write down that grayscale value on a piece of paper.
4. Use the Eyedropper tool to find the darkest pixel, then write down that number.
5. Click the Layer menu, point to New Adjustment Layer, then click Curves.
6. Name the new adjustment layer **White/Black Point**, and be sure to use the previous layer as a clipping mask. (*Hint*: Be sure to click the Use Previous Layer as Clipping Mask check box whenever you create a new adjustment layer in the remainder of this Project Builder.)
7. Use the Curves adjustment to improve the image by resetting the white point and the black point.
8. Show the Bottom Left layer, target it, then zoom in so that you are viewing the image at 50%.
9. Find the brightest pixel in the image.
10. Find the darkest pixel.
11. Create a new Curves adjustment layer named **Midtone Adjustment**.
12. Improve the image by correcting the white point and the black point.
13. Lighten or darken the midtones to a level that you think looks best.
14. Show the Bottom Right layer, target it, then zoom in so that you are viewing the image at 50%.
15. Use the Magic Wand tool to select only the white background of the image.

16. Click the Select menu, click Inverse, then hide the selection marquee.
17. Create a new Curves adjustment layer named **Head Selection**.
18. Make the image look the best you think it can look.
19. Make only the Top Left layer visible, target it on the Layers panel, then zoom in so that you are viewing the image at 50%.
20. Create a new Curves adjustment layer.
21. Click the pencil button (Draw to modify the curve).

Figure 51 *Completed Project Builder 1*

22. Draw four horizontal lines of any length anywhere on the grid to create a posterized effect.
23. Compare your results to Figure 51.
24. Save your work, then close Curves Review.psd.

1. Open AP 4-9.psd, then save it as **Half and Half**.
2. Target the layer named **Left Side**.
3. Create a Black & White adjustment layer at the top of the Layers panel so that you can fix the contrast between the halves without having to look at color.
4. Target the Left Side layer, then create a clipped Curves adjustment layer.
5. Increase the contrast on the left side so that it's not so flat.
6. Target the Right Side layer, then create a clipped Curves adjustment layer.
7. Darken the black point on the curve until the beard on the right half looks as similar as possible to the beard on the left.
8. Use the curve to increase the contrast on the right half until it looks like the left side.
9. Hide the Black & White adjustment layer.
10. Use clipped Color Balance and Hue/Saturation adjustments on either half to make both halves match.
11. Use additional Curves adjustments if necessary to adjust contrast, and feel free to tweak your existing adjustments. Figure 52 shows one result.

Figure 52 *Completed Project Builder 2*

© 2013 Ken Weingart Getty Images. Source Adobe® Photoshop®, 2013.

CHAPTER **5**

WORKING WITH TYPE
AND SHAPE LAYERS

1. Design chiseled type.

2. Design plastic type.

3. Design recessed type.

4. Mask images with type.

5. Use shape layers to design eroded type.

Design Chiseled TYPE

What You'll Do

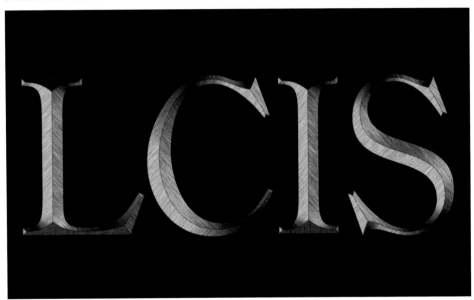

Image courtesy of Chris Botello. Source Adobe® Photoshop®, 2013.

Photoshop has a number of settings and styles that allow you to make gorgeous chiseled type, which is a good thing because chiseled type works well with a number of different design concepts. Chiseling type has many applications: it can be used for metallic textures, stone textures, and wood textures. It can be shiny or dull, dark or bright. Chiseled text is timeless. Of course, it's the first thing you think of when you think of ancient writing, Roman numerals, and mythology. Yet it is just as appropriate to use it in modern contexts. It connotes hardness, yet it also connotes elegance. In this lesson, you'll explore the many options Photoshop makes available for working with this essential and versatile style.

Figure 1 *Filling the text with gray*

Image courtesy of Chris Botello. Source Adobe® Photoshop®, 2013.

When creating chiseled text, I like to use a serif typeface because it has interesting lines and arcs. This typeface is Century Old Style, 160 pt.

Chisel text

1. Open AP 5-1.psd, then save it as **Chisel Text**.
2. Set the foreground color to **128R/128G/128B**, fill the text on the Text layer with the foreground color, then compare your canvas to Figure 1.

 When designing text, it's usually a good idea to start with gray text using 128R/128G/128B, because this gives you the full upper half of the grayscale to create highlights and the full lower half of the grayscale to create shadows.
3. Click the **Layer menu**, point to **Layer Style**, then click **Bevel & Emboss**.

TIP Position the dialog box so that you can see the changes to the image as you work.

4. Verify that the Style is set to **Inner Bevel**, click the **Technique list arrow**, then click **Chisel Hard**.
5. Drag the **Depth slider** back and forth to see its effect.

 All bevel and emboss effects are created by making one edge of a graphic darker and the other side brighter. The Depth slider controls the darkness of the shadows and brightness of the highlights. Increasing the Depth value increases the contrast between the shadows and highlights.

(continued)

Lesson 1 Design Chiseled Type

6. Drag the **Depth slider** to **150**.

7. Slowly drag the **Size slider** to the right to increase the chisel effect.

8. Drag the **Size slider** to **42**, then compare your canvas to Figure 2.

9. Click the **Gloss Contour list arrow**, click through each setting in the list, then click **Cone – Inverted**, the third contour in the top row.

10. Verify that the Anti-aliased check box is not checked, click **OK**, then compare your result to Figure 3.

Figure 2 *Setting the Chisel Hard technique in the Layer Style dialog box*

Image courtesy of Chris Botello. Source Adobe® Photoshop®, 2013.

Figure 3 *Chisel effect*

Image courtesy of Chris Botello. Source Adobe® Photoshop®, 2013.

AUTHOR'S NOTE

Of the many looks available in the Bevel & Emboss layer style category, the chisel effect in Figure 3 is one of my favorites. I really like the way it raises the center of the letterform to a sharp point that is defined by the dark gray line. However, from a design perspective, this is in no way original art. Though the artwork is pleasing, it's a "canned solution," meaning anybody could recreate it simply by dragging the same sliders and inputting the same values. The challenge when working with layer styles is to create a unique effect. Therefore, it's a good idea to think of the art at this stage as the base effect to which you can add your own techniques and create an original piece of artwork.

Figure 4 *Overlaying the fill color layer*

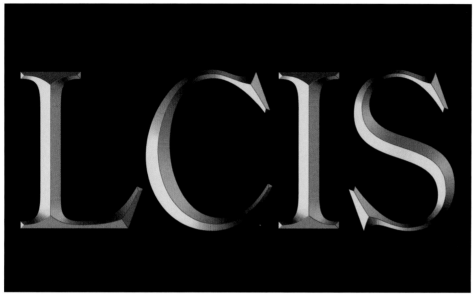

Image courtesy of Chris Botello. Source Adobe® Photoshop®, 2013.

Apply a fill layer

1. Click the **Layer menu**, point to **New Fill Layer**, then click **Solid Color**.

2. Type **Orange** in the Name text box, click the **Use Previous Layer to Create Clipping Mask check box**, then click **OK**.

3. Type **205R/111G/0B** in the Color Picker, click **OK**, then compare your screen to Figure 4.

 This solid color layer is simply that, a solid fill of color. Its blending mode is set to Normal. However, it appears transparent because it is clipped into the Text layer, and it therefore takes on the Bevel & Emboss layer style applied to the Text layer. If you were to unclip it, it would appear as a simple solid color.

Create selection masks from artwork

1. Press and hold **[Shift][Ctrl][Alt][E]** (Win) or **[Shift][option]** ⌘ **[E]** (Mac).

 For the remainder of this chapter, I will refer to this move as "Create a new stamp visible layer."

2. Name the new layer **Stamp Visible**.

3. Click the **Magic Wand tool** , set the Tolerance value to **4**, then verify that the **Anti-alias** and **Contiguous check boxes** are both checked.

4. Select the top and bottom sections of the letters *L* and *I* so that your selections resemble Figure 5.

5. Click the **Select menu**, point to **Modify**, then click **Expand**.

6. Type **1** in the Expand By text box, then click **OK**.

7. Save the selection as **Tops/Bottoms**, then deselect.

8. On the Channels panel, click the **Channel thumbnail** for the Tops/Bottoms channel to see the selection mask.

9. Click the **Channel thumbnails** for the **Red**, **Green**, and **Blue channels** to see what's on each of them.

(continued)

Figure 5 *Selecting the tops and bottoms of L and I*

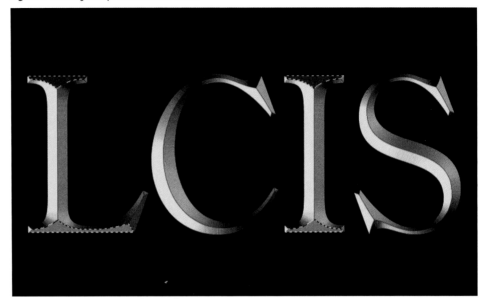

Image courtesy of Chris Botello. Source Adobe® Photoshop®, 2013.

Working with Type and Shape Layers

Figure 6 *Blue channel loaded as a selection*

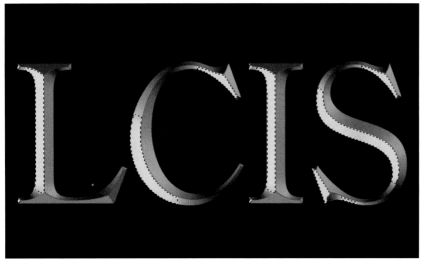

Image courtesy of Chris Botello. Source Adobe® Photoshop®, 2013.

Figure 7 *Half Round gloss contour*

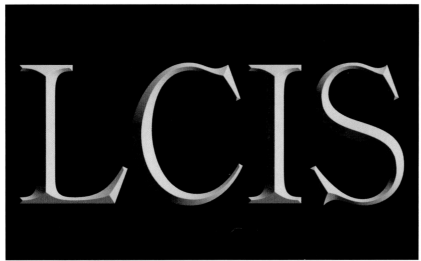

Image courtesy of Chris Botello. Source Adobe® Photoshop®, 2013.

10. Click the **Channel thumbnail** on the RGB channel, press and hold **[Ctrl]** (Win) or ⌘ (Mac), then click the **Channel thumbnail** on the Blue channel.

TIP Pressing and holding [Ctrl] (Win) or ⌘ (Mac) when clicking a Channel thumbnail loads the channel as a selection mask.

Our goal is to create a selection mask for the left side of each letter. As shown in Figure 6, the Blue channel gets us the closest to that goal—but not close enough.

11. Deselect, return to the Layers panel, then delete the Stamp Visible layer.

We needed the Stamp Visible layer only to create the Tops/Bottoms selection.

12. Double-click the **Bevel & Emboss effects layer**, click the **Gloss Contour list arrow**, click **Half Round**, then click **OK**.

As shown in Figure 7, with the Half Round gloss contour, the chisel effect has very light highlights.

(continued)

13. On the Channels panel, duplicate the Blue channel, rename it as **Right Side**, then compare the new channel, as shown in Figure 8.

14. Open the Levels dialog box, drag the **white triangle** left until the third Input text box reads **182**, then click **OK**.

The right side of the letterforms are now white in the selection mask. However, the tops of the letters are also white, which means they too would be part of any selection made from this mask.

TIP You can open the Levels dialog box by pressing [Ctrl] [L] (Win) or ⌘ [L] (Mac).

15. Press and hold [**Ctrl**] (Win) or ⌘ (Mac), then click the **Channel thumbnail** for the Tops/Bottoms channel.

The Tops/Bottoms channel is loaded as a selection in the Right Side channel.

16. Fill the selection with black, deselect, then compare your selection mask to Figure 9.

We have now successfully isolated the right side of the letterforms from the left side and from the tops and bottoms of the letterforms. The tops of the C and S letters are white or light gray; they will be selected or partially selected when this mask is loaded. As you'll see, this won't be a problem; keep an eye on these areas as we move forward.

17. Duplicate the Right Side channel, then name the new channel **Left Side**.

(continued)

Figure 8 *Duplicated Blue channel*

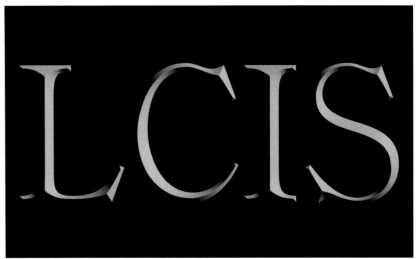

Image courtesy of Chris Botello. Source Adobe® Photoshop®, 2013.

Figure 9 *Masking out the tops and bottoms*

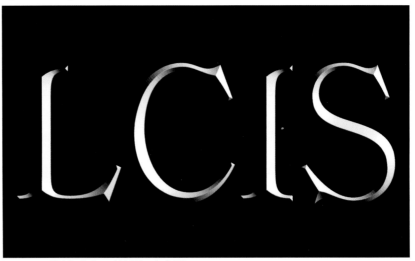

Image courtesy of Chris Botello. Source Adobe® Photoshop®, 2013.

Figure 10 *Inverted channel*

Image courtesy of Chris Botello. Source Adobe® Photoshop®, 2013.

Figure 11 *Masking out the tops and bottoms*

Image courtesy of Chris Botello. Source Adobe® Photoshop®, 2013.

18. Press [**Ctrl**][**I**] (Win) or ⌘ [**I**] (Mac) to invert the channel.

19. Open the Levels dialog box, drag the **black triangle** right until the first Input text box reads **40**, then click **OK**.

 Compare your screen to Figure 10.

20. Load the Tops/Bottoms channel as a selection, expand the selection by 1 pixel, fill the selection with black, then deselect so that your Left Side channel resembles Figure 11.

21. Click the **RGB channel**, then return to the Layers panel.

22. Double-click the **Bevel & Emboss effects layer**, click the **Gloss Contour list arrow**, click **Cone – Inverted**, then click **OK**.

23. Save your work.

Create a texture

1. Click the **Image menu**, click **Duplicate**, type **Texture** in the As text box, then click **OK**.

2. Flatten the duplicate file, then fill the canvas with the gray foreground color.

3. Save the file as **Texture**.

4. Click the **Filter menu**, point to **Noise**, then click **Add Noise**.

5. Type **124** in the Amount text box, verify that the **Uniform option button** is selected, then verify that the **Monochromatic check box** is checked.

6. Click **OK**, duplicate the Background layer, then name the new layer **Left Angle**.

(continued)

7. Duplicate the Left Angle layer, name the new layer **Top**, then hide it.

8. Target the **Left Angle layer**, click the **Filter menu**, point to **Blur**, then click **Motion Blur**.

9. Set the **Angle** to **45**, drag the **Distance slider** to **32**, compare your Motion Blur dialog box to Figure 12, then click **OK**.

10. Show and target the **Top layer**, click the **Filter menu**, point to **Blur**, then click **Motion Blur**.

11. Change the Angle to **90**, then click **OK** to close the dialog box.

12. Hide the Top layer, target the **Left Angle layer**, select all, then copy.

13. Return to the Chisel Text document, then target the **Orange layer**.

Figure 12 *Motion Blur dialog box*

Source Adobe® Photoshop®, 2013.

Working with Type and Shape Layers

Figure 13 *Pasting the left-side texture*

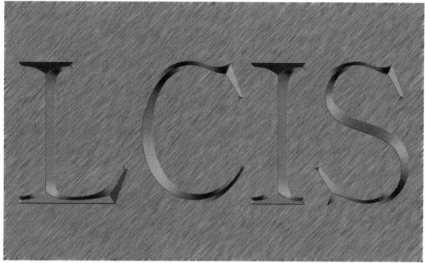

Image courtesy of Chris Botello. Source Adobe® Photoshop®, 2013.

Figure 14 *Flipping the artwork*

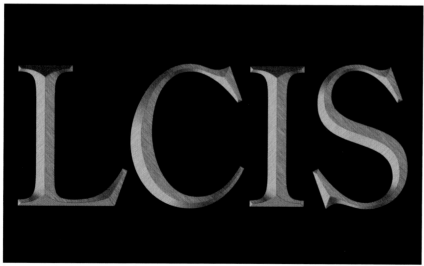

Image courtesy of Chris Botello. Source Adobe® Photoshop®, 2013.

Apply textures

1. Verify that the **Orange layer** is targeted, then load the **Left Side** selection.

2. Click the **Edit menu**, point to **Paste Special**, click **Paste Into**, then compare your canvas to Figure 13.

 The texture has been pasted everywhere on the canvas except the right sides and the tops and bottoms, which are masked in the Left Side selection that you loaded.

3. Name the new layer **Left**, set its blending mode to **Multiply**, then set its Opacity to **40%**.

4. Load the **Right Side** selection, click the **Edit menu**, point to **Paste Special**, then click **Paste Into**.

 The same Left Angle artwork is pasted into the Right Side selection.

5. Click the **Edit menu**, point to **Transform**, then click **Flip Horizontal**.

 As shown in Figure 14, the texture on the right side of the letterforms is now angled in the opposite direction.

 (continued)

6. Name the new layer **Right**, then change its blending mode to **Overlay**.

7. Load the **Tops/Bottoms** selection.

8. Switch to the Texture document, show and target the **Top layer**, select all, (if necessary), copy, then return to the Chisel Text document.

9. Click the **Edit menu**, point to **Paste Special**, then click **Paste Into**.

10. Name the new layer **Top/Bottom**, set the blending mode to **Overlay**, then compare your artwork to Figure 15.

11. Save your work.

Figure 15 *Tops and bottoms with texture*

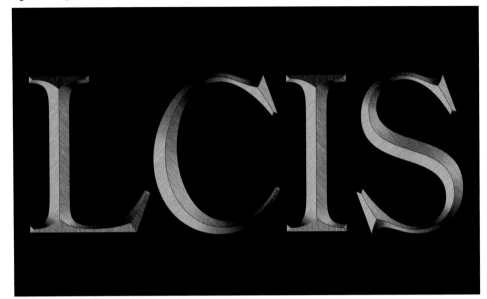

Image courtesy of Chris Botello. Source Adobe® Photoshop®, 2013.

Working with Type and Shape Layers

Figure 16 *Duplicating the left side*

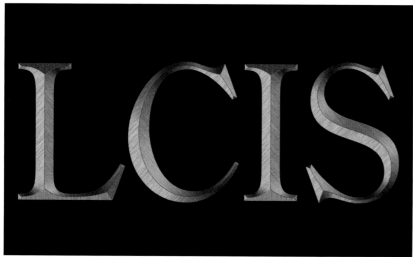

Image courtesy of Chris Botello. Source Adobe® Photoshop®, 2013.

Figure 17 *Final artwork*

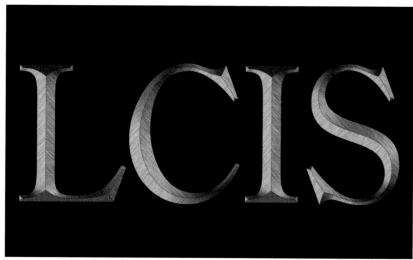

Image courtesy of Chris Botello. Source Adobe® Photoshop®, 2013.

Modify blending modes to modify effects

1. Target the **Left layer,** then press [**Ctrl**][**J**] (Win) or ⌘ [**J**] (Mac) to duplicate the layer.

2. Change the blending mode to **Overlay**, then change the opacity to **100%**.

 As shown in Figure 16, the texture is more distinct and detailed without darkening highlights.

3. Duplicate the Right layer.

 Duplicating the Right layer intensifies the color and texture on the right side of the letterforms.

4. Target the **Top/Bottom layer**, then change its blending mode to **Multiply**.

 As shown in Figure 17, the Multiply blending mode darkens both the tops and bottoms of the letterforms, allowing the right sides of the letterforms to be the brightest and most saturated areas of the illustration. The effect is that a gold light source is shining on the letters from the right.

5. Save your work, close Chisel Text.psd, then save and close Texture.psd.

Design Plastic
TYPE

What You'll Do

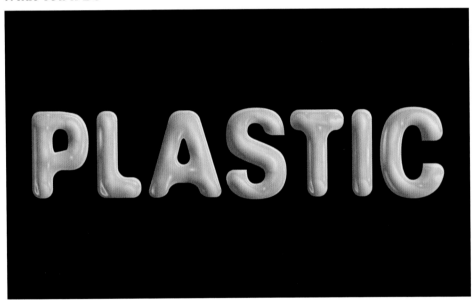

Image courtesy of Chris Botello. Source Adobe® Photoshop®, 2013.

Plastic type, unlike chiseled text, is unusual and not regularly seen, which makes it a great technique for you to have in your skills set. One of the great things about working with type is that it allows you to use some of the more extreme filters—ones that would have little or no application for a realistic image. The Plastic Wrap filter is one of those filters—a very cool effect, but one that is rarely used with images, except maybe for dramatic special effects. When you learn how to use it with text, it opens the door for a number of practical applications: it's fun, it's playful, and it's an eye-catcher.

Figure 18 *Applying the Round Corners effect to Illustrator text*

PLASTIC

Image courtesy of Chris Botello. Source Adobe® Photoshop®, 2013.

Figure 19 *Pasting text as a shape layer*

Image courtesy of Chris Botello. Source Adobe® Photoshop®, 2013.

Create text with rounded corners

1. Open AP 5-2.ai in Adobe Illustrator, then save it as **Round Corners**.
2. Select all, click the **View menu**, then click **Hide Edges**.
3. Click the **Effect menu**, point to the first **Stylize** command, then click **Round Corners**.
4. Type **.1"** in the Radius text box, click **OK**, then compare your artwork to Figure 18.
5. Click the **Edit menu**, click **Copy**, then save your work.
6. Switch to Photoshop, open AP 5-3.psd, then save it as **Plastic**.
7. Set the foreground color to **128R/128G/128B**, then paste.
8. In the Paste dialog box, click the **Shape Layer option button**, click **OK**, then compare your canvas to Figure 19.

 The artwork is pasted on its own layer as a vector graphic and uses the current foreground color as its fill. The path that defines the letterforms is a vector graphic. As a vector graphic, the path—and therefore the letterforms—can be scaled, rotated, and otherwise transformed without any loss in quality.

 (continued)

9. Show the Paths panel.

When you create a shape layer, the path on the layer is automatically listed in the Paths panel as a vector mask. The vector graphic on the shape layer is no different than creating a path in Photoshop using the Pen tool.

10. Double-click **Shape 1 Shape Path** on the Paths panel.

11. Type **Text Path** in the Name text box of the Save Path dialog box, then click **OK**.

The path on the shape layer is added to the Paths panel as a path.

12. Switch to the Layers panel, click the **Vector mask thumbnail** on the Shape 1 layer to make the path invisible, then compare your canvas to Figure 20.

13. Save your work.

Figure 20 *"Base text" in Photoshop*

Image courtesy of Chris Botello. Source Adobe® Photoshop®, 2013.

Figure 21 *Applying the Pillow Emboss*

Image courtesy of Chris Botello. Source Adobe® Photoshop®, 2013.

Emboss for a plastic effect

1. Click the **Layer menu**, point to **Layer Style**, then click **Bevel & Emboss**.

2. Set the Style to **Pillow Emboss**, then verify that the Technique is set to **Smooth**.

3. Drag the **Depth slider** to **100**, drag the **Size slider** to **98**, then drag the **Soften slider** to **7**.

4. Verify that the Gloss Contour is set to **Linear**, click **OK**, then compare your canvas to Figure 21.

 The Pillow Emboss gave us the texture we want for the letterforms; it also gave us the white shadows behind the letterforms, which we don't want.

5. Press and hold [**Ctrl**] (Win) or ⌘ (Mac), then click the **vector mask** on the Shape 1 layer to load it as a selection.

6. Click the **Edit menu**, then click **Copy Merged**.

 Copy Merged is an important and very useful command. When you apply the Copy Merged command to layered artwork, it copies the selected artwork as though all the layers were merged and the image was flattened. To put it in other terms, the Copy Merged command copies selected artwork as it *appears*, regardless of how many different layers are involved in creating the appearance.

 (continued)

7. Click the **Edit menu**, click **Paste**, then name the new layer **Plastic Text**.

8. Hide the Shape 1 layer, then compare your canvas to Figure 22.

9. Save your work.

Apply color for a plastic effect

1. Click the **Layer menu**, point to **New Fill Layer**, then click **Solid Color**.

2. Type **Gold** in the Name text box, click the **Use Previous Layer to Create Clipping Mask check box**, then click **OK**.

3. Type **255R/234G/94B** in the Color Picker, then click **OK**.

(continued)

Figure 22 *Letterforms alone*

Image courtesy of Chris Botello. Source Adobe® Photoshop®, 2013.

Plastic objects are created by pouring a liquid into a mold and then allowing it to solidify. My goal with the pillow emboss was to make the text appear rounded, with soft shadows and soft highlights as though it were created from a mold. The round corners were created in Illustrator with the Round Corners effect.

Working with Type and Shape Layers

Figure 23 *Increasing saturation*

Image courtesy of Chris Botello. Source Adobe® Photoshop®, 2013.

4. Set the blending mode on the Gold layer to **Soft Light**.

5. Press and hold [**Alt**] (Win) or [**option**] (Mac), click the **Create new fill or adjustment layer button** on the Layers panel, then click **Hue/Saturation**.

TIP When you use this method to create an adjustment layer, the New Layer dialog box opens.

6. Click the **Use Previous Layer to Create Clipping Mask check box**, then click **OK**.

7. Drag the **Saturation slider** to **+50**, then compare your result to Figure 23.

 The combination of the Soft Light blending mode and the increased saturation creates an effect that mimics the vibrant color and muted sheen of plastic. Note that the overall texture is smooth and round because the shadows are not too deep. Though the highlights are distinct, they are not harsh or glaring.

8. Save your work.

Apply the Plastic Wrap filter

1. Verify that the **Hue/Saturation adjustment layer** is targeted, select all, click the **Edit menu**, then click **Copy Merged**.

2. Click the **Edit menu**, click **Paste**, then name the new layer **Plastic Wrap**.

TIP The Select All – Copy Merged – Paste sequence yields the same result as the Stamp Visible keyboard command.

3. Click the **Rectangular Marquee tool** , then select the left side of the canvas as shown in Figure 24.

4. Press [**Ctrl**][**H**] (Win) or ⌘ [**H**] (Mac) to hide the selection edges, click the **Filter menu**, then click **Filter Gallery**.

5. Click the **Artistic folder** in the Filter Gallery dialog box to open it, then click **Plastic Wrap**.

6. Drag the **Highlight Strength slider** to **15**, drag the **Detail slider** to **8**, then drag the **Smoothness slider** to **9**.

7. Click **OK**, then compare your result to Figure 25.

 The Plastic Wrap filter has different effects on different selections. For example, if we had selected the entire image, the filter would have yielded a different result. We selected only the first four letters because, after experimenting, this was my favorite result for the *P*, the *L*, the *A*, and the *S*.

8. Click the **Edit menu**, then click **Fade Filter Gallery**.

(continued)

Figure 24 *Selecting the first four letters*

Image courtesy of Chris Botello. Source Adobe® Photoshop®, 2013.

Figure 25 *Applying the Plastic Wrap filter to the selection*

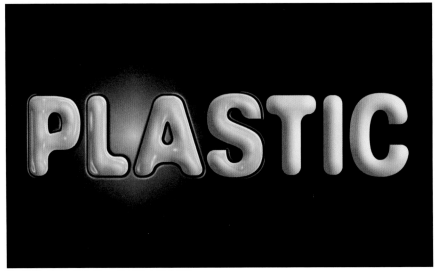

Image courtesy of Chris Botello. Source Adobe® Photoshop®, 2013.

Working with Type and Shape Layers

Figure 26 *Applying the Plastic Wrap filter to the remainder*

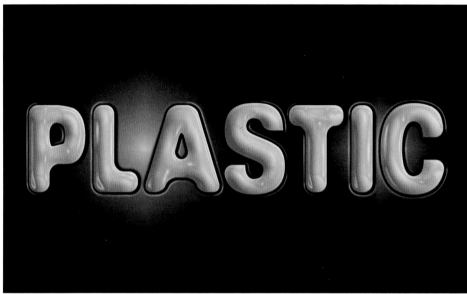

Image courtesy of Chris Botello. Source Adobe® Photoshop®, 2013.

9. In the Fade dialog box, verify that the **Preview check box** is checked, drag the **Opacity slider** to **75%**, click the **Mode list arrow**, click **Hard Light**, and keep the Fade dialog box open.

 The Fade dialog box is something of a secret when it comes to working with filters. It offers a "one-time" chance to apply an opacity setting and/or a blending mode to a filter. I think of it as a secret because who would think to check the Edit menu to modify a filter? We're not going to execute this Fade Filter Gallery command. Because we are applying the filter to a merged layer, we can apply an opacity setting and/or a blending mode to the layer itself. This way, we'll be able to modify the opacity and/or blending mode whenever we want to.

10. Click **Cancel**.

11. Click the **Select menu**, then click **Inverse**.

12. Hide the selection, click the **Filter menu**, click **Filter Gallery** at the very top of the Filter menu, then compare your result to Figure 26.

TIP The Filter menu lists the last filter used (with the settings last used) at the top of the menu.

13. Save your work.

Using blending modes to modify a filter effect

1. Verify that the **Plastic Wrap layer** is targeted, press and hold [**Ctrl**] (Win) or ⌘ (Mac), then click the **vector mask** on the hidden Shape 1 layer to load a selection of the shape.

2. Click the **Add layer mask button** 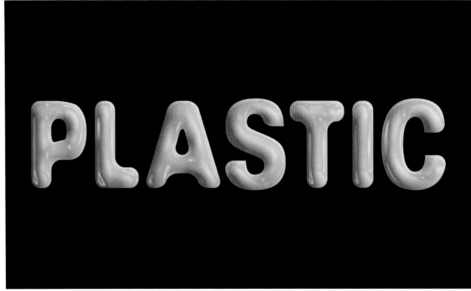 on the Layers panel, then compare your result to Figure 27.

 On its own, with no blending mode, this effect could be used for a number of real-world applications, especially for graphic projects like a comic book, a graphic novel, or as cover art for a video game. In terms of looking like plastic, however, without a blending mode, the result looks a bit more like wax than it does plastic.

3. Change the blending mode to **Hard Light**.

 The Hard Light blending mode saturates the yellow overall. It removes the midrange effects from the filter while maintaining the extreme highlights. The result is a very dramatic effect that does indeed look like plastic.

 (continued)

Figure 27 *Plastic Wrap filter applied*

Working with Type and Shape Layers

Figure 28 *Applying the Luminosity blending mode*

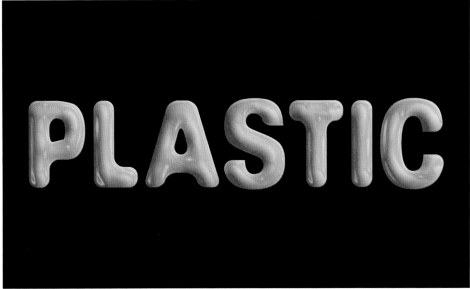

Image courtesy of Chris Botello. Source Adobe® Photoshop®, 2013.

4. Change the blending mode to **Lighten**.

 With the Lighten blending mode, only the areas of the top layer that are lighter than those of the image below it remain visible. With this artwork, this means that the grayish, midrange "plastic" from the filter becomes invisible, because it is darker than the image below. Only the white highlights from the filter remain visible, because they are so much lighter than the image below.

5. Change the blending mode to **Luminosity**, then compare your result to Figure 28.

 Luminosity is just another word for brightness. The Luminosity blending mode applies the brightness information of the image on the targeted layer to the image below. It doesn't alter the hue or the saturation of the pixels below, only the brightness. For this artwork, I found Luminosity to be the most interesting choice. As with the Hard Light and Lighten blending modes, it maintains the highlights from the filter. Unlike the Hard Light and Lighten blending modes, Luminosity allows the midrange plastic wrap effects from the filter to show through.

6. Save your work, then close Plastic.psd.

Design Recessed TYPE

What You'll Do

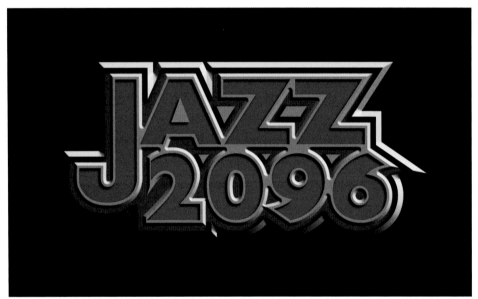

Image courtesy of Chris Botello. Source Adobe® Photoshop®, 2013.

Recessed type is one of those effects that always looks good. As a designer, I often find myself working to *build up*—to make my artwork three-dimensional, to make it jump off of the canvas. Let's just say that I use the Bevel & Emboss layer style quite often. This lesson is designed to remind you to look the other way and to remember that dimensionality can also be created by pushing things back, pushing them in, and pushing them away. This is a complex, in-depth exploration into one of my favorite techniques for creating dramatic recessed type effects. It's also a great example of a great challenge—how to make multiple layer styles work together to produce a single effect.

Figure 29 *Inner Shadow settings in the Layer Style dialog box*

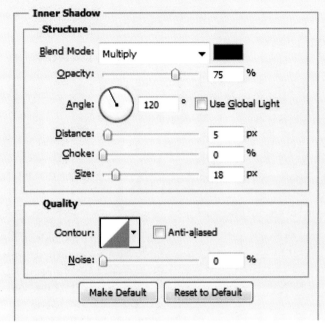

Source Adobe® Photoshop®, 2013.

Figure 30 *Inner Shadow effect*

INDENT

Image courtesy of Chris Botello. Source Adobe® Photoshop®, 2013.

Use the Inner Shadow layer style

1. Open AP 5-4.psd, then save it as **Inner Shadow**.

2. Target **Layer 1**, click the **Add a layer style button** *fx.* on the Layers panel, then click **Inner Shadow**.

3. Verify that the **Use Global Light check box** is not checked, set the **Angle** to **120**, then drag the **Size slider** to **18** so that your dialog box resembles Figure 29.

4. Click **OK**, then compare your artwork to Figure 30.

 This is the most basic effect from the Inner Shadow layer style.

5. Save your work, then close Inner Shadow.psd.

Use the Inner Shadow layer style in conjunction with a drop shadow

1. Open AP 5-5.ai in Adobe Illustrator.

 In this Illustrator file, I used the Offset Path command to create the larger black type behind the red type.

2. Close AP 5-5.ai, switch to Photoshop, open AP 5-6.psd, then save it as **Indent**.

 I exported the Illustrator file with its layers as a .psd document, then added the hidden gradient layer when I opened it in Photoshop.

 TIP For an in-depth explanation of exporting layered artwork from Illustrator to Photoshop, see Chapter 2.

3. Target the **Background layer**, then fill it with black.

4. Target the **Offset layer**, fill the black type with white, then compare your result to Figure 31.

5. Click the **Add a layer style button** ![fx] on the Layers panel, then click **Inner Shadow**.

6. Check the **Use Global Light check box**, set the Angle to **135**, then set the Opacity to **85%**.

7. Drag the **Distance slider** to 9, drag the **Size slider** to 8, then click **OK**.

 The black area is now a foreground element, and it is casting a shadow on the white and red type, which are both on one plane behind the black area.

 (continued)

Figure 31 *Modifying the artwork*

Image courtesy of Chris Botello. Source Adobe® Photoshop®, 2013.

Working with Type and Shape Layers

Figure 32 *Applying a drop shadow to the red type*

Image courtesy of Chris Botello. Source Adobe® Photoshop®, 2013.

Figure 33 *Sample letterforms with interesting negative spaces*

Image courtesy of Chris Botello. Source Adobe® Photoshop®, 2013.

8. Target the **Red Type layer**, click [fx] on the Layers panel, then click **Drop Shadow**.

9. Verify that the Angle is set to **135** and that the **Use Global Light check box** is checked, then set the Opacity to **85%**.

10. Drag the **Distance slider** to **9**, then drag the **Size slider** to **8**.

 Since we want the red text and the black areas to appear to be on the same plane, they must cast the same shadow. Therefore, we are inputting the same specifications for the drop shadow as we did for the inner shadow.

11. Click **OK**, then compare your artwork to Figure 32.

12. Note the black at the center of the letter *D* and between the lines of the *E*.

 When working with type, you're always at the mercy of the letters that make up the word. In this case, the word *INDENT* is a bit boring—all straight lines except for the letter *D*.

13. Compare your artwork to Figure 33.

 The letters in Figure 33 are a bit more interesting for this effect—the triangle in the letter *A*, the two half circles in the letter *B*, and the black negative space that defines the letter *C*. For these letters, the black negative spaces add an interesting component to the overall effect. For the word *INDENT*, the black negative spaces are awkward, especially in the letter *E*.

(continued)

14. Target the **Offset layer**, then unlock the transparent pixels.

15. Drag a **rectangular marquee** around the two black rectangles in the letter *E*.

16. Fill the selection with white, deselect, then compare your artwork to Figure 34.

17. Using the same method, remove the negative space from the center of the letter *D*, then deselect.

18. Target the **Red Type layer**, click the **Filter menu**, point to **Noise**, then click **Add Noise**.

19. Type **15** in the Amount text box, verify that the **Uniform option button** is selected and that the **Monochromatic check box** is checked, then click **OK**.

20. Click the **Edit menu**, click **Fade Add Noise**, set the blending mode to **Multiply**, then click **OK**.

 When working with type only, say for a logo or a headline, adding noise is a favorite technique of mine for adding texture to the type and making the artwork more interesting. I think it adds richness to the text and the suggestion of sparkle.

21. Show the Gradient layer, set its blending mode to **Multiply**, then clip it into the Red Type layer.

22. Compare your artwork to Figure 35.

23. Save your work, then close Indent.psd.

Figure 34 *Removing the black rectangles*

Image courtesy of Chris Botello. Source Adobe® Photoshop®, 2013.

Figure 35 *Multiplying the gradient layer*

Image courtesy of Chris Botello. Source Adobe® Photoshop®, 2013.

Working with Type and Shape Layers

Figure 36 *Original artwork*

Figure 37 *Applying the Bevel & Emboss layer style*

Use the Inner Shadow layer style in conjunction with the Bevel & Emboss layer style

1. Open AP 5-7.psd, save it as **Jazz 2096**, then compare your screen to Figure 36.

 I created this artwork in Illustrator. The red type was set in a Universe bold typeface. I used the Offset Path command to create the three offset outlines, then exported the artwork to Photoshop. Note that this illustration could not have been created in Photoshop, because Photoshop doesn't offer an Offset Path command.

2. Set the foreground color to **128R/128G/128B**.

 TIP From this point on in this lesson, we'll refer to this color as "neutral gray."

3. Hide the Red and Orange layers.

4. Fill the Blue layer with neutral gray.

 TIP The Lock transparent pixels option is activated on all four layers.

5. Click the **Add a layer style button** [fx] on the Layers panel, then click **Bevel & Emboss**.

6. Verify that the Style is set to **Inner Bevel**, click the **Technique list arrow**, then click **Chisel Hard**.

7. Verify that **Use Global Light check box** is checked, set the Angle to **45**, then set the Altitude to **30**.

8. Set the Depth slider to **100**, slowly drag the **Size slider** to **100**, verify that the Gloss Contour is set to **Linear**, then click **OK**.

 As shown in Figure 37, at a 100-pixel size the chiseled edge butts up against the edge of the green artwork.

(continued)

9. Fill the Green layer with neutral gray.

10. Click *fx* on the Layers panel, then click **Inner Shadow**.

11. Verify that the Blend Mode is set to **Multiply**, the Opacity is set to **75%**, the Angle is set to **45**, and that the **Use Global Light check box** is checked.

 The Use Global Light option allows you to set one "master" lighting angle that you can then apply quickly to any other layer styles that use shading. This is a great option for quickly applying a consistent light source to all of your layer styles.

12. Drag the **Distance slider** to **11**, drag the **Choke slider** to **14**, drag the **Size slider** to **16**, then compare your artwork to Figure 38.

 The illustration at this point is composed of two pieces of artwork on two different layers. The two layer styles are working in conjunction so that the artwork appears as one object. The bevel and emboss creates the outer edge of the object. The inner shadow creates indentations to the interior of the object. Take a moment to analyze the overall effect, because it's a fine example of an important concept: Don't get caught up in trying to make one layer style carry the whole load. More often than not, it's *many* layer styles working together that create a *single* effect.

 (continued)

Figure 38 *Applying the Inner Shadow layer style*

Image courtesy of Chris Botello. Source Adobe® Photoshop®, 2013.

Working with Type and Shape Layers

Figure 39 *Applying the Pattern Overlay*

Image courtesy of Chris Botello. Source Adobe® Photoshop®, 2013.

13. Click the words **Pattern Overlay** on the left side of the dialog box.

TIP If you clicked the Pattern Overlay check box instead of the words, the Pattern Overlay style would be activated with the current texture. Because you clicked the words, the Pattern Overlay style is activated and its dialog box is visible.

14. Click the **Pattern list arrow**, then click the pattern named **Woven**.

 If you do not see Woven, click the pull down menu to the right of the first row of patterns, then click Patterns. The Woven pattern will appear in the first row.

15. Click the **Blend Mode list arrow**, click **Soft Light**, click **OK**, then compare your artwork to Figure 39.

16. Show the Orange layer, then fill it with neutral gray.

17. Click the **Add a layer style button** ![fx] on the Layers panel, then click **Bevel & Emboss**.

18. Verify that the Style is set to **Inner Bevel**, click the **Technique list arrow**, then click **Chisel Hard**.

19. Drag the **Size slider** to **9**.

20. Click the **Gloss Contour list arrow**, click **Ring**, then click the **Anti-aliased check box** to activate it.

(continued)

21. Click **OK**, then compare your artwork to Figure 40.

22. Show the Red layer, then fill it with neutral gray.

23. Click 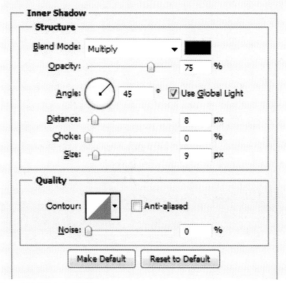 on the Layers panel, then click **Inner Shadow**.

24. Type the settings shown in Figure 41, then click **OK**.

(continued)

Figure 40 *The second Bevel & Emboss effect*

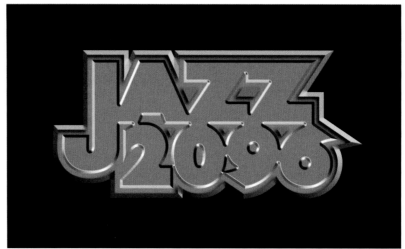

Image courtesy of Chris Botello. Source Adobe® Photoshop®, 2013.

Figure 41 *Inner Shadow settings in the Layer Style dialog box*

Source Adobe® Photoshop®, 2013.

Working with Type and Shape Layers

Figure 42 *The second Inner Shadow effect*

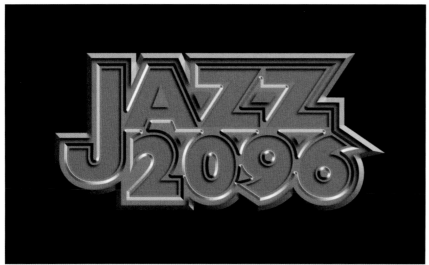

Image courtesy of Chris Botello. Source Adobe® Photoshop®, 2013.

Figure 43 *Applying a fill layer to the artwork*

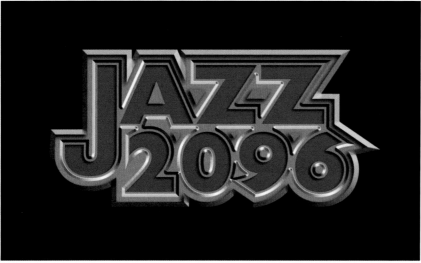

Image courtesy of Chris Botello. Source Adobe® Photoshop®, 2013.

25. Compare your artwork to Figure 42.

26. Click the **Create new fill or adjustment layer button** on the Layers panel, then click **Solid Color**.

27. Create a color that is **147R/55G/144B**, then click **OK**.

28. Clip the new fill layer into the Red layer, then compare your artwork to Figure 43.

 Now that the text has been filled with purple, the pattern overlay looks too light; there's no contrast between it and the letters above it.

 (continued)

29. Double-click the **Pattern Overlay effects layer style** (in the Green layer), change the blending mode to **Multiply**, change the Opacity to **65%**, click **OK**, then compare your artwork to Figure 44.

When designing this illustration, at this point, the effect was not working for me. My goal with this illustration was to create the effect of recessed type; I wanted the purple letters to be *indented* into the layer beneath. I wasn't sure what was wrong, but I knew the effect wasn't right.

The essential problem for me was that the most notable effect of the illustration was an embossing, which is exactly the opposite of the recessed effect that I was going for.

If you look at the purple letters, you can see the Inner Shadow effect, and they appear to be recessed. But you can look at them another way in which the inner shadow looks like an emboss!

Since the word *embossed* kept coming up as the problem for me, I decided that I would make the embossing less shiny and eye-catching, with the hopes that it would no longer dominate the Inner Shadow effect.

(continued)

Figure 44 *Changing the blending mode on the Pattern Overlay*

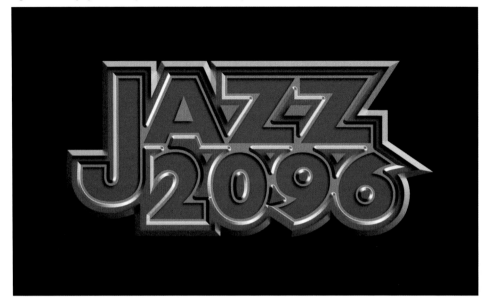

Image courtesy of Chris Botello. Source Adobe® Photoshop®, 2013.

Working with Type and Shape Layers

Figure 45 *Removing the gloss contour from the beveled edge*

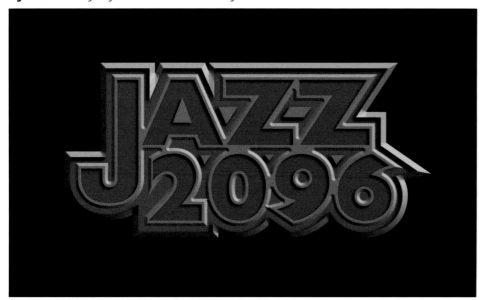

Image courtesy of Chris Botello. Source Adobe® Photoshop®, 2013.

Take a moment to think back to the original artwork. The purple text was taken from the original text that I set in Illustrator. Knowing what I was trying to achieve, I made some specific design decisions when setting the type. The first was the letter *J*. I made it extra large so that it would integrate the two lines of text into one piece of artwork: the *J* is the bridge, so to speak. But even more importantly, I used the hook of the big *J* to get that interesting shape on the left side of the artwork. I knew that it would show off the embossing and the inner shadow effects quite dramatically. I did the same thing with the number *6*. Note how the point at the top extends farther to the right than the *Z* above it. I knew that the *6*, with its point and its round base, would be very interesting once the layer styles were applied.

30. Double-click the **Bevel & Emboss effects layer** on the Orange layer.

We used the Bevel & Emboss layer style on two layers: the Blue layer and the Orange layer. However, only on the Orange layer did we apply a gloss contour.

31. Click the **Gloss Contour list arrow**, click **Linear**, click **OK**, then compare your result to Figure 45.

This one step solved the entire problem! If you undo and redo the last step, you'll see what a dramatic difference it made. With the gloss contour removed, the embossed artwork is no longer the dominant effect. Instead, the eye goes immediately to the purple letters.

The purple letters themselves are unmistakably recessed—they are inset into the embossed artwork. Even if you try, you can't make your eye see them as embossed. The only problem is that, without the gloss contour, the artwork is now a bit boring; it's gray overall and lacks contrast. The solution for that is very straightforward: if the art works, but it lacks contrast, don't change the art, just increase the contrast.

(continued)

32. Target the **Color Fill 1 layer**, click 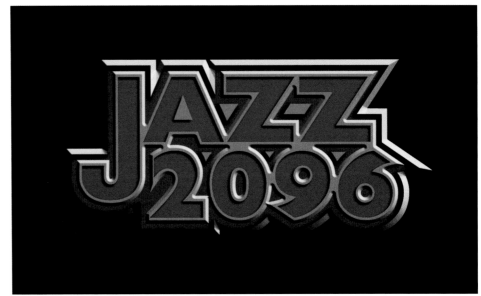 on the Layers panel, then click **Curves**.

33. Add a point to the curve, then set its Input value to **80** and its Output value to **47**.

34. Add a second point to the curve, set its Input value to **155**, then set its Output value to **185**.

35. Compare your artwork to Figure 46.

 Again, one step solved the entire problem. Note that although the increase in contrast is substantial, we did not go too far. The shadows on the embossed artwork are dark gray, not black. The highlights are light gray, not white.

 There's an interesting design lesson to be learned here. My initial instinct was to use the gloss contour to add contrast and snap to the artwork. But the gloss contour ended up working against the effect. As it turns out, all I needed to do was add contrast to get contrast.

36. Save your work, then close Jazz 2096.psd.

Figure 46 *Final artwork with increased contrast*

Image courtesy of Chris Botello. Source Adobe® Photoshop®, 2013.

Working with Type and Shape Layers

Mask Images
WITH TYPE

What You'll Do

Image courtesy of Chris Botello. Source Adobe® Photoshop®, 2013.

In this lesson, you're going to create lots of different effects using type to mask images. The lesson is not designed to show you how to do it—it's designed more to show you how to *think* it: how to choose images that work well with a given style of typography, how to combine blending modes to create an effect, how to duplicate and invert layers to branch off into unexpected directions.

When I created this lesson, I really had no final artwork in mind. Instead, I just wrote the steps as I went along. Now you get to take that trip with me. Where you end up is where I ended up. This lesson is designed to show you how I got there, and then you're free to keep going in any direction your imagination leads you.

Use chiseled type to mask images

1. Open AP 5-8.psd, then save it as **Chisel Type Images**.
2. Hide the Orange layer, then show and target the **Wave layer**.
3. Clip the Wave layer into the Text layer, then compare your artwork to Figure 47.

 The image adds an interesting color dynamic that works very well with the silver layer style and texture overlay.
4. Invert the Wave layer, then compare your artwork to Figure 48.

 Another simple move that yields a dramatic effect. Inverted, the whites of the Wave image overlaying the chiseled text creates a sheen that fades into steel blues—perfect for this illustration.

(continued)

Figure 47 *Clipping the Wave image*

Image courtesy of Chris Botello. Source Adobe® Photoshop®, 2013.

Figure 48 *Inverting the Wave image*

Image courtesy of Chris Botello. Source Adobe® Photoshop®, 2013.

Working with Type and Shape Layers

Figure 49 *Color Burn mode*

Image courtesy of Chris Botello. Source Adobe® Photoshop®, 2013.

Figure 50 *Duplicating the Wood layer to achieve a richer image*

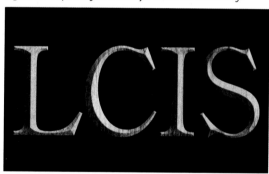

Image courtesy of Chris Botello. Source Adobe® Photoshop®, 2013.

Figure 51 *Inverting and multiplying the Wood layer*

Image courtesy of Chris Botello. Source Adobe® Photoshop®, 2013.

Lesson 4 Mask Images with Type

5. Change the blending mode to **Color Burn**, then compare your result to Figure 49.

6. Hide the Wave layer, show and target the **Wood layer**, click the **Blending mode list arrow**, then click **Overlay**.

 Though the effect is visually interesting, the shine on the text has too much sheen and is too shiny to appear realistically as a wooden texture. Also, the overlayed texture looks too much like brushed steel to work with the wood artwork.

7. Hide the Texture layer.

8. Double-click the **Bevel & Emboss layer style**, change the Gloss Contour to **Linear**, then click **OK**.

9. Duplicate the Wood layer, then compare your artwork to Figure 50.

 Duplicating artwork set to Overlay intensifies the color of the artwork.

10. Invert the Wood copy layer to create a wood effect that is much smoother.

11. Change the blending mode to **Multiply**, then compare your artwork to Figure 51.

(continued)

12. Change the blending mode to **Color**, change the Gloss Contour on the **Bevel & Emboss** layer style to **Cone-Inverted**, click **OK**, then compare your artwork to Figure 52.

13. Hide the two wood layers, show and target the **Granite layer**, change its blending mode to **Overlay**, then compare your artwork to Figure 53.

Unlike the Wood image, the Granite image can overlay the shiny gloss contour and maintain a realistic appearance.

(continued)

Figure 52 *Color mode*

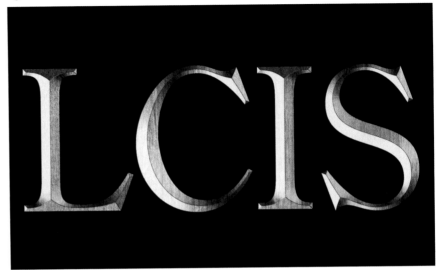

Image courtesy of Chris Botello. Source Adobe® Photoshop®, 2013.

Figure 53 *Granite image overlayed*

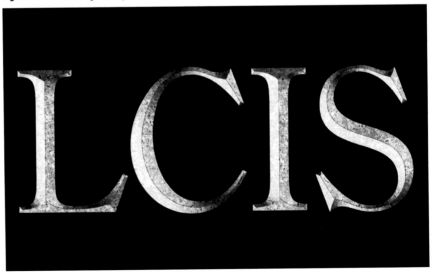

Image courtesy of Chris Botello. Source Adobe® Photoshop®, 2013.

Working with Type and Shape Layers

Figure 54 *Granite image multiplied*

Image courtesy of Chris Botello. Source Adobe® Photoshop®, 2013.

Figure 55 *Final artwork*

Image courtesy of Chris Botello. Source Adobe® Photoshop®, 2013.

14. Change the blending mode to **Multiply**, then compare your artwork to Figure 54.

15. Duplicate the Granite layer, then change the blending mode on the copy to **Overlay**.

16. Make the Wood copy layer visible, then compare your artwork to Figure 55.

 We now have two images and three different blending modes working together to create the final effect.

17. Save your work, then close Chisel Type Images.psd.

Use plastic type to mask images

1. Open AP 5-9.psd, then save it as **Plastic Type Images**.
2. Show and target the **Abstract blue layer**, then change its blending mode to **Overlay**.
3. Hide the Abstract blue layer, show and target the **Mountains layer**, change its blending mode to **Overlay**, then compare your artwork to Figure 56.
4. Hide the Mountains layer, show and target the **Geometry layer**, then change its blending mode to **Overlay**.
5. Hide the Geometry layer, show and target the **Flowers layer**, change its blending mode to **Overlay**, then compare your artwork to Figure 57.
6. Save your work, then close Plastic Type Images.psd.

Use inset type to mask images

1. Open AP 5-10.psd, then save it as **Inset Type Images**.
2. Open AP 5-11.psd, select all, copy, then close the file.
3. Hide the Red, Orange, and Green layers, then target the **Blue layer**.

(continued)

Figure 56 *Mountains artwork overlayed*

Image courtesy of Chris Botello. Source Adobe® Photoshop®, 2013.

Figure 57 *Flowers artwork overlayed*

Image courtesy of Chris Botello. Source Adobe® Photoshop®, 2013.

Working with Type and Shape Layers

Figure 58 *Clipping the image into the Blue layer*

Source Adobe® Photoshop®, 2013. Comstock Images/Getty Images

Figure 59 *Final artwork*

Source Adobe® Photoshop®, 2013. Comstock Images/Getty Images

4. Paste, clip the image into the Blue layer, then compare your artwork to Figure 58.

5. Show and target the **Green layer**, paste, then clip the image into the Green layer.

6. Change the blending mode on the pasted image to **Color Dodge**.

7. Show and target the **Orange layer**, paste, then clip the image into the Orange layer.

8. Show and target the **Red layer**, paste, then clip the image into the Red layer.

9. Compare your artwork to Figure 59.

10. Save your work, then close Inset Type Images.psd.

Lesson 4 Mask Images with Type

Use Shape Layers to
DESIGN ERODED TYPE

What You'll Do

Image courtesy of Chris Botello. Source Adobe® Photoshop®, 2013.

The need for type with rough edges comes up regularly, and the ability to create it is an essential skill every designer must have. It's ironic, really, when you consider that in the early days of desktop publishing the great goal and the great achievement was to produce smooth lines and curves, both for type and for line art. And yet, you will find that smooth lines and curves are exactly what you don't want for a number of types of artwork.

This lesson offers practical examples of a more complex use of shape layers and vector masks in conjunction with conventional layer masks and layer styles. Watch how the letterforms in the illustration are defined by vectors, and how those vectors interact with the filters and other special effects you apply.

Working with Type and Shape Layers

Figure 60 *Artwork added in white as a layer named Shape 1*

Image courtesy of Chris Botello. Source Adobe® Photoshop®, 2013.

Icon indicates a shape layer

Figure 61 *Path Selection and Direct Selection tools*

Source Adobe® Photoshop®, 2013.

Lesson 5 Use Shape Layers to Design Eroded Type

Experiment with shape layers

1. Open AP 5-12.psd, then save it as **Eroded Text**.
2. Set the foreground color to **white**.
3. In Illustrator, open AP 5-13.ai, select all the artwork, click the **Edit menu**, then click **Copy**.
4. Return to the Eroded Text document, click the **Move tool** ▶⊕ , click the **Edit menu**, then click **Paste**.

 The Paste dialog box opens. When pasting between Illustrator and Photoshop, it's a good idea to have the Move tool selected in Photoshop, because it is a neutral tool.

5. In the Paste dialog box, click the **Shape Layer option button**, then click **OK**.

 As shown in Figure 60, the artwork is pasted as a vector graphic in the white foreground color. The new layer is automatically named Shape 1.

6. Note the selection tools, identified in Figure 61.

 The Path Selection tool and the Direct Selection tool are designed specifically to select and work with paths and shape layers.

7. Click the **Path Selection tool** ▶.
8. Click the large letter **M**, then drag it down to the lower-left corner.

 The letter M moves as a single object.

9. Undo your last step.

 (continued)

10. Select the **letters in "WORKS"** then drag them to the upper-right corner.

 The letters move as a single object.

11. Undo your last step.

12. Click the lower-right corner of the artwork to deselect the paths, then note that Shape 1 is still the targeted layer in the Layers panel.

13. Click the **Edit menu**, point to **Transform Path**, click **Rotate 180 degrees**, then compare your artwork to Figure 62.

 All of the artwork is rotated. Paths used in a shape layer can be transformed just like any other path or any other artwork in Photoshop.

14. Undo your last step.

15. Zoom in on the letter **W**, then click the **Direct Selection tool** ▶.

16. Position your cursor at the edge of the letter **W**, then click the **path**.

 The anchor points on the path become visible. They all have a hollow center, which indicates that they can be selected individually. That is the difference between the Path Selection tool and the Direct Selection tool – with the Direct Selection tool, you can select individual anchor points on a path.

17. Click and drag any anchor point on the letter **W** to a different location, then compare your result to Figure 63.

 The path is redrawn, and more of the layer's white fill fills the new path. With a shape layer, the fill is dynamic: if you change the path, the fill changes with the path.

18. Delete the Shape 1 layer, then save your work.

Figure 62 *Shape layer rotated*

Image courtesy of Chris Botello. Source Adobe® Photoshop®, 2013.

Figure 63 *Dragging a single point on the path with the Direct Selection tool*

Image courtesy of Chris Botello. Source Adobe® Photoshop®, 2013.

Working with Type and Shape Layers

Figure 64 *Shape 1 Shape Path on the Paths panel*

Shape layer targeted

Source Adobe® Photoshop®, 2013.

Figure 65 *Path 1 on the Paths panel*

Source Adobe® Photoshop®, 2013.

Lesson 5 Use Shape Layers to Design Eroded Type

Create paths from shape layers

1. Click the **View menu**, then click **Fit on Screen**.

 In this set of steps, you will again paste objects from Illustrator into Photoshop. When the canvas is fit on the screen, anything you paste will automatically be centered on the canvas.

2. Open the Paths panel.

 No paths are listed in the Paths panel.

3. Return to the Illustrator file AP 5-13.ai.

4. Deselect all, then select the **blue M**, copy it, then return to the Photoshop file.

5. Click the **Edit menu**, click **Paste**, click the **Shape Layer option button** in the Paste dialog box, then click **OK**.

 The letter M is centered on the canvas. As shown in Figure 64, the Layers panel shows that a Shape 1 layer was created, and the Paths panel shows a path named Shape 1 Shape Path.

6. On the Layers panel, click the layer named **Black Iron**.

 The path in the Paths panel is no longer listed because the Shape 1 layer is no longer selected.

7. On the Layers panel, click the **Shape 1 layer**.

 The path in the Paths panel is once again listed. Whenever you click a shape layer, its path becomes available—as a path—in the Paths panel.

8. Double-click **Shape 1 Shape Path** on the Paths panel.

 The Save Path dialog box opens, offering the name Path 1 as a default name for the path.

(continued)

9. Click **OK**.

As shown in Figure 65, Path 1 is now listed on the Paths panel. As a saved path, Path 1 is independent from the Shape 1 layer. Note too that the Shape 1 Shape Path continues to be listed, because the Shape 1 layer is still targeted.

TIP The path associated with a shape layer is always listed in italics. A saved path is not listed in italics.

10. Return to the Illustrator file, select the **red text**, then copy it.

11. Return to the Photoshop file, click the **Edit menu**, then click **Paste**.

12. In the Paste dialog box, click the **Shape Layer option button**, then click **OK**.

As shown in Figure 66, the pasted artwork is centered on the canvas and aligns with the letter M artwork. A new shape layer—Shape 2—is added to the Layers panel, and its path is listed on the Paths panel as Shape 2 Shape Path.

13. Double-click **Shape 2 Shape Path** on the Paths panel.

14. Accept the default name as **Path 2**, then click **OK**.

Your Paths panel should resemble Figure 67.

15. Save your work.

Figure 66 *Shape 2 Shape Path on the Paths panel*

Image courtesy of Chris Botello. Source Adobe® Photoshop®, 2013.

Figure 67 *Path 2 on the Paths panel*

Source Adobe® Photoshop®, 2013.

Working with Type and Shape Layers

Figure 68 *Two "rust" layers on the Layers panel*

Source Adobe® Photoshop®, 2013.

Figure 69 *Vector mask added to the Rusty M layer*

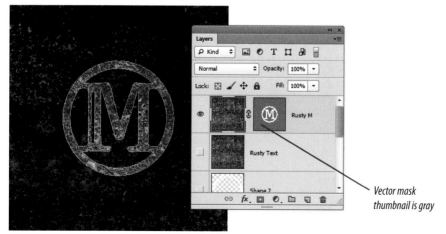

Vector mask
thumbnail is gray

Image courtesy of Chris Botello. Source Adobe® Photoshop®, 2013.

Lesson 5 Use Shape Layers to Design Eroded Type

Create vector masks from paths

1. Hide the Shape 1 and Shape 2 layers.

2. Duplicate the Rust layer.

3. Rename the top rust layer **Rusty M**.

4. Rename the second rust layer **Rusty Text**.

5. Verify that only the Rusty M layer is showing and that it is targeted.

 Your Layers panel should resemble Figure 68.

6. On the Paths panel, click **Path 1** to target it.

7. Click the **Layer menu**, point to **Vector Mask**, click **Current Path**, then compare your canvas and your screen to Figure 69.

 The Rusty M artwork is masked by Path 1. A gray mask appears on the Rusty M layer. This is a vector mask, and it is gray to distinguish it from a basic layer mask. A vector mask uses a vector graphic—a path—to mask pixels on a layer.

(continued)

8. Show the Rusty Text layer, then target it on the Layers panel.

9. On the Paths panel, click **Path 2** to highlight and target it.

10. Click the **Layer menu**, point to **Vector Mask**, then click **Current Path**.

Your canvas and Layers panel should resemble Figure 70.

11. Save your work.

Figure 70 *Vector mask added to the Rusty Text layer*

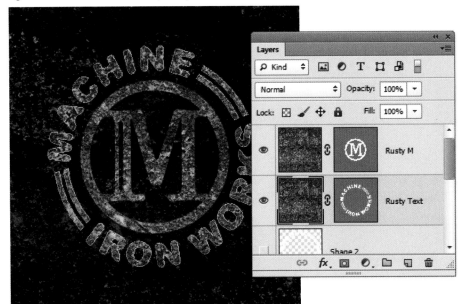

Image courtesy of Chris Botello. Source Adobe® Photoshop®, 2013.

Working with Type and Shape Layers

Figure 71 *Bevel & Emboss layer style settings*

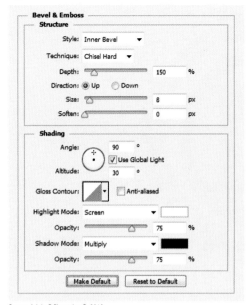

Source Adobe® Photoshop®, 2013.

Figure 72 *Drop Shadow layer style settings*

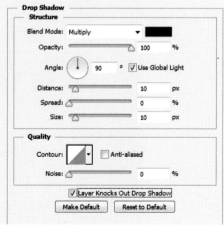

Source Adobe® Photoshop®, 2013.

Apply a Bevel & Emboss layer style

1. Hide the Black Iron layer.

 The Black Iron layer is so dark that it would be difficult to see the subtle changes we're about to make.

2. Target the **Rusty M layer**, click the **Add a layer style button** fx. on the Layers panel, then click **Bevel & Emboss**.

3. Apply the settings shown in Figure 71 and leave the Layer Style dialog box open when finished.

 The Chisel Hard edge is an important component to this effect. We want to "erode" the type along its edges, so the visual qualities of the edges play an important role in the final effect. The Chisel Hard style creates a clean, sharp edge that readily shows the pits and dents that create the erosion effect.

4. Click the **Set color for highlight box** (next to Highlight Mode), type **250R/250G/150B**, then click **OK**.

 The yellow highlight works better with the orange rust.

5. Click the words **Drop Shadow** on the left side of the Layer Styles dialog box, then enter the settings shown in Figure 72.

(continued)

6. Click **OK**, then compare your artwork to Figure 73.

7. Copy the layer styles from the Rusty M layer to the Rusty Text layer.

8. Show the Black Iron layer, then compare your artwork to Figure 74.

 Ultimately, this lesson is about creating eroded text, so take a moment at this stage of the work to look at the logo. The drop shadow and the bevel and emboss effects contribute greatly to the illusion of this logo being raised from an iron background. It's a cool effect, but notice how the clean straight lines and smooth curves work against the concept of rusted iron. *Smooth* is the last word you would think of when you think of rust.

9. Save your work.

Figure 73 *Layer styles applied to the Rusty M artwork*

Image courtesy of Chris Botello. Source Adobe® Photoshop®, 2013.

Figure 74 *The artwork edge is too smooth*

Image courtesy of Chris Botello. Source Adobe® Photoshop®, 2013.

Working with Type and Shape Layers

Figure 75 *Layer mask added to the Rusty M layer*

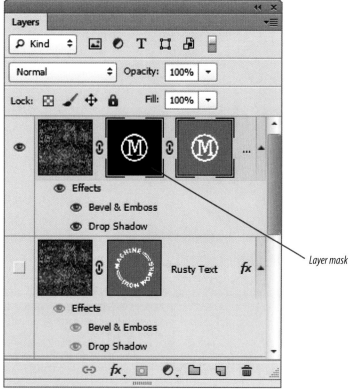

Layer mask

Source Adobe® Photoshop®, 2013.

Use a vector mask in conjunction with a layer mask

1. Hide the Rusty Text layer, then target the **Rusty M layer**.

2. Press and hold [**Ctrl**] (Win) or ⌘ (Mac), then click the **Vector mask thumbnail** on the Rusty M layer to load it as a selection.

3. Click the **Add layer mask button** on the Layers panel, then compare your Layers panel to Figure 75.

 A layer mask is added to the layer. When a layer has both a vector mask and a layer mask, all of the basic rules still apply. The vector mask works like a vector mask, and the layer mask works like a layer mask; nothing changes in terms of how they function.

 TIP As you move forward through these steps, keep clear in your head which is the vector mask and which is the layer mask.

4. Press and hold [**Alt**] (Win) or [**option**] (Mac), then click the **layer mask thumbnail** on the M layer.

 The canvas changes to show the contents of the layer mask.

5. Click the vector mask thumbnail on the M layer to hide the path.

 TIP Clicking a vector mask thumbnail hides and shows a path.

6. Click the **Filter menu**, then click **Filter Gallery**.

(continued)

7. Close the Artistic folder, if necessary, click the **Brush Strokes folder** to open it, then click **Spatter**.

8. Drag the **Spray Radius slider** to **25**, then drag the **Smoothness slider** to **15**.

9. Click **OK**, click the **Vector mask thumbnail** to make the path visible, then compare your screen to Figure 76.

 The path shows the outline of the original artwork. The Spatter filter modified the layer mask in such a way that some of the white areas extend outside of the original outline, and some of the black areas extend into the outline, thus creating the rough edge. It's important that you realize that the layer mask is subordinate to the vector mask. Any of the white areas in the layer mask that are outside of the vector mask will not be visible – nothing outside the vector mask is visible.

10. Click the **layer thumbnail** on the Rusty M layer to see the artwork, then compare your screen to Figure 77.

 No part of the rust artwork is visible outside of the vector mask, which is *perfect* for this illustration. Our goal is to create eroded type— in this case, rusted type. When metal rusts, its edges chip and fall away, leaving indentations *into* the edge. It doesn't corrode *outside* of its original shape; it doesn't get bigger when it corrodes. Even though the layer mask, because of the Spatter filter, would show rust outside the original shape, the vector mask allows only the spatter inside the original shape to show.

11. Hide the Rusty M layer.

(continued)

Figure 76 *Viewing the filter applied to the layer mask and its relationship with the vector mask*

Image courtesy of Chris Botello. Source Adobe® Photoshop®, 2013.

Figure 77 *Viewing the "eroded" effect*

Image courtesy of Chris Botello. Source Adobe® Photoshop®, 2013.

Working with Type and Shape Layers

Figure 78 *Final artwork*

Image courtesy of Chris Botello. Source Adobe® Photoshop®, 2013.

12. Show the Rusty Text layer, load the selection from its shape layer, then create a new layer mask.

13. Press and hold [**Alt**] (Win) or [**option**] (Mac), click the **layer mask thumbnail** to view it, click the **Filter** menu, click **Filter Gallery**, then click **Spatter**.

14. Drag the **Spray Radius slider** to **20**, then click **OK**.

15. Click the **layer thumbnail** on the Rusty Text layer to view the artwork.

TIP Hide the path if necessary.

16. Press and hold [**Shift**], then click the layer mask repeatedly to see the eroded text effect on the letters. When you're done, make sure that the layer mask is activated.

17. Show the Rusty M layer, then compare your artwork to Figure 78.

18. Save your work, then close Eroded Text.psd.

1. Open AP 5-14.psd, then save it as **Carved Wood**.
2. Target the Logo layer, add an Inner Shadow layer style using the settings shown in Figure 79, then keep the Layer Style dialog box open.
3. Click the words Inner Glow on the left side of the Layer Styles dialog box.
4. Click Center as the source, then enter the settings shown in Figure 80.
5. Click OK, then set the Logo layer to Multiply.
6. Duplicate the Outer layer, then name the new layer **Inner**.
7. Drag the Inner layer below the Outer layer.
8. Load the selection of the Logo layer.
9. Target the Outer layer, then click the Add layer mask button on the Layers panel.
10. Invert the layer mask.
11. Add a Bevel & Emboss layer style to the Outer layer, enter the settings shown in Figure 81, then keep the Layer Style dialog box open.
12. Change the color on both the Highlight and Shadow modes to 250R/250G/140B.
13. Set the Opacity on the Highlight mode to 100%.
14. Change the blending mode on the Shadow mode to Screen, change its Opacity setting to 45%, then click OK.
15. Target the Inner layer, then move it 3 pixels to the left.
16. Target the Outer layer, then lock the transparent pixels.
17. Click the Edit menu, then click Fill.
18. Fill the layer with 15% White, click OK, then compare your result to Figure 82.
19. Save your work, then close Carved Wood.psd.

Figure 79 *Applying the Inner Shadow*

Figure 80 *Applying the Inner Glow*

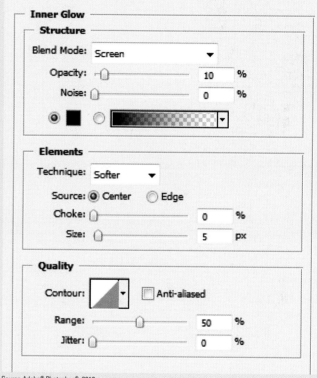

Source Adobe® Photoshop®, 2013.

Source Adobe® Photoshop®, 2013.

Working with Type and Shape Layers

Figure 81 *Applying the Bevel & Emboss*

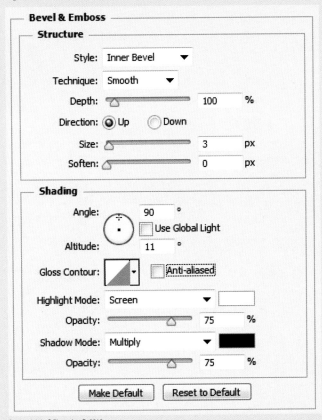

Source Adobe® Photoshop®, 2013.

Figure 82 *Completed Project Builder 1*

Image courtesy of Chris Botello. Source Adobe® Photoshop®, 2013.

1. Open AP 5-15.psd, then save it as **White Mischief**. (*Hint*: What you see is a well-known effect, created with a Drop Shadow layer style. This exercise will show you a neat variation that is less common.)
2. Change the foreground color to **235R/235G/235B**.
3. Fill the Background layer with the new foreground color, then fill the text with the new foreground color.
4. Double-click the Drop Shadow effect, then change its size to 6 pixels.
5. Click Bevel & Emboss, then drag the Depth slider all the way to the right.
6. Set the Opacity slider on the Highlight mode to 100%.
7. Drag the Opacity slider on the Shadow mode to 0, then click OK.
8. Compare your artwork to Figure 83. (*Hint*: The effect is similar, but improved by the subtle and elegant white highlight at the top right of the letterforms. You can manipulate the size and distance settings on both the Drop Shadow and Bevel & Emboss layer styles to create many effective variations.)
9. Save your work, then close White Mischief.psd.

Figure 83 *Completed Project Builder 2*

Image courtesy of Chris Botello. Source Adobe® Photoshop®, 2013.

LAURA KENT ANTHONY BURTON

BLACK KNIGHT

THEATRUM MUNDI PICTURES PRESENTS

MIRIBILE VISU AND THEATRUM MUNDI PRESENT IN ASSOCIATION WITH AD ASTRA AND AD CROMENUM A ALEA IACTA EST PRODUCTION "IPSISSIMA VERBA"
DUX FEMINA FACTI PLACENS UXOR AND DRAMATIS PERSONAE CASTING INTER PARES MAKEUP SIMPLEX MUNDITIIS COSTUMES VESTITUS AMPLUS PRODUCTION DESIGNER IGNIS FATUUS
EDITOR TOTIDEM VERBIS DIRECTOR OF PHOTOGRAPHY FIAT LUX MUSIC BY SCHOLA CANTORUM PRODUCERS DATA ET ACCEPTA STORY BY "IPSISSIMA VERBA" BY EDITO PRINCEPS EXECUTIVE PRODUCERS FATA VIAM INVENIENT
SCREENPLAY BY OPUS ARTIFICEM PROBAT PRODUCED BY NIHIL QUOD TETIGIT NON ORNAVIT DIRECTED BY LAPSUS CALAM

HOLLYWOOD STUDIO
© 2005 ALL RIGHTS RESERVED

CHAPTER **6** DESIGNING WITH
MULTIPLE IMAGES

1. Create a concept for a poster.
2. Assess supplied images.
3. Position images for a background setting.
4. Integrate multiple images into a single background image.
5. Position foreground images.
6. Merge two images.
7. Integrate foreground images.
8. Finish artwork.

Create a Concept
FOR A POSTER

What You'll Do

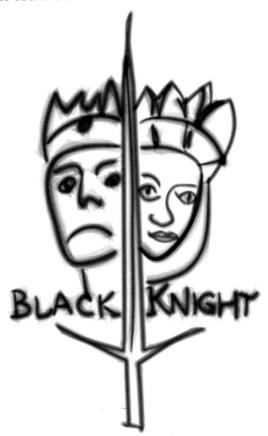

Image courtesy of Chris Botello. Source Adobe® Photoshop®, 2013.

Fasten your seatbelts; you're in for a great ride. Throughout the eight lessons in this chapter, you're going to build a movie poster—from scratch. Actually, you're going to build the movie poster that I built when I first wrote this chapter. The design dialog that runs throughout the chapter will be first-person commentary from me, sharing with you the decisions I made—and why I made them—as I created this poster.

Step by step, you'll build the poster with me. You'll even make the mistakes that I made and take the same wrong turns that I took. And then you'll backtrack and fix your mistakes just like I did. My goal here was to create as much of a real-world project as I could, and then strap you in beside me—my designer copilot—as I retrace my steps.

Real-world is the key here. The images you'll use are stock images that I researched myself—having no idea if they'd actually work together for the concept I had in mind. About the only thing that I created in advance was the concept.

The concept is this: We are art directors working for a Hollywood agency that designs

Designing with Multiple Images

and produces first-run movie posters. We've just been brought in on a new project: *Black Knight*. Here's what the client has told us about *Black Knight*:

- It's an American-produced film, but it was shot in England.
- It stars two respected actors.
- The actress has the leading role. She is played by a very popular American actress (doing a solid English accent).
- The actor is British, well-respected for both his stage and film work.
- The plot, in a nutshell, is as follows: The king has been away at battle for months. The queen falls in love with another man—a knight, believing that her jealous king is far away and may never return. Unknown to her, he has actually returned and is masquerading as a servant in the castle. The queen's handmaiden alerts the queen to the King's ruse. Before the king can confront the queen about her admirer, she has him jailed as a thief who has invaded the castle. A battle of wills develops between the royals—she knows that he knows, and he knows that she knows that he knows. Trying to test her,

he sentences the man to death, believing the queen will have no choice but to confess her infidelity. To his surprise, the defiant queen accepts his gambit. Vowing vengeance, the "thief" is suited in armor and burned at the stake. His silver armor is blackened. After his death, stories begin circulating that a mysterious black knight has been seen in the dark of night. The royals dismiss this as mere hysteria—until the queen's handmaiden is found dead.

Figure 1 *Sketch for black knight element*

Image courtesy of Chris Botello. Source Adobe® Photoshop®, 2013.

■ The marketing team has positioned this film in two important ways: first, as a historical thriller, with lots of action, suspense, and sword battles between mounted knights and kings; however, it's also positioned as a costume-drama-romance. The client's marketing team wants your agency to design a poster expressing both these approaches.

After coming up with this concept, I sketched out the thumbnails shown in Figures 1, 2, 3 and 4. Based on the marketing strategy, I determined that I wanted the following

Figure 2 *Knight and Castle sketch*

Figure 3 *King and Queen sketch*

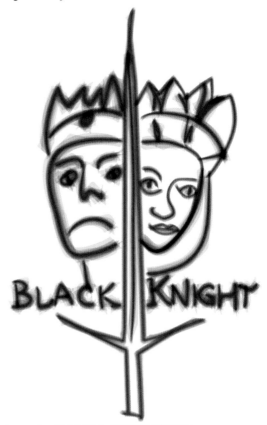

Designing with Multiple Images

five elements in the poster: the queen, the king, the black knight, a sword, and a castle. The king and queen are the "star sell"—the famous actors that everybody likes and wants to pay money to see. The black knight is the title character.

A black knight is so visually interesting that I knew on its own would define the mysterious, menacing quality that I wanted the poster to have. Working in concert with the beautiful queen, it would also generate the romantic aspect that I needed to convey: a dangerous story of forbidden love and revenge.

Figure 4 *Knight with sword sketch*

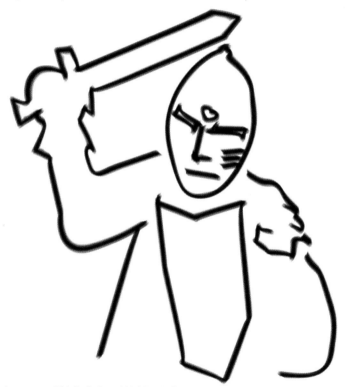

Image courtesy of Chris Botello. Source Adobe® Photoshop®, 2013.

Assess Supplied IMAGES

What You'll Do

Source Adobe® Photoshop®, 2013. Willie Maldonado/Getty Images

Before I even think about starting to design a poster, I prepare myself for at least a few hours of assessing, retouching, and preparing my supplied images to be used as artwork.

You've probably heard thousands of times that "those beautiful people in the ads don't really look like that." Well guess what...it's true. In every case, posters, advertisements, magazine covers, you name it, the final images you see have gone through substantial amounts of preparation and retouching.

As a designer, this stage for you has two components. First you must assess the images to get a sense of how they can be positioned and combined to achieve the look that you are working toward. Second, you must clean up the raw materials.

Whenever you're working with photographs of people, some amount of retouching will be involved. It may be minor, or it may be extensive, but it will always be necessary.

When retouching, I approach an image from three perspectives: cosmetic, enhancement, and practical. From the cosmetic perspective, I work to hide flaws. Those flaws might be problems with the photograph such as dust or hairs in the image, or they might be problems with the subject, such as skin imperfections.

From the enhancement perspective, I work to improve the overall effect of the image. Especially when you are working on a project like this, which is romantic and atmospheric, it's important that your artwork be effective.

This type of retouching would include making the color of the image more vivid, the eyes more entrancing, and so on.

Finally, from the practical perspective, I try to identify problems with the originals that won't work realistically within my concept. These could include any number of problems, and they're not always easy to identify before you start working.

One example would be lighting. If I'm planning to combine two headshots of two different actors, it will be a practical problem if one is lit from the right and the other from the left. Or if one has a blue highlight and the other has a red highlight.

In this lesson, you will examine three photographs to see the changes and retouching that I applied. You won't actually do the retouching—that's something you'll do in an upcoming chapter—but you will be able to see the work that I did to the images long before I began designing the poster. I timed myself, and in total, I spent about two and one-half hours working on the images you're about to assess.

Assess the image of the big knight

1. Open Big Knight.psd, shown in Figure 5.

2. Hide and show the Curves 1 adjustment layer.

 This was a standard move in which I darkened the shadow point to increase contrast and to improve the depth of the shadows. When you are done examining the change, verify that the adjustment layer is showing.

 TIP Throughout this chapter, you will be asked to hide and show layers to see a before and after effect. In every case, verify that the layer is showing when you are done.

3. Hide and show the Remove Sword layer.

 As shown in Figure 6, I removed the sword entirely using the Clone Stamp tool. The area where the sword overlaps the armor was a bit challenging. If you look closely you'll see that I wasn't overly concerned with making the armor "perfect." This is because I knew in advance that the knight will be very dark against a dark background, and not too much detail would be visible.

 (continued)

Figure 5 *Big Knight.psd original*

Source Adobe® Photoshop®, 2013. Erik Von Weber/Getty Images

Figure 6 *Removing the sword*

Source Adobe® Photoshop®, 2013. Erik Von Weber/Getty Images

Figure 7 *The silhouette*

Source Adobe® Photoshop®, 2013. Erik Von Weber/Getty Images

Figure 8 *Actress.psd original*

Source Adobe® Photoshop®, 2013. Willie Maldonado/Getty Images

4. Show only the Silo layer.

 Because the background was basically one color, I was able to use the Magic Wand tool to quickly select the background. I refined the selection in the Refine Selection dialog box, then created the silhouette in Figure 7.

5. Close Big Knight.psd without saving changes.

Assess the image of the actress

1. Open Actress.psd, shown in Figure 8.

2. Verify that the Background layer is the only layer visible and that it is targeted.

 The very first problem I noticed was a big one—my lead actress was not in costume. Often, actors and actresses are photographed in their street clothes simply for a face shot. Another model is then photographed in the costume for the movie. As the poster designer, you're expected to merge the face of the actor into the costume. Head swaps, costume swaps, hair swaps, etc., are all very common with entertainment advertising projects.

 (continued)

3. Open Damsel.psd.

 I chose this image for the costume. Eventually, I'll need to replace the damsel's face with the actress's face. I must keep this in mind as I assess the photo of the actress.

4. Return to the Actress.psd file, then click the **Zoom tool** on her nose until you are viewing the entire head at 100%.

 The blue highlight and the very soft edge on the right side of her face will present a problem when she's copied into the damsel's costume.

5. Show the No Highlight layer.

 As shown in Figure 9, this change involved replacing the soft, highlighted edge of her face. I created a path to define the edge of her face, then spent about 30 minutes cloning with the Clone Stamp tool and the Healing Brush tool to create a flesh tone that was continuous with the rest of her face. I didn't worry about the hard edge because I knew that it would be in shadow when I merged it with the damsel's costume.

6. Show the Remove Scar layer.

 There's a faint but noticeable horizontal scar on the bridge of the woman's nose, between her eyes—nobody's perfect.

 (continued)

Figure 9 *Removing a highlight from the face*

Source Adobe® Photoshop®, 2013. Willie Maldonado/Getty Images

Designing with Multiple Images

Figure 10 *Enhancing the eyes*

Source Adobe® Photoshop®, 2013. Willie Maldonado/Getty Images

7. Show the Smooth Eyeshadow layer.

 Conceptually, this one was trickier than it seems. A woman in medieval times wouldn't have had such dramatic eyeshadow, if any at all. My choice was to keep her beautiful and glamorous, but to reduce the obvious touches.

8. Show the Reduce Lip Gloss layer.

9. Show the Shadow right side layer.

 Nobody's face exists on a flat plane, so I added shadow to convey a sense of dimension. Also, I knew in advance that her face would be shadowed on the sides when she's pasted into the damsel's costume.

10. Show the Whiten Eyes, Outline Iris, and Eye Power layers.

 As shown in Figure 10, these standard moves can make the eyes far more interesting and entrancing.

11. Show the Darken Eyebrows layer.

 From reading the script, I know that the character of the queen is both the heroine and the villain. Darkening the brows adds intensity and an edge to her features.

12. Target the **No Highlight layer**, press and hold [**Shift**], then select all the layers above it.

TIP Only the Background layer should not be selected.

13. Press [**Ctrl**][**G**] (Win) or ⌘ [**G**] (Mac).

 The selected layers are collected into a single folder named Group 1.

(continued)

14. Hide and show the Group 1 layer to see a before-and-after comparison of all the retouching changes applied to the image.

15. Keep the Actress file open, but do not save changes at this point.

16. Close the Damsel.psd document.

Assess the image of the king

1. Open King.psd, then zoom in so that you are viewing his face at 100%.

2. Target the **Background layer**, then verify that the Background layer is the only layer visible.

 Normally, I would do this work with adjustment layers, but in this case I created duplicate layers so that you could look at each layer individually.

3. Arrange the King.psd and the Actress.psd documents side by side, if possible.

 The focus and the lighting on the king image is very different from the actress image. Since they will be positioned side by side in the final poster, I needed to make the two images as similar in tonal range as possible.

4. Show the No Sword layer.

5. Show the Match Actress layer.

 As shown in Figure 11, I lightened the highlights and midtones dramatically to improve contrast and to mimic the overall lightness of the actress image.

6. Show the Lighten eyes layer.

(continued)

Figure 11 *Lightening the king to match the actress*

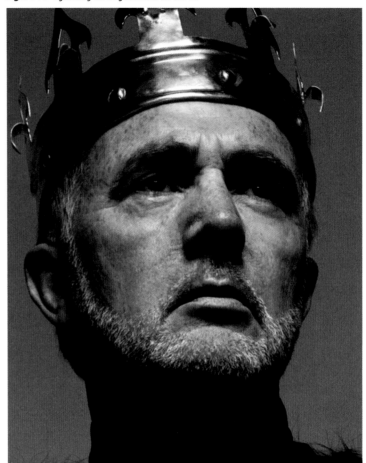

Source Adobe® Photoshop®, 2013. Erik Von Weber/Getty Images

Designing with Multiple Images

Figure 12 *Smothing the king's face*

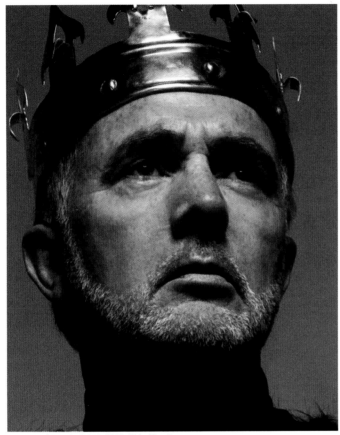

Source Adobe® Photoshop®, 2013. Erik Von Weber/Getty Images

AUTHOR'S NOTE

The older actor lacks the near-flawless complexion of our youthful actress. That's not such a big deal, as he is indeed older and, as a king, he's rugged and manly. However, 20 minutes with the Clone Stamp tool and the Healing Brush tool softened the harsh texture overall and helped to make our leading man just a bit more Hollywood handsome.

7. Show the Smooth skin layer.

 As shown in Figure 12, the face is smoothed out overall.

8. Show the next three layers to see the same standard eye retouches as you saw in the actress file.

9. Show the Add Grain layer.

 The Actress.psd document has a distinct grainy quality that the King.psd document lacks.

10. Create a new layer group with all the retouched layers, then hide and show the new group for a before-and-after view of all the changes.

11. Close King.psd and Actress.psd, without saving changes to either.

Position Images for
A BACKGROUND SETTING

What You'll Do

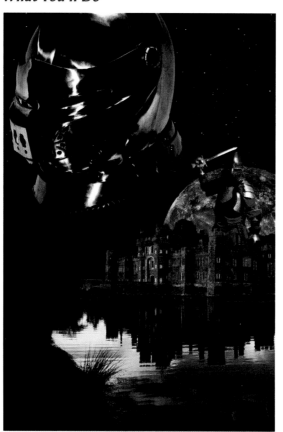

Source Adobe® Photoshop®, 2013. Small Knight: Chip Simons/Getty Images, Moon: StockTrek/Jupiter Images, Big Knight: Erik Von Weber/Getty Images, Pete Turner/Castle: Getty Images, Stars: Paul Beard/Jupiter Images

The great thing about designing movie posters is that you need to tell a story. Sometimes, when there's a really big star in the movie, all you need to do is run a picture of the star and the title. Any poster for a movie with Sandra Bullock would be a good example of this. For most titles, however, the poster needs to show more to convey some aspect of the story.

For the designer, this means that telling the story will happen in the background, usually behind a big headshot of the big movie star.

With this type of poster, the challenge for you is to design the poster as a world unto itself. It's almost as if the poster is a glimpse into the world of the movie. This means that much of your work will be focused on the background imagery of the poster—and that's usually the place you start to work.

Designing with Multiple Images

Figure 13 *Stars.psd image in the poster file*

Image courtesy of Paul Beard/Jupiter Images. Source Adobe® Photoshop®, 2013.

Position images

1. Open AP 6-1.psd, then save it as **Black Knight Poster**.

2. Click the **Window menu**, point to **Workspace**, then click **Essentials (Default)**.

TIP If your workspace is already set to Essentials, click Reset Essentials to restore the workspace to the default.

3. Open Stars.psd, select all, copy, then close the file.

4. Paste the selection into the poster, then name the new layer **Stars**.

5. Compare your canvas to Figure 13.

6. Sample the blacks in the Stars image to verify that they are truly black.

 This is an example of how you need to be conscious of grayscale values while you work. In our concept, this is a deep, dark black night sky. Take the time to sample the image to verify that the black pixels are truly black—in this case, they are.

7. Open Billing.psd, select all, copy, then close the file.

(continued)

8. Paste the selection into the poster, then name the new layer **Billing**.

In the final version of this poster, I would recreate this layer as an editable live type layer, either in Photoshop or in InDesign. I also have the option to create the complex billing block text in Illustrator and paste it as a shape layer in this Photoshop file.

TIP Be sure to name layers with descriptive names. By the end of this chapter, this file will have about 50 layers, and you'll be so thankful when you're scrolling through the Layers panel that you took the time to name each individual layer.

9. On the Layers panel, change the blending mode for the Billing layer to **Screen**, then compare your canvas to Figure 14.

The Screen blending mode makes black pixels completely transparent.

10. Save your work.

Figure 14 *Result of the Screen blending mode*

Image courtesy of Paul Beard/Jupiter Images. Source Adobe® Photoshop®, 2013.

AUTHOR'S NOTE

When I design posters, one of the first things I do is position the important text elements. The type elements do a lot to define the look of the piece. Already, this looks like a movie poster, and that helps me to visualize the final poster while I'm working. Also, I place the type elements in the beginning of the project simply to reserve space for them while I'm working. Otherwise, I might create a great piece of artwork then realize I've not left enough room for the billing block!

Figure 15 *The Big Knight artwork pasted on the Big Knight layer*

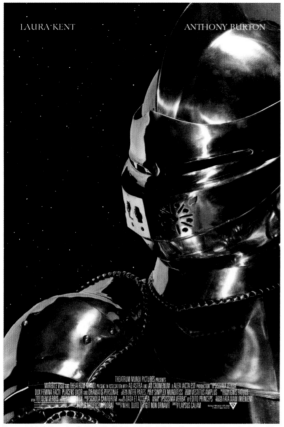

Source Adobe® Photoshop®, 2013. Big Knight: Erik Von Weber/Getty Images, Stars: Paul Beard/
Jupiter Images

Position an image precisely

1. Click the **View menu**, click **Fit on Screen**, then target the **Stars layer**.

2. Open Big Knight.psd, show and target only the **Silo layer**, select all, copy, then close the file.

 Don't save changes if prompted.

3. Paste the selection, then name the new layer **Big Knight**.

 Your canvas should resemble Figure 15.

4. Hide the Billing layer.

5. Press [**Ctrl**][**T**] (Win) or ⌘ [**T**] (Mac) to scale the image.

 Once you press [**Ctrl**][**T**] (Win) or ⌘ [**T**] (Mac), the Options bar displays the physical attributes of the image within the bounding box, such as its X and Y locations and its horizontal and vertical scale.

6. Verify that the center point is selected in the Reference point location in the Options bar.

7. Moving left to right, type **555.7** in the X text box, press [**Tab**], type **514.7** in the Y text box, press [**Tab**], type **80** in the W text box, press [**Tab**], type **80** in the H text box, then press [**Tab**].

 (continued)

8. Click the **Move tool** 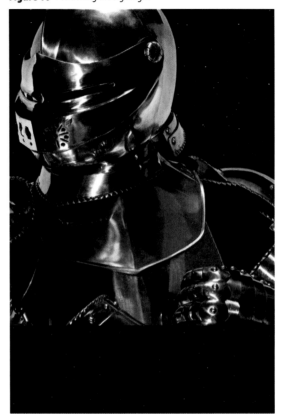, click **Apply** to execute the transformation, then compare your screen to Figure 16.

 The Big Knight image was scaled 80%; the location of its center point is 555.7 pixels from the left edge of the canvas and 514.7 pixels from the top.

9. Save your work.

Figure 16 *Positioning the big knight*

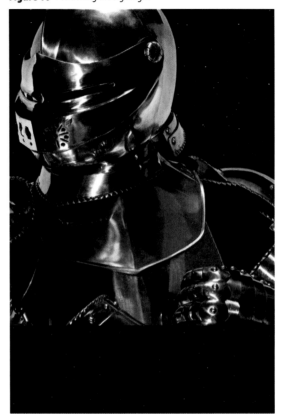

Source Adobe® Photoshop®, 2013. Big Knight: Erik Von Weber/Getty Images, Stars: Paul Beard/Jupiter Images

AUTHOR'S NOTE

At this point, an alert is sounding in my head. I'm thinking that the knight is looking a lot like Darth Vader, especially against that black starry sky that looks so much like outer space. This is not a big shock—Darth Vader really does look a lot like a knight. From my design perspective, this is first a bad thing, but also a good thing. It's bad because I don't want the final image to look silly or like a cheap knock-off of *Star Wars*. It's a good thing because I remember the great *Star Wars* posters and how Darth Vader was used so effectively as a background image.

Designing with Multiple Images

Figure 17 *Hard Light blending mode*

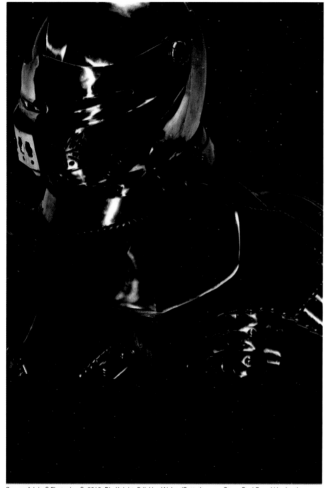

Source Adobe® Photoshop®, 2013. Big Knight: Erik Von Weber/Getty Images, Stars: Paul Beard/Jupiter Images

Use the Hard Light blending mode

1. Verify that the **Big Knight layer** is targeted.
2. Experiment with all of the blending modes on the Layers panel.

 So much of working with blending modes involves experimentation. Through experimentation, you can become familiar with the basic functions of the major blending modes. Be sure to take note of how they are grouped in the panel menu. Modes that lighten an image are grouped together, as are modes that darken an image.
3. Choose the **Hard Light blending mode**, then compare your screen to Figure 17.
4. Click the **Layer menu**, point to **New Adjustment Layer**, then click **Hue/Saturation**.
5. Type **Desaturate** in the Name text box, click the **Use Previous Layer to Create Clipping Mask check box**, then click **OK**.

 TIP Whenever you are asked to create an adjustment layer, always click the Use Previous Layer to Create Clipping Mask check box unless you are instructed not to.

6. Drag the **Saturation slider** to **-50**.

 Because the Hard Light blending mode made the knight artwork transparent, we can see the stars artwork through the knight artwork, which is not an effect I want. The knight is too transparent.

 (continued)

7. Press and hold [**Ctrl**] (Win) or [⌘] (Mac), then click the **layer thumbnail** on the Big Knight layer to load its selection.

8. Click the **Rectangular Marquee tool** , press and hold [**Shift**], then add the bottom of the canvas to the selection so that your screen resembles Figure 18.

9. Target the **Stars layer**.

10. Press and hold [**Alt**] (Win) or [**option**] (Mac) then click the **Add layer mask button** on the Layers panel.

 The stars within the marquee disappear. As shown in Figure 19, a layer mask is added with the selected area automatically filled with black. Everything is automatically deselected.

TIP When any selection is loaded, pressing and holding [Alt] (Win) or [option] (Mac), then clicking the Add layer mask button creates a layer mask in which the selected pixels are filled with black. If you are not holding [Alt] (Win) or [option] (Mac) when you click the Add layer mask button, the selected pixels will be filled with white in the layer mask and the inverse will be black.

11. Select the **Big Knight layer** and the adjustment layer above it.

12. Press [**Ctrl**][**G**] (Win) or [⌘] [**G**] (Mac).

13. Rename the new group **Black Knight Group**.

14. Show the Billing layer to see how things are looking, hide it again, then save your work.

Figure 18 *Selecting areas for a mask*

Source Adobe® Photoshop®, 2013. Big Knight: Erik Von Weber/Getty Images, Stars: Paul Beard/ Jupiter Images

Figure 19 *Masking out the stars where they overlap the big knight*

Source Adobe® Photoshop®, 2013.

Designing with Multiple Images

Figure 20 *Reducing the opacity of the White layer*

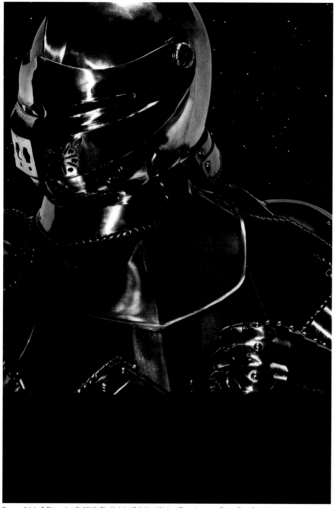

Source Adobe® Photoshop®, 2013. Big Knight: Erik Von Weber/Getty Images, Stars: Paul Beard/Jupiter Images.

Control the effect of the Hard Light blending mode

1. Assess the appearance of the Black Knight artwork.

 The knight is too black, so much so that he's mostly invisible against the black background and difficult to identify as a knight. Since there's no way to control the degree to which the Hard Light blending mode affects the artwork, I'm going to use a work-around technique.

2. Click the **gray triangle** to expand the Black Knight Group, then target the **Big Knight layer**.

3. Press and hold [**Ctrl**] (Win) or ⌘ (Mac), then click the **Create a new layer button** on the Layers panel.

 A new empty layer is added *below* the Big Knight layer.

4. Name the new layer **White**.

5. Press and hold [**Ctrl**] (Win) or ⌘ (Mac), then click the **layer thumbnail** on the Big Knight layer to load its selection.

6. Fill the selection with white, then deselect.

7. Reduce the Opacity of the White layer to **30%**, then compare your screen to Figure 20.

 With this method, we can use the White layer as an intermediary to control the effect that the Hard Light blending mode has on the relationship between the knight and the background.

 (continued)

8. Add a layer mask to the White layer.

9. Click the **Brush tool** ✏️, press [**X**] to switch to a black foreground color, verify that the Opacity is set to **100%**, then choose a medium-sized hard brush.

10. Mask out every area of the White layer except the head.

11. Drag the **layer mask** from the White layer up to the Black Knight Group folder layer.

 Your Layers panel should resemble Figure 21. The mask on the group folder masks all layers within the group.

12. Reduce the Opacity of the White layer to **10%**, then compare your screen to Figure 22.

13. Collapse the Black Knight Group layer.

14. Save your work.

Figure 21 *Masking the group folder*

Mask on the Group folder masks all artwork in the folder

Source Adobe® Photoshop®, 2013.

Figure 22 *The final effect*

Source Adobe® Photoshop®, 2013. Big Knight: Erik Von Weber/Getty Images, Stars: Paul Beard/Jupiter Images

Designing with Multiple Images

Figure 23 *Positioning the castle*

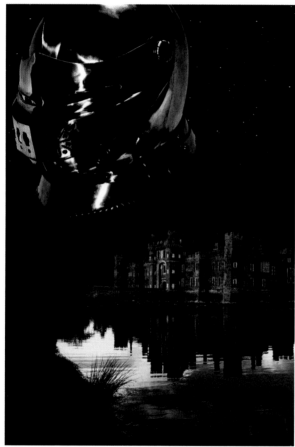

Source Adobe® Photoshop®, 2013., Big Knight: Erik Von Weber/Getty Images, Castle: Pete Turner/Getty Images, Stars: Paul Beard/Jupiter Images, Moon: StockTrek/Jupiter Images

Position three background images

1. Verify that the **Black Knight Group layer** is targeted.
2. Open Castle.psd, target and show only **Silo layer**, select all, copy, then close the file without saving changes.
3. Paste the selection, then name the new layer **Castle**.

TIP The new layer should be immediately above the Black Knight Group layer.

4. Press **[Ctrl][T]** (Win) or ⌘ **[T]** (Mac) to scale the image.
5. Type **692** in the X text box, press **[Tab]**, type **1283** in the Y text box, press **[Tab]**, type **63** in the W text box, press **[Tab]**, type **63** in the H text box, then press **[Tab]**.
6. Click the **Move tool** to execute the transformation, click **Apply**, then compare your screen to Figure 23.
7. Target the **Black Knight Group layer**.
8. Open Moon.psd, target and show only the **Silo layer**, select all, copy, then close the file.

(continued)

AUTHOR'S NOTE

The castle plays such an important role. First, it identifies a recognizable place. Second, it provides depth to the background. The black grass provides a much-needed foreground object, which also adds to the sense of depth.

9. Paste the selection into the poster, then name the new layer **Moon**.

10. Press [**Ctrl**][**T**] (Win) or ⌘ [**T**] (Mac) to scale the image.

11. Type **881** in the X text box, press [**Tab**], type **843** in the Y text box, press [**Tab**], type **52** in the W text box, press [**Tab**], type **52** in the H text box, then press [**Tab**].

12. Click the **Move tool** 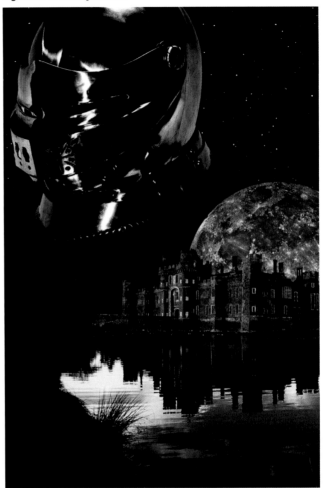 to execute the transformation, click **Apply**, then compare your screen to Figure 24.

 Picture choice is so important. Look at this image of the moon. It's not a typical image of our moon. In fact, it looks more like a sci-fi planet. This was an intentional choice on my part. I wanted to give the poster an other-worldly feel. This gigantic moon adds an unsettling strangeness to the scene and keeps the setting from seeming too much like romance novel artwork.

13. Open Small Knight.psd, target and show only the **Knight and Trees layer**, select all, then copy.

14. In the Black Knight Poster file, verify that the **Moon layer** is targeted, paste the selection, then name the new layer **Trees**.

(continued)

Figure 24 *Positioning the moon*

Source Adobe® Photoshop®, 2013. Big Knight: Erik Von Weber/Getty Images, Castle: Pete Turner/Getty Images, Moon: StockTrek/Jupiter Images, Stars: Paul Beard/Jupiter Images

Designing with Multiple Images

Figure 25 *Positioning the small knight and trees*

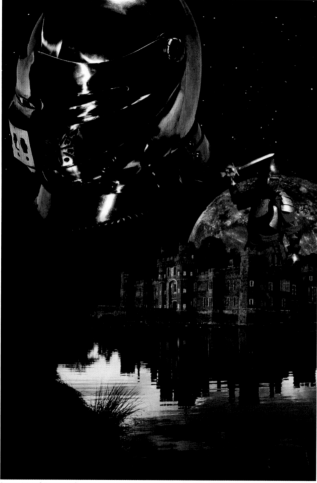

Source Adobe® Photoshop®, 2013. Small Knight: Chip Simons/Getty Images, Moon: Stock Trek/Jupiter Images, Big Knight: Erik Von Weber/Getty Images, Castle: Pete Turner/Getty Images, Stars: Paul Beard/Jupiter Images

15. Press [**Ctrl**][**T**] (Win) or ⌘[**T**] (Mac) to scale the image.

16. Type **867** in the X text box, press [**Tab**], type **685** in the Y text box, press [**Tab**], type **40** in the W text box, press [**Tab**], type **40** in the H text box, then press [**Tab**].

17. Click ▶✦ to execute the transformation, click **Apply**, then compare your screen to Figure 25.

18. Save your work.

Integrate Multiple Images into a
SINGLE BACKGROUND IMAGE

What You'll Do

Source Adobe® Photoshop®, 2013. Small Knight: Chip Simons/Getty Images, Moon: Stock Trek/ Jupiter Images, Big Knight: Erik Von Weber/Getty Images, Castle: Pete Turner/Getty Images, Stars: Paul Beard/Jupiter Images

Once you've positioned the images that you want to use in a poster, there always comes a critical point where the hodgepodge needs to be integrated into one piece of art. This is often a strange, exciting, and nerve-wracking transition. Positioning the images is a challenge for a designer's layout skills. Integrating the images challenges a whole different set of skills. This is where your individuality as a designer really comes into play. Given the layout in this chapter, 10 different designers would create 10 different pieces of artwork— even though they're all working with the same base imagery. And that's great—because design is all about individuality, and there's never a right solution. However, the challenge itself is always that same one: How do you use a bunch of photos to make one piece of art?

Designing with Multiple Images

Figure 26 *Aligning the small knights*

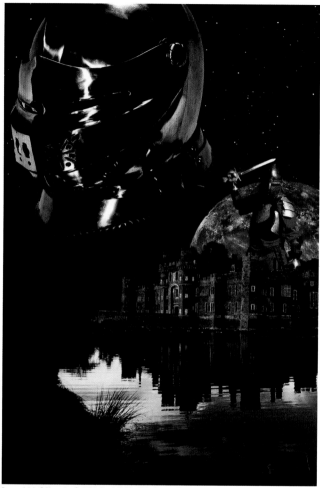

Source Adobe® Photoshop®, 2013. Small Knight: Chip Simons/Getty Images, Moon: StockTrek/Jupiter Images, Big Knight: Erik Von Weber/Getty Images, Stars: Paul Beard/Jupiter Images, Castle: Pete Turner/Getty Images

Create depth between placed images

1. Assess the relationships between the castle, the small knight and the moon.

 The castle is in front of the knight, the knight is in front of the trees and everything is in front of the moon. By definition, there's depth, and we want to increase that sense of depth. Note how the trees play an important role: they create a world—a setting—behind the small knight.

2. Return to the Small Knight.psd file, target and show only the **Silo layer**, select all, copy, then close the file without saving changes.

3. Paste, name the new layer **Small Knight**, then scale the small knight silo **40%**.

4. Reduce the Opacity of the Small Knight layer to 50%.

5. Click the **Move tool** ![Move tool icon], move the Small Knight so that it is aligned with the knight on the Trees layer, then return the layer Opacity to 100%.

 Your artwork should resemble Figure 26. Because the two small knights are aligned, the appearance hasn't changed, but now you can affect the Trees artwork independently form the Small Knight artwork.

 (continued)

6. Hide the Small Knight layer, target the **Trees layer**, then change its blending mode to **Multiply**.

 Your artwork should resemble Figure 27. Multiply is a commonly used blending mode; pixels retain their color but become transparent. Note how the orange glow around the edges of the trees is reduced. The darker trees now appear further in the distance behind the small knight.

7. Show the Small Knight layer.

 Note how the small knight is brighter than the castle. Note too how that brightness makes the small knight appear to be on the same plane as the castle instead of behind the castle.

8. Click the **Brush tool** , specify black as the foreground color, then choose a soft round 200 pixel brush with 0% Hardness.

9. Create a new layer above the Small Knight layer and name it **Shadow**.

 (continued)

Figure 27 *The Multiply blending mode applied to Trees*

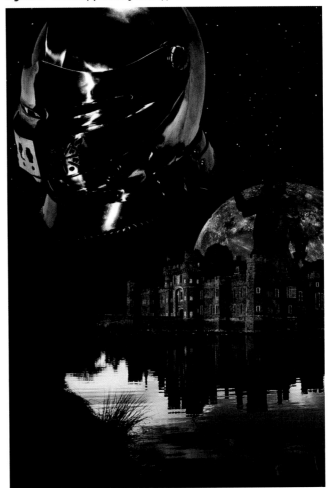

Source Adobe® Photoshop®, 2013. Small Knight: Chip Simons/Getty Images, Moon: StockTrek/Jupiter Images, Big Knight: Erik Von Weber/Getty Images, Castle: Pete Turner/Getty Images, Stars: Paul Beard/Jupiter Images

Designing with Multiple Images

Figure 28 *Painting black to convey depth and distance*

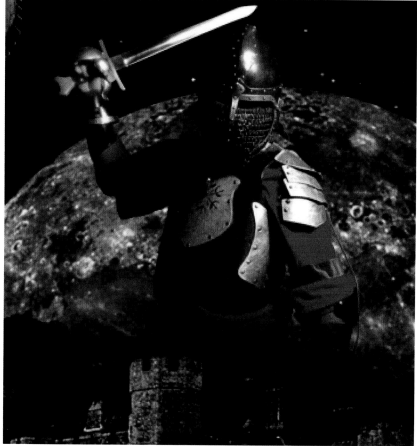

Source Adobe® Photoshop®, 2013. Small Knight: Chip Simons/Getty Images, Moon: StockTrek/Jupiter Images, Castle: Pete Turner/Getty Images, Stars: Paul Beard/Jupiter Images

10. Paint a black streak across the bottom half of the small knight, below his belt, as shown in Figure 28.

11. Set the Shadow layer's blending mode to **Multiply**, then reduce the layer Opacity to 85%.

12. Clip the Shadow layer into the Small Knight layer.

13. Apply the Fit on Screen command.

 The simple black streak creates the illusion that the knight is farther back behind the castle—as though the castle is casting a shadow on the knight. This is a standard technique: put color between two overlapping images to create depth. It's just an illusion, but the eye registers it instantly as depth.

14. Select the Trees, Small Knight and Shadow layers, make a new group, then name the group **Small Knight Group**.

15. Save your work.

Use adjustment layers to integrate artwork

1. Target the **Castle layer**.

2. Click the **Layer menu**, point to **New Adjustment Layer**, then click **Hue/Saturation**.

3. Type **Desaturate Background** in the Name text box, do not check the Use Previous layer to Create Clipping Mask check box, then click **OK**.

4. Drag the **Saturation slider** to **-80**, then compare your canvas to Figure 29.

5. Undo and redo to examine how this simple move does so much to integrate the artwork.

 Desaturated, the images all share a common look. Also, the setting is more realistic. With the desaturation, it is reasonable to believe that both the castle and the knight are illuminated by the moon.

 (continued)

Figure 29 *Desaturating the castle*

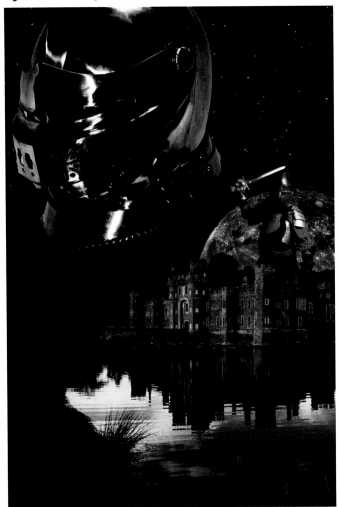

Source Adobe® Photoshop®, 2013. Small Knight: Chip Simons/Getty Images, Moon: StockTrek/Jupiter Images, Big Knight: Erik Von Weber/Getty Images, Stars: Paul Beard/Jupiter Images, Castle: Pete Turner/Getty Images

Figure 30 *Darkened shadows in small knight artwork*

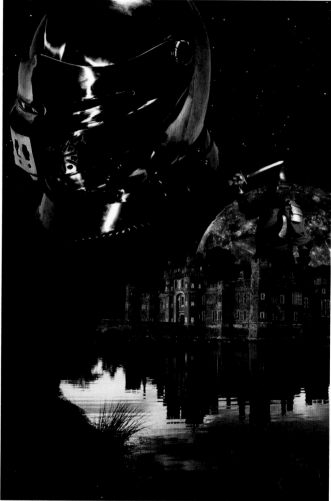

Source Adobe® Photoshop®, 2013. Small Knight: Chip Simons/Getty Images, Moon: StockTrek/Jupiter Images, Big Knight: Erik Von Weber/Getty Images, Stars: Paul Beard/Jupiter Images, Castle: Pete Turner/Getty Images

6. Display the Info panel, then sample the shadow areas on the small knight.

 The small knight suffers from weak shadows. We need to adjust both the Small Knight and Trees layers.

7. Expand the Small Knight Group folder then target the **Shadow layer**.

8. Create a Curves adjustment layer and verify that it's not clipped.

9. Drag the **black triangle** to the right so that its Input value is **15**.

 Because the Curves adjustment layer is not clipped, it is affecting all the layers beneath it, but we want it to affect just the Small Knight group.

10. Select the Small Knight Group folder, change its blending mode from Pass Through to **Normal**, then compare your artwork to Figure 30.

 When a group folder is set to Normal, adjustment layers in the group affect only artwork on layers within the group.

(continued)

11. Collapse the Small Knight Group layer, then target the **Castle layer**.

 As a foreground image, both the castle and the water in front of it should be brighter, sharper, and more distinct than the shadowy knight.

12. Apply a Levels adjustment layer named **Brighten Castle**.

 TIP Be sure to click the Use Previous Layer to Create Clipping Mask check box.

13. Type **20** in the left Input text box, type **1.3** in the middle text box, type **240** in the right text box, then compare your artwork to Figure 31.

14. Make a new layer group named **Castle Group** for the Castle layer and its adjustment layer.

15. Target the **Moon layer**.

16. Create a Curves adjustment layer.

 TIP Be sure to click the Use Previous Layer to Create Clipping Mask check box.

17. Click to add a point to the curve, set its Input value to **58**, then set its Output value to **96**.

18. Make a new layer group named **Moon Group** for the Moon layer and its adjustment layer.

19. Save your work.

Figure 31 *Adjusting levels*

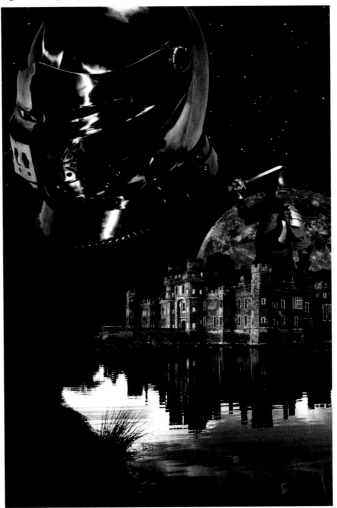

Source Adobe® Photoshop®, 2013. Small Knight: Chip Simons/Getty Images, Moon: StockTrek/Jupiter Images, Big Knight: Erik Von Weber/Getty Images, Stars: Paul Beard/Jupiter Images, Castle: Pete Turner/Getty Images

Figure 32 *The background*

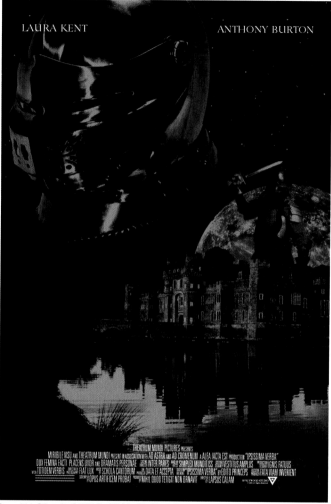

Source Adobe® Photoshop®, 2013. Small Knight: Chip Simons/Getty Images, Moon: StockTrek/Jupiter Images,
Big Knight: Erik Von Weber/Getty Images, Stars: Paul Beard/Jupiter Images, Castle: Pete Turner/Getty Images

Use a fill adjustment layer to integrate artwork

1. Target the **Desaturate Background layer**.
2. Click the **Layer menu**, point to **New Fill Layer**, then click **Solid Color**.
3. Type **Colorize Background** in the Name text box, do not click the Use Previous Layer to Create Clipping Mask check box, then click **OK**.
4. Type **84** in the R text box, type **110** in the G text box, type **179** in the B text box, then click **OK**.
5. Experiment by applying different blending modes to the layer.

 The Color Dodge and Overlay blending modes create particularly interesting results.
6. Set the blending mode to **Multiply** so that the blue fill layer becomes transparent.
7. Reduce the Opacity to **70%**.
8. Show the Billing layer, then compare your screen to Figure 32.
9. Save your work.

Position Foreground IMAGES

What You'll Do

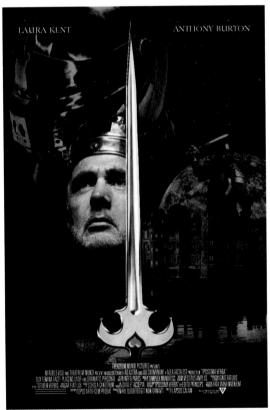

Source Adobe® Photoshop®, 2013. King: Erik Von Weber/Getty Images, Small Knight: Chip Simons/ Getty Images, Moon: StockTrek/Jupiter Images, Big Knight: Erik Von Weber/Getty Images, Castle: Pete Turner/Getty Images, Stars: Paul Beard/Jupiter Images, Sword: Chris Botello

Transitioning from background to foreground is always an interesting step when building a composite image. In many ways, it's like shifting gears.

When working on the background, the focus of your work often involves pushing things back, making them less distinct, blurring the line between one image and another, muting colors, and so on. The opposite is usually true when working with the foreground. With this type of poster—a lush, romantic thriller—I think of the foreground as the "eye candy." The foreground sells the poster, it sells the story, and it sells the movie.

This lesson is about positioning the foreground elements. Note how you'll use bright colors and central locations to make these elements the focus of the poster.

Designing with Multiple Images

Figure 33 *Positioning the sword*

Source Adobe® Photoshop®, 2013. Small Knight: Chip Simons/Getty Images, Moon: StockTrek/Jupiter Images,
Big Knight: Erik Von Weber/Getty Images, Castle: Pete Turner/Getty Images, Stars: Paul Beard/Jupiter Images,
Sword: Chris Botello

Position the sword

1. Hide the Billing layer.
2. Open Sword.psd.
3. Target the **Silo layer**, select all, copy, then close the file.
4. Target the **Colorize Background layer**, paste, then name the new layer **Sword**.
5. Click the **Edit menu**, point to **Transform**, then click **Rotate 180°**.
6. Press [**Ctrl**][**T**] (Win) or [⌘] [**T**] (Mac) to scale the image.
7. Type **506** in the X text box, press [**Tab**], type **833** in the Y text box, press [**Tab**], type **37** in the W text box, press [**Tab**], type **37** in the H text box, then press [**Tab**].
8. Click the **Move tool**, click **Apply**, then compare your screen to Figure 33.
9. Save your work.

Enhance the sword

1. Click the **Layer menu**, point to **Layer Style**, click **Bevel & Emboss**, then verify that the **Preview check box** is checked.

2. Verify that the Style is set to **Inner Bevel** and that Technique is set to **Smooth**.

3. Set the Depth to **750%**.

4. Set the Size to **8 px**.

5. Set the Opacity of the Highlight Mode and Shadow Mode to **90%**.

6. Click the **Gloss Contour list arrow**, click the eighth contour named **Ring**, then click the **Anti-aliased check box**.

7. Click **OK**, then compare your artwork to Figure 34.

8. Click the **Layer menu**, point to **New Adjustment Layer**, then click **Levels**.

9. Type **Brighten Sword** in the Name text box, click the **Use Previous Layer to Create Clipping Mask check box**, then click **OK**.

10. Drag the **black triangle** in the Input Levels section to the right until the far-left Input text box reads **18**, drag the **white triangle** left until the far-right Input text box reads **235**.

11. Target the **Sword layer**.

(continued)

Figure 34 *The sword enhanced with a layer style*

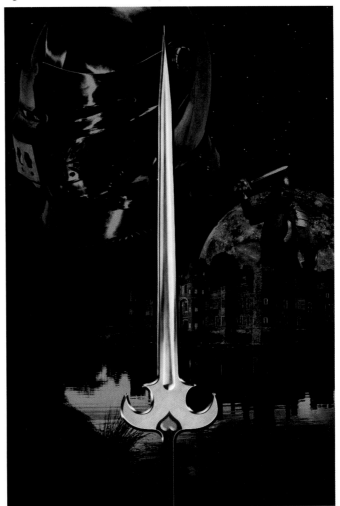

Source Adobe® Photoshop®, 2013. Small Knight: Chip Simons/Getty Images, Moon: StockTrek/Jupiter Images, Big Knight: Erik Von Weber/Getty Images, Castle: Pete Turner/Getty Images, Stars: Paul Beard/Jupiter Images, Sword: Chris Botello

Designing with Multiple Images

Figure 35 *Selecting the sword*

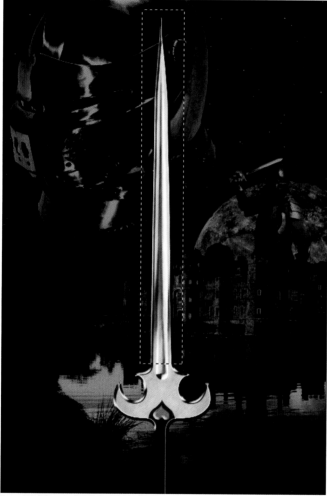

Source Adobe® Photoshop®, 2013. Small Knight: Chip Simons/Getty Images, Moon: StockTrek/Jupiter Images,
Big Knight: Erik Von Weber/Getty Images, Castle: Pete Turner/Getty Images, Stars: Paul Beard/Jupiter Images,
Sword: Chris Botello

12. Drag a rectangular selection marquee around the sword but not the handle, as shown in Figure 35.

13. Apply a 6-pixel feather to the selection, click the **Filter menu**, point to **Sharpen**, then click **Unsharp Mask**.

14. Type **100** in the Amount text box, then click **OK**.

 The tones in the sword become much more distinct and hard edged. You will study sharpening techniques in more detail in upcoming chapters.

15. Deselect, create a new layer group for the Sword and its adjustment layer, then name the new group **Sword Group**.

16. Save your work.

Place the king

1. Target the **Colorize Background layer**.

2. Open King.psd, make all layers visible except for the top layer named Silo, then target the **Background layer**.

3. Press and hold [**Ctrl**] (Win) or ⌘ (Mac), then click the **layer thumbnail** on the Silo layer to load its selection.

 The selection is loaded but the Silo layer remains hidden.

4. Click the **Edit menu**, then click **Copy Merged**.

 The Copy Merged command is very useful if you want to copy an image on your screen that is being created from multiple layers. The Copy Merged command copies all the visible layers as though they were a single, merged layer.

(continued)

5. Close King.psd, switch to the Black Knight Poster document, paste, then name the new layer **King**.

 This is a good method for file management. Rather than bring all the layers from the King file into the Black Knight document, we're working with a single merged image of the king. Our layers still exist in the King file if we need them, so there's no need to increase the complexity and file size of the Black Knight Poster document with all those layers.

6. Click the **Edit menu**, point to **Transform**, then click **Flip Horizontal**.

7. Press **[Ctrl][T]** (Win) or ⌘ **[T]** (Mac) to scale the image.

8. Type **426** in the X text box, press **[Tab]**, type **947** in the Y text box, then press **[Tab]**.

9. Click the **Move tool** , click **Apply**, then compare your screen to Figure 36.

 It's difficult to see, but a horizontal white line above the king's head was inadvertently copied from the King.psd file. If you zoom in or move the image of the king around, you'll see it more clearly. These glitches happen often, and you must keep an eye out for them.

10. Add a layer mask to the King layer, make the selection shown in Figure 37, then fill the selection in the layer mask with black.

11. Deselect, then save your work.

Figure 36 *Positioning the king*

Source Adobe® Photoshop®, 2013. King: Erik Von Weber/Getty Images, Small Knight: Chip Simons/Getty Images, Moon: StockTrek/Jupiter Images, Big Knight: Erik Von Weber/Getty Images, Castle: Pete Turner/Getty Images, Stars: Paul Beard/Jupiter Images, Sword: Chris Botello

Figure 37 *Masking an unintended white line*

Source Adobe® Photoshop®, 2013. King: Erik Von Weber/Getty Images, Small Knight: Chip Simons/Getty Images, Moon: StockTrek/Jupiter Images, Big Knight: Erik Von Weber/Getty Images, Castle: Pete Turner/Getty Images, Stars: Paul Beard/Jupiter Images, Sword: Chris Botello

Designing with Multiple Images

Figure 38 *Masking the king on the right of the sword*

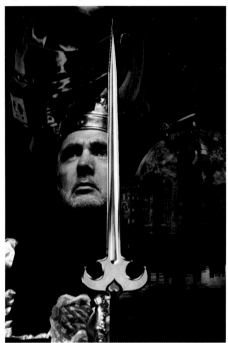

Source Adobe® Photoshop®, 2013. King: Erik Von Weber/Getty Images, Small Knight: Chip Simons/Getty Images, Moon: StockTrek/Jupiter Images, Big Knight: Erik Von Weber/Getty Images, Castle: Pete Turner/Getty Images, Stars: Paul Beard/Jupiter Images, Sword: Chris Botello

Figure 39 *Final mask effect for the king*

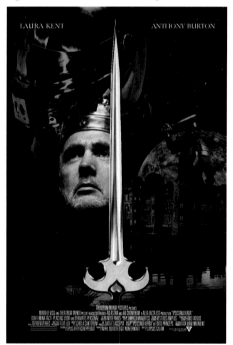

Source Adobe® Photoshop®, 2013. King: Erik Von Weber/Getty Images, Small Knight: Chip Simons/Getty Images, Moon: StockTrek/Jupiter Images, Big Knight: Erik Von Weber/Getty Images, Castle: Pete Turner/Getty Images, Stars: Paul Beard/Jupiter Images, Sword: Chris Botello

Mask the king

1. Select the entire right half of the canvas, then mask out all elements of the king image that are on the right side of the sword.

2. Deselect all, then compare your screen to Figure 38.

3. Click the **Brush tool** , choose the **Soft Round 100 pixels brush**, then mask out only the hand, the gold handle and white areas of the costume.

4. Moving upward slowly and making small moves, mask the king's black costume so that it merges with the shadows that surround the blue water.

5. Show the Billing layer so that your artwork resembles Figure 39. As shown in the figure, the king's costume merges seamlessly with the shadows in the water. Rather than a floating head, we now recognize the king's shoulder, his collar, and the shiny detail on his chest and sleeve. However, those elements transition into the shadows in a way that you really can't tell where the king ends and the shadows on the water begin.

6. Hide the Billing layer, then save your work.

Merge Two
IMAGES

What You'll Do

Source Adobe® Photoshop®, 2013. Willie Maldonado/Getty Images

Merging two images to create a third image is perhaps the most delicate surgery you can do in Photoshop, especially when it involves somebody's face. It's one thing to paste a tree into a field; it's a whole different thing to take the eyes from one photo and paste them onto the face in another photo—with nobody catching on. You might be surprised at how often it's done. I do a lot of work with movie posters, and in most cases, the actor's head and the actor's body are from two different original photos. This happens because, when choosing from originals, the face in one photo might be perfect for the concept, but the body might be in the wrong position. But in another photo, the body is in a great position, but the actor won't approve the face shot. So a merge is necessary—put this head on that body.

If you're really good and you do it well, the best compliment is no compliment at all—because nobody realizes the tricks you've been playing.

Designing with Multiple Images

Figure 40 *Masking the face*

Source Adobe® Photoshop®, 2013. Willie Maldonado/Getty Images

Prepare the base image for merging

1. Open Actress.psd.

2. Open Damsel.psd, then position it beside Actress.psd so that you can see both images.

 The angles in the two photographs aren't compatible. In the Actress photo, the model's head tilts slightly right. In the Damsel photo, the model's head tilts left.

3. In the **Damsel.psd** file, click the **Image menu**, point to **Image Rotation**, then click **Flip Canvas Horizontal**.

4. Show the Final layer to see the retouching that was done.

 The veil was removed from the side of the face and the cloth on her chest was brought up so that it meets the scarf around her head.

5. Show the Green Screen layer, then add a layer mask to the Final layer.

6. Zoom in on the face, click the **Brush tool** ![brush tool icon], then choose the a **19-pixel brush** with a Hardness setting of **85**.

7. Mask out the entire face, using Figure 40 as a guide.

 Try to paint your mask as similarly to the figure as you can.

8. Save the file as **Actress Damsel Merge**.

Place the paste image behind the base image

1. Switch to the Actress.psd file, then make every layer visible.

2. Display the Paths panel, press and hold [**Ctrl**] (Win) or ⌘ (Mac), then click **Path 1**.

 Path 1 is loaded as a selection.

3. Click the **Edit menu**, then click **Copy Merged**.

4. Switch to the Actress Damsel Merge file, then target the **Green Screen layer**.

5. Paste.

6. Name the new layer **Actress**.

7. Click the **Move tool** , then position the actress artwork as shown in Figure 41.

8. Press [**Ctrl**][**T**] (Win) or ⌘[**T**] (Mac) to scale the image.

(continued)

Figure 41 *Positioning the artwork before scaling*

Source Adobe® Photoshop®, 2013. Willie Maldonado/Getty Images

Designing with Multiple Images

Figure 42 *Positioning the artwork before scaling*

Source Adobe® Photoshop®, 2013. Willie Maldonado/Getty Images

9. Type **588** in the X text box, press [**Tab**], type **469** in the Y text box, press [**Tab**], type **77** in the W text box, press [**Tab**], type **77** in the H text box, then press [**Tab**].

10. Click , click **Apply**, then compare your screen to Figure 42.

11. Save your work.

Create a shadow

1. Delete the Green Screen layer.

2. Create a new layer above the Actress layer.

3. Name the new layer **Shadow**, then change its blending mode to Multiply.

4. Set the Foreground color to Black.

5. Click the **Brush tool** , set the Size to **70 px**, then set the Hardness to **0%**.

6. Set the Opacity on the Brush tool to **40%**.

7. Using Figure 43 as a guide, paint a similar shadow.

 Note how a wide, soft shadow creates the visual impression that the queen's face is far inside the blue scarf—that the scarf on this side of her face is not touching her face.

TIP Because the shadow layer is set to Multiply, any area of the layer that is white will be transparent. Therefore, if you want to remove some of the shadow you painted, simply paint that area with white. You don't need to use a layer mask.

8. Reduce the brush size to **20 px**.

9. Using Figure 44 as a guide, paint along the blue scarf on the left side of her face so that a thin shadow "peeks" out.

 Note how a thin shadow creates the impression that the scarf is close to touching the face. The closer and harder a shadow, the closer it appears to an object.

10. Increase the brush size back to **70 px**.

(continued)

Figure 43 *Painting a wide soft shadow on the face*

Source Adobe® Photoshop®, 2013. Willie Maldonado/Getty Images

Figure 44 *Painting a small shadow at the left side of the face*

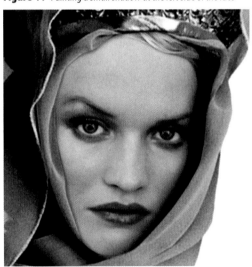

Source Adobe® Photoshop®, 2013. Willie Maldonado/Getty Images

Designing with Multiple Images

Figure 45 *Final shadow effect*

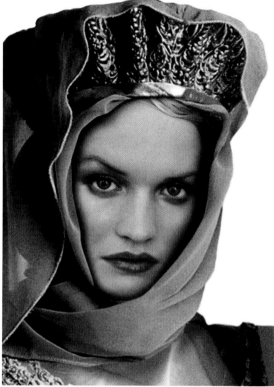

Source Adobe® Photoshop®, 2013. Willie Maldonado/Getty Images

11. Alternating between black and white paint, use Figure 45 as a guide to create a shadow that makes the queen's entire face to be peering out from *inside* the scarf.

 Note how this choice makes the character of the queen more mysterious. She's hiding. This fits very well in our overall concept for the character and the poster.

12. Save your work.

 Don't be frustrated if your merge doesn't look "perfect." This was a challenging set of steps. In the next lesson, you will have the choice to use a supplied merged file for the queen artwork if you prefer.

AUTHOR'S NOTE

Use this exercise as an opportunity to practice painting shadows. Practice creating wide soft shadows to create depth and narrow harder shadows to imply that elements are close and almost touching. Experiment with different brush sizes, hardness values and colors. For example, would the blue scarf cast a black shadow or a dark blue shadow, or would the blue shadow be so dark that there would be no difference? Also, note how the shadow plays the very important role of hiding any merge issues between the damsel and the actress. When you stop to consider this, you'll learn in the future how to rely on painting and shadows and glows as a secret weapon for covering up issues.

Integrate Foreground IMAGES

What You'll Do

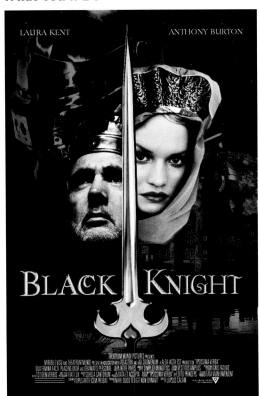

Source Adobe® Photoshop®, 2013. King: Erik Von Weber/Getty Images, Queen: Willie Maldonado/Getty Images, Small Knight: Chip Simons/Getty Images, Moon: StockTrek/ Jupiter Images, Big Knight: Erik Von Weber/Getty Images, Castle: Pete Turner/Getty Images, Stars: Paul Beard/Jupiter Images, Sword: Chris Botello

When finishing the background art, we responded to a central challenge: How do you use a bunch of photos to make one piece of art? For the background, that meant creating a night world of stars and a black sky, a shadowy castle and menacing knights, barely visible. This night world is dark, and we used the concept of darkness to integrate the artwork. Now, with the foreground, we need to switch gears. The challenge is the same: use the photos of the sword, the king, and the queen to make one piece of art. But in this case, the art is foreground art. It needs to be bright and eye-catching. It needs to sell the concept. Darkening, desaturating, muting, blurring—none of these useful techniques are the answer for the foreground images— at least not in the way they were used for the background art. In this lesson, you will utilize the power of blending modes to integrate the foreground artwork while maintaining brightness and color.

Designing with Multiple Images

Figure 46 *Positioning the queen*

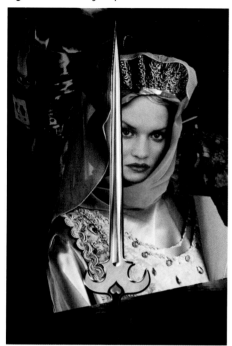

Source Adobe® Photoshop®, 2013.Queen: Willie Maldonado/Getty Images, Small Knight: Chip Simons/Getty Images, Moon: StockTrek/Jupiter Images, Big Knight: Erik Von Weber/Getty Images, Castle: Pete Turner/Getty Images, Stars: Paul Beard/Jupiter Images, Sword: Chris Botello

Figure 47 *Masking the queen*

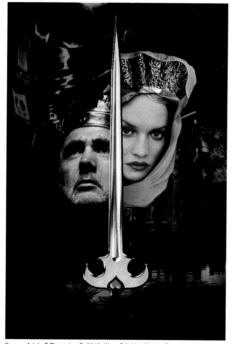

Source Adobe® Photoshop®, 2013. King: Erik Von Weber/Getty Images, Queen: Willie Maldonado/Getty Images, Small Knight: Chip Simons/Getty Images, Moon: StockTrek/Jupiter Images, Big Knight: Erik Von Weber/Getty Images, Castle: Pete Turner/Getty Images, Stars: Paul Beard/Jupiter Images, Sword: Chris Botello

Position the queen

1. Open Author Merge.psd and decide if you'd prefer to use this merge or the one you created.

2. Verify that the top layer is targeted and that all the layers are showing.

3. Click the **Select menu**, click **Load Selection**, click the **Channel list arrow**, then load the Head and Shoulders selection.

4. Click the **Edit menu**, then click **Copy Merged**.

5. Switch to the Black Knight Poster file, then target the **King layer**.

6. Paste, then name the new layer **Queen**.

7. Press [**Ctrl**][**T**] (Win) or ⌘ [**T**] (Mac).

8. Type **640** in the X text box, press [**Tab**], type **793** in the Y text box, then press [**Tab**].

9. Click the **Move tool** ⊕, click **Apply**, compare your screen to Figure 46, then save.

 At this stage of the design, I'm noticing that I really like the relationship between the king and queen artwork, but the queen is uncomfortably close to the small knight. That's a problem I'll address at the very end stages of the work.

Mask the queen

1. Add a layer mask to the Queen layer.

2. Select the entire left half of the canvas, then mask out all elements of the queen image that are on the left side of the sword.

3. Deselect all.

4. Click the **Brush tool** ⊿, choose a **Soft Round 65-pixel brush**, mask the queen's dress so that your artwork resembles Figure 47, then save.

Use adjustment layers to apply blending modes

1. Select both the **King** and **Queen layers** then create a new layer group named **Royals**.
2. Set the blending mode on the Royals layer group to **Normal**.
3. Expand the Royals layer group, target the **Queen layer**, then add a new Hue/Saturation adjustment layer.
4. Verify that the adjustment is not clipped into the Queen layer, and make no modifications to the adjustment.
5. Name the new adjustment layer **Hard Light Desat**.
6. Change the blending mode to **Hard Light**, then compare your result to Figure 48.

 This is an example of one of the more complex concepts when working with adjustment layers. An adjustment layer is like a virtual copy of the layers beneath it. In this case, it's like a copy of the king and the queen on top of the original king and queen artwork. When you set the adjustment layer to Hard Light, it's the same thing as if you'd duplicated the King and the Queen layers, merged them, then set the merged layer to Hard Light. What's better about this method is that you can now modify the adjustment layer to manipulate the Hard Light effect.

7. Drag the **Saturation slider** to **-90**.
8. Create an unclipped Curves adjustment layer, then drag the **black triangle** right until its Input value reads **15**.
9. Compare your artwork to Figure 49.

 The adjustment layers you added are affecting only the king and queen artwork because the Royals folder is set to Normal.

Figure 48 *Hard lighting the king and queen*

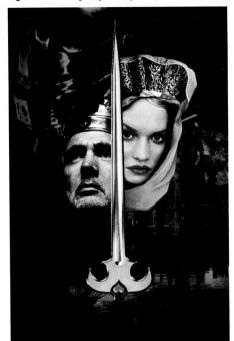

Source Adobe® Photoshop®, 2013. King: Erik Von Weber/Getty Images, Queen: Willie Maldonado/Getty Images, Small Knight: Chip Simons/Getty Images, Moon: StockTrek/Jupiter Images, Big Knight: Erik Von Weber/Getty Images, Castle: Pete Turner/Getty Images, Stars: Paul Beard/Jupiter Images, Sword: Chris Botello

Figure 49 *Final color effect*

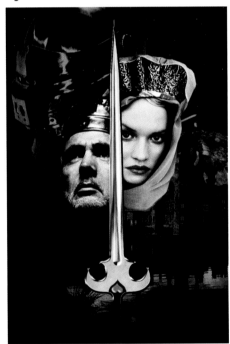

Source Adobe® Photoshop®, 2013. King: Erik Von Weber/Getty Images, Queen: Willie Maldonado/Getty Images, Small Knight: Chip Simons/Getty Images, Moon: StockTrek Jupiter Images, Big Knight: Erik Von Weber/Getty Images, Castle: Pete Turner/Getty Images, Stars: Paul Beard/Jupiter Images, Sword: Chris Botello

Designing with Multiple Images

Figure 50 *Positioning the title*

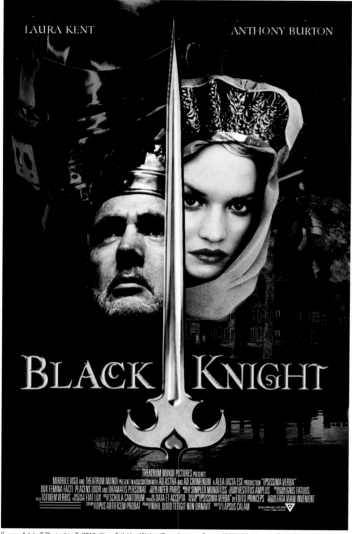

Source Adobe® Photoshop®, 2013. King: Erik Von Weber/Getty Images, Queen: Willie Maldonado/Getty Images, Small Knight: Chip Simons/Getty Images, Big Knight: Erik Von Weber/Getty Images, Castle: Pete Turner/Getty Images, Moon: StockTrek/Jupiter Images, Stars: Paul Beard/Jupiter Images, Sword: Chris Botello.

Position the title

1. Open Title.psd.
2. Target the **Title layer**, select all, copy, then close the file.
3. In the Black Knight Poster file, show and target the **Billing layer**.
4. Paste, then name the new layer **Title**.
5. Press [**Ctrl**][**T**] (Win) or ⌘ [**T**] (Mac) to scale the image.
6. Type **503** in the X text box, press [**Tab**], type **1056** in the Y text box, then press [**Tab**].
7. Click the **Move tool** , click **Apply**, compare your screen to Figure 50, then save.

Finish
ARTWORK

What You'll Do

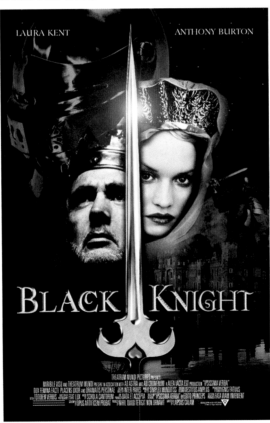

Source Adobe® Photoshop®, 2013. King: Erik Von Weber/Getty Images, Queen: Willie Maldonado/ Getty Images, Small Knight: Chip Simons/Getty Images, Moon: StockTrek/Jupiter Images, Big Knight: Erik Von Weber/Getty Images, Castle: Pete Turner/Getty Images, Stars: Paul Beard/Jupiter Images, Sword: Chris Botello

Finish artwork may sound like, "Get it done." But in the design world, finish is used the way a carpenter would apply a finish to a table. Finishing artwork is the final design stage of a project.

In some ways, finishing is everything, and everything leads up to finishing. It is the point at which you must distill your work into one cohesive piece of art in which all components are fully integrated and working together.

Designing with Multiple Images

Figure 51 *Scaling and repositioning the castle, small knight, and moon*

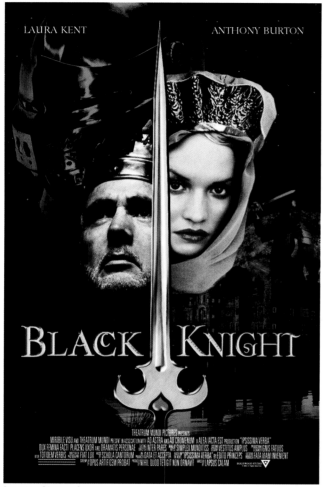

Source Adobe® Photoshop®, 2013. King: Erik Von Weber/Getty Images, Queen: Willie Maldonado/Getty Images, Small Knight: Chip Simons/Getty Images, Moon: StockTrek/Jupiter Images, Big Knight: Erik Von Weber/Getty Images, Castle: Pete Turner/Getty Images, Stars: Paul Beard/Jupiter Images, Sword: Chris Botello

Reposition elements

1. Assess the poster in terms of layout—the position of elements and how they relate to each other.

 Overall, the poster is working well. However, there are issues that need to be addressed. Most critical: the queen is covering the castle and is in conflict with the small knight. Overall, the poster is a bit top-heavy. I'm not sure about the moon—I'm feeling that it makes the top half of the poster crowded and congested.

2. Target the **Castle Group layer**, press and hold ⌘ [**Shift**], then click the **Small Knight Group** and **Moon Group layer groups**.

 The three groups should all be selected.

3. Press [**Ctrl**][**T**] (Win) or ⌘ [**T**] (Mac).

4. Type **766** in the X text box, press [**Tab**], type **1197** in the Y text box, press [**Tab**], type **92** in the W text box, press [**Tab**], type **92** in the H text box, then press [**Tab**].

5. Click the **Move tool** , click **Apply**, then compare your screen to Figure 51.

6. Target the **Royals layer group**, press and hold [**Shift**], then press ↓ three times.

 The royals are moved down 30 pixels.

 (continued)

7. Compare your artwork to Figure 52.

 The last two steps shift the focus more toward the vertical center of the poster. It also creates a much-needed relationship between the king and the title. However, I feel like the moon is still making the right side feel very crowded

8. Target the **Moon Group layer**, reduce its Opacity to **60%**.

 With the moon's opacity reduced, the entire top half of the poster feels less crowded. The royals are now the only bright characters in the piece, which seems right, and the small knight is so much more creepy now that he appears to be emerging from the shadows.

9. Save your work.

Figure 52 *Repositioning the royals*

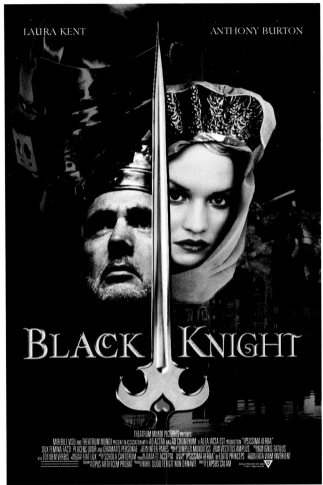

Source Adobe® Photoshop®, 2013. King: Erik Von Weber/Getty Images, Queen: Willie Maldonado/Getty Images, Small Knight: Chip Simons/Getty Images, Moon: StockTrek/Jupiter Images, Big Knight: Erik Von Weber/Getty Images, Castle: Pete Turner/Getty Images, Stars: Paul Beard/Jupiter Images, Sword: Chris Botello

Figure 53 *Applying an outer glow effect to the sword*

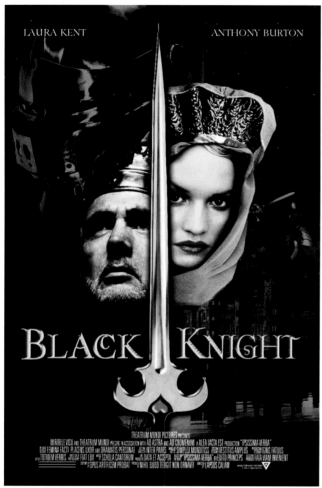

Use shadows to increase depth

1. Expand the Sword Group layer.
2. Double-click the **Bevel & Emboss effect** to open the Layer Style dialog box.
3. In the Styles list on the left, click **Outer Glow**.
4. Click the **Set color of glow button** to open the Color Picker.
5. Type **0** in the R, G, and B text boxes, then click **OK**.
6. Change the blending mode to **Multiply**.
7. Change the Spread value to **8**, change the Size value to **24**, click **OK**, then compare your artwork to Figure 53.
8. Press and hold **[Alt]** (Win) or **[option]** (Mac), then drag the **Outer Glow effect** up to the Title layer so that the title has the same effect.
9. Save your work.

Mask a layer group

1. Assess the relationship between the queen's head scarf and the background.

 The queen's head scarf and crown both have a hard edge. Also, the queen could still be moved down a bit to integrate better with the king and the castle.

2. Target the **Queen layer**, move it down 10 pixels, target the **Royals layer group**, then add a layer mask.

3. Paint with a large soft brush and a low opacity to fade the queen's blue scarf, so that your artwork resembles Figure 54.

 Applying the mask to the Royals layer group rather than to the mask on the Queen layer is a strategic move: with this method, the change to the scarf could be easily removed or modified because it is separate from the mask on the Queen layer.

TIP Feel free to mask the queen's pink head scarf so that it too fades into the background. Be sure that none of your moves accidentally fade the king's face.

4. Save your work.

Figure 54 *Masking the scarf by masking the layer group*

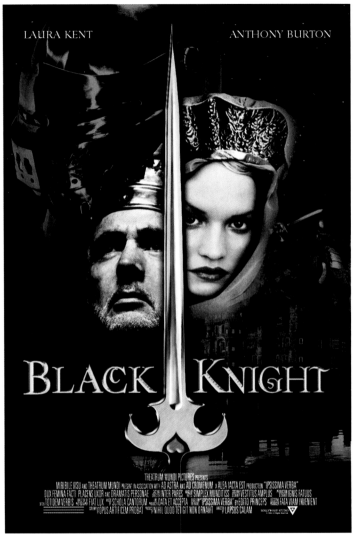

Source Adobe® Photoshop®, 2013. King: Erik Von Weber/Getty Images, Queen: Willie Maldonado/Getty Images, Small Knight: Chip Simons/Getty Images, Moon: StockTrek/Jupiter Images, Big Knight: Erik Von Weber/Getty Images, Castle: Pete Turner/Getty Images, Stars: Paul Beard/Jupiter Images, Sword: Chris Botello

Designing with Multiple Images

Figure 55 *Lens Flare dialog box*

Source Adobe® Photoshop®, 2013.

Figure 56 *Positioning the lens flare*

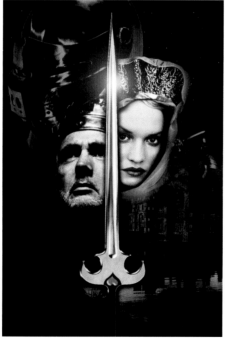

Source Adobe® Photoshop®, 2013. King: Erik Von Weber/Getty Images, Queen: Willie Maldonado/Getty Images, Small Knight: Chip Simons/Getty Images, Moon: StockTrek/Jupiter Images, Big Knight: Erik Von Weber/Getty Images, Castle: Pete Turner/Getty Images, Stars: Paul Beard Jupiter Images, Sword: Chris Botello

Add a lens flare effect

1. Hide the Billing and Title layers.
2. Target the **Sword Group layer**, verify that it is compressed, then click the **Create a new layer button** on the Layers panel.
3. Name the new layer **Lens Flare**, then fill the layer with the black foreground color.
4. Click the **Filter menu**, point to **Render**, then click **Lens Flare**.
5. Click **105mm Prime**, with the settings shown in Figure 55.
6. Click **OK**.
7. Click the **Layer menu**, point to **New Adjustment Layer**, then click **Hue/Saturation**.
8. Type **Desat** in the Name text box, click the **Use Previous Layer to Create Clipping Mask check box**, then click **OK**.
9. Drag the **Saturation slider** to **-100**.
10. Change the blending mode on the Lens Flare layer to **Screen**, then change the Opacity of the layer to **90%**.
11. Click the **Move tool**, then position the flare as shown in Figure 56.

Integrate the entire concept

1. Show the Billing layer and the Title layer.

2. Open Smoke.psd.

 Smoke.psd is a photograph that I shot with my own camera. I lit a cigar and positioned it against a large piece of black foam core. I then shined a bright spotlight on the setting to illuminate the smoke.

3. Select all, copy, then close Smoke.psd.

4. Target the **Title layer**.

5. Paste, then name the new layer **Smoke**.

6. Press [**Ctrl**][**T**] (Win) or ⌘ [**T**] (Mac).

7. Type **600** in the X text box, press [**Tab**], type **752** in the Y text box, press [**Tab**], type **53** in the W text box, press [**Tab**], type **53** in the H text box, then press [**Tab**].

8. Click the **Move tool** ![move tool icon], then click **Apply**.

9. Change the blending mode to **Screen**, then compare your artwork to Figure 57.

 With the Screen blending mode, the black areas become invisible. This is why I shot the smoke against the black background: I knew I could remove the black background and show only the smoke.

10. Drag the **Smoke layer** down below the Colorize Background layer on the Layers panel.

(continued)

Figure 57 *Screening the smoke*

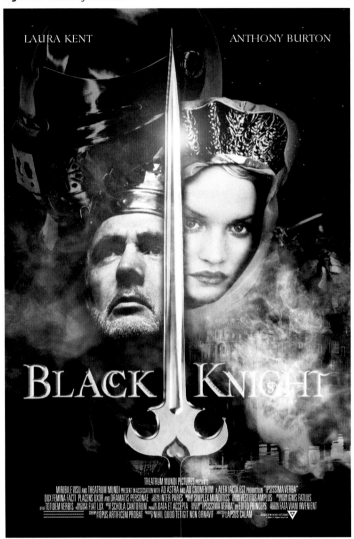

Source Adobe® Photoshop®, 2013. King: Erik Von Weber/Getty Images, Queen: Willie Maldonado/Getty Images, Small Knight: Chip Simons/Getty Images, Moon: StockTrek/Jupiter Images, Big Knight: Erik Von Weber/Getty Images, Castle: Pete Turner/Getty Images, Stars: Paul Beard/Jupiter Images, Sword: Chris Botello

Figure 58 *The final poster*

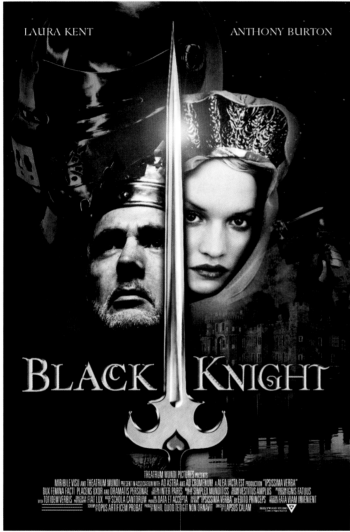

Source Adobe® Photoshop®, 2013. King: Erik Von Weber/Getty Images, Queen: Willie Maldonado/Getty Images, Small Knight: Chip Simons/Getty Images, Moon: StockTrek/Jupiter Images, Big Knight: Erik Von Weber/Getty Images, Castle: Pete Turner/Getty Images, Stars: Paul Beard/Jupiter Images, Sword: Chris Botello

11. Reduce the Opacity to **60%**.

12. Add a layer mask, then reduce the visibility of the smoke above and below the word KNIGHT to see more of the castle and the shadows in the water.

13. Reduce the Opacity of the Outer Glow on the Title layer to **50%**.

14. Use a layer mask to mask out the Lens Flare layer anywhere that it overlaps the moon and the small knight.

15. Compare your screen to Figure 58.

Evaluate how the flare, the smoke, and the repositioning of the elements has created a balanced image. The background is monochromatic enough that it doesn't fight with the title or the foreground elements, yet it still creates a setting and tells a story. There are still some standard finishing touches that can be done. You will do these in the end-of-unit exercises.

16. Save your work.

17. Close the Black Knight Poster document.

1. Open AP 6-2.psd, then save it as **Project Builder 1**.
2. Hide the All Type group.
3. Duplicate the Background layer, then rename it **High Pass 3**.
4. Click the Filter menu, point to Other, then click High Pass.
5. Drag the Radius slider to 3, then note the preview. (The High Pass filter converts all the pixels to a neutral gray, then finds high-contrast areas of the image—"edges" where dark and light pixels meet.)
6. Drag the Radius slider to 10, then note the Preview. (*Hint*: The greater the amount, the more the high-contrast edges show through the gray.)
7. Drag the slider back to 3, then click OK.
8. Change the blending mode on the High Pass 3 layer to Overlay.
9. Toggle the layer on and off to see the effect. (The image is sharpened overall.)
10. Change the blending mode to Soft Light.
11. Change the blending mode to Linear Light.
12. Change the blending mode back to Overlay, then add a layer mask.
13. Use the layer mask to reduce the effect in areas where it might be a bit harsh, such as the king's crown, the queen's headpiece, and the king's face.
14. Show the All Type layer group.
15. Compare your results to Figure 59.
16. Save your work, then close Project Builder 1.psd.

Figure 59 *Completed Project Builder 1*

Source Adobe® Photoshop®, 2013. King: Erik Von Weber/Getty Images, Queen: Willie Maldonado/Getty Images, Small Knight: Chip Simons/Getty Images, Moon: StockTrek/Jupiter Images, Big Knight: Erik Von Weber/Getty Images, Castle: Pete Turner/Getty Images, Stars: Paul Beard/Jupiter Images, Sword: Chris Botello

1. Open AP 6-3.psd, then save it as **Project Builder 2**.
2. Target the High Pass 3 layer.
3. Press and hold [Alt] (Win) or [option] (Mac), then click the Create a new layer button on the Layers panel.
4. Type **Noise 7** in the Name text box.
5. Click the Mode list arrow, then click Overlay.
6. Click to activate Fill with Overlay-neutral color (50% gray), then click OK.
7. Click the Filter menu, point to Noise, then click Add Noise.
8. Set the Amount to 7, the Distribution to Gaussian, then click to activate Monochromatic.
9. Click OK.
10. Toggle the Noise 7 layer off and on to see the noise effect.
11. Compare your screen to Figure 60.
12. Save your work, then close Project Builder 2.psd.

Figure 60 *Completed Project Builder 2*

Source Adobe® Photoshop®, 2013. King: Erik Von Weber/Getty Images, Queen: Willie Maldonado/Getty Images, Small Knight: Chip Simons/Getty Images, Moon: StockTrek/Jupiter Images, Big Knight: Erik Von Weber/Getty Images, Castle: Pete Turner/Getty Images, Stars: Paul Beard/Jupiter Images, Sword: Chris Botello

LAURA KENT

ANTHONY BURTON

BLACK KNIGHT

ADOBE PHOTOSHOP CS6 ADVANCED

CHAPTER 7

INVESTIGATING PRODUCTION
TRICKS AND TECHNIQUES

1. Explore issues with resolution.
2. Create a high-resolution mechanical for a billboard.
3. Create black and white from color.
4. Use the Unsharp Mask filter to Sharpen Edges.
5. Apply grain effects.
6. Automate workflow.

Explore Issues
WITH RESOLUTION

What You'll Do

Source Adobe® Photoshop®, 2013.

All digital images are bitmap images. All bitmap graphics are composed of pixels. The word **pixel** is derived from the words picture and element—pixel. You can think of a **bitmap image** as being a grid of pixels—thousands of them.

Resolution is a term that refers to the number of pixels per inch (ppi) in a digital image. For example, if you had a 1"×1" Photoshop file with a resolution of 100 pixels per inch, that file would contain a total of 10,000 pixels (100 pixels width×100 pixels height=10,000 pixels).

High-resolution files have more pixels. 300 ppi is considered a high resolution for any file that will be professionally printed. For your home desktop printer, 150 ppi is generally enough resolution for a good-looking print. For web and other "on screen" graphics, the standard resolution is low—just 72 ppi.

Image size refers to the dimensions of the Photoshop file. Image size is not dependent on resolution; in other words, you could create two 3"×5" files, one at 72 ppi and the other at 300 ppi. They'd have the same image size, but different resolutions.

Image size is, however, related to resolution, because anytime you modify a file's image size, that will have a direct affect on its resolution. And because resolution is so closely associated with image quality, resizing an image can affect quality.

This lesson is a quick refresher course in image resolution and the many issues and considerations involved when specifying resolution and resizing an image.

Figure 1 *Decreasing resolution without resampling*

Image Size

Pixel Dimensions: 1.03M

Width: 600 pixels

Height: 600 pixels

OK

Cancel

Auto...

Document Size:

Width: 6 Inches

Height: 6 Inches

Resolution: 100 Pixels/Inch

☑ Scale Styles
☑ Constrain Proportions
☐ Resample Image:

Bicubic Automatic

Understand and manipulate resolution

1. Open AP 7-1.psd, then save it as **Freckles Resize**.

2. Click the **Image menu**, then click **Image Size**.

 The Document Size section specifies that this is a 2" × 2" file with a resolution of 300 ppi—thus making this a high-resolution file. The Pixel Dimensions section specifies that the full width of the file is 600 pixels (300 ppi × 2") and the height is 600 pixels. Thus, this image is composed of exactly 360,000 pixels.

3. Click the **Resample Image check box** to remove the check mark.

 The Resample Image check box is perhaps the most important option in this dialog box. When Resample Image is not checked, the total number of pixels in the image must remain the same. In other words, no matter how you resize the image or change the resolution, no pixels can be added or discarded.

4. Double-click the **Resolution text box**, type **100**, press [**Tab**], then note the changes in the Width and Height values.

 As shown in Figure 1, the width and height of the file changes to 6". Because the total number of pixels cannot change, when the number of pixels per inch is reduced to 100, the file must enlarge to six inches wide and high to accommodate all the pixels. In other words, no pixels were added or discarded with the change in resolution— they were simply redistributed.

 (continued)

5. Press and hold [**Alt**] (Win) or [**option**] (Mac) so that the Cancel button changes to the Reset button, then click the **Reset button**.

 The Image Size dialog box returns to its original values and the Resample Image check box is once again checked.

6. Change the resolution from 300 to 150, press [**Tab**], then note the changes to the Width and Height values and to the pixel dimensions.

 As shown in Figure 2, the resolution is reduced to 150 ppi, but the width and height remain at 2". The pixel dimensions show that the full width of the file is 300 pixels (150 ppi × 2") and the full height is 300 pixels. This means that, if you click OK, the total number of pixels will be 90,000. Think about this: 75% of the original 360,000 pixels will be discarded because of the reduction in resolution from 300 to 150 ppi.

7. Click **OK**.

 Though the image doesn't look much different on your screen, 75% of its original data has been discarded.

8. Click the **File menu**, then click **Revert**.

TIP The Revert command returns a file to the condition it was in when opened or last saved.

Figure 2 *Decreasing resolution with resampling*

Source Adobe® Photoshop®, 2013.

Figure 3 *Increasing image size and resampling pixels*

Source Adobe® Photoshop®, 2013.

Manipulate image size

1. Open the Image Size dialog box.

2. Note that the Resample Image check box is checked by default.

 When the Resample Image check box is checked, pixels can be added or discarded when you resize an image. This file is 2" × 2" and we need it to be 4" × 4".

3. Type **4** in the Width text box, then compare your dialog box to Figure 3.

TIP The Height value changes automatically because the Constrain Proportions check box is checked.

 In order to be used in a color magazine at the specified size of 4" × 4", the file must be 300 ppi at that size. Photoshop is able to scale the image to that size and resolution. However, note the pixel dimensions. Because we've doubled the size of the original, the new size now must contain 1,440,000 pixels to maintain a resolution of 300 pixels per inch. The supplied image was scanned at 360,000 total pixels. Where did all the new pixels come from? If you click OK, Photoshop will create them from the existing pixels using a process called interpolation.

4. Click **OK**, double-click the **Zoom tool** to view the image at 100%, then evaluate the enlargement in terms of image quality.

TIP When inspecting an image for quality, you must be viewing at 100% or larger.

(continued)

Photoshop has done a good job enlarging the image and overall it still looks good. However, as a high-resolution image for quality print reproduction, this image is unacceptable because it is composed of 75% interpolated data. In other words, 75% percent of the pixels are not "real" samples scanned from the original photo or captured in a digital camera. In a real world situation, you would contact the client to let them know that the image size and resolution of the file delivered was too small to be used at 4" × 4". They might tell you to go ahead and "res it up"—use the enlarged file with interpolated data—but that's a choice for which the client should be responsible.

5. Revert the file, then open the Image Size dialog box, and ensure that **Resample Image** is checked.

 Next we will resize the file so that it could be used on a website.

6. Change the Width and Height values to **4**, change the Resolution to **72**, then compare your dialog box to Figure 4.

 All you need to do is look at the before-and-after file sizes above the Pixel Dimensions section to see that the new size requires fewer pixels than the original size. At the new specifications, the file size will be reduced from 1.03 MB to 243 K. Even though we doubled the image size from 2" × 2" to 4" × 4", the reduction in resolution from 300 ppi to 72 ppi resulted in the need for fewer than 25% of the number of original pixels.

 (continued)

Figure 4 *Decreasing image size and resampling pixels*

Source Adobe® Photoshop®, 2013.

AUTHOR'S NOTE

What is a "high-res" file? Generally speaking, a "high-res," or high-resolution, file pertains only to the world of printing. Web graphics and any other graphics for on-screen display are generally 72 ppi. So when you think of "high-res," think of images—color or black and white—printing at a high quality, like in a magazine or a poster. This type of reproduction requires the industry standard of 300 pixels per inch.

AUTHOR'S NOTE

Inevitably, there will come a time when you have no other choice but to increase the resolution or the image size of a file and live with the results. When this happens, it's best to use the Bicubic Smoother (best for enlargement) method in the Image Size dialog box. Also, remember that since Photoshop is running complex algorithms to create the new data, don't make it more complicated by enlarging by odd numbers. For example, if you had a 3" square image that needs to print at 5.75" square, double the image size to 6" square. It's much easier for Photoshop to interpolate data by doubling the existing image size; this will result in a higher-quality interpolation and a better result for your enlarged image. Remember though, it's always better to avoid using interpolated data.

7. Click **OK**, then evaluate the enlargement in terms of image quality.

 Viewed at 100%, the image looks great on screen, which is our goal, given that it will be used on a website. Even though Photoshop has discarded more than 75% of the original number of pixels, the reduced image contains only original data and no interpolated data.

 TIP Reducing an image's image size or resolution does not involve the creation of interpolated data and is therefore acceptable in terms of image quality.

8. Save your work, then close Freckles Resize.psd.

Create a High-Resolution
MECHANICAL FOR A BILLBOARD

What You'll Do

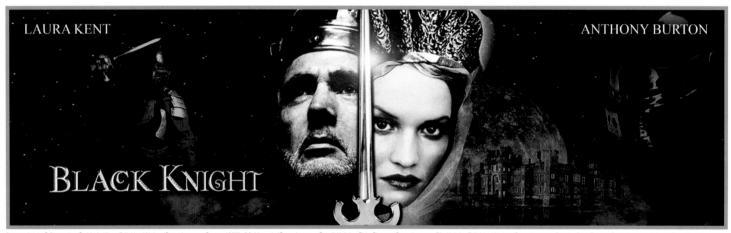

Source Adobe® Photoshop®, 2013. King: Erik Von Weber/Getty Images, Queen: Willie Maldonado/Getty Images, Small Knight: Chip Simons/Getty Images, Big Knight: Erik Von Weber/Getty Images, Castle: Pete Turner/Getty Images, Moon: StockTrek/ Jupiter Images, Stars: Paul Beard/Jupiter Images, Sword: Chris Botello.

Sizing a file and determining resolution can become very challenging very quickly when you are working with large scale output like posters, billboards, bus wraps, and wallscapes. A simple movie poster, for example, is 27"×40". If you were creating artwork for a movie poster in Photoshop, at what physical size would you build the file, and at what resolution? If you built it at 27"×40" at 300 ppi, the file size would be 278 megabytes—without layers!

This lesson is based on a challenging production project: building the mechanical for a 14'×48' billboard. Use this exercise as an opportunity to learn industry-standard rules for determining resolution for large-scale output and for building a file with that all-important production element: a bleed. Finally, don't miss Project Builder 2, where you'll learn how to create an extension for the billboard.

Figure 5 *Dimensions and resolution of the composite*

Image Size

Pixel Dimensions: 2.70M

Width: 1800 Pixels ▼
Height: 525 Pixels ▼

Document Size:

Width: 12 Inches ▼
Height: 3.5 Inches ▼
Resolution: 150 Pixels/Inch ▼

☑ Scale Styles
☑ Constrain Proportions
☑ Resample Image:

Bicubic Smoother (best for enlargement) ▼

OK Cancel Auto...

Source Adobe® Photoshop®, 2013.

Resize a comp for a high-resolution billboard mechanical

1. Open AP 7-2.psd, then save it as **48 × 14 Billboard**.

 The file is a designer's low-res comp file for a 48' × 14' billboard based on an original poster.

 TIP When naming files for outdoor media—billboards, wallscapes, etc.—the dimensions of the file precede the file name. 48' × 14' is a standard and common billboard size: 48-feet wide by 14-feet high.

2. Click the **Image menu**, click **Image Size**, then compare your Image Size dialog box to Figure 5.

 This file is not built to the full size of the output. A 48-foot by 14-foot billboard would be 576 inches by 168 inches. This file is 12 inches by 3.5 inches. It must be resized to be output as a high-resolution file for a 48' × 14' billboard.

3. Verify that the **Scale Styles**, **Constrain Proportions**, and **Resample Image check boxes** are all checked and that **Bicubic Smoother (best for enlargement)** is chosen for the interpolation method.

 The Scale Styles option is critical. Think of all the styles applied in this artwork—drop shadows, outer glows, bevels and embosses, etc. If you were to double the image size, you would want the settings for those styles to double as well so that they would have the same relationship to the resized artwork. The Scale Styles option scales all styles in proportion to the artwork.

 (continued)

4. In the Document Size section, change the Width value to **48**, change the Resolution value to **300**, press [**Tab**], then compare your Image Size dialog box to Figure 6.

The first basic rule for determining resolution for large-scale media is the 1 foot = 1 inch at 300 ppi rule. As shown in Figure 6, the Image Size dialog box now shows just that: A 48" × 14" document at 300 ppi for a 48' × 14' output.

5. Note the Pixel Dimensions value at the top of the dialog box.

At this new size, the file would be 173 megabytes—with just one layer! Given that this file has nearly 50 layers—all of which increase the file size—if we were to click OK, the layered file would be approximately 1.5 gigabytes. That is a very large file size for most computers to work with effectively. Also, that would mean that the images—the king and queen, for example—would be 14 feet tall. The high-res image of the king certainly would not have been captured at 14 feet tall and would need to be scaled up to be used at this size. Therefore, it's pointless to build the file at such a large size.

6. Note the number of pixels in the Width text box of the Pixel Dimensions section.

The second rule for determining resolution for large-scale files is the 6000-pixels rule. This means that for all large-scale sizes—48-foot wide billboards or 100-foot tall wallscapes—6000 pixels is the target for the number of pixels in the mechanical, either width or height. In other words, anything over 6000 pixels is overkill. At its present dimensions and resolution, the billboard file would have 14,400 pixels in its width, more than double the 6000 pixel target.

(continued)

Figure 6 *Dimensions and resolution using the 1 foot = 1 inch @ 300 ppi rule*

Source Adobe® Photoshop®, 2013.

Investigating Production Tricks and Techniques

Figure 7 *Dimensions and resolution using the 6000 pixels rule*

Source Adobe® Photoshop®, 2013.

Figure 8 *Viewing the entire canvas*

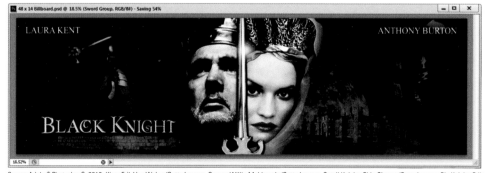

Source Adobe® Photoshop®, 2013. King: Erik Von Weber/Getty Images, Queen: Willie Maldonado/Getty Images, Small Knight: Chip Simons/Getty Images, Big Knight: Erik Von Weber/Getty Images, Castle: Pete Turner/Getty Images, Moon: StockTrek/Jupiter Images, Stars: Paul Beard/Jupiter Images, Sword: Chris Botello.

Lesson 2 Create a High-Resolution Mechanical for a Billboard

7. Change the Resolution to **125**, press [**Tab**], then compare your dialog box to Figure 7.

 At 6000 pixels wide, this is high resolution for the the 48' × 14' billboard mechanical—regardless of the number in the Resolution text box.

8. Click **OK**.

 The new layered file is approximately 290 megabytes.

9. Save your work.

Use the Reveal All command

1. Zoom down so that you can see the entire canvas, as shown in Figure 8.

 The comp file was built at 12" × 3.5", which we scaled up to the trim size of 48" × 14". This is an issue because the comp file at 12" × 3.5" was built without a bleed. All four sides of the image should extend the trim by .25".

2. Open the file named 20x3.tif, select all, copy, then close the file.

 The file is 20 inches tall, which is 6 inches taller than the height of the billboard mechanical.

3. Target the **Names layer** on the Layers panel, then paste.

 The file is pasted at the center of the billboard file.

 (continued)

4. Click the **Image menu**, click **Reveal All**, then compare your screen to Figure 9.

 The Reveal All command reveals the areas of the 20x3.tif artwork that were pasted off of the canvas. It also reveals all of the other artwork in the comp that was pasted outside of the canvas dimensions. It's important to understand that all of this artwork—even when not revealed—is taking up memory. The file size of the image is based on the reveal all dimensions necessary to show all of the artwork.

 TIP It's our hope that some of this "extra" artwork will be usable for the bleed for the mechanical.

5. Undo, delete the new layer with the 20x3.tif artwork, then save your work.

Create a bleed for a high-resolution mechanical

1. Verify that the Paths panel is visible.
2. Select all on the canvas, click the **Paths panel menu button** , then click **Make Work Path**.
3. Type **.5** in the Make Work Path dialog box, then click **OK**.

 A new path named *Work Path* is added to the Paths panel.
4. Double-click *Work Path*, then name it **TRIM SIZE**.

 The new path is the size of the trim of the document.
5. Target the **Background layer** on the Layers panel.

 (continued)

Figure 9 *Viewing all of the artwork in the file with the Reveal All command*

Image data outside of original canvas size

Source Adobe® Photoshop®, 2013. King: Erik Von Weber/Getty Images, Queen: Willie Maldonado/Getty Images, Small Knight: Chip Simons/Getty Images, Big Knight: Erik Von Weber/Getty Images, Castle: Pete Turner/Getty Images, Moon: StockTrek/Jupiter Images, Stars: Paul Beard/Jupiter Images, Sword: Chris Botello.

Figure 10 *Canvas Size dialog box*

Source Adobe® Photoshop®, 2013.

Figure 11 *Billboard mechanical with the increased canvas size*

Path defines trim line

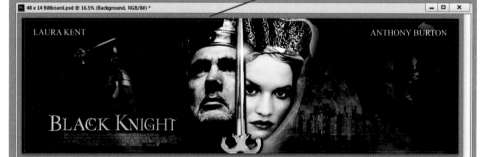

Source Adobe® Photoshop®, 2013. King: Erik Von Weber/Getty Images, Queen: Willie Maldonado/Getty Images, Small Knight: Chip Simons/Getty Images, Big Knight: Erik Von Weber/Getty Images, Castle: Pete Turner/Getty Images, Moon: StockTrek/Jupiter Images, Stars: Paul Beard/Jupiter Images, Sword: Chris Botello.

Lesson 2 Create a High-Resolution Mechanical for a Billboard

6. Click the **Image menu**, click **Canvas Size**, then compare your dialog box to Figure 10.

 A .25" bleed needs to be added to all four sides of the canvas.

7. Click the **Canvas extension color list arrow**, then click **Black**.

8. Type **48.5** in the Width text box, type **14.5** in the Height text box, click **OK**, then compare your canvas to Figure 11.

 The path identifies the trim and the area outside of the path as the bleed area. We got very lucky in that there was enough image outside of the canvas to fill the bleed area. Had there not been, we would be facing the major challenge of rebuilding the entire document with imagery in the bleed area. The solution to this potential problem should have been implemented at the beginning of the process: the designer should have created the comp at a larger size to include the necessary bleed elements.

9. Target the **Names folder** on the Layers panel.

10. Click the **Path Selection tool**, then click the path on the canvas to select it.

11. Click the **Layer menu**, point to **New Fill Layer**, then click **Solid Color**.

12. Type **Bleed** in the Name text box, then click **OK**.

13. Type **0** in the R and B text boxes, type **255** in the G text box, then click **OK**.

(continued)

14. Click the **path** with the Path Selection tool to select it.

15. Click the **Subtract Front Shape menu item** on the Options bar, identified in Figure 12.

 When you choose Subtract Front Shape, the bleed area is masked with a shape layer, defined by the path. Masking out the bleed area allows you to view the artwork at the trim size—the way it will appear on the real billboard—without the bleed elements.

16. Select all, click the **Image menu**, click **Crop**, then deselect.

 The image is cropped to the bleed size. All of the unnecessary artwork that we viewed with the Reveal All command is discarded, and the file size is reduced accordingly.

17. Save your work.

Replace low-resolution images with high-resolution images

1. Identify which images need to be replaced with high-resolution images.

 The comp was built at a very low resolution. We enlarged that comp 400% to be a high-resolution sized mechanical. The images that need to be replaced include:

 - King
 - Queen
 - Sword
 - Big Knight

 (continued)

Figure 12 *Billboard mechanical with the bleed area masked*

Subtract Front Shape menu item

Source Adobe® Photoshop®, 2013. King: Erik Von Weber/Getty Images, Queen: Willie Maldonado/Getty Images, Small Knight: Chip Simons/Getty Images, Big Knight: Erik Von Weber/Getty Images, Castle: Pete Turner/Getty Images, Moon: StockTrek/Jupiter Images, Stars: Paul Beard/Jupiter Images, Sword: Chris Botello.

Figure 13 *Viewing the result of the Invert/Align*

Image courtesy of Chris Botello. Source Adobe® Photoshop®, 2013.

- Small Knight
- Title Treatment
- Castle
- Moon

Because the image will be used on a billboard, it's not necessary to replace the stars background with a high resolution version—the change wouldn't be noticeable. For the same reason, it's not necessary to replace the smoke artwork. It's not necessary to replace the billing block or the stars' names, as those will be replaced by actual type in the final mechanical.

2. Open AP 7-3.psd, then save it as **Invert Align**.

3. Show the Info panel, verify that the Info panel is set to RGB Color as the mode for tracking actual color, then duplicate the Background layer.

4. Target the **Background layer**, then press [**Ctrl**] [**I**] (Win) or ⌘ [**I**] (Mac) to invert the layer.

5. Target the **Background copy layer**, set its Opacity to **50%**, then compare your result to Figure 13.

 As shown in the figure, the entire image becomes gray. If you sample anywhere in the image, you'll see that the RGB values on the Info panel are all the same—either all 127 or all 128.

6. Save your work, then close Invert Align.psd.

 That's the end of this exercise. Its purpose was only for you to see the Invert/Align procedure performed on a simple image. The procedure is very useful for aligning two identical images or, in this project, replacing a low resolution image with a high resolution image. You will now apply the same procedure to the complex billboard file.

 (continued)

7. In the 48 × 14 Billboard.psd file, expand the Royals layer group, then target the **King layer**.

8. Open King Hi-Res.psd, then view the two documents side by side.

TIP You can tile the two documents vertically by clicking the Window menu, pointing to Arrange, and then clicking Tile.

9. Verify that the **King Hi-Res layer** is targeted, click the **Move tool** , then drag and drop the artwork into the 48 × 14 Billboard.psd file.

 The artwork is positioned on a new layer, named King High-Res, above the King layer.

10. Close the King Hi-Res.psd file.

11. Move the King Hi-Res artwork so that it is positioned over the King artwork.

 The King Hi-Res artwork is smaller than the scaled-up King artwork. This is often the case when working on large-scale projects: Even high-res files aren't large enough for the high-res mechanical.

12. Target the **King layer**, click the **Create new fill or adjustment layer button** on the Layers panel, then click **Invert**.

 A new Invert adjustment layer appears above the King layer and the King artwork is inverted. Because the Royals layer group is set to Normal, the Invert adjustment layer doesn't affect any other artwork.

 (continued)

AUTHOR'S NOTE

Whenever you duplicate a layer, then invert the bottom layer and set the opacity of the top layer to 50%, the composite result of the two layers will be an entirely gray image. If you run the numbers, it makes sense. To keep things simple, let's say you're working with a single-channel grayscale image. Let's say a pixel in the original image on the Background layer had a grayscale value of 150. When you duplicate the layer, you now have two identical pixels with the grayscale value of 150 on top of one another. When you invert the bottom of the two layers, the grayscale value of the pixel changes to 106 ($256 - 150 = 106$). You now have two overlapping pixels that, if added together, must equal 256. However, you can't see the inverted image because it is beneath the duplicated image above it. Then you set the opacity on the duplicated layer to 50%. Now ask yourself: How much of each of the two layers is visible? The answer is 50% of each. The top layer is set to 50% opacity, so by definition, only 50% of it is visible. Therefore, it only makes sense that the artwork on the layer beneath it is 50% visible. With that in mind, ask yourself: What do the two overlapping pixels now add up to? The answer is explained with the following equation:

$$(150 + 106) / 2 = 128.$$

The grayscale values of the two overlapping pixels add up to 256. Then, when divided by two, the result of their overlapping must be a grayscale value of 128, which is gray. This will be the result for all the overlapping pixels in an image. Thus, when you overlap duplicate images in this manner, the result must be a completely gray image.

Figure 14 *Aligning the high-res king with the low-res king*

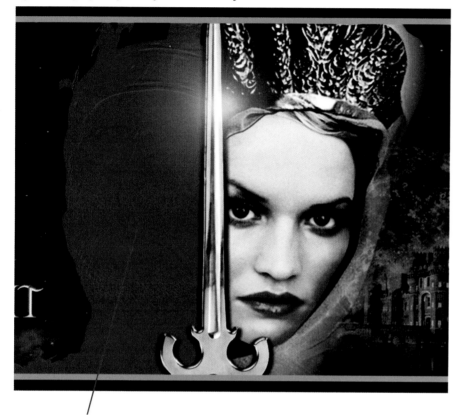

High-res king aligned
with low-res king

Source Adobe® Photoshop®, 2013. King: Erik Von Weber/Getty Images, Queen: Willie Maldonado/Getty Images, Castle: Pete Turner/Getty Images, Moon: StockTrek/Jupiter Images, Stars: Paul Beard/Jupiter Images, Sword: Chris Botello.

13. Target the **King Hi-Res layer**, then reduce its Opacity to **50%**.

14. Click the **Edit menu**, point to **Transform**, then click **Scale**.

15. Verify that the center point on the Reference point location icon on the Options bar is selected.

16. Type **125** in the Width and Height text boxes.

17. Type **2830** in the X text box, type **1641** in the Y text box, press [**Enter**] (Win) or [**return**] (Mac), click the **Move tool** , click **Apply**, then compare your screen to Figure 14.

18. Set the Opacity on the King Hi-Res layer to **100%**, then delete the Invert 1 adjustment layer.

19. Press and hold [**Alt**] (Win) or [**option**] (Mac), then drag the **layer mask** from the King layer to the King Hi-Res layer.

 An identical layer mask is added to the King Hi-Res layer.

20. Delete the King layer.

 In a real-world project, we would need to repeat this procedure on all the other photographic images in the layout.

21. Be sure to save your work at this point.

Convert a layered file from RGB to CMYK

1. Click the **Image menu**, point to **Mode**, then click **CMYK Color**.

 A warning dialog box appears.

2. Click **OK**, then compare your artwork to Figure 15.

 As shown in the figure, converting a file from RGB to CMYK when it contains adjustment layers and layers with blending modes can't be done. The adjustment layers and blending modes cannot be translated correctly from one mode to another. In most cases, designers build their files in RGB Color mode. There are many more benefits of working in RGB Color mode, not the least of which is that more filters and third-party programs only work in RGB Color mode. However, this requires that, when the file is converted to CMYK Color, all adjustment layers and any layers with blending modes must be merged.

3. Undo your last step.

4. Target the **Colorize Background layer**.

 This layer is set to Multiply over all of the images beneath it. Therefore, it must be merged with all the layers beneath it.

5. Press [**Shift**], then click the **Background layer** so that all the layers between the two are selected, as shown in Figure 16.

6. Click the **Layers panel menu button** ▼≣ then click **Merge Layers**.

 (continued)

Figure 15 *Viewing a bad CMYK conversion*

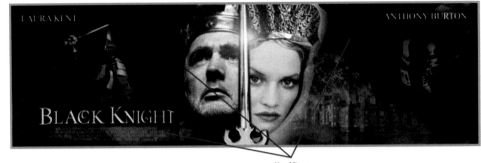

Hard lines

Source Adobe® Photoshop®, 2013. King: Erik Von Weber/Getty Images, Queen: Willie Maldonado/Getty Images, Small Knight: Chip Simons/Getty Images, Big Knight: Erik Von Weber/Getty Images, Castle: Pete Turner/Getty Images, Moon: StockTrek/Jupiter Images, Stars: Paul Beard/Jupiter Images, Sword: Chris Botello.

Figure 16 *Targeting layers to be merged*

Source Adobe® Photoshop®, 2013.

Investigating Production Tricks and Techniques

Figure 17 *Targeting layers to be merged*

Source Adobe® Photoshop®, 2013.

Figure 18 *Identifying problems with the merged artwork*

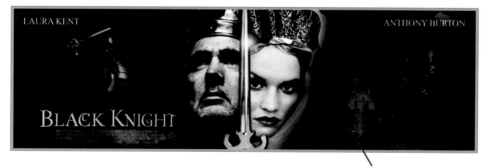

Black background

Source Adobe® Photoshop®, 2013. King: Erik Von Weber/Getty Images, Queen: Willie Maldonado/Getty Images, Small Knight: Chip Simons/Getty Images, Big Knight: Erik Von Weber/Getty Images, Moon: StockTrek/Jupiter Images, Stars: Paul Beard/Jupiter Images, Sword: Chris Botello.

Lesson 2 Create a High-Resolution Mechanical for a Billboard

7. Target the **Royals layer group**.

 The Royals layer group is set to Normal, which means it doesn't need to be merged with the background. However, the group contains two adjustment layers and each has a blending mode applied to it.

8. Click the **Layers panel menu button** then click **Merge Group**.

 The two adjustment layers are merged with the two layers of artwork (the king and queen), but the resulting merged artwork is set to Normal.

9. Examine the contents of the Sword Group layer group.

 It contains a single adjustment layer which is clipped into a layer with effects applied. Effects are often applied with built-in blending modes.

10. Merge the **Sword Group layer group**.

11. Target the **Lens Flare layer**.

 The Lens Flare layer is set to Screen. Because the screened lens flare artwork affects the sword and the king and queen artwork, they all must be merged.

12. Target the layers shown in Figure 17.

13. Merge the targeted layers, then compare your result to Figure 18.

(continued)

As shown in the figure, because of the built-in relationships between the layers, the merge doesn't work. At this point, one solution would be to discard the Lens Flare layer, convert the file, then recreate the lens flare in CMYK Color mode. However, the Lens Flare filter is not available in CMYK Color mode. Rather than flatten all the artwork, we will convert the lens flare and see what we get.

14. Undo the merge.

 See the Author's note on this page.

15. Convert the file to CMYK Color mode, then compare your result to Figure 19.

 Everything worked well except the billing block and the lens flare. We don't care about the billing block, because it's "for position only" (FPO) and will be replaced in the output stage. However, the lens flare needs work.

16. Delete the Billing layer.

17. Hide and show the Lens Flare layer so that you can see how it's affecting the elements behind it.

18. Add a clipped Levels adjustment layer to the Lens Flare layer, then drag the **black triangle** on the Properties panel to **86**.

 Compare your result to Figure 20. We have succeeded in converting the artwork to CMYK while maintaining the segregation of various art elements to separate layers.

19. Save your work.

Figure 19 *Converting the file—with problems*

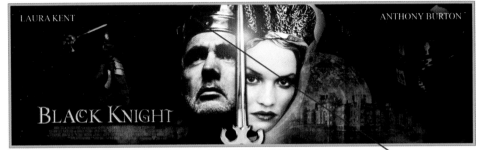

Source Adobe® Photoshop®, 2013. King: Erik Von Weber/Getty Images, Queen: Willie Maldonado/Getty Images, Small Knight: Chip Simons/Getty Images, Big Knight: Erik Von Weber/Getty Images, Castle: Pete Turner/Getty Images, Moon: StockTrek/Jupiter Images, Stars: Paul Beard/Jupiter Images, Sword: Chris Botello.

Lens Flare file not fully transparent

Figure 20 *Fixing the Lens Flare artwork*

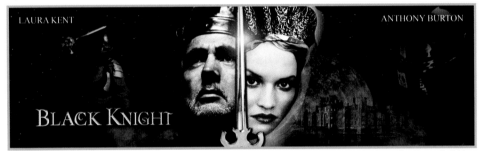

Source Adobe® Photoshop®, 2013. King: Erik Von Weber/Getty Images, Queen: Willie Maldonado/Getty Images, Small Knight: Chip Simons/Getty Images, Big Knight: Erik Von Weber/Getty Images, Moon: StockTrek/Jupiter Images, Stars: Paul Beard/Jupiter Images, Sword: Chris Botello.

AUTHOR'S NOTE

At this point, you might be wondering, why not just flatten the whole thing, save a CMYK copy, and keep the RGB file layered. That works, but the key is that you want to deliver a CMYK file to the printer or output service as editable as possible. When they output the file, they will want to tweak the color in the file based on the calibration of their output device. At that point, you would much prefer that they make those tweaks in a simplified, layered CMYK file rather than go back to your highly complex RGB file with all of its blending modes and adjustment layers. And once they'd made their tweaks, they'd need to convert the RGB file all over again. So in the case of this billboard, it's our goal to deliver a file with the background artwork all on one layer, the king and queen on their own layer, the sword on its own layer, and the lens flare above them all.

Figure 21 *Viewing the artwork after applying the High Pass filter*

Only "edges" are visible

Use the High Pass filter to sharpen artwork

1. Open AP 7-4.psd, then save it as **Overlay Tricks**.
2. Hide the Bleed layer, then target the **Names layer group**.
3. Select all, click the **Edit menu**, then click **Copy Merged**.
4. Paste, then name the new layer **High Pass 3.0**.
5. Click the **Filter menu**, point to **Other**, then click **High Pass**.
6. Type **3.0** in the Radius text box, click **OK**, then compare your canvas to Figure 21.

 The High Pass filter first grays out the entire image—it changes all pixels to 128. Then, as you increase the Radius value, it reveals edges in the image. **Edges** are defined as any place in the image where high contrast pixels abut. For example, the line where the queen's bright face meets the dark background would be an edge. At a radius of 3.0, that edge becomes visible within the grayed-out image.

7. Change the blending mode of the High Pass 3.0 layer to **Overlay**.
8. Zoom in on the king's face, then hide and show the High Pass 3.0 layer.

 In Overlay mode, all gray pixels become invisible. Thus, the non-edge areas of the image that remained gray are not visible. The edges that were revealed are now being overlayed over the artwork. The result is that the edge areas of the image are exaggerated and the overall effect is that of a sharper image with greater detail.

 (continued)

TIP You must view an image at a minimum of 100% to get a reliable representation of the sharpening effect.

9. Change the blending mode to **Soft Light**.

 All of the blending modes in the Overlay section make grays invisible, so all of them will work with the High Pass filter. The Soft Light blending mode produces a sharpening effect that is less intense than the Overlay blending mode.

10. Change the blending mode to **Linear Light**.

 Linear Light produces the most intense sharpening effect with high pass artwork. It is seldom used.

11. Change the blending mode back to **Overlay**, then save your work.

Add noise to high resolution artwork

1. Verify that the **High Pass 3.0 layer** is targeted.

2. Create a new layer, then name it **Noise 6.0**.

3. Click the **Edit menu**, then click **Fill**.

4. Enter the settings shown in Figure 22, then click **OK**.

(continued)

Figure 22 *Filling the layer with 100% of 50% gray*

Source Adobe® Photoshop®, 2013.

Investigating Production Tricks and Techniques

Figure 23 *Add Noise dialog box*

Figure 24 *The final high-resolution billboard mechanical*

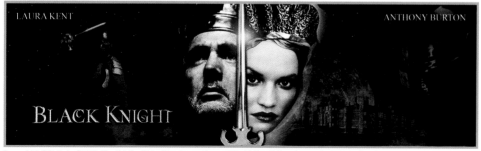

Lesson 2 Create a High-Resolution Mechanical for a Billboard

5. Click the **Filter menu**, point to **Noise**, then click **Add Noise**.

6. Enter the settings shown in Figure 23, then click **OK**.

7. Change the blending mode of the Noise 6.0 layer to **Overlay**.

 All of the gray pixels in the layer become invisible, because gray is invisible in Overlay mode. Only the noise pixels—slightly brighter or darker than neutral gray—affect the image.

8. Zoom in on the queen's face, then hide and show the Noise 6.0 layer.

 The graininess of the noise produces a subtle sharpening effect overall. Noise is also useful for creating a consistent texture across an entire image. This can be very useful for artwork like the billboard, which is composed of multiple images. The consistent texture has a unifying effect.

TIP You must view an image at a minimum of 100% to get a reliable representation of a noise effect.

9. Change the blending mode to **Soft Light**.

 The Soft Light blending mode produces a noise effect that is less intense than the Overlay blending mode.

10. Change the blending mode to **Linear Light**.

 Linear Light produces the most intense noise effect. It is seldom used, except in cases when noise is meant to be a noticeable effect.

11. Change the blending mode back to **Overlay**, then make the Bleed layer visible.

12. Compare your canvas to Figure 24.

13. Save your work, then close Overlay Tricks.psd.

Create Black and White
FROM COLOR

What You'll Do

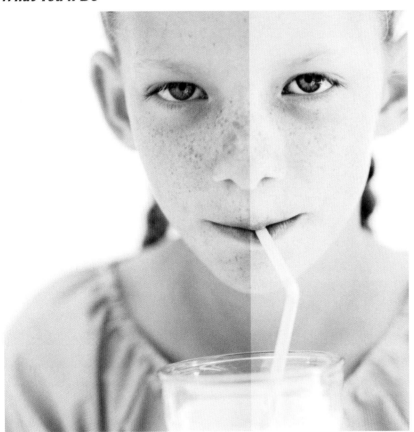

Source Adobe® Photoshop®, 2013. Jupiter Images, Stockbyte

It's always smart to question single-method solutions. Take creating a black-and-white image, for example. If you have a color image that you want to use as a black-and-white image, the most basic solution is to convert it to grayscale or completely desaturate it in the Hue/Saturation dialog box.

Those are solutions, that's true. To some, they're the only solution. That's false. Photoshop offers many alternative methods for creating a black-and-white version of a color image; you aren't stuck with only the image in Grayscale mode.

In this lesson, you'll use the Lab Color mode to create a variety of grayscale images, and you'll also use the powerful Black and White adjustment layer. The techniques you learn here will provide you with alternative methods for creating grayscale images and, perhaps more importantly, prompt you to experiment with different methods for other challenges you encounter in Photoshop.

Figure 25 *Result of converting to Grayscale mode*

Source Adobe® Photoshop®, 2013. Jupiter Images, Stockbyte

Figure 26 *Image from the Blue channel*

Source Adobe® Photoshop®, 2013. Jupiter Images, Stockbyte

1. ⌂ Gray*mode to create a
 Grayscale mode

2. Click the **Ima** ⌂t as **Simple
 Grayscale**, click **D** ⌂
 Discard in the Message ⌂ode, click

3. Compare your canvas to Figure ⌂ click
 ⌂ollows.

4. Open AP 7-6.psd, then save it as **LAB G** ⌂

5. Display the Channels panel, click the **Channel
 thumbnail** on the Blue channel, then compare
 your canvas to Figure 26.

TIP If your channel appears blue as opposed to gray
as shown in the figure, you need to change your
preferences. Open the Interface Preferences dialog
box, then verify that the Show Channels in Color
check box is not checked.

(continued)

The Channel th___ ___nel
often provide i___ ___ayscale
images. In t___ ___the Blue
channel i___ ___resting. If you were
designi___ ___tional look, this image
wou___ ___better choice. Remember,
too ___always modify the image.
___ ___ws the image from the Blue channel
___ ___ple levels correction, and the result is a
___ning black and white.

TIP If you want to use an image in a channel as a file, click the Channel thumbnail, select all and copy, click the File menu, click New to create a new document, then paste the copied channel.

6. Click the **RGB Channel thumbnail** on the Channels panel.

7. Click the **Image menu**, point to **Mode**, then click **Lab Color**.

8. Note the channels in the Channels panel as shown in Figure 28.

 In Lab Color mode, the image is created by three channels: Lightness, a, and b.

 (continued)

Figure 27 *Image from the Blue channel after Levels correction*

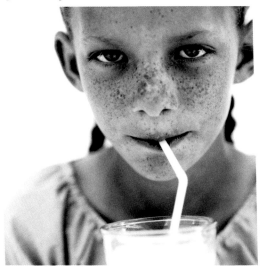

Source Adobe® Photoshop®, 2013. Jupiter Images, Stockbyte

Figure 28 *Channels panel in Lab Color mode*

Source Adobe® Photoshop®, 2013. Jupiter Images, Stockbyte

Investigating Production Tricks and Techniques

Figure 25 *Result of converting to Grayscale mode*

Source Adobe® Photoshop®, 2013. Jupiter Images, Stockbyte

Figure 26 *Image from the Blue channel*

Source Adobe® Photoshop®, 2013. Jupiter Images, Stockbyte

Use the Lab Color mode to create a grayscale image

1. Open AP 7-5.psd, then save it as **Simple Grayscale**.

2. Click the **Image menu**, point to **Mode**, click **Grayscale**, click **Don't Flatten**, then click **Discard** in the Message dialog box that follows.

3. Compare your canvas to Figure 25.

4. Open AP 7-6.psd, then save it as **LAB Grayscale**.

5. Display the Channels panel, click the **Channel thumbnail** on the Blue channel, then compare your canvas to Figure 26.

TIP If your channel appears blue as opposed to gray as shown in the figure, you need to change your preferences. Open the Interface Preferences dialog box, then verify that the Show Channels in Color check box is not checked.

(continued)

The Channel thumbnails on the Channels panel often provide interesting versions of grayscale images. In this case, the image on the Blue channel is darker and very interesting. If you were designing for an unconventional look, this image would probably be a better choice. Remember, too, that you can always modify the image. Figure 27 shows the image from the Blue channel with a simple levels correction, and the result is a stunning black and white.

TIP If you want to use an image in a channel as a file, click the Channel thumbnail, select all and copy, click the File menu, click New to create a new document, then paste the copied channel.

6. Click the **RGB Channel thumbnail** on the Channels panel.

7. Click the **Image menu**, point to **Mode**, then click **Lab Color**.

8. Note the channels in the Channels panel as shown in Figure 28.

 In Lab Color mode, the image is created by three channels: Lightness, a, and b.

(continued)

Figure 27 *Image from the Blue channel after Levels correction*

Source Adobe® Photoshop®, 2013. Jupiter Images, Stockbyte

Figure 28 *Channels panel in Lab Color mode*

Source Adobe® Photoshop®, 2013. Jupiter Images, Stockbyte

Investigating Production Tricks and Techniques

Figure 29 *Image from Lightness channel*

Source Adobe® Photoshop®, 2013. Jupiter Images, Stockbyte

9. Click the **Channel thumbnail** on the Lightness channel, then compare your canvas to Figure 29.

 To paraphrase a well-known saying, Lab Color is like a box of chocolates—you never know what you're gonna get. The Lightness channel is always a black-and-white image, and sometimes it produces an interesting alternative. In this case, the image from the Lightness channel is quite beautiful in the smoothness of its light gray tones. What this image lacks, however, is detail and definition in the eyes. As you know, there are a number of methods to correct this. When working in Lab Color mode, don't forget that the a and b channels are also there for your use.

10. Duplicate the Lightness channel, select all, copy, then click the **Channel thumbnail** on the Lab channel.

11. Return to the Layers panel, then paste the copy as a new layer.

12. Name the new layer **Lightness Art**, then hide it.

13. Duplicate the b channel on the Channels panel select all, copy, then click the **Channel thumbnail** on the Lab channel.

(continued)

14. Return to the Layers panel then paste the copy as a new layer so that your canvas resembles Figure 30.

TIP It was critical that you hid the Lightness Art layer in Step 12. Remember, art in the Channels panel is dynamic; whatever is visible on the canvas is represented in the channels. Had you kept the Lightness Art layer visible, the a and b channels would have been completely gray with no art.

15. Name the new layer **b Art**, then show the Lightness Art layer.

From this point, there are a number of directions you can experiment with. However, whenever you have a predominantly gray image on a layer, the first move you should try is the Overlay mode, because gray becomes invisible in Overlay mode.

16. Set the blending mode on the b Art layer to **Overlay**, then compare your canvas to Figure 31.

TIP Hide and show the b Art layer to see the change.

The result is not very satisfactory; the eyes are still too light, and the image as a whole is too light. This is an important hint of what to try next. The image as a whole was lightened in Overlay mode—the opposite of what we wanted. This tells us that the image on the b Art layer is too light; we want its opposite.

(continued)

Figure 30 *Image from b channel pasted as the top layer*

Source Adobe® Photoshop®, 2013. Jupiter Images, Stockbyte

Figure 31 *Image from b channel in Overlay mode*

Source Adobe® Photoshop®, 2013. Jupiter Images, Stockbyte

Investigating Production Tricks and Techniques

Figure 32 *Inverted b channel image in Overlay mode*

Figure 33 *Multiplying the b channel image*

Lesson 3 Create Black and White from Color

17. Invert the b Art layer, then compare your canvas to Figure 32.

 Now we're moving in the right direction. Inverted, the Channel thumbnail on the b channel is darker in the areas of detail, like the eyes, eyebrows, lips, and so on. The detail has definitely improved, but the image has darkened over all. This means that we've lost those airy, light gray flesh tones from the Lightness channel. We could, of course, use a layer mask and allow only the eyes, lips, and so on from the b Art layer to show, but we're going to go with another method.

18. Undo your last step.

 The image on the b Art layer is no longer inverted.

19. Change the blending mode of the b Art layer to **Multiply**, then compare your artwork to Figure 33.

 The darkest areas of the b channel art were in the eyes. It follows logically that, if multiplied, the b channel artwork must darken the eyes.

20. Select all, click the **Edit menu**, then click **Copy Merged**.

21. Paste a new layer, name it **Merged**, then hide the b Art layer.

 (continued)

22. Change the blending mode on the Merged layer to **Overlay**, then compare your canvas to Figure 34.

The result is stunning. Overlayed, the merged art has dramatically darker eyes. However, because the other areas of the merged art are close to a neutral gray, they have very little impact when the Overlay mode is applied.

(continued)

Figure 34 *Overlaying the merged art*

Source Adobe® Photoshop®, 2013. Jupiter Images, Stockbyte

Investigating Production Tricks and Techniques

Figure 35 *Comparing the simple grayscale to the LAB grayscale*

23. Compare this black-and-white image to the black-and-white image in the Simple Grayscale file.

 As shown in Figure 35, the two images are dramatically different. The important point to remember is that there is no standard color correction—curves, levels, and so on—that you could apply to the simple grayscale black and white that would mimic the nuance and depth of the Lab Color black and white.

24. Close the LAB Grayscale and Simple Grayscale documents, saving your work in both of them.

Use a Black & White adjustment layer

1. Open AP 7-7.psd, then save it as **BW Adjustment**.

2. Click the **Create new fill or adjustment layer button** on the Layers panel, then click **Black & White**.

 The Properties panel, shown in Figure 36, shows the Black & White adjustment settings and the image changes to black and white.

3. Drag the **Greens slider** left and right and note the effect on the image.

 Because there are really no green areas in the artwork, moving the Greens slider has very little effect.

4. Drag the **Greens slider** all the way to the left.

5. Drag the **Cyans slider** left and right, then position it at **40**.

 Because there's so much blue throughout the image, the Cyans slider has a broad effect, but the effect is strongest on the queen's scarf. With the ability to manipulate the scarf from light gray to dark gray, you can differentiate the scarf from the dark background and the lightness of the queen's face. At 40, it's exactly between the two.

 (continued)

Figure 36 *Black & White adjustment*

Source Adobe® Photoshop®, 2013.

Investigating Production Tricks and Techniques

Figure 37 *A color image with a Black & White adjustment*

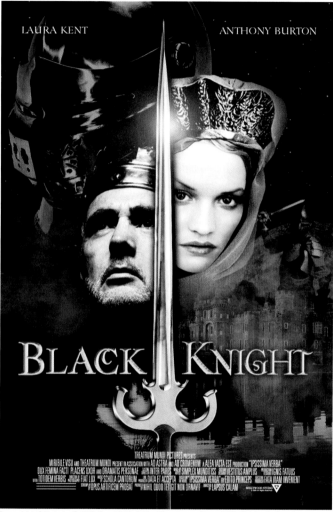

Source Adobe® Photoshop®, 2013. King: Erik Von Weber/Getty Images, Queen: Willie Maldonado/Getty Images, Small Knight: Chip Simons/Getty Images, Big Knight: Erik Von Weber/Getty Images, Castle: Pete Turner/Getty Images, Moon: StockTrek/Jupiter Images, Stars: Paul Beard/Jupiter Images, Sword: Chris Botello.

6. Click ▓ on the Properties panel, position the cursor over the queen's forehead, then click and drag over the queen's forehead and face.

 Because red is the dominant color in the queen's face, the Reds slider moves as you drag over the image. This is a good technique for identifying which slider to move to adjust a specific area of the image.

7. Drag the **Reds slider** to **79** so that the faces are the brightest elements of the image.

 At this relatively high setting, the faces seem to glow against the background.

8. Experiment with various settings of the Blues slider.

 Blue is by far the most dominant color in the image overall, so the Blues slider will affect almost all areas of the background.

9. Drag the **Blues slider** to **25**, then compare your artwork to Figure 37.

 The controls on the Properties panel allowed you to create a customized black-and-white image with a bright foreground, a dark background, and detailed grays in the midground.

10. Save your work, then close BW Adjustment.psd.

Use the Unsharp Mask Filter
TO SHARPEN EDGES

What You'll Do

Source Adobe® Photoshop®, 2013. Getty Images, Barbara Maurer

When you scan an image, the resulting scan is, by definition, of lesser quality than the original. That's because it's a second-generation reproduction, and a reproduction is always inferior to an original. When you scale an image—especially when you enlarge an image—you will suffer a loss of quality as well. In both of these examples, the loss of quality will be a blurring of the image—a loss of fine detail.

Unsharp Mask is an important filter that addresses this issue. It's a sophisticated algorithm that creates the effect of sharpening an image. It's only an effect, of course. The filter works by shifting color to create contrast, which the eye perceives as sharpness—an increase in focus and detail.

Because Unsharp Mask is so useful, it's a smart idea for you to take some time to investigate it, to understand its settings, and to get a sense of how it does what it does.

Your ability to apply unsharp masking in a way that is best for a given image can really make the difference in attaining excellent results.

Figure 38 *Image Size dialog box*

```
Image Size                                              [X]

 ┌─ Pixel Dimensions: 759.4K ──────────────┐    ┌────────┐
 │                                          │    │   OK   │
 │   Width:  [432    ]  [Pixels    ▼] ─┐    │    └────────┘
 │                                    │⊕   │    ┌────────┐
 │   Height: [600    ]  [Pixels    ▼] ─┘    │    │ Cancel │
 │                                          │    └────────┘
 └──────────────────────────────────────────┘    ┌────────┐
                                                  │ Auto...│
 ┌─ Document Size: ─────────────────────────┐    └────────┘
 │                                          │
 │   Width:  [2.88   ]  [Inches       ▼] ─┐ │
 │                                       │⊕│
 │   Height: [4      ]  [Inches       ▼] ─┘ │
 │                                          │
 │   Resolution: [150 ] [Pixels/Inch  ▼]    │
 └──────────────────────────────────────────┘

 ☑ Scale Styles
 ☑ Constrain Proportions
 ☑ Resample Image:
        [ Bicubic Automatic              ▼]
```

Source Adobe® Photoshop®, 2013.

Use the Unsharp Mask filter to sharpen edges

1. Open AP 7-8.psd, then save it as **Unsharp Mask**.

2. Assess the image for contrast.

 The Unsharp Mask filter creates the illusion of sharpness by increasing the contrast at the image's edges—where high contrast pixels abut. It would be a mistake to use the Unsharp Mask filter to improve contrast overall. When you are about to use the Unsharp Mask filter, it's a good idea to first verify that the image's contrast is where you want it to be.

3. Show the Contrast layer.

 With the Contrast layer visible, it is clear that the image needs a bit of a contrast bump. Curves are designed to do just that, not the Unsharp Mask filter.

4. Target the **Background layer**, click the **Image menu**, then click **Image Size**.

 As shown in Figure 38, the image is 4" tall at 150 pixels per inch. In other words, if you were to count one column of pixels from bottom to top, you would count a total of 600 pixels, which is what is shown in the top section of the dialog box.

 (continued)

5. Type **7** in the Height text box in the Document Size section so that your Image Size dialog box matches Figure 39.

 By making this move, you are saying you want this image to be resized to the height of seven inches. Note that the Resample Image check box is checked. This means that at seven inches tall you still want 150 pixels per inch. From top to bottom, that's a total of 1050 pixels per column. Where will you get 450 extra pixels per column?

6. Click **OK**, then compare your image to Figure 40.

7. Click the **Rectangular Marquee tool** select the left half of the image, then hide the selection marquee.

8. Zoom in so that you are viewing the boy's face at 100%, if necessary.

 (continued)

Figure 39 *Image Size dialog box*

Source Adobe® Photoshop®, 2013.

Figure 40 *Image enlarged with interpolated pixel data*

Source Adobe® Photoshop®, 2013. Getty Images, Barbara Maurer

Investigating Production Tricks and Techniques

Figure 41 *Filter applied with a high Amount value*

Source Adobe® Photoshop®, 2013. Getty Images, Barbara Maurer

9. Click the **Filter menu**, point to **Sharpen**, then click **Unsharp Mask**.

 The Unsharp Mask filter works by identifying the edges of the image then increasing the contrast in those areas to create the effect of focus and sharpness. For example, in this image, the line where the boy's white shirt color meets the coat's brown collar would be an edge, as would the point where his dark hairline meets the pale forehead.

10. Type **150** in the Amount text box.

 For high-resolution images—images that are 300 pixels per inch or more—an amount of 150–200% is typically recommended. Though this image is not high resolution, we have entered a high Amount value so that the effect will be dramatic and noticeable. The higher the Amount value, the more pronounced the effect. For example, Figure 41 shows the image sharpened drastically with a high Amount value. Note the sharpness especially in the hair and the tweed coat. The effect is most visible in these areas because they include so many dark pixels that abut light pixels.

 (continued)

AUTHOR'S NOTE

Though the Unsharp Mask dialog box has a preview window, you are much better off moving the box to the side and viewing the effect on the image at 100%. The result of the Unsharp Mask filter is much more noticeable on screen than when printed because of the many factors in play during the offset printing process that blend and blur fine detail.

11. Drag the **Radius slider** to **2.0 pixels**.

 The Radius value determines the number of pixels surrounding the edge pixels that are included in the calculation that produces the sharpening. That's not a calculation that you need to keep in your head. Instead, remember that the higher the Radius value, the wider and more visible the sharpened edges will be. For high-resolution images, set the Radius value to 1 or 2. Figure 42 shows an example of the Radius value set at 24.

12. Set the Threshold value to **0**, if necessary.

 The Threshold value offers significant control of how this filter is applied—it determines what Photoshop defines as an edge. For example, if the Threshold were set to 10 pixels, that would mean that pixels surrounding a given pixel would need to be at least 10 grayscale values higher or lower than that given pixel to be considered an edge and therefore sharpened. When the Threshold value is higher, fewer areas of the image are sharpened. Zero is the default Threshold value meaning that, by default, all areas of the image will be sharpened to some degree.

 (continued)

Figure 42 *Filter applied with a high Radius value*

Source Adobe® Photoshop®, 2013. Getty Images, Barbara Maurer

Figure 43 *Image with left side sharpened*

Source Adobe® Photoshop®, 2013. Getty Images, Barbara Maurer

AUTHOR'S **NOTE**

The Unsharp Mask filter doesn't necessarily need to be used for practical, realistic image improvement. When applied at high values, it also produces an interesting special effect, one that can be used especially when you want to exaggerate the lines within an image, such as for cartooning purposes.

13. Click **OK**, then compare your result to Figure 43.

 On screen, the effect is especially noticeable. If you undo and redo your last step, you'll see that it is most noticeable in the hair, the tie, and the tweed coat. If you zoom in on the tweed coat, then undo and redo again, you'll get a vivid example of how the filter lightens the lights and darkens the darks. Viewed at 100%, note the more subtle sharpening in the areas with less contrast, such as on the boy's cheeks and even in the texture on the wall behind him.

14. Save and then close the file.

Apply Grain EFFECTS

What You'll Do

Source Adobe® Photoshop®, 2013. Jupiter Images, Stockbyte

Adding grain to an image is a very popular design technique, one that most designers use very often. Grain adds texture and nuance to an image. Applying grain across multiple images from different sources is useful for making them all appear to be more consistent in tone and texture.

Photoshop offers a number of options for creating and simulating grain. The techniques you'll learn in this lesson offer the ability to apply grain and the flexibility to determine where and how the grain affects the image.

Investigating Production Tricks and Techniques

Figure 44 *Grain dialog box*

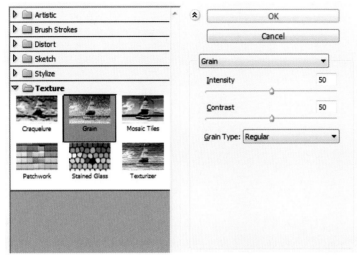

Source Adobe® Photoshop®, 2013.

Figure 45 *Multicolored grain*

Source Adobe® Photoshop®, 2013. Jupiter Images, Stockbyte

Apply a basic grain effect

1. Open AP 7-9.psd, then save it as **Grain**.

2. Zoom in so that you are viewing the image at 100%, then center the girl's face in the window.

TIP When working with fine detail such as grain, you must view the image at 100% to get a realistic representation of the effect.

3. Create a new layer, name it **Regular Grain**, then fill it with **128R/128G/128B**.

4. Click the **Filter menu**, point to **Filter Gallery**, expand the Texture folder, then click **Grain**.

5. Click the **Grain Type list arrow**, view the list of grain types, then click **Regular**.

6. Set the Intensity and Contrast values to **50** so that your Grain dialog box resembles Figure 44, then click **OK**.

7. Change the blending mode on the Regular Grain layer to **Overlay**, then compare your artwork to Figure 45.

(continued)

8. Use the Hue/Saturation dialog box to completely desaturate the Regular Grain layer, then compare your results to Figure 46.

Undo and redo your last step to see the change between the colored grain effect and the desaturated grain effect. The change is subtle but important. Generally speaking, when creating grain effects, you will want monochromatic as opposed to color grain. Use color grain when you're specifically looking for a color grain effect.

9. Duplicate the Regular Grain layer, name the new layer **Black Grain**, then compare your artwork to Figure 47.

10. Save your work.

Figure 46 *Desaturated grain*

Source Adobe® Photoshop®, 2013. Jupiter Images, Stockbyte

Figure 47 *Grain effect doubled*

Source Adobe® Photoshop®, 2013. Jupiter Images, Stockbyte

Investigating Production Tricks and Techniques

Figure 48 *Image with black grain effect*

Source Adobe® Photoshop®, 2013. Jupiter Images, Stockbyte

Figure 49 *Overlaying the Black Grain layer*

Source Adobe® Photoshop®, 2013. Jupiter Images, Stockbyte

Apply black grain and white grain

1. Hide the Regular Grain layer.
2. Set the blending mode of the Black Grain layer to **Normal**, then fill it with **White**.
3. Click the **Filter menu**, point to **Noise**, then click **Add Noise**.
4. Type **30** in the Amount text box, click the **Gaussian option button**, then click the **Monochromatic check box** to select it.
5. Click **OK**.
6. Set the layer's blending mode to **Multiply**, then compare your artwork to Figure 48.

TIP When multiplied, white pixels become transparent.

7. Change the blending mode to **Overlay**, set the Opacity to **50%**, then compare your screen to Figure 49.

 This effect is a nice alternate to a basic grain overlay. It's not for every image, and not for every type of project, but as an effect, it's an interesting and rather unusual method for adding grain.

 (continued)

8. Hide the Black Grain layer, create a new layer named **White Grain**, then fill it with Black.

9. Click the **Filter menu**, point to **Noise**, then click **Add Noise**.

10. Set the Amount value to **40%**, verify that the Gaussian option button and the Monochromatic check box are selected, then click **OK**.

11. Set the layer's blending mode to **Screen**, then compare your artwork to Figure 50.

TIP When screened, black pixels become transparent.

12. Click the **Filter menu**, point to **Blur**, then click **Motion Blur**.

13. Set the Angle to **-45°**, set the Distance to **5 pixels**, then click **OK**.

(continued)

Figure 50 *Image with white grain effect*

Source Adobe® Photoshop®, 2013. Jupiter Images, Stockbyte

Investigating Production Tricks and Techniques

Figure 51 *White grain artwork in Color Dodge mode*

Figure 52 *Using two grain layers and two grain effects*

14. Set the blending mode to **Color Dodge**, then compare your result to Figure 51.

Dodge is synonymous with light; the Color Dodge blending mode lightens the image using information on the blended layer as brightening information for the layers beneath. With the Color Dodge blending mode, black has no effect, which makes sense as this mode is all about lightening. Light pixels lighten areas of the image, with white pixels having the most extreme brightening effect.

15. Set the blending mode back to **Screen**, make the Black Grain layer visible, then compare your canvas to Figure 52.

16. Save your work, then close Grain.psd.

Automate WORKFLOW

What You'll Do

Source Adobe® Photoshop®, 2013.

The title says it all: Automate workflow. As designers, we like to focus on the big projects: the magazine covers, the posters, the billboards, the CD covers. But in the real world, it's not only the big projects that come across the desk. No, it's often the small stuff that you've got to handle as well. And often, the small stuff requires repetition. For example, here are 25 RGB files. Please convert them to CMYK, and resize them so that they're all seven inches wide. Or, here's a folder full of PSD files. Please open them all, convert to Grayscale, then save them as 72-dpi JPEG files that we can use on our website. Sound like fun?

Fortunately, Adobe has made an enormous commitment to automation, especially since the advent of the Internet and the enormous amount of image processing that creating and maintaining a website demands.

You might have played with the Actions panel before, but in this lesson, you're going to take a more rigorous and in-depth tour, and you're going to use more advanced features like batch processing and modal controls. Also, you're going to use Photoshop's Image Processor, which is a file conversion dream come true. Then, you can move on to that billboard. And that magazine cover. And that poster...

Figure 53 *Image Processor dialog box*

Source Adobe® Photoshop®, 2013.

Use the Image Processor

1. Open the seven files in the Automation folder located in the Chapter 7 Data Files folder.

 The files are all Photoshop (.psd) files. The goal of this lesson is to create one TIFF and one JPEG copy of each of the seven files.

2. Click the **File menu**, point to **Scripts**, then click **Image Processor**.

3. In Section 1, click the **Use Open Images option button**.

4. In Section 2, click the **Save in Same Location option button**.

5. In Section 3, click the **Save as JPEG check box**, then type **12** in the Quality text box.

6. In Section 3, click the **Save as TIFF check box**.

7. Verify that nothing is checked in Section 4, then compare your Image Processor dialog box to Figure 53.

8. Click **Run**.

 The seven PSD files remain open after the Image Processor is done.

9. Navigate to the Automation folder, then open it.

 The Automation folder contains the seven original PSD files. It also contains a folder named JPEG and a folder named TIFF. These two folders contain the JPEG and TIFF copies generated by the Image Processor.

10. Return to Photoshop.

Create and run an action in the Actions panel

1. Click the **Window menu**, then click **Flowers.psd**.

2. Click the **Window menu**, then click **Actions**.

3. Click the **Actions panel menu button** then remove the check mark next to Button Mode to deactivate Button Mode, if necessary.

4. Click the **Actions panel menu button** then click **New Action**.

5. Type **Invert** in the Name text box, click **Record**, then compare your Actions panel to Figure 54.

 A new action named Invert appears in the list and is highlighted. The red Begin recording button is activated on the Actions panel.

 TIP The other actions listed in your Actions panel may vary.

6. Click the **Image menu**, point to **Adjustments**, then click **Invert**.

 The Flowers.psd image is inverted.

7. Click the **File menu**, then click **Save**.

8. Click the **File menu**, then click **Close**.

9. Compare your Actions panel to Figure 55.

 The three commands that you executed— Invert, Save, and Close—are listed as commands under the Invert action.

10. Click the **Stop playing/recording button** on the Actions panel.

(continued)

Figure 54 *Actions panel*

Source Adobe® Photoshop®, 2013.

Record button activated

Figure 55 *Invert action with three commands*

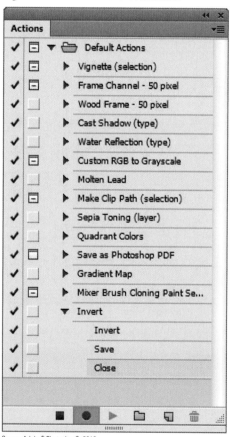

Source Adobe® Photoshop®, 2013.

Figure 56 *Invert action targeted in Actions panel*

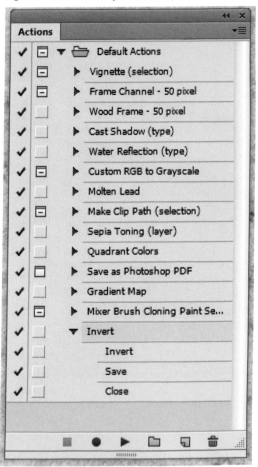

Source Adobe® Photoshop®, 2013.

11. Cl... **Marb...** then clic...

12. Click **Inve**menu, then click...
 is highlighted ... ns panel list so th...

TIP When running actions, th... Figure 56.
you must target the action its... step to miss—
apply it. ...you can

13. Click the **Play selection button** ... the
 Actions panel.

 You will see nothing happen other than the
 image closing. This is because Close is the final
 command of the action.

14. Repeat the Invert action for the remaining
 open images.

15. Open all seven PSD files in the Automation
 folder.

 All seven images have been inverted.

Batch process an action

1. Click the **File menu**, point to **Automate**, then
 click **Batch**.

2. In the Play section, click the **Action list arrow**
 to see all the actions available, then click
 Invert.

3. In the Source section, verify that Folder is
 chosen, then click **Choose**.

4. Navigate to and select the **Automation folder**,
 then click **OK** (Win) or **Choose** (Mac).

(continued)

5. Verify that none of [the check] boxes in the Source section [are] [checked].

Remember, b[ut] the first lesson of this chapter, the Image [rot]ation folder now contains two subfold[ers], JPEG and TIFF. We do not want to apply [the action] to the contents of those folders.

6. In [the D]estination section, verify that **None** [is cho]sen.

[N]o destination means that we want to affect the targeted images in the folder and for those images to be saved with the change. If we wanted to affect them and save the affected images as *copies*, then we'd need to specify a destination for the copies.

7. In the Errors section, verify that **Stop for Errors** is chosen, then compare your Batch dialog box to Figure 57.

8. Click **OK**.

The seven images are all affected by the action then closed.

9. Open all seven PSD files from the Automation folder.

All seven files have been inverted and now appear as they did originally.

Create a complex action

1. Click the **Window menu**, then click **Bricks.psd**.

2. Click the **Actions panel menu button** 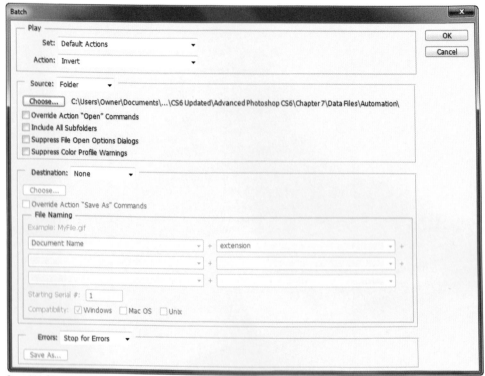 then click **New Action**.

(continued)

Figure 57 *Batch dialog box*

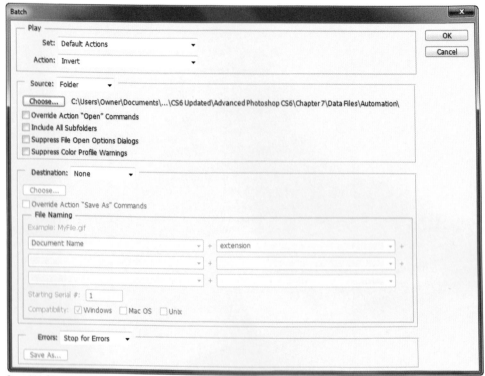

Source Adobe® Photoshop®, 2013.

Figure 56 *Invert action targeted in Actions panel*

Source Adobe® Photoshop®, 2013.

11. Click the **Window menu**, then click **Marble.psd**.

12. Click **Invert** on the Actions panel list so that it is highlighted as shown in Figure 56.

TIP When running actions, this is an easy step to miss—you must target the action itself before you can apply it.

13. Click the **Play selection button** on the Actions panel.

 You will see nothing happen other than the image closing. This is because Close is the final command of the action.

14. Repeat the Invert action for the remaining open images.

15. Open all seven PSD files in the Automation folder.

 All seven images have been inverted.

Batch process an action

1. Click the **File menu**, point to **Automate**, then click **Batch**.

2. In the Play section, click the **Action list arrow** to see all the actions available, then click **Invert**.

3. In the Source section, verify that Folder is chosen, then click **Choose**.

4. Navigate to and select the **Automation folder**, then click **OK** (Win) or **Choose** (Mac).

(continued)

5. Verify that none of the four check boxes in the Source section is checked.

Remember, because of the work we did with the Image Processor in the first lesson of this chapter, the Automation folder now contains two subfolders—JPEG and TIFF. We do not want to apply the action to the contents of those folders.

6. In the Destination section, verify that **None** is chosen.

No destination means that we want to affect the targeted images in the folder and for those images to be saved with the change. If we wanted to affect them and save the affected images as *copies*, then we'd need to specify a destination for the copies.

7. In the Errors section, verify that **Stop for Errors** is chosen, then compare your Batch dialog box to Figure 57.

8. Click **OK**.

The seven images are all affected by the action then closed.

9. Open all seven PSD files from the Automation folder.

All seven files have been inverted and now appear as they did originally.

Create a complex action

1. Click the **Window menu**, then click **Bricks.psd**.

2. Click the **Actions panel menu button** then click **New Action**.

(continued)

Figure 57 *Batch dialog box*

Source Adobe® Photoshop®, 2013.

Investigating Production Tricks and Techniques

Figure 58 *Image Size dialog box*

Figure 60 *Curves bump*

Figure 59 *Unsharp Mask dialog box*

3. Type **Processed Textures**, then click **Record**.

4. Click the **Image menu**, point to **Mode**, then click **CMYK Color**.

5. Click the **Image menu**, then click **Image Size**.

6. Type **150** in the Resolution text box, then verify that all three check boxes in the Image Size dialog box are checked so that your dialog box resembles Figure 58.

7. Click **OK**.

8. Click the **Filter menu**, point to **Sharpen**, then click **Unsharp Mask**.

9. Enter the settings shown in Figure 59, then click **OK**.

10. Click the **Create new fill or adjustment layer button** on the Layers panel, then click **Curves**.

11. Create a contrast bump similar to the one shown in Figure 60.

12. Click the **File menu**, then click **Save As**.

13. Navigate to the Automation folder, then create a new folder named **Processed Textures**.

14. Save the file as a .PSD in the Processed Textures folder.

 Note that we did not enter a new name for the file.

15. Click the **Stop playing/recording button** on the Actions panel.

(continued)

16. Click the triangle next to **Set current adjustment layer** on the Actions panel to expand the action, then compare your panel to Figure 61.

The specific settings that you used when creating the contrast bump in the curves adjustment layer are recorded with the command. (Your settings will differ slightly based on the specific curve that you made.)

17. Expand the Save action on the Actions panel.

The file format and the destination folder are recorded with the command.

18. Collapse the two actions.

19. Click the **Window menu**, click **Wood.psd**, then target the **Processed Textures action** on the Actions panel.

20. Click the **Play selection button** 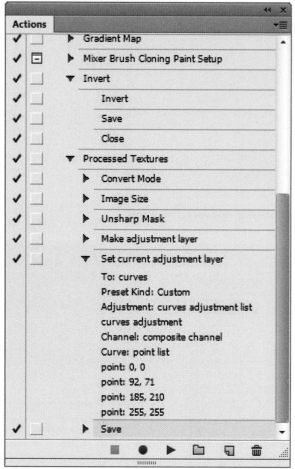 on the Actions panel.

All of the commands are applied to the Wood .psd file and it is saved to the new folder as a .PSD file. All of the commands were applied with the exact settings that you entered when creating the action.

Figure 61 *Expanding an action to see its settings*

Actions

- ✓ ▶ Gradient Map
- ✓ ⊟ ▶ Mixer Brush Cloning Paint Setup
- ✓ ▼ Invert
- ✓ Invert
- ✓ Save
- ✓ Close
- ✓ ▼ Processed Textures
- ✓ ▶ Convert Mode
- ✓ ▶ Image Size
- ✓ ▶ Unsharp Mask
- ✓ ▶ Make adjustment layer
- ✓ ▼ Set current adjustment layer

 To: curves
 Preset Kind: Custom
 Adjustment: curves adjustment list
 curves adjustment
 Channel: composite channel
 Curve: point list
 point: 0, 0
 point: 92, 71
 point: 185, 210
 point: 255, 255

- ✓ ▶ Save

Source Adobe® Photoshop®, 2013.

Investigating Production Tricks and Techniques

Figure 62 *Modal controls activated for two actions*

The modal control icon beside the Processed Textures action indicates that the action contains some commands that are modal

Make these two icons visible

Apply modal controls to an action

1. Click the **Window menu**, then click **Water.**

2. Click the **Toggle dialog on/off button** to the left of the Unsharp Mask command and the Set current adjustment layer command so that your Actions panel resembles Figure 62. When running an action, the Toggle dialog on/off buttons toggle a dialog box on or off. When showing, they are set to toggle on the dialog boxes. This type of button is known as a **modal control**.

TIP The Toggle dialog on/off button is the empty gray square to the left of the command.

3. Target the **Processed Textures action** on the Actions panel.

4. Click the **Play selection button** ▶ .

 The Processed Textures action is run as before; however, this time, when it comes to the Unsharp Mask command, it opens the dialog box and awaits your input.

5. Change the Amount value to **75%**, then click **OK**.

 The command is executed, then the Properties panel opens showing the exact curve that was originally created for this command.

6. Tweak the contrast bump to increase the contrast even more.

 The remaining commands run through to completion.

7. Apply the Processed Textures action to the remaining four PSD files, entering whatever settings you like.

8. Close all open files.

PROJECT BUILDER 1

1. Open AP 7-10.psd, then save it as **Project Builder 1**.
2. Click the Image menu, point to Mode, then click Lab Color.
3. On the Channels panel, click the Channel thumbnail on the Lightness channel.
4. Duplicate the Lightness channel, select all, copy, then click the Lab Channel thumbnail on the Channels panel.
5. Return to the Layers panel, then paste the copy as a new layer.
6. Name the new layer **Lightness Art**, then be sure to hide it.
7. Duplicate the b channel, select all, copy, then click the Lab Channel thumbnail on the Channels panel.
8. Return to the Layers panel, then paste the copy as a new layer named **B**.
9. Show the Lightness Art layer.
10. Set the blending mode of the B layer to Multiply.
11. Select all, click the Edit menu, then click Copy Merged.
12. Paste a new layer, name it **Merged**, then hide the B layer.
13. Change the blending mode on the Merged layer to Overlay.
14. Set the opacity of the Merged layer to 40%, then compare your result to Figure 63.
15. Save your work, then close Project Builder 1.psd.

Figure 63 *Completed Project Builder 1*

Source Adobe® Photoshop®, 2013. Getty Images, Monica Lau

1. Open AP 7-11.psd, then save it as **Extension Billboard**.

 The client for this project has requested that the mechanical for this billboard be recreated into an extension billboard where the sword artwork extends the actual artwork above the rectangular billboard. The client informs you that the specifications for the billboard allow for artwork to exceed the billboard area by five feet at the top.

2. Target the Background layer, then open the Canvas Size dialog box.

 The mechanical is built at 48 inches by 14 inches (with an additional .25 inches on all sides for bleed). At 48 inches × 14 inches, the mechanical is 1/12 the size of the actual output of 48 feet by 14 feet. (The resolution on this mechanical has been reduced to make the file size more manageable.)

3. Click the bottom-center square of the anchor, then change the height value to 19.25.

 We know from the client that the extension at the top can be five feet maximum, or 60 inches. Since the mechanical is 1/12 the size of the actual output, that means we can add 5 inches to the top of the mechanical—from the trim line—for the extension. That brings the new height of the file to 19.25 inches: .25 inches for the bottom bleed, 14 inches for the actual artwork, and 5 inches for the extension at the top.

4. Click OK.

 Because the Bleed layer was created as a shape layer, the gray fill is extended with the increase in canvas size. This is a great example of why it's useful to create a bleed layer as a shape layer.

5. Target the Sword Group layer group, the Lens Flare layer, and the Levels adjustment layer above the Lens Flare layer, then drag all three to the top of the Layers panel, so that all are above the Bleed layer.

6. Expand the Sword Group layer group, then add a layer mask to the Sword Shadow layer.

7. Mask the shadow where it extends the billboard, then compare your work to Figure 64.

8. Save your work, then close Extension Billboard.psd.

Figure 64 *The final extension billboard mechanical*

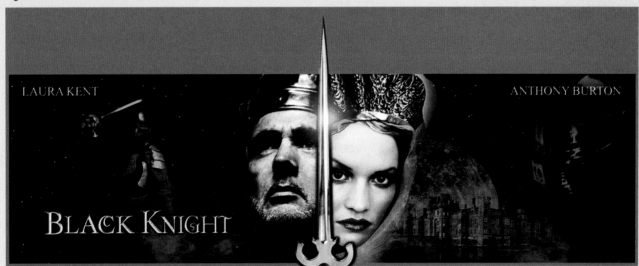

Source Adobe® Photoshop®, 2013. King: Erik Von Weber/Getty Images, Queen: Willie Maldonado/Getty Images, Small Knight: Chip Simons/Getty Images, Big Knight: Erik Von Weber/Getty Images, Castle: Pete Turner/Getty Images, Moon: StockTrek/Jupiter Images, Stars: Paul Beard/Jupiter Images, Sword: Chris Botello.

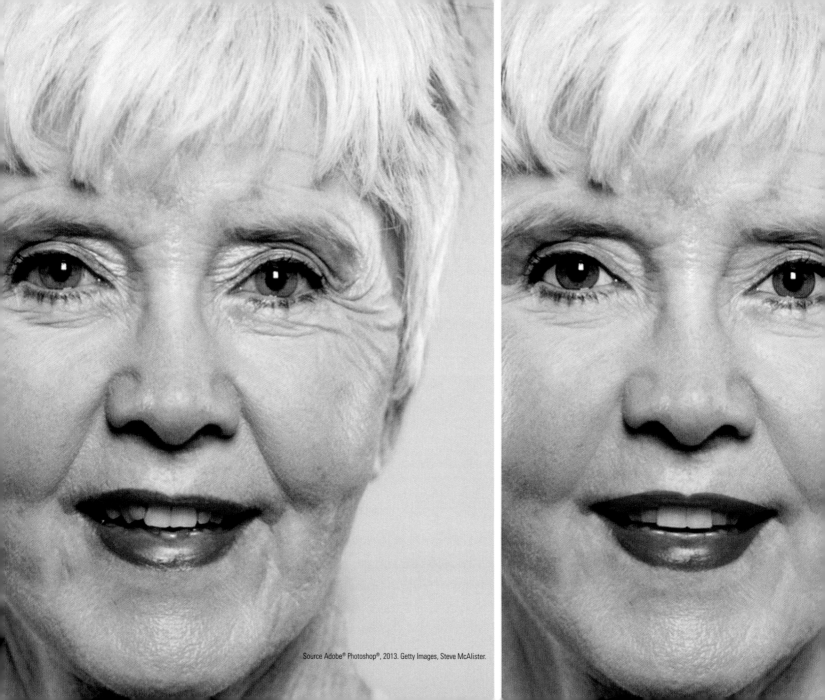

Source Adobe® Photoshop®, 2013. Getty Images, Steve McAlister.

CHAPTER 8 RETOUCHING AND ENHANCING IMAGES

1. Whiten eyes.
2. Investigate the Overlay blending mode.
3. Overlay detail.
4. Use a channel as a mask.
5. Use the cloning tools.
6. Retouch teeth.
7. Clone strategically within adjustment layers.
8. Analyze the Healing Brush tool.
9. Employ content-aware techniques.
10. Retouch with the Overlay blending mode.

Whiten EYES

What You'll Do

Source Adobe® Photoshop®, 2013. Getty Images, Ken Weingart

Whitening eyes is a standard move in almost every retouching project that involves a person's face.

People's eyes are seldom perfect. Even the "perfect" models in the magazines get bloodshot eyes. However, it's not only for cosmetic reasons that eyes usually require retouching. In actuality, it's difficult to photograph a subject in a way that the whites of eyes are white, as opposed to a dull bluish gray. It usually requires professional lighting techniques to capture a bright, white eye for a portrait.

There are many techniques for whitening eyes, and it seems like every retoucher has his or her own tricks. The technique we're going to execute in this lesson is a standard approach that retouchers use.

Figure 1 *Assessing the histogram*

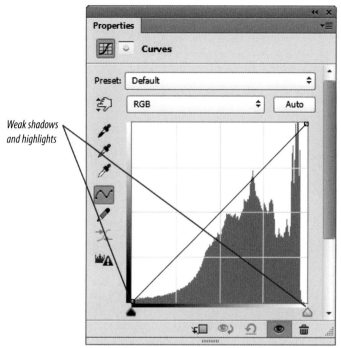

Weak shadows and highlights

Source Adobe® Photoshop®, 2013.

AUTHOR'S NOTE

Before you do any retouching, it is critical that you know the context in which an image is to be used. This is the major determining factor of the artistic goal that you set for the retouching. For example, if this image were to be used to profile a new young author in the Sunday section of the *New York Times Book Review*, that fact would have enormous impact on how I want the final image to appear. I would retouch only obvious flaws in the image, with the goal of keeping the image very realistic and not stylized. When an author—even a hip young author—is being profiled in the *New York Times*, that author wants to be taken seriously. For this project, the image is being used to profile a rap star in a music magazine, like *Rolling Stone*. With that in mind, we're going to use techniques that exaggerate and define elements of the image so that the photo is vivid and eye-catching, but we're not going to overdo it—we do not want the final image to be obviously retouched or to look like a computer-generated special effect.

Whiten eyes

1. Open AP 8-1.psd, then save it as **Bright Eyes**.
2. Assess the image.

 This is an image that has very few obvious problems. The model is young; he has clear skin, no wrinkles, etc. His mouth is closed, so if he has chipped yellow teeth, we can't see them. Overall, it's a good photograph. Even though there's not a lot going on in the picture, the model's expression is fairly intense.

3. Verify that the **Background layer** is targeted, add a new Curves adjustment layer, then compare your histogram to Figure 1.

 The first step in retouching is adjusting levels or curves to create the best image to start with. Most images, whether they come from a stock house or from a photographer, require some degree of adjustment. In the case of this photograph, the histogram shows that there is minimal detail in the shadow areas, which explains why the image is flat and has weak shadows.

 (continued)

4. Drag the **black triangle** to Input 33/Output 0, drag the **white triangle** to Input 243/Output 255, then compare your screen to Figure 2.

5. Hide and show the adjustment layer to see the change.

6. Create a new layer above the Curves adjustment layer, then name the new layer **Whiten Eyes**.

7. Zoom in to 200% and position the eyes in the document window so that you have a good view of them.

TIP Throughout this chapter, all references to right and left are screen-right and screen-left. Thus, if we refer to the "left eye," we mean the eye that's on your left as you're looking at your monitor.

Both eyes are noticeably bloodshot, especially at the outer sides. Note too the red line in the left eye, just below and left of the iris.

(continued)

Figure 2 *Adjusted curves*

Source Adobe® Photoshop®, 2013. Getty Images, Ken Weingart

Figure 3 *Painting the whites white*

Source Adobe® Photoshop®, 2013. Getty Images, Ken Weingart

Figure 4 *Reducing opacity for realism*

Source Adobe® Photoshop®, 2013. Getty Images, Ken Weingart

8. Click the **Brush tool** , select a small soft brush, then using Figure 3 as an example, paint the white areas of the eyes white.

 In Figure 3, a Soft Round 5-pixel brush was used. For the corner areas, I reduced it to 2 pixels.

TIP Be sure to paint up to but not over the iris. Note too that the pink corners of the eye were not painted.

9. Zoom out so that you are viewing the image at 50%, reduce the opacity of the Whiten Eyes layer to what you think is the best whitening you can achieve while still maintaining realism, then compare your artwork to Figure 4.

10. Set the opacity of the Whiten Eyes layer to **30%**.

11. Add a layer mask, then paint with black to soften any edges on the white that need softening.

 The Whiten Eyes layer is serving two purposes. It is whitening the eyes, and it is also hiding the red bloodshot lines. The opacity of the Whiten Eyes layer in Figure 4 is 30%—the eyes are whitened dramatically, yet they still look realistic. I used the layer mask to reduce the whites on the outside of the eyes and to soften the edge where the white paint meets the irises.

12. Save your work.

Investigate the Overlay
BLENDING MODE

What You'll Do

Source Adobe® Photoshop®, 2013. Getty Images, Ken Weingart

If you get a chance to observe a professional retoucher working, you'll see that the Overlay blending mode plays an important role for enhancing detail. "High-end" retouchers refer to overlay techniques as *overlay detail*. These techniques produce remarkable effects, but it's difficult to appreciate how they are achieved until you understand the basics of how the Overlay blending mode works.

Overlay is one of the most practical and powerful of the blending modes, one you use for retouching, for enhancing an image, and for producing special effects. Although most designers use it and are familiar with the effects it produces, many do not understand—on a technical level—how it works.

Use this chapter as an opportunity to investigate this blending mode. Understanding how a blending mode works increases your Photoshop skills set exponentially.

Figure 5 *Darkening the image by moving the shadow point*

Source Adobe® Photoshop®, 2013. Getty Images, Ken Weingart

Figure 6 *Lightening the image by moving the highlight point*

Source Adobe® Photoshop®, 2013. Getty Images, Ken Weingart

Investigate the Overlay blending mode

1. Make the Highlight/Shadow layer visible, target it, select the entire right half of the image, then hide the selection edges.

2. Open the Levels dialog box.

3. Drag the **Input Levels black triangle** to **128**, click **OK**, then compare your artwork to Figure 5.

 The pixels in the selection are darkened dramatically. The pixels that were 128–255 are now 0–255. Any pixel that was 127 or lower is now 0, black.

4. Select the inverse, then open the Levels dialog box.

5. Drag the **white triangle** to **128**, click **OK**, then compare your artwork to Figure 6.

 The pixels in the selection are lightened dramatically. Any pixel that was 129 or higher is now 255.

6. Deselect all.

7. Hide the Highlight/Shadow layer, then make the Overlay White Black layer visible.

(continued)

8. Change the blending mode on the Overlay White Black layer to **Overlay**, then compare your screen to Figure 7.

 The effect is identical to the levels moves. Overlaying black is the same as moving the shadow point to 128. Overlaying white is the same as moving the highlight point to 128.

9. Hide the Overlay White Black layer, then make the Overlay White Gray Black layer visible.

10. Change the blending mode on the Overlay White Gray Black layer to **Overlay**, then compare your screen to Figure 8.

 With the Overlay blending mode, neutral gray (grayscale value 128) becomes transparent. The fact that gray becomes transparent is one of the key components of the Overlay blending mode.

11. Hide the Overlay White Gray Black layer, then show the Overlay Gradient layer.

(continued)

Figure 7 *Overlaying white and black*

Source Adobe® Photoshop®, 2013. Getty Images, Ken Weingart

Figure 8 *Overlaying gray*

Source Adobe® Photoshop®, 2013. Getty Images, Ken Weingart

Retouching and Enhancing Images

Figure 9 *Overlaying a gradient*

Source Adobe® Photoshop®, 2013. Getty Images, Ken Weingart

12. Change the blending mode on the Overlay Gradient layer to **Overlay**, then compare your screen to Figure 9.

 Overlaying the gradient showcases the true nature (and power) of the Overlay blending mode. It's not just black, white, and gray. Black and white are the extremes—black overlayed produces the darkest effect; white overlayed produces the lightest effect. Gray is neutral. The range between gray and black gradually darkens the image, while conversely, the range between gray and white gradually lightens the image.

13. Hide and show the Overlay Gradient layer to see the effect before and after.

14. Hide the Overlay Gradient layer, then save your work.

AUTHOR'S NOTE

Note that black overlay has a more dramatic effect on darker areas. For example, on the right cheek, note that the redness has become much darker, while the effect on the adjacent flesh tones is not so dramatic. Note too—this is very important—that the black areas of the gradient have only a minimal effect on the white background. On the opposite side of the gradient, note that the light areas under the right eye become almost white with the white overlay. However, the effect on the dark areas in the beard and eyebrows is minimal.

Overlay DETAIL

What You'll Do

Source Adobe® Photoshop®, 2013. Getty Images, Ken Weingart

Overlay detail is a term retouchers use for a technique that enhances detail in an image. When you paint on a layer set to the Overlay blending mode, painting with white or black either lightens or darkens the pixels below, respectively.

This is very different from painting with white or black in Normal mode, and it's important that you understand the distinction. When you paint with white or black in Normal mode, you change the targeted pixels to white or black. Even with reduced opacity, the ultimate expression of the move is to push the pixels toward white or black.

In Overlay mode, you use white and black "paint" to lighten or darken the original pixel information. The ultimate expression of the move is not a white or black pixel. Instead, it is a much lighter or much darker version of the original, but never all white or all black.

With the Overlay blending mode, you are quite literally painting with light.

Figure 10 *Darkening the edge of the left iris*

Source Adobe® Photoshop®, 2013. Getty Images, Ken Weingart

Figure 11 *Darkening the edge of the right iris*

Source Adobe® Photoshop®, 2013. Getty Images, Ken Weingart

Overlay detail

1. Click the **Brush tool** , select a small soft brush, then set the opacity of the tool to **10%**.

2. Press [**D**], then press [**X**] to access a white foreground color.

3. Target the **Whiten Eyes layer**, then create a new layer above it.

4. Name the new layer **Overlay Detail**, then set the blending mode to **Overlay**.

5. Zoom in on the eyes, then paint over both eyes, lightening the hazel parts of the iris to a point that you think looks good but is still realistic.

TIP Paint *inside* the iris—don't lighten the edge of the iris, where it meets the whites of the eyes.

6. Press [**X**] to access a black foreground color, then reduce your brush size to 2 pixels.

7. Darken the edge of the left iris—literally paint a dark line around it—then compare your result to Figure 10.

 The effect is stunning yet remarkably realistic. This is a standard retouching technique: lighten the iris, darken the edge of the iris.

TIP You don't necessarily need to paint the edge in one move. The Brush tool is at only 10% opacity and it does not flow, so the change will be subtle. You will need to paint over the edge a few times to achieve the effect shown in the figure.

8. Darken the edge of the right iris, hide and show the Overlay Detail layer to see a before-and-after view of the effect, then compare your result to Figure 11.

(continued)

9. Note the areas of the eye identified in Figure 12.

 These are the edges of the eyelids. Note that, even without retouching, they already have a highlight.

10. Switch your foreground color to white, then lighten these areas to a point that you feel enhances the eyes but maintains realism.

11. Compare your result to Figure 13.

 We human beings like to see distinct features, even exaggerated. In the movies, we like our leading men and women with square jaws (think Brad Pitt), prominent cheekbones (think Tom Cruise), long necks (think Gwyneth Paltrow), and defined lips (think Angelina Jolie). We look for this detail especially in the eyes. This move exaggerates that definition, and it makes the eyes more interesting. However, this move needs to be very slight and subtle; if you lighten too much, it is noticeably retouched and looks bizarre.

12. Lighten the highlight on the top lip slightly.

13. Switch your foreground color to black, then darken the dark area of the top lip beneath the ridge, identified in Figure 14.

14. Zoom in on the eyes, then darken the top eyelashes on each eye.

15. Change your brush to a **Hard Round 1-pixel** brush, set the brush opacity to **18%**, darken each of the eyelashes, one at a time, at the bottom of both eyes, and add eyelashes where they're missing.

 This is easier than it sounds. Remember, you are not painting with black, you're painting with dark. Therefore, you can't paint "out of the lines." If you miss an eyelash, all you'll do is darken the skin behind it, and it will be almost unnoticeable.

 (continued)

Figure 12 *Identifying areas to be enhanced*

Source Adobe® Photoshop®, 2013. Getty Images, Ken Weingart

Figure 14 *Identifying an area to be darkened*

Source Adobe® Photoshop®, 2013. Getty Images, Ken Weingart

Figure 13 *Enhancing eye areas*

Source Adobe® Photoshop®, 2013. Getty Images, Ken Weingart

Retouching and Enhancing Images

Figure 15 *Darkening and adding eyelashes*

Source Adobe® Photoshop®, 2013. Getty Images, Ken Weingart

Figure 16 *Darkening eyebrows*

Source Adobe® Photoshop®, 2013. Getty Images, Ken Weingart

Figure 17 *Darkening the neck and jacket*

Source Adobe® Photoshop®, 2013. Getty Images, Ken Weingart

16. Compare your results to Figure 15.
17. Choose a larger soft brush, then darken the eyebrows.
18. Compare your results to Figure 16.
19. Choose a big soft brush (I used Soft Round 100 pixels), then darken the jacket, the neck, and the line where the jaw meets the neck.
20. Compare your results to Figure 17.

 Darkening the jacket and neck serves two important purposes. First, it brings the entire head forward in the image: that which is lighter we interpret as closer; that which is darker we interpret as recessed. Second, darkening the neck but not the jaw makes the jawline appear stronger and more distinct.
21. Hide and show the Overlay Detail layer to see the image with and without the detail, then save your work.

Use a Channel
AS A MASK

What You'll Do

Source Adobe® Photoshop®, 2013. Getty Images, Ken Weingart

Most Photoshop users work with channels on a basic level—in most cases when saving selections. You'll find that it's usually the more experienced users who work more aggressively with channels, who are able to use them as a means to achieve a desired goal.

In this chapter, we are going to use a channel to perform a delicate color move on a nonspecific area of an image. This exercise is a great example of how powerful and useful channels can be. It also demonstrates a great solution for targeting and manipulating hard-to-select areas of an image.

Figure 18 *Green channel*

Source Adobe® Photoshop®, 2013. Getty Images, Ken Weingart

Reduce reds in flesh tones

1. Verify that the **Overlay Detail layer** is targeted, create a new Hue/Saturation adjustment layer, then click **OK** without making any adjustments.

 The goal of this lesson is to reduce the distinct red flesh tones in the cheeks, the ears, and the nostrils. The question is, how would you select those areas to reduce the reds? Instead of using the selection tools or creating a layer mask, we're going to use one of the RGB channels as a ready-made layer mask.

2. View the Red, Green, and Blue channels one at a time.

 We're looking for the channel in which the red cheeks are most distinct from the adjacent flesh tones. The Green channel, shown in Figure 18, best meets this criterion.

3. Drag the **Green channel** to the Create new channel button ⬚ on the Channels panel.

 The Green channel is duplicated and the canvas now shows the image in the new channel.

4. Name the new channel **First Selection**, then assess it as a selection mask for the red flesh tones.

 As a selection mask, the cheeks are darker than the adjacent flesh tones. If you loaded this channel as a selection, the cheeks would be less selected than the adjacent flesh tones.

 (continued)

5. Click the **Image menu**, point to **Adjustments**, click **Invert**, then compare your channel to Figure 19.

 With the channel inverted, the cheeks are now lighter than the surrounding areas, meaning they will be more selected. However, they are very close in tone to those surrounding areas—not very distinct at all.

6. Click the **RGB channel thumbnail** to return to the composite image.

7. Change the blending mode of the Hue/Saturation adjustment layer to **Overlay**, then compare your screen to Figure 20.

 Overlaying the Hue/Saturation adjustment layer is the same as overlaying a duplicate of the image over itself. The result is what you should expect, based on our investigation of the Overlay mode earlier in this chapter: the dark areas get darker and the light areas get lighter. With this image, the dark red cheeks get darker while the adjacent flesh tones, which were lighter to begin with, get even lighter.

(continued)

Figure 19 *Selection mask inversed*

Source Adobe® Photoshop®, 2013. Getty Images, Ken Weingart

Figure 20 *Overlaying an image over itself*

Source Adobe® Photoshop®, 2013. Getty Images, Ken Weingart

Retouching and Enhancing Images

Figure 21 *New selection mask*

Source Adobe® Photoshop®, 2013. Getty Images, Ken Weingart

Figure 22 *Selection mask inverted*

Source Adobe® Photoshop®, 2013. Getty Images, Ken Weingart

Lesson 4 Use a Channel as a Mask

8. Return to the Channels panel, duplicate the Green channel, name it **Second Selection**, then compare it to Figure 21.

 The channels always reflect the image in its current state. Therefore, the cheeks and the sides of the nose are dramatically darker than the adjacent flesh tones.

9. Invert the channel, then compare it to Figure 22.

TIP Use quick keys to invert the channel: [Ctrl][i] (Win) or ⌘ [i] (Mac).

(continued)

10. Open the Levels dialog box, type **24** in the first Input text box, type **.90** in the second Input text box, type **199** in the third Input text box, click **OK**, then compare your result to Figure 23.

 Our goal is to make the cheek area as light as possible and the areas of normal flesh tone surrounding the cheeks as dark as possible.

11. Click the **Brush tool** , set the opacity to **100%**, choose a big soft brush, then paint black so that your selection mask resembles Figure 24.

 We've blackened out the eyes, mouth, facial hair, and jacket so that they won't be affected by the following steps.

12. Switch the foreground color to white, then change the opacity to **20%**.

13. Click the **Mode list arrow** on the Options bar, then click **Overlay**.

(continued)

Figure 23 *Selection mask adjusted*

Source Adobe® Photoshop®, 2013. Getty Images, Ken Weingart

Figure 24 *"Masking out" areas of the mask*

Source Adobe® Photoshop®, 2013. Getty Images, Ken Weingart

Retouching and Enhancing Images

Figure 25 *Lightening the mask*

Source Adobe® Photoshop®, 2013. Getty Images, Ken Weingart

Figure 26 *Loading the selection mask*

Source Adobe® Photoshop®, 2013. Getty Images, Ken Weingart

14. Paint the cheeks, the sides of the nose, and the ears to lighten them so that your mask resembles Figure 25.

 This is a different technique but the same concept for working with Overlay. The brush does not paint white—it lightens. What's really powerful in this case is that the brush can't affect the black areas, so you can very effectively brighten the areas you want to affect.

15. Click the **RGB channel thumbnail**, return to the Layers panel, then delete the Hue/Saturation adjustment layer.

16. Click the **Select menu**, click **Load Selection**, click the **Channel list arrow**, click **Second Selection**, click **OK**, then compare your selection marquee to Figure 26.

TIP A faster way to load a selection is to [Ctrl] (Win) or ⌘ (Mac)-click the channel.

(continued)

17. Apply a 4-pixel feather to the selection, then hide the selection marquee.

18. Create a new unclipped Hue/Saturation adjustment layer, drag the **Hue slider** to **+14**, drag the **Lightness slider** to **+12**, then compare your result to Figure 27.

19. Deselect all.

20. Select the **Whiten Eyes layer**, the **Overlay Detail layer** and the **Hue/Saturation adjustment layer**, then make them into a new layer group named **Retouched**.

21. Hide and show the Retouched layer group to see the image with and without the retouching, then compare your artwork to Figure 28.

 Though all of the adjustments we made were subtle, the overall improvement of the image is stunning, especially the reduction of red in the cheeks, ears, and nostrils and the enhancement of the eyes. Take a moment to appreciate that the image does not look doctored or fake—it just looks like a good photograph.

22. Expand the Retouched layer group, target the **Hue/Saturation adjustment layer**, then add a new Curves adjustment layer named **Contrast Bump**.

23. Add a point anywhere on the curve, change its Input value to **75**, then change its Output value to **65**.

TIP Expand the Properties panel, if necessary to see the Input and Ouput values.

(continued)

Figure 27 *Adjusting hue and lightness*

Source Adobe® Photoshop®, 2013. Getty Images, Ken Weingart

Figure 28 *Image before and after retouching*

Source Adobe® Photoshop®, 2013. Getty Images, Ken Weingart

Retouching and Enhancing Images

Figure 29 *Original image and final image below*

Source Adobe® Photoshop®, 2013. Getty Images, Ken Weingart

24. Add a second point, change its Input value to **188**, then change its Output value to **198**.

25. Hide and show the Retouched layer group, then compare your artwork to Figure 29.

 One important thing to take away from this lesson is the idea of subtlety. Almost by definition, good retouching does not call attention to itself. When we first assessed the image, we noted that it was a pretty good image—there wasn't anything glaringly wrong with the photograph or the subject. Yet, look at how much we were able to enhance the image without doing anything obvious or showy.

26. Save your work, then close Bright Eyes.psd.

Use the
CLONING TOOLS

What You'll Do

Source Adobe® Photoshop®, 2013. Getty Images, Steve McAlister

Everybody loves the cloning tools. Whenever Photoshop is being demonstrated, you can be sure that a substantial amount of time will be given to wowing the crowd with cloning tricks: Creating an extra eye, replacing the head of a dog with the head of a horse, cloning the picture of a cat onto the surface of the planet Mars—you know the routine. The cloning tools are a blast, and it doesn't take long for any novice user to find them and start playing. Mastering the cloning tools is a whole different game because they're some of the trickiest tools to use effectively. *Effectively* means achieving the goal you want to achieve. Using the Clone Stamp tool effectively means choosing the right brush, sampling from the right area, and cloning with the best technique to make your work look realistic. That's the challenge. For many versions, the Clone Stamp tool was the only cloning tool in Photoshop. Then the Patch tool and the Healing Brush tool were introduced to provide options that the Clone Stamp tool just couldn't. In this lesson, you'll work with all three.

Figure 30 *First area to retouch*

Source Adobe® Photoshop®, 2013. Getty Images, Steve McAlister

Figure 31 *Positioning the brush*

Source Adobe® Photoshop®, 2013. Getty Images, Steve McAlister

Use the Clone Stamp tool

1. Open AP 8-2.psd, then save it as **Smooth Lines**.
2. Hide and show the Eyes Retouched layer group to see the retouching work that I've already done on the eyes.
3. Verify that the Eyes Retouched layer group is showing and targeted, then create a new layer above it named **Smooth**.
4. Figure 30 identifies the first area that we want to retouch.
5. Click the **Clone Stamp tool** ![icon], verify that the Mode is set to **Normal**, that Sample is set to **All Layers**, and that its Opacity and Flow are both set to **100%**.
6. Create a Soft Round 70-pixel brush, then position it over the area shown in Figure 31.

 We will use this area as the sample. It is very close in color and tone to the area we want to fix, and it is also smooth, with no wrinkles or indents.

 (continued)

AUTHOR'S NOTE

The goal of this exercise is to retouch this image so that it can be used in a medical advertisement in a magazine targeted toward senior citizens. The client has instructed you that the model should represent a vibrant older woman—a portrait of healthy aging.

7. Press and hold [**Alt**] (Win) or [**option**] (Mac) then click to sample the area.

 For this lesson, I will presume that you know the basics of how to use the Clone Stamp tool to clone areas of an image. From this point on, I will simply tell you to sample an area.

8. Position the pointer over the area to be fixed (Figure 30), click once, then compare your result to Figure 32.

9. Using the same method, but with a smaller brush size, clone out the blemish shown in Figure 33.

 (continued)

Figure 32 *Result of clicking Clone Stamp tool*

Source Adobe® Photoshop®, 2013. Getty Images, Steve McAlister

Figure 33 *Cloning out the blemish*

Source Adobe® Photoshop®, 2013. Getty Images, Steve McAlister

AUTHOR'S NOTE

After you sample, you might notice that the Clone Brush tool shows a preview of the sample you took. This is intended to allow you to see what the sample will look like when positioned in a different area of the image. Some users love this relatively new feature—others find it distracting. If you want to disable this feature, open the Clone Source panel, then remove the check mark in the Show Overlay check box.

Retouching and Enhancing Images

Figure 34 *Next area to be fixed*

Source Adobe® Photoshop®, 2013. Getty Images, Steve McAlister

Figure 35 *Result of cloning using smooth area of cheek*

Source Adobe® Photoshop®, 2013. Getty Images, Steve McAlister

10. See Figure 34 for the next area to be fixed.

 This area is usually problematic, whether the model is younger or older. In this image, the area is dotted with small highlights. Possibly, the model's makeup was clumpy or flaky in this area, or maybe the skin itself had large pores or small pock marks. In any case, it's distracting and can be fixed easily.

11. Change the brush size back to 70 pixels, sample a smooth area from the left cheek, then clone out the area completely, so that your image resembles Figure 35.

TIP I clicked two times to completely cover the area.

(continued)

Lesson 5 Use the Cloning Tools

12. Reduce the brush size to 27 pixels, then see Figure 36.

13. Sample the area indicated by the black circle, then clone out the entire cheek line by clicking in the area indicated by the green circle and dragging to the area indicated by the red circle.

14. Compare your result to Figure 37.

 Yes, this looks fake. Reality is not our goal at this stage of retouching. Our goal is to cover lines with similar flesh tones. Later, we will bring back some of the detail using opacity.

 (continued)

Figure 36 *Third area to be fixed*

Source Adobe® Photoshop®, 2013. Getty Images, Steve McAlister

Figure 37 *Result of cloning out the cheek line*

Source Adobe® Photoshop®, 2013. Getty Images, Steve McAlister

Figure 38 *Smooth light area*

Figure 39 *Result of cloning out wrinkles*

15. Sampling from the smooth light area at the top of the left cheek, identified in Figure 38, clone out all of the wrinkles under the left eye, then compare your results to Figure 39.

(continued)

Lesson 5 Use the Cloning Tools

16. Sampling from the same area, but with a smaller brush, clone out the line in the forehead to the upper left of the left eyebrow, then compare your result to Figure 40.

17. See Figure 41.

This area is perhaps the most problematic in the image. The flesh tone is bright, making the wrinkles that much more noticeable. The eyes are the first thing everybody looks at, so improving this area is important. The problem with fixing this area is that there's very little area to sample. We have no choice but to clone from another area of the image.

(continued)

Figure 40 *Cloning out the line in the forehead*

Source Adobe® Photoshop®, 2013. Getty Images, Steve McAlister

Figure 41 *Assessing a problematic area*

Source Adobe® Photoshop®, 2013. Getty Images, Steve McAlister

Retouching and Enhancing Images

Figure 42 *Cloning over the eye*

Source Adobe® Photoshop®, 2013. Getty Images, Steve McAlister

Figure 43 *Identifying lines on the neck*

Source Adobe® Photoshop®, 2013. Getty Images, Steve McAlister

18. Sample from the middle of the left cheek, then clone over the eye as shown in Figure 42.

19. Save your work.

Use the Healing Brush tool

1. Note the lines on the neck identified in Figure 43.

 The Clone Stamp tool is not very effective for cloning out these lines simply because there's no place to sample—there's no other area of the image that has a smooth flesh tone that is as dark as this area.

 (continued)

2. Set the brush size to 27 pixels, then sample the area shown in Figure 44.

3. Clone out the lower heavy wrinkle so that your artwork resembles Figure 45.

 The sample area is too light for the area being replaced.

4. Undo the last step.

5. Click the **Healing Brush tool** , then verify that the Mode is set to **Normal**, that the **Sampled option button** is selected, and that Sample is set to **Current & Below**.

 Make sure you are using the Healing Brush tool and not the Spot Healing Brush tool.

 (continued)

Figure 44 *Area to be sampled*

Source Adobe® Photoshop®, 2013. Getty Images, Steve McAlister

Figure 45 *Result is too light*

Source Adobe® Photoshop®, 2013. Getty Images, Steve McAlister

Retouching and Enhancing Images

Figure 46 *Result using the Healing Brush tool*

Source Adobe® Photoshop®, 2013. Getty Images, Steve McAlister

Figure 47 *Cloning upper wrinkle*

Source Adobe® Photoshop®, 2013. Getty Images, Steve McAlister

6. Repeat Steps 2 and 3, then compare your result to Figure 46.

 The Healing Brush tool clones just like the Clone Stamp tool. The big difference is that the Healing Brush tool automatically adjusts the color of the clone to match its new surroundings as closely as possible.

7. Using the same method and sampling from the same location, smooth out the entire area, then compare your screen to Figure 47.

(continued)

8. Increase the brush size to 32 pixels, then see Figure 48.

9. Sample the area indicated by the black circle, click the area indicated by the green circle, [**Shift**]-click the area indicated by the red circle, then compare your result to Figure 49.

 The result is odd. This is the type of clone that the Healing Brush tool doesn't do as well as the Clone Stamp tool. Compare this result to the same area on the left cheek that we cloned out with the Clone Stamp tool. We will investigate this further in the next lesson.

10. Undo the last move, click the **Clone Stamp tool** then completely clone out the entire area indicated in Figure 48.

 (continued)

Figure 48 *Sampling an area*

Source Adobe® Photoshop®, 2013. Getty Images, Steve McAlister

Figure 49 *Results of Healing Brush tool*

Source Adobe® Photoshop®, 2013. Getty Images, Steve McAlister

Figure 50 *Using the Healing Brush tool on the neck*

Source Adobe® Photoshop®, 2013. Getty Images, Steve McAlister

Figure 51 *Selecting an area*

Source Adobe® Photoshop®, 2013. Getty Images, Steve McAlister

11. Practice with the Healing Brush tool on the entire neck so that your work resembles Figure 50.

 The Healing Brush tool will work on all areas of the neck except if you get too close to the jawline.

12. Save your work.

Use the Patch tool

1. Verify that the **Smooth layer** is targeted, select all, click the **Edit menu**, then click **Copy Merged**.

2. Paste, then name the new layer **Patch**.

 The new layer is a copy of the original image with all of the retouching we've done so far.

3. Click the **Patch tool** 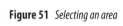, verify that the **Source option button** is chosen on the Options bar, then select the area shown in Figure 51.

(continued)

4. Drag the selection up to a smooth area of the left cheek, as shown in Figure 52, then release the mouse button.

5. Deselect, then compare your result to Figure 53.

The Patch tool works like the Healing Brush tool, but with the added benefit of a visual preview. First, you select the area that you want to replace. Then, you drag the selection to an area that has a texture that you want to use. As you drag, you get a dynamic preview of the clone before the color adjustment. When you release the mouse button, the Patch tool clones the area where you deselect, "patches" it into the original selection, then color corrects it to match the tonal range of the original selection. The Patch tool is often very successful in matching the clone to the tonal range of the original, and because you can work with large selections, the Patch tool is very effective for getting a lot of retouching done quickly.

TIP The Patch tool won't work on a transparent layer, like the cloning we did on the Smooth layer. This is why we needed to create the copy merged Patch layer to use the Patch tool.

(continued)

Figure 52 *Dragging selection to smooth area of left cheek*

Source Adobe® Photoshop®, 2013. Getty Images, Steve McAlister

Figure 53 *Result of using the Patch tool*

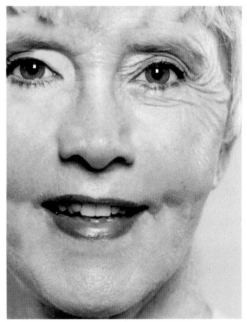

Source Adobe® Photoshop®, 2013. Getty Images, Steve McAlister

Figure 54 *Selecting an area to patch*

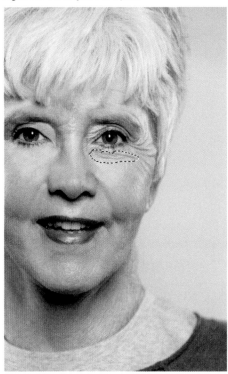

Source Adobe® Photoshop®, 2013. Getty Images, Steve McAlister

Figure 55 *Result of using the Patch tool*

Source Adobe® Photoshop®, 2013. Getty Images, Steve McAlister

6. Select the area shown in Figure 54, hide the selection edges, drag the selection to the smooth area under the left eye, release the mouse button, then deselect.

7. Compare your result to Figure 55.

(continued)

Lesson 5 Use the Cloning Tools

8. Select the area shown in Figure 56, clone from the smooth cheek above it, deselect, then compare your result to Figure 57.

(continued)

Figure 56 *Selecting an area to patch*

Source Adobe® Photoshop®, 2013. Getty Images, Steve McAlister

Figure 57 *Result of using the Patch tool*

Source Adobe® Photoshop®, 2013. Getty Images, Steve McAlister

Retouching and Enhancing Images

Figure 58 *Selecting the eyelid*

Source Adobe® Photoshop®, 2013. Getty Images, Steve McAlister

Figure 59 *Result of using the Patch tool on eyelid*

Source Adobe® Photoshop®, 2013. Getty Images, Steve McAlister

9. Select the area shown in Figure 58, then clone from the smooth area under the left eye.

10. Compare your result to Figure 59.

 Note how much better (and faster and easier) the Patch tool worked on this eye than the Clone Stamp tool did on the left eye.

11. Use the **Healing Brush tool** to remove the deep wrinkles to the right of the right eye and the scar on the lower-right cheek.

TIP If you get unwanted results, feel free to switch to the Clone Stamp tool or the Patch tool.

(continued)

12. Smooth out any other areas of the image that you think need retouching, then compare your work to Figure 60.

13. Group the Smooth and the Patch layers into a new layer group named **Cloning**.

14. Add a layer mask to the Cloning layer group, click the **Edit menu**, then click **Fill**.

15. Click the **Use list arrow**, choose **50% Gray**, verify that the blending mode is set to **Normal** and the opacity is set to **100%**, then click **OK**.

 Rather than set the Cloning layer group to 50% opacity, we have used a mask with 50% gray to achieve the effect. This leaves us the option of painting in the layer mask to intensify or lessen the retouching in local areas. Remember this trick; it's always best to leave yourself with options.

16. Select both the **Cloning layer group** and the **Eyes Retouched layer group**, then make a new layer group named **Retouching**.

(continued)

Figure 60 *Result of removing wrinkles and scar*

Source Adobe® Photoshop®, 2013. Getty Images, Steve McAlister

Figure 61 *Before and after results*

Source Adobe® Photoshop®, 2013. Getty Images, Steve McAlister

17. Hide and show the Retouching layer group to see the before-and-after results, then compare your screen to Figure 61.

 We have not removed a single wrinkle. We've only reduced them. Allowing 50% of the original image to show through grounds the image in reality; there's no visible blurring, cloning, or awkward textures. The retouching is invisible. Note that in a real-world situation, this wouldn't be the sum total of all the retouching done. Instead, it would be an important base of overall retouching. From here, you'd perform other local moves to perfect specific areas of the image.

18. Save your work, then close Smooth Lines.psd.

Retouch TEETH

What You'll Do

Source Adobe® Photoshop®, 2013. Getty Images, Steve McAlister

If you liked whitening eyes and reducing wrinkles, you're going to love working with teeth. Teeth are usually the greatest challenge to the retoucher. They almost always need work—a little whitening here, a little straightening there. What's really tough about retouching teeth is that it usually requires making precise selections and many small moves with the retouching and paint tools. And the margin of error is small—make that, the margin of reality is small. It's very tricky to retouch teeth in a way that is not noticeable, to fool the eye into believing that the retouched teeth—the color, the shape, and the texture—are the real thing.

In this lesson, instead of retouching the teeth yourselves, you're going to click through the layers to see the retouching that I applied. As I was working, I didn't know if the techniques I was using would ultimately work. They did, and the goal of this chapter is to have you retrace my steps to see the objectives that I identified, the techniques I used to achieve them, and the choices I made along the way.

Figure 62 *Assessing the model's teeth*

Source Adobe® Photoshop®, 2013. Getty Images, Steve McAlister

Figure 63 *Three teeth squared off*

Source Adobe® Photoshop®, 2013. Getty Images, Steve McAlister

Fix teeth

1. Open AP 8-3.psd, then save it as **Fix Teeth**.
2. Look at Figure 62 to assess the model's teeth.

 Teeth almost always need retouching. Sometimes, it's light retouching, such as a slight whitening. Other times . . . let's just say it's extensive.

 The subject of this photo does not have perfect teeth. On the left side, one yellow tooth overlaps another, her lip is hooked on one of the bottom teeth, and a filling is visible. On the right side, the teeth are a bit chipped, and one bottom tooth is bent behind the others. Other than that, the right side isn't so bad, and we're going to use that to our advantage. One more note: Did you notice that whoever did the makeup for this model didn't do a very good job? The application of the lipstick is uneven—note her bottom lip. The edges are very soft and the line of her lips is indistinct and unflattering.

3. Zoom in so that you are viewing the teeth at 100%, then expand the Teeth layer group to view the layers within.
4. Show the Square Off Teeth layer.

 As shown in Figure 63, I squared off the three teeth on the right side of the mouth. To do so, I made a clipping path in the shape that I wanted the teeth to be, used the path as a selection, then cloned to make the teeth larger and more square.

 (continued)

5. Show the Fix Bottom Row layer.

The bottom row was more of a challenge because one tooth is bent all the way back. As shown in Figure 64, I cloned out the bent tooth. I then cloned the tooth to the right to replace the old tooth. Then came the challenge: the teeth weren't lining up. The line between the two top front teeth was still to the left of the left edge of the clone. I enlarged the clone slightly, then stretched it to the left.

6. Show the Darken Lipstick layer.

As shown in Figure 65, I darkened the lips to make the lipstick darker, more distinct, and more consistent in tone throughout. I used the overlay detail technique, which worked well, but it was not without its challenges. With red, the color shifts quickly and dramatically. Parts of the lips had lipstick, and parts were bare, and I wanted everything darker. Trying to match the two areas was tricky.

(continued)

Figure 64 *Lining up the teeth in the bottom row*

Source Adobe® Photoshop®, 2013. Getty Images, Steve McAlister

Figure 65 *Darkened lipstick*

Source Adobe® Photoshop®, 2013. Getty Images, Steve McAlister

Retouching and Enhancing Images

Figure 66 *Sharper lipstick line*

Source Adobe® Photoshop®, 2013. Getty Images, Steve McAlister

Figure 67 *Selecting the right side of the mouth*

Source Adobe® Photoshop®, 2013. Getty Images, Steve McAlister

7. Show the Improve Edge layer.

 As shown in Figure 66, I created a sharper line for the lipstick to cover the indistinct line beneath it. First, I created a path to use as a selection. When I made the path, I drew the path above the top lip a bit to increase its size, then cloned red into the new area. I did the same to strengthen the edge of the bottom lip.

8. See Figure 67.

 I selected the right half of the mouth as shown, copied it, then pasted it on its own layer. Note the left edge of the selection marquee. I positioned that left edge very carefully. I zoomed in to be sure that the pixels that made up the left edge of my selection were the pixels that drew the line between the top two teeth.

(continued)

Lesson 6 Retouch Teeth

9. Show the Flip Horizontal layer.

 As shown in Figure 68, I flipped the "good side" of the mouth, then positioned it over the "bad" left side. Up to this point, I wasn't certain that my idea would work. The flipped artwork looked pretty good, but pretty good doesn't cut it when retouching. It needed to be unnoticeable. It needed to hide in plain sight.

10. Show the Distort layer.

 As shown in Figure 69, I distorted the mouth so that the two sides weren't perfect mirror images of one another. The mouth is stretched wider on the left side and is rotated clockwise. It is a subtle move, but it needs to be there. The two sides can't be perfect mirrors. However, the adjustment is too subtle to completely solve the problem, and the horizontal flip is still evident.

11. Hide the Flip Horizontal layer.

 The Distort layer artwork replaces the Flip Horizontal artwork, so we no longer want the Flip Horizontal artwork to be visible.

 (continued)

Figure 68 *Right side of mouth flipped to left side*

Source Adobe® Photoshop®, 2013. Getty Images, Steve McAlister

Figure 69 *Distorting mouth to create natural look*

Source Adobe® Photoshop®, 2013. Getty Images, Steve McAlister

Figure 70 *Results of layer mask*

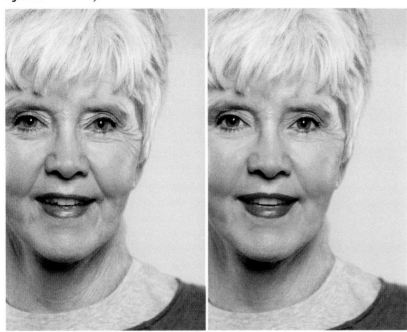

Source Adobe® Photoshop®, 2013. Getty Images, Steve McAlister

12. Press and hold [**Shift**], then click the **Layer mask thumbnail** on the Distort layer to activate it.

 As shown in Figure 70, the layer mask sells it. Hide and show the layer mask to see the change. I used the mask to allow some of the original left sides of the lips to show through. That small but important move solved the problem.

 The eye is quick to pick up a mirror image. However, it's just as quick to stop scanning when it picks up asymmetrical detail. It doesn't take much: note the bump on the upper lip, the darker edge at the left side of the bottom lip, and the softer highlight on the bottom lip. They are enough to convince the eye to move on without questioning it.

13. Collapse the Teeth layer, create a new layer group using the Teeth and Retouching layers, then name it **Final Retouch**.

14. Hide and show the Final Retouch layer group to assess the final effect.

15. Save your work, then close Fix Teeth.

Clone Strategically Within
ADJUSTMENT LAYERS

What You'll Do

Source Adobe® Photoshop®, 2013. Getty Images, Steve McAlister

When working with the cloning tools, often you will find that you need to do some retouching after you've applied adjustment layers like Curves adjustments or Hue/Saturation adjustments. In these cases, where you position your retouching layer in the Layers panel relative to the adjustment layers becomes a critical decision. Also critical is how you sample the adjusted artwork.

The issues that must be navigated in this situation involve the adjustment layers. The big thing about adjustment layers is that they can be adjusted—over and over again. This big benefit can become a big problem when you clone adjusted artwork, because if you modify an adjustment layer *after* you clone, your cloning can become visible with the modification. In other words, when you clone adjusted artwork, you want to sample in a way that allows you the option to modify the adjustment layers without exposing your retouching.

Figure 71 *White scratch in hood*

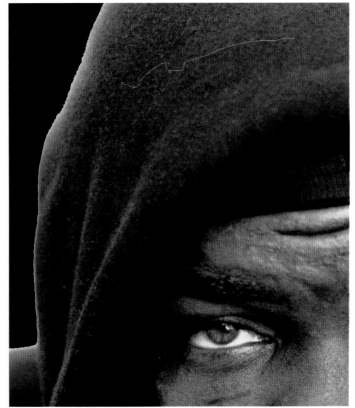

Source Adobe® Photoshop®, 2013. Getty Images, Steve McAlister

Clone strategically within adjustment layers

1. Open AP 8-4.psd, then save it as **Smart Sampling**.

2. Note the two adjustment layers on the Layers panel.

 The original image has been modified with a Curves and a Hue/Saturation adjustment layer.

3. Note the white scratch in the hood, as shown in Figure 71, that needs to be removed.

 The scratch can be removed easily with the Clone Stamp tool or the Healing Brush tool. The question though, is where do you position the layer to do your retouching in relation to the adjustment layers.

4. Target the **Hue/Saturation adjustment layer**, then create a new layer above it.

5. Name the new layer **Clone All Layers**.

6. Click the **Clone Stamp tool**, click the **Sample list arrow**, then click **All Layers**.

7. Use the Clone Stamp tool to remove the white scratch.

 Understand that when you sample, you are sampling the composite of all three of the layers beneath the new layer. In other words, when you click to sample, you're sampling the image as it appears as the result of the three layers—the original image with the Curves adjustment and the Hue/Saturation adjustment.

 (continued)

8. Hide both adjustment layers, then compare your image to Figure 72.

 As shown in the figure, the way you sampled when you cloned has resulted in the problem that you can no longer adjust either of the two adjustment layers. This is because both were involved in the sample when you cloned.

9. Delete the new layer, then make the two adjustment layers visible again.

10. Target the **Background layer**, create a new layer, click the **Clone Stamp tool** 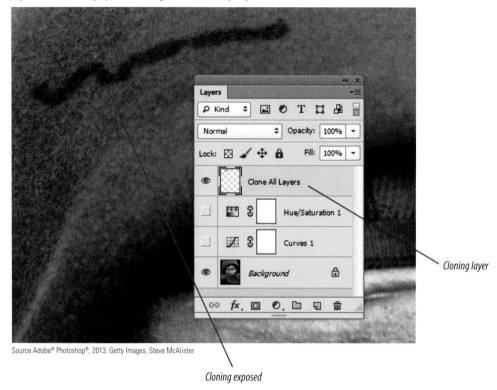, click the **Sample list arrow**, then click **Current & Below**.

TIP These same sampling options are also available for the Healing Brush tool.

11. Use the Clone Stamp tool to remove the white scratch on the hood.

 Because the Current & Below option is selected, when you sample with the Clone Stamp tool, you are sampling only the current (empty) layer and the layer beneath it. You are not sampling either of the two adjustment layers above.

 (continued)

Figure 72 *Retouching layer in the wrong location in the Layers panel*

Source Adobe® Photoshop®, 2013. Getty Images, Steve McAlister

Cloning layer

Cloning exposed

Figure 73 *Retouching layer in the correct position in the Layers panel*

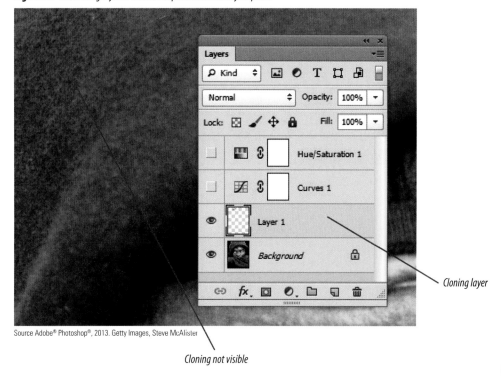

Source Adobe® Photoshop®, 2013. Getty Images, Steve McAlister

Cloning layer

Cloning not visible

12. Hide the two adjustment layers, then compare your image to Figure 73.

Hiding the Hue/Saturation layer has no adverse effect on the image. The Hue/Saturation layer wasn't involved in the cloning.

13. Note once again the position of the new layer on the Layers panel and the Current & Below option on the Options bar.

Remember this setup. Whenever you need to retouch an image and adjustment layers are involved, position your retouching layer immediately above the artwork that needs retouching.

14. Save your work, then close Smart Sampling.psd.

Analyze the Healing
BRUSH TOOL

What You'll Do

Source Adobe® Photoshop®, 2013. Getty Images, Steve McAlister

The Healing Brush tool has emerged as a central, go-to cloning tool. Its power is based on its simplicity and its effectiveness. Let's say you wanted to clone out a wrinkle from under someone's eye, and you were using the smooth skin from the cheek as your source for the clone. Let's say too that the smooth cheek is brighter and a different color than the area under the eye. If you use the Healing Brush tool, you'll clone the smooth skin from the cheek, but the tool will match the color of the clone to the surrounding areas under the eye.

How does the brush work? That's the essence of this lesson. Use these steps and this exercise as an opportunity to analyze and gain an understanding of how the powerful Healing Brush tool functions.

Retouching and Enhancing Images

Figure 74 *Cloning from an entirely different area of the image*

Source Adobe® Photoshop®, 2013. Getty Images, Steve McAlister

Analyze the Healing Brush tool

1. Open AP 8-5.psd, then save it as **Healing Brush**.
2. Create a new layer above the Background layer, then name it **Healing**.
3. Note the wrinkles under the eye screen right.
4. Click the **Healing Brush tool** , then set the Sample on the Options bar to **Current & Below**.
5. Sample the light blue background from the right edge of the image.
6. Begin cloning over one of the wrinkles, as shown in Figure 74.

 As shown in the figure, while you're cloning, the Healing Brush tool behaves like the Clone Stamp tool: a blue clone appears over the woman's face.

 (continued)

7. Release the mouse button, then compare your result to Figure 75.

Even though the blue clone is a dramatically different color than the woman's skin, the Healing Brush tool matches the clone to the surrounding areas.

For more information about the Healing Brush tool, read the Author's Note on the next page.

(continued)

Figure 75 *Wrinkle line is replaced with smooth texture from clone area*

Source Adobe® Photoshop®, 2013. Getty Images, Steve McAlister

Retouching and Enhancing Images

This exercise, by using a clone from an entirely different part of the image, provides insight as to how the Healing Brush tool works. While the actual algorithm that the brush uses is far too complex to discuss here, you can get a general sense of how the brush works in terms of HSB. Every pixel has HSB values; the hue and saturation values affect only the chromatic component of the pixels, their color. The brightness component creates the range or "shape" of the image, from black to white.

You can think of the Healing Brush tool as cloning brightness. In areas of an image where the brightness component of pixels is relatively the same, those areas will by definition appear "smooth."

In the case of this exercise, the blue pixels in the background all have very similar brightness values and the background area therefore appears "smooth." The brightness values of the pixels under the eye were very dissimilar. The wrinkle, for example, was much darker than other areas. The Healing Brush tool cloned the brightness values from the blue area, the smooth area, replacing the wrinkles. The Healing Brush tool ignores the color component of the clone and instead uses the hue and saturation values from surrounding pixels for the clone.

Of course, this is a very simplified explanation of how the tool works, but it gives you an idea of how you can clone a "smooth" blue area to replace wrinkled areas in the face.

8. Using the same method, remove other wrinkles around the same eye.

9. Save your work, then close Healing Brush.psd.

Employ Content-Aware
TECHNIQUES

What You'll Do

Source Adobe® Photoshop®, 2013.

The term "content-aware" refers to Photoshop features—all of them relatively new to the software—that perform operations automatically with an understanding of the image and what you're trying to accomplish.

The two most used content-aware features are content-aware fills and content-aware cloning. An example of each goes far in explaining content-awareness.

Imagine you have an image of a rowboat floating in the ocean. You draw a marquee around the boat, click the Edit/Fill command, and the selection is filled with ocean. In a content-aware fill, Photoshop fills a selection with new data based on surrounding data.

You use the Spot Healing Brush tool for content-aware cloning. The Spot Healing Brush tool is the only cloning tool that does not require that you first sample before cloning. Instead, simply drag the Spot Healing Brush over the area you want to "correct," and Photoshop will automatically clone where you drag to match surrounding areas.

Generally speaking, content-aware features are best used as a means to an end, especially when cloning. Using the rowboat in the ocean example, you could use the content-aware fill to let Photoshop do the work in getting the rowboat out of the picture. Then, use the more traditional cloning tools to perfect the result.

Retouching and Enhancing Images

Figure 76 *Selecting the buoy*

Image courtesy of Chris Botello. Source Adobe® Photoshop®, 2013.

Figure 77 *Fill dialog box set for a Content-Aware fill*

Source Adobe® Photoshop®, 2013.

Execute content-aware fills

1. Open AP 8-6.psd, then save it as **Bali Seaweed Farmer**.

 Note the large rock in the upper-left area of the image and the white buoy in the upper-right.

2. Draw a rectangular marquee around the buoy, as shown in Figure 76.

 With a content-aware fill, you need only make a simple selection around the object you want to remove. You must draw the selection so that it includes some of the area surrounding the object.

3. Click the **Edit menu**, then click **Fill**.

4. Click the **Use list arrow**, then click **Content-Aware**.

 Your Fill dialog box should resemble Figure 77.

 (continued)

5. Click **OK**.

 The selection is filled with "water." Photoshop has created this fill as new data based on the surrounding data.

6. Click the **Select menu**, click **Load Selection**, then load the selection named **Rock**.

 The selection was made quickly with the Lasso tool. Note that it extends the rock slightly on all sides to include the surrounding water.

7. Execute a content-aware fill, then compare your image to Figure 78.

8. Open AP 8-7.psd, then save it as **Bali Beach Girl**.

9. Use content-aware fills to remove the three circled swimmers in the water, circled in Figure 79.

10. Use the **Lasso tool** 🔲 to select the girl in the foreground.

 (continued)

Figure 78 *Image after the fill*

Image courtesy of Chris Botello. Source Adobe® Photoshop®, 2013.

Figure 79 *Identifying areas to be filled*

Image courtesy of Chris Botello. Source Adobe® Photoshop®, 2013.

Retouching and Enhancing Images

Figure 80 *Results of removing the girl*

Image courtesy of Chris Botello. Source Adobe® Photoshop®, 2013.

Figure 81 *Selecting the umbrella for a content-aware fill*

Image courtesy of Chris Botello. Source Adobe® Photoshop®, 2013.

Figure 82 *Umbrella selection filled with "rocks"*

Image courtesy of Chris Botello. Source Adobe® Photoshop®, 2013.

11. Use a content-aware fill to remove the girl from the scene.

 As shown in Figure 80, the content-aware fill does a great job in removing the girl, but the result is not "perfect." You would need to do some extra work with the other cloning tools to make the final results untraceable.

12. Open AP 8-8.psd, then save it as **Umbrella**.

13. Use the **Polygonal Lasso tool** to select around the umbrella as shown in Figure 81.

14. Execute a content-aware fill.

15. Compare your results to Figure 82.

 The figure shows a good example of how the content-aware fill works. It's obvious that some of the rocks in the fill are direct copies of rocks in other areas of the image. However, the fill is not a continuous clone—it's random. Imagine trying to get to this point on your own without the content-aware fill. Imagine trying to do this with a copy/paste or with the Clone Stamp tool, and you'll appreciate how powerful this feature is.

16. Save all your work and close all open files.

Lesson 9 Employ Content-Aware Techniques

Execute a content-aware clone with the Spot Healing Brush tool

1. Open AP 8-9.psd, then save it as **Spot Healing Brush**.

2. Note the white scratch on the jaw line, circled in Figure 83.

 This is an actual scratch that was in the photograph, downloaded from a photography website. In this case, the photo has been modified with a Black and White adjustment. This is a great example of a real-world challenge—finding a great photo but having to fix damage. The scratch is a problem that needs to be addressed. It would be difficult to fix it with the Clone Stamp tool, but the Spot Healing Brush tool will work well in this instance.

 (continued)

Figure 83 *Identifying the scratch to be fixed*

Retouching and Enhancing Images

Figure 84 *Fixing the first half of the scratch*

Figure 85 *The scratch completely removed*

3. Create a new layer above the Background layer, then name it **Spot Healing Brush**.

4. On the Tools panel, click the **Spot Healing Brush tool** .

5. On the Options bar, verify that both the **Content Aware** and **Sample All Layers** options are chosen on the Options bar.

6. Drag the **Spot Healing Brush tool** half way up the scratch, as shown in Figure 84, then release the mouse button. The scratch is removed and replaced with data from surrounding areas of the image.

7. Continue dragging over the scratch so that your image resembles Figure 85.

 As shown in the figure, the Spot Healing Brush tool does a very good job removing the scratch.

8. Save your work, then close Spot Healing Brush.psd.

Retouch with the Overlay
BLENDING MODE

What You'll Do

© 2013 Cengage Learning. Source Adobe® Photoshop®, 2013.

Tough cloning challenges usually involve areas that are too small to sample and clone effectively. You will find that in some cases, none of the cloning tools are sufficient to meet the cloning challenge.

In an earlier lesson, you learned about enhancing an image with the "Overlay Detail" technique. As we discussed, when you create a layer set to the Overlay blending mode, painting white or black in the layer paints "light" and "dark" over any artwork on layers below. This technique has a powerful application as a retouching solution and is referred to as "Overlay Retouching."

In many cases, especially involving faces, areas that you want to remove are visible because they are darker or lighter than surrounding areas. For example, wrinkles are visible as darker lines on a face, whereas shiny areas are visible as lighter areas. Using the Overlay blending mode, you can use the accuracy of a paint brush to lighten or darken problem areas to make them better match surrounding areas.

One of the key components to remember about the Overlay Retouching technique is that there's no sampling and no cloning involved. Therefore there's no unwanted softening or blurring of the image that often happens with the soft-edge cloning tools.

Retouching and Enhancing Images

Figure 86 *Brush settings on the Options bar*

*Enable airbrush-style
build-up effects button*

AUTHOR'S NOTE

Using the Content-Aware Move Tool

A great new addition to Photoshop's content-aware abilities is the CS6 introduction of the Content-Aware Move tool, located on the Tools panel behind the Spot Healing Brush tool. In many ways, the tool works like a combination of content-aware fills and content-aware cloning. Let's say you have a picture of three ducks on a pond, two of them close together and the third too far away from the other two. You could draw a marquee around the third duck, then move it closer to the other two ducks. With the Content-Aware Move tool, the area left behind will fill with pixels that match the surrounding background. The selection of the duck, once moved, will automatically transition to the new location, much like a content-aware clone. Like all content-aware behavior, the Content-Aware Move tool offers a giant step towards the goal you're trying to achieve. It's seldom a turn-key solution, but it will usually get you 80% of the way there, and then you can use other tools to complete the challenge.

Use the Overlay Retouching technique on a difficult image

1. Open AP 8-10.psd, then save it as **Overlay Retouching**.

2. Assess the image for retouching to remove the freckles.

 Trying to remove the freckles with any of the cloning tools would be nearly impossible, because there are so many freckles in so many areas and no freckle-free areas to sample from. In addition to the freckles, there's a dark line under the bottom lip, and there's a light stray hair over the eyebrow at screen right. Fixing this image would qualify as a legitimate challenge.

3. Hide and show the **Black and White 1** adjustment layer.

 The Overlay Retouching technique is especially effective on black and white or desaturated images. Be sure the Black and White 1 adjustment layer is showing when you are done.

4. Create a new layer above the Spot Healing Brush layer.

5. Name the new layer **Overlay Retouch**, then set its blending mode to **Overlay**.

6. Click the **Brush tool**, set the Size to **7 px**, then set the Hardness to **0%**.

7. Set the Opacity to **5%**, then click the **Enable airbrush-style build-up effects button** on the Options bar as shown in Figure 86.

 (continued)

8. Zoom in so that you are viewing the image at a minimum of 100%.

 The Overlay Retouching technique is all about subtle moves. You'll work with a small brush at low opacity. The Enable airbrush-style option makes the Brush tool paint continuously when you hold down the mouse button—much like a conventional airbrush. For this exercise, you're gradually painting over the image to lighten or darken it, and the Enable airbrush-style option is useful because it will make the brush paint continuously.

9. Press [**D**] on your keypad, then press [**X**] to set the foreground color to white.

10. Using small strokes, paint over a dark freckle area to gradually lighten it.

 When you make the first stroke, you won't see a change. But as you continue to paint, you will see that the dark area gradually lightens. Continue painting until the dark area matches the surrounding area.

11. Continue painting to remove all or most of the freckles in the image.

 Feel free to enlarge or reduce the size of the brush as you think necessary. You can increase the opacity slightly. Remember that this technique is all about a gradual build up; that's what makes it invisible. The goal is not to try to lighten a freckle in one move. Be sure to read the Author's Note: Mastering the Technique.

 (continued)

Figure 87 *Image before and after retouching*

© 2013 Cengage Learning. Source Adobe® Photoshop®, 2013.

AUTHOR'S NOTE

Mastering the Technique

It will seem at first that the Overlay Retouching technique will take forever to complete the image. You'll be surprised, however, at how quickly you will adapt to the technique, especially if you are using a pen tablet. If you are using a pen tablet, experiment with pressure sensitivity and other options in the Brush panel. This technique requires a little bit of patience and practice from you. Once you get the feel for how gradually the dark areas lighten, you'll find that you can work quite rapidly in tackling the challenge. But make no mistake—this level of retouching is never a quick fix. Any good retoucher faced with this challenge would expect to put in at least thirty minutes of Overlay Retouching to remove the freckles.

Retouching and Enhancing Images

© 2013 Cengage Learning. Source Adobe® Photoshop®, 2013.

12. Using the same technique, lighten the dark line under the bottom lip.

13. Using the same technique, lighten the dark lines in the whites of the eyes.

 This is another area that would be difficult to fix with the cloning tools but is effectively remedied with this technique.

14. Switch to a black foreground color, then paint to remove the white line over the eyebrow at screen right.

 Don't try to paint one dark line to remove the white hair. Instead, use the dark paint to break up the continuity of the line. The more and more you break up the line, the more it will disappear into the eyebrow.

15. Use Figure 87 on the left and right pages of this spread as a reference for your work.

 The retouched artwork in Figure 87 was completed exclusively with the Overlay Retouching technique. The final result took about 45-55 minutes to complete.

16. Save your work.

Use the Overlay Retouching technique on a color image

1. Click the **File menu**, click **Save As**, then save the file as **Overlay Retouching Color**.

2. Hide the Black and White 1 adjustment layer, then compare your image to Figure 88.

 The technique is remarkably effective on the color image. However, because the Overlay blending mode increases contrast, areas where you painted white are more saturated and the color is slightly "hotter" and bright orange.

3. Target the **Overlay Retouch layer**, then change its blending mode to **Soft Light**.

 The retouching becomes much more subtle, but the freckles become visible again. You can think of the Soft Light blending mode as a reduced version of the Overlay blending mode. Soft Light works within the same basic parameters, but it's not as extreme. It doesn't increase contrast as dramatically, so the retouched areas do not appear more saturated.

 (continued)

Figure 88 *Retouching in Overlay mode*

Figure 89 *Duplicated retouching in Soft Light mode*

Lesson 10 Retouch with the Overlay Blending Mode

4. Press **[Ctrl][J]** (Win) or ⌘ **[J]** (Mac) to duplicate the Overlay Retouch layer, then compare your result to Figure 89, which shows a before/after view of the retouching.

 Duplicating the layer doubles the strength of the soft-light content. The color image is effectively retouched, and the painted areas do not appear overly saturated as they did in Overlay mode. At this point, if this were a real world exercise, you would be perfectly able to retouch any remaining problem areas with the conventional cloning tools.

5. Save your work, then close Overlay Retouching Color.psd.

1. Open AP 8-11.psd, then save it as **Red Boy**.
2. Whiten the eyes and increase the saturation on the irises.
3. Use the overlay detail method to add detail to the irises.
4. Reduce the harsh lines and bluish tones under the boy's eyes.
5. Create a new, unclipped Hue/Saturation adjustment layer.
6. Overlay the new adjustment layer so that the red cheeks, ears, and chin get darker and redder.
7. Duplicate the Green channel, then name it **Hot Spots**.
8. Invert the channel.
9. Open the Levels dialog box, then make the whites whiter, the blacks blacker, and the midtones darker.
10. Blacken out the areas that you don't want to be affected. (*Hint*: Figure 90 shows one example of the selection mask.)
11. Click the RGB layer thumbnail, then delete the Hue/Saturation adjustment layer.
12. Load the Hot Spots channel as a selection, apply a 4-pixel feather, then hide the selection.
13. Create a new unclipped Hue/Saturation adjustment layer.
14. On the Properties panel, click the Master list arrow, then choose Reds. (*Hint*: For this image, we are going to modify specifically the red hues in the selection.)
15. Drag the Hue slider to +14.
16. Open the Curves dialog box, increase the contrast to a degree that you feel improves the image, then click OK.
17. Compare your results to Figure 91.
18. Save your work, then close Red Boy.psd.

Figure 90 *Selection mask*

Source Adobe® Photoshop®, 2013. Getty Images, Barbara Maurer

Figure 91 *Completed Project Builder 1*

Source Adobe® Photoshop®, 2013. Getty Images, Barbara Maurer

1. Open AP 8-12.psd, then save it as **Teeth Project**.
2. Click the Rectangular Marquee tool, then make a square marquee that selects the entire mouth.
3. Click the Edit menu, then click Copy Merged.
4. Paste, then name the new layer **Square Off Teeth**.
5. Zoom in, click the Pen tool, then draw a path that represents the shape of the top-right row of teeth as you would want them to be. (*Hint*: Figure 92 shows one example of the path.)
6. Convert the path to a selection with no feather, then use the Clone Stamp tool to clone the original teeth into the new shape.
7. Use the Clone Stamp tool, the Pencil tool, the Sponge tool (set to Desaturate) or a combination of the three to remove the yellow stains between the teeth. (*Hint*: Be sure you don't remove the lines between the teeth.)
8. Paint out or clone out the bent bottom tooth where it breaks the line between the top row of teeth and the bottom row of teeth.
9. Click the Pen tool, then draw a path around the tooth to the right of the original bent tooth. (*Hint*: Figure 93 shows an example of the path.)
10. Convert the path to a selection with no feather, copy, paste a new layer, then name the new layer **Fix Bottom Row**.
11. Scale the new tooth slightly, then stretch it horizontally so that its left edge aligns with the line between the top two front teeth.
12. Use a layer mask, if necessary, to hide any of the unwanted areas of the copy.
13. Create a new layer, name it **Darken Lipstick**, then set the layer to the Overlay blending mode.
14. Paint with the overlay detail technique to darken the lipstick over the entire mouth and to make it all more consistent in color.
15. Click the Pen tool, then draw a path around the lips.
16. Tweak the path to improve the shape of the top lip. (*Hint*: Figure 94 shows an example of the path.)
17. Convert the path to a selection with no feather, copy, then paste a new layer named **Improve Edge**.
18. Use the Clone Stamp tool, the Paint Brush tool, or a combination of both to increase the lips to fill the new selection.
19. Click the Rectangular Marquee tool, then select the right half of the mouth.
20. Click the Edit menu, then click Copy Merged.
21. Paste the selection, then name the new layer **Flip Horizontal**.
22. Click the Edit menu, point to Transform, then click Flip Horizontal.
23. Reposition the artwork to create the left side of the mouth.
24. Duplicate the Flip Horizontal layer, name the new layer **Distort**, then hide the Flip Horizontal layer.
25. Target the Distort layer, then distort or rotate or scale (or any combination of the three transformations) the artwork so that it is no longer a perfect mirror image of the right side of the mouth.
26. Add a layer mask, then mask out the lipstick on the Distort layer to show as much of the original lipstick as you can while maintaining realism.
27. Compare your results to Figure 95.
28. Save your work, then close Teeth Project.psd.

Figure 92 *Clipping path for top row*

Source Adobe® Photoshop®, 2013. Getty Images,
Steve McAlister

Figure 93 *Clipping path for bottom tooth*

Source Adobe® Photoshop®, 2013. Getty Images,
Steve McAlister

Figure 94 *Clipping path for lips*

Source Adobe® Photoshop®, 2013. Getty Images,
Steve McAlister

Figure 95 *Completed Project Builder 2*

Source Adobe® Photoshop®, 2013. Getty Images,
Steve McAlister

(banned)

CHAPTER 9 CREATING SPECIAL EFFECTS

1. Work with smart filters.
2. Create a solarize effect.
3. Create mezzotint and halftone effects.
4. Create neon effects.
5. Create a ripped effect.
6. Create monotones and duotones.
7. Create a high dynamic range (HDR) composite.

Work with SMART FILTERS

What You'll Do

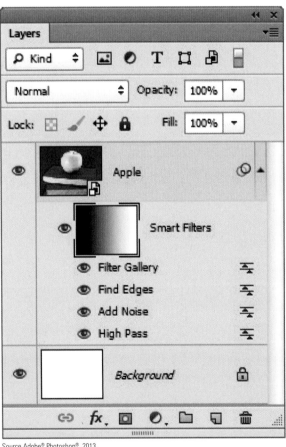

Source Adobe® Photoshop®, 2013.

Photoshop has long offered non-destructive adjustment layers, allowing you to apply curves, hue/saturation, and levels adjustments, among many others, without permanently affecting the artwork beneath. Another big key with adjustment layers is that the adjustment is editable: You can go back at any time and modify the adjustment.

The Smart Filters feature applies this same concept to filters. You can apply filters without permanently altering the original image. Just as with adjustment layers, you can go back and modify the filter at any time. And an important added bonus with Smart Filters is the default layer mask, which allows you to show or mask the filter to control how it affects the artwork beneath.

Creating Special Effects

Figure 1 *Converting a layer to a Smart Object*

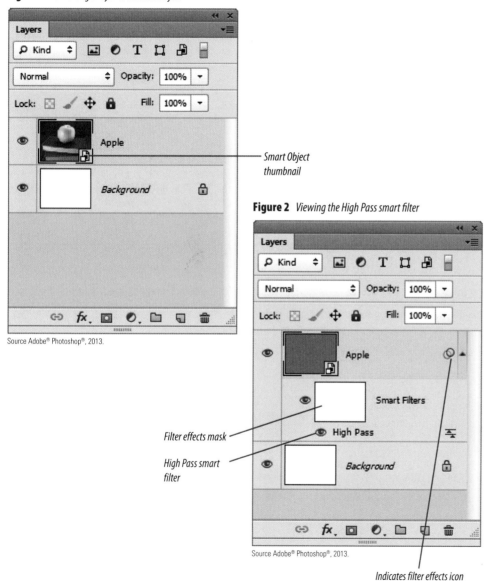

Smart Object
thumbnail

Source Adobe® Photoshop®, 2013.

Figure 2 *Viewing the High Pass smart filter*

Filter effects mask

High Pass smart
filter

Source Adobe® Photoshop®, 2013.

Indicates filter effects icon

Create and apply smart filters

1. Open AP 9-1.psd, then save it as **Smart Filters**.

2. Target the **Apple layer**, click the **Filter menu**, click **Convert for Smart Filters**, then click **OK** in the warning box that follows.

 In order to apply smart filters, a layer must first be converted to a smart object. The Apple layer now includes an icon called Smart Object thumbnail, as shown in Figure 1.

3. Click the **Filter menu**, point to **Other**, then click **High Pass**.

4. Type **2.0** in the Radius text box, then click **OK**.

 As shown in Figure 2, a new Smart Filters layer appears beneath the Apple layer. The High Pass smart filter is listed under the Smart Filters layer.

5. Double-click the **icon** ⤓ to the right of High Pass on the Layers panel.

 The Blending Options (High Pass) dialog box opens.

6. Click the **Mode list arrow**, click **Overlay**, then click **OK**.

 Applying the High Pass filter with the Overlay blending mode is a standard sharpening technique that we explored in Chapter 6 without using smart filters.

7. Click the **Toggle all smart filter visibilities icon** 👁 repeatedly to hide and show the High Pass smart filter.

 The artwork on the Apple layer exists independently from the High Pass filter. The smart filter can be shown or hidden.

 (continued)

TIP Be sure that the High Pass filter is showing when you complete this step.

8. Click the **Filter menu**, point to **Noise**, then click **Add Noise**.

9. Enter the settings shown in Figure 3, then click **OK**.

10. Compare your Layers panel to Figure 4.

 The Add Noise smart filter is listed above the High Pass smart filter. Photoshop applies smart filters from the bottom up. In this case, that means that the High Pass filter is applied to the apple artwork first, then the Add Noise filter is applied.

11. Save your work.

Modify smart filters

1. Double-click **High Pass** on the Layers panel.

2. If a warning dialog box appears, click the **Don't show again check box**, then click **OK**.

 The High Pass filter dialog box opens showing the setting – Radius 2.0 – previously applied.

3. Type **4** in the Radius text box, then click **OK**.

4. Double-click the **Add Noise filter** to open the dialog box.

5. Click the **Monochromatic check box** to activate it, then click **OK**.

 As shown in Figure 5, the artwork reflects the changes in both filters.

6. Save your work.

Figure 3 *Add Noise settings*

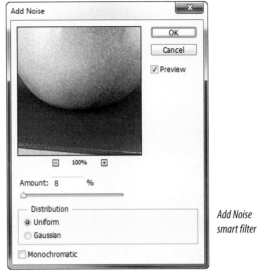

Image © 2013 Cengage Learning. Source Adobe® Photoshop®, 2013.

Figure 4 *Viewing the Add Noise smart filter*

Add Noise smart filter

Image © 2013 Cengage Learning. Source Adobe® Photoshop®, 2013.

Figure 5 *Viewing the result of changing both smart filters*

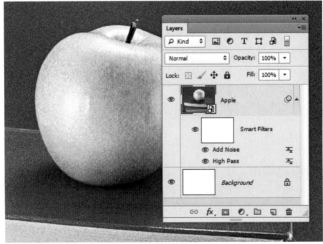

Image © 2013 Cengage Learning. Source Adobe® Photoshop®, 2013.

Creating Special Effects

Figure 6 *Crosshatch filter settings*

Figure 7 *Viewing the Filter Gallery/Crosshatch smart filter applied*

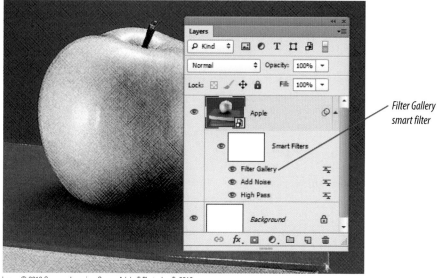

Filter Gallery smart filter

Lesson 1 Work with Smart Filters

Reorder smart filters

1. Verify that the Apple layer is targeted on the Layers panel.

2. Click the **Filter menu**, point to **Filter Gallery**, click the **Brush Strokes folder** to open it, then click **Crosshatch**.

3. Enter the settings shown in Figure 6, then click **OK**.

 The Filter Gallery smart filter is listed on the Layers panel, above Add Noise and High Pass.

4. Double-click the **icon** ⥮ to the right of Filter Gallery on the Layers panel.

 The Blending Options (Filter Gallery) dialog box opens.

5. Click the **Mode list arrow**, then click **Color Burn**.

6. Set the Opacity value to **50%**, click **OK**, then compare your screen to Figure 7.

 The Filter Gallery smart filter is applied at 50% opacity with the Color Burn blending mode.

7. Click the **Filter menu**, point to **Stylize**, then click **Find Edges**.

 The Find Edges smart filter is listed on the Layers panel, above Filter Gallery, Add Noise, and High Pass.

 (continued)

8. Double-click the **icon** 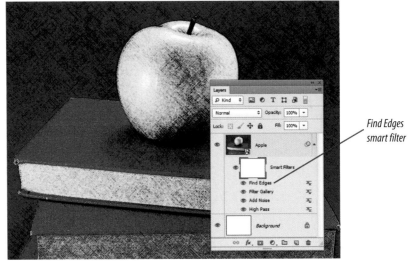 to the right of Find Edges on the Layers panel.

9. Click the **Mode list arrow**, click **Overlay**, type **75** in the Opacity dialog box, then click **OK**.

 Figure 8 shows the results of applying the four smart filters to the artwork in the order shown on the Layers panel.

10. Drag the **Find Edges smart filter** below the Filter Gallery smart filter, then compare your result to Figure 9.

 The artwork reflects the change in order of the smart filters. The Crosshatch smart filter is now being applied to the artwork after the Find Edges smart filter is applied.

11. Save your work.

Figure 8 *Viewing the image with the Find Edges smart filter applied*

Find Edges smart filter

Image © 2013 Cengage Learning. Source Adobe® Photoshop®, 2013.

Figure 9 *Viewing the image with the Find Edges smart filter relocated*

Find Edges smart filter

Image © 2013 Cengage Learning. Source Adobe® Photoshop®, 2013.

Creating Special Effects

Figure 10 *Targeting the filter effects mask on the Smart Filters layer*

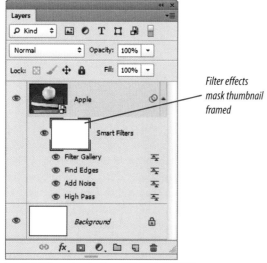

Filter effects mask thumbnail framed

Image © 2013 Cengage Learning. Source Adobe® Photoshop®, 2013.

Figure 11 *Viewing all smart filters being applied through the layer mask*

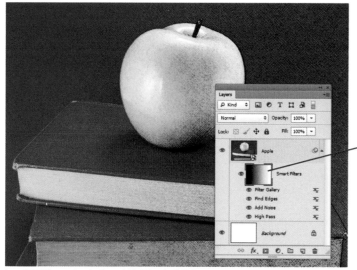

Black-to-white blend added to filter effects layer mask

Image © 2013 Cengage Learning. Source Adobe® Photoshop®, 2013.

Lesson 1 Work with Smart Filters

Use a layer mask with smart filters

1. Click the **Filter effects mask thumbnail** on the Smart Filters layer so that it is framed, as shown in Figure 10.

2. On the Tools panel, set the foreground color to black and the background color to white.

3. Create a black-to-white blend from the left edge of the image to the right edge of the image.

 A black-to-white blend is added to the filter effects mask on the Layers panel.

4. Compare your results to Figure 11.

 As shown in the figure, all of the four filters are masked on the left edge and gradually become visible from left to right.

5. Hide and show the Smart Filters layer on the Layers panel.

 The original artwork is not permanently affected by the smart filters.

6. Save your work, then close Smart Filters.psd.

Create a
SOLARIZE EFFECT

What You'll Do

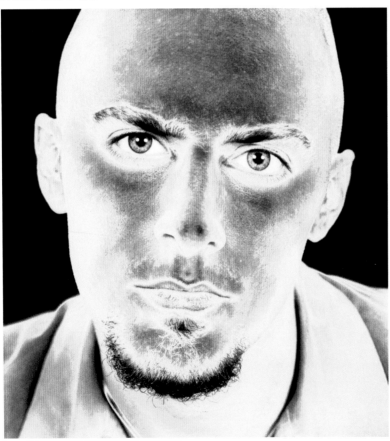

Source Adobe® Photoshop®, 2013. Getty Images, Ken Weingart

Solarize is a filter that has been available since the first release of Photoshop. It mimics a long-established effect in photography: mixing both the positive areas with negative areas. What's really interesting is that you can use the Curves adjustment to reproduce the Solarize filter's effect or to create your own version of the effect. The Solarize filter does not offer settings that you can adjust. It simply executes an algorithm and you are stuck with the results. However, because the solarize effect can be created and manipulated with curves, this gives you the power to create a customized solarize effect that is just right for a given image.

Figure 12 *Image inverted*

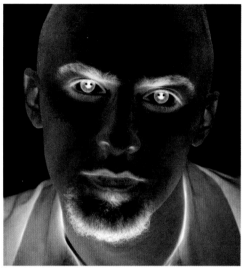

Source Adobe® Photoshop®, 2013. Getty Images, Ken Weingart

Figure 13 *Image with the Solarize filter applied*

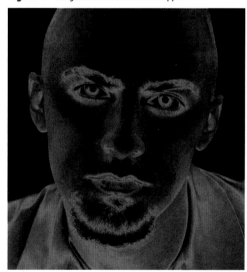

Source Adobe® Photoshop®, 2013. Getty Images, Ken Weingart

Solarize an image

1. Open AP 9-2.psd, then save it as **Solarize**.
2. Convert to Grayscale mode, click **Don't Flatten** in the first warning box and then click **Discard** in the second warning box.
3. Convert back to RGB Color mode, then click **Don't Flatten** in the warning box.
4. Show and target the **Invert layer**, click the **Image menu**, point to **Adjustments**, click **Invert**, then compare your result to Figure 12.

 Note especially the dark areas that have become white, such as the man's beard and eyebrows.
5. Hide the Invert layer, then show and target the **Solarize layer**.
6. Click the **Filter menu**, point to **Stylize**, click **Solarize**, then compare your result to Figure 13.

 With the Solarize filter, the light areas of the image are inverted, while the dark areas are not affected. If you compare this to the fully inverted image in Figure 12, you can see the difference. Note how the dark areas of the beard and the black pupils in his eyes remained black.
7. Hide the Solarize layer, then target the **Background layer**.

 You're going to recreate the Solarize effect with a Curves adjustment.

(continued)

8. Click the **Create new fill or adjustment layer button** on the Layers panel, then click **Curves**.

9. Click the **pencil icon** on the Properties panel, then click the lower-left corner of the grid.

10. [Shift]-click the center point of the grid, then [Shift]-click the lower-right corner of the grid so that your Properties panel resembles Figure 14.

 This curve is easy to "read." From 0–128, nothing has changed. From 129–255, everything has been inverted—the curve moves downward instead of upward, meaning the pixels move back toward black rather than toward white.

11. Compare your canvas to Figure 15.

 The result is identical to Figure 13, because this is the exact curve Photoshop uses to apply the Solarize filter. However, using the Curves adjustment to solarize opens up many options for manipulating the effect.

12. On the Properties panel, starting at the lower-left corner, redraw the curve so that it resembles Figure 16.

 The shadow half of the curve is shortened by this move, and the dark areas of the image are therefore darkened. It's an interesting move, but with a Solarize effect, the goal is usually to create a "silver" person or image, which involves brightening, not darkening the image.

 (continued)

Figure 14 *Standard solarize curve*

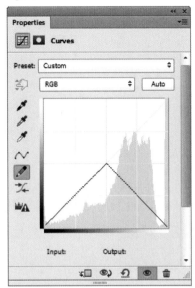

Source Adobe® Photoshop®, 2013.

Figure 15 *Image solarized*

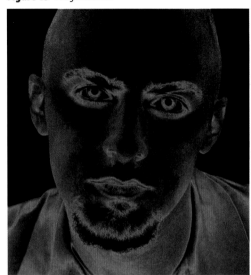

Source Adobe® Photoshop®, 2013. Getty Images, Ken Weingart

Figure 16 *Darkening the solarize effect*

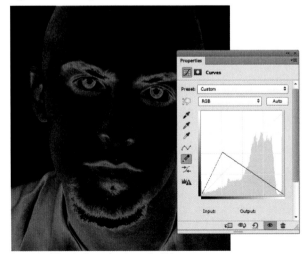

Source Adobe® Photoshop®, 2013. Getty Images, Ken Weingart

Figure 17 *Lightening the solarize effect*

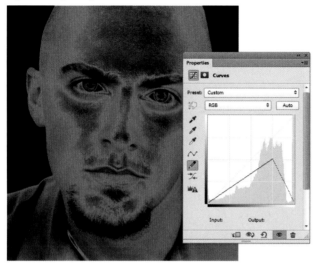

Source Adobe® Photoshop®, 2013. Getty Images, Ken Weingart

Figure 18 *Lightening the effect substantially*

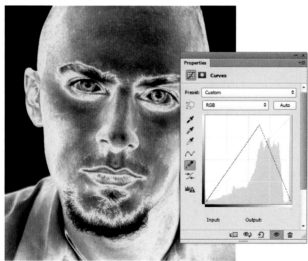

Source Adobe® Photoshop®, 2013. Getty Images, Ken Weingart

13. Using the same method, redraw the curve so that it resembles Figure 17.

 This move is more in the right direction to achieve the silver effect, and actually has a more interesting effect on the image than the standard Solarize filter. Note how the cheeks, eyes and eyebrows are starting to take on a distinct glow.

14. Redraw the curve to match Figure 18.

 Using the curve to create the effect, you are able to modify the curve to increase the glowing effect dramatically.

15. Click the **Create new fill or adjustment layer button** ⬤ on the Layers panel, then click **Solid Color**.

(continued)

16. Type **255R/216G/0B**, click **OK**, set the new layer's blending mode to **Overlay**, then compare your artwork to Figure 19.

17. Click the **Brush tool** , set the Opacity to **100%**, then set the foreground color to black.

18. Using the layer mask beside the curves adjustment layer, mask the solarization effect over the eyes so that your artwork resembles Figure 20.

 Since the solarize effect at this point is very extreme, we can always reduce the contrast by adjusting the curve.

19. Redraw the curve as shown in Figure 21.

20. Compare your result to Figure 22.

21. Save your work, then close Solarize.psd.

Figure 19 *Applying a color fill*

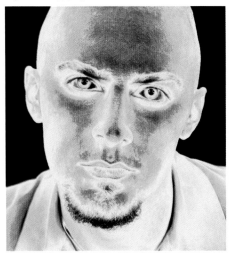

Source Adobe® Photoshop®, 2013. Getty Images, Ken Weingart

Figure 21 *Reducing the effect in the highlights*

Source Adobe® Photoshop®, 2013.

Figure 20 *Masking the effect from the eyes*

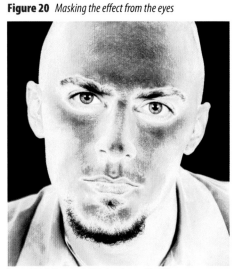

Source Adobe® Photoshop®, 2013. Getty Images, Ken Weingart

Creating Special Effects

Figure 22 *Final effect*

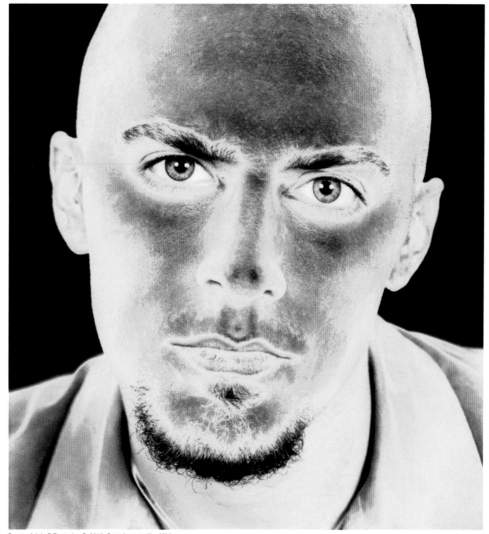

Source Adobe® Photoshop®, 2013. Getty Images, Ken Weingart

Create Mezzotint and HALFTONE EFFECTS

What You'll Do

Source Adobe® Photoshop®, 2013. Getty Images, Barbara Maurer

Mezzotints and halftoning are long-established procedures in the world of printing and prepress. Of the two, you are certainly most familiar with halftoning. A continuous-tone image is reproduced with dots of ink that are various sizes. In prepress and printing, a mezzotint is a screening technique that you can use as an alternative to a conventional halftone. As a special effect, it's a great alternative to applying a conventional grain overlay and still, after all these years, a beautiful, classic effect. Photoshop's blending modes—Overlay and Soft Light—have made it much quicker and easier to apply these filters in a way that *integrates* the effect with the base image.

Figure 23 *Mezzotint filter*

Source Adobe® Photoshop®, 2013. Getty Images, Barbara Maurer

Figure 24 *Mezzotint filter in Overlay mode*

Source Adobe® Photoshop®, 2013. Getty Images, Barbara Maurer

Create a Mezzotint effect

1. Open AP 9-3.psd, then save it as **Mezzotint**.
2. Duplicate the Background layer, then name the new layer **Mezzotint**.

TIP If you like, feel free to execute the following steps with smart filters.

3. Click the **Filter menu**, point to **Pixelate**, then click **Mezzotint**.
4. Verify that the Type is set to **Fine Dots**, click **OK**, then compare your result to Figure 23.
5. Zoom in on the effect so that you can see the pixels.

 The effect produced by the Mezzotint filter is often called a "bitmap effect" because it renders the image with only black or white pixels. Though this file is in Grayscale mode—256 shades of gray available per pixel—there are no gray pixels that make up the filtered image.

6. Zoom out so that you are viewing the image at 50%.
7. Set the blending mode on the Mezzotint layer to **Overlay**, then compare your result to Figure 24.

 Overlayed, the Mezzotint effect produces a grainy, high-contrast image with bright whites, dark blacks, and very few midtones.

(continued)

8. Change the blending mode to **Soft Light**, then compare your result to Figure 25.

 The Soft Light blending mode produces a much softer grain effect with less contrast and more detail in the midtones.

9. Save your work, then close Mezzotint .psd.

Create a halftone effect

1. Open AP 9-4.psd, then save it as **Halftone**.

2. Duplicate the Background layer, then name the new layer **Halftone**.

3. Click the **Filter menu**, point to **Pixelate**, then click **Color Halftone**.

4. Type **4** in the Max. Radius text box, click **OK**, then compare your result to Figure 26.

5. Convert the file to RGB Color mode, then click **Don't Flatten** in the dialog box that follows.

TIP Throughout this chapter, always click Don't Flatten when prompted.

6. Zoom in on the image so that you can see the pixels.

 Unlike with the Mezzotint filter, the Color Halftone filter produces both black and gray pixels to create the effect.

 (continued)

Figure 25 *Mezzotint filter in Soft Light mode*

Source Adobe® Photoshop®, 2013. Getty Images, Barbara Maurer

Figure 26 *Color Halftone filter*

Source Adobe® Photoshop®, 2013. Getty Images, Barbara Maurer

Creating Special Effects

Figure 27 *The Blue, Red, Yellow gradient*

Image courtesy of Chris Botello. Source Adobe® Photoshop®, 2013.

7. Click the **Magic Wand tool**, type **8** in the Tolerance text box, then verify that the Anti-alias and Contiguous check boxes are not checked.

8. Click a white pixel.

 All of the white pixels in the image are selected.

9. Click the **Select menu**, then click **Inverse**.

 All of the non-white pixels that make up the filtered image are selected.

10. Zoom out so that you are viewing the image at 50%.

11. Copy, paste a new layer, then name the new layer **Halftone Transparent**.

 With this step, you have isolated the filtered image on a transparent layer—the pixels that were originally white are now transparent.

12. Delete the Halftone layer, then create a new layer named **BRY Gradient** above the Halftone Transparent layer.

13. Click the **Gradient tool**, click the **Gradient picker list arrow** on the Options bar, then click the **Blue, Red, Yellow gradient**.

14. Drag the **Gradient tool pointer** from the upper-left corner to the bottom-right corner of the canvas so that your result resembles Figure 27.

(continued)

15. Clip the BRY Gradient layer into the Halftone Transparent layer so that your canvas resembles Figure 28.

16. Select both the Halftone Transparent and the BRY Gradient layers on the Layers panel, click the **Layers panel menu button** then click **Merge Layers**.

17. Change the blending mode on the new merged layer to **Overlay**.

18. Compare your result to Figure 29.

19. Save your work, then close Halftone.psd.

Figure 28 *Clipping the gradient into the filtered artwork*

Source Adobe® Photoshop®, 2013. Getty Images, Barbara Maurer

Figure 29 *Overlaying the merged artwork*

Source Adobe® Photoshop®, 2013. Getty Images, Barbara Maurer

Creating Special Effects

Figure 30 *Final variation*

Source Adobe® Photoshop®, 2013. Getty Images, Barbara Maurer

Create a variation of a halftone effect

1. Open AP 9-4.psd, then save it as **Halftone Variation**.

2. Duplicate the Background layer, then name the new layer **Halftone**.

3. Click the **Filter menu**, point to **Pixelate**, then click **Color Halftone**.

4. Type **4** in the Max. Radius text box, then click **OK**.

5. Convert the file to RGB Color mode.

6. Create a new layer named **BRY Gradient** above the Halftone layer.

7. Click the **Gradient tool** , click the **Gradient picker list arrow** on the Options bar, then click the **Blue, Red, Yellow gradient**.

8. Drag the **Gradient tool pointer** from the upper-left corner to the bottom-right corner of the canvas.

9. Change the blending mode on the BRY Gradient layer to **Overlay**.

10. Merge the BRY Gradient and the Halftone layers, then set the blending mode on the merged layer to **Overlay**.

11. Compare your result to Figure 30.

12. Save your work, then close Halftone Variation.psd.

Create Neon
EFFECTS

What You'll Do

Image courtesy of Chris Botello. Source Adobe® Photoshop®, 2013.

Neon effects are another Photoshop staple, one that you've been able to do one way or another since the first release. They make for stunning special effects, and they're practical because they work so well with type. Neon is effective and it's classic: it can be used as a title treatment for many different types of projects.

Many books and manuals supply tips and tricks for creating simple neon effects—and that's the problem. They stop at the simple, which usually involves using the basic Inner Glow or Outer Glow layer styles. But if you spend some time driving around and noticing the many types of neon signs in the real world, you'll see soon enough that you can get a lot more creative than simply applying a layer style.

That's what this lesson is about—creating a complex neon effect. You'll explore complex design concepts that will lead you to a multilayered effect that shines and fades and glows hot.

Creating Special Effects

Figure 31 *Path 2 stroked with Top Blue*

Image courtesy of Chris Botello. Source Adobe® Photoshop®, 2013.

Create a neon effect

1. Open AP 9-5.psd, then save it as **Neon**.
2. Display the Paths panel, then click **Path 2** to activate it.
3. Create a new foreground color that is **0R/127G/254B**, then save it in the Swatches panel as **Top Blue**.

TIP To add a color to the Swatches panel, click the Swatches panel menu button, then click New Swatch, enter a name in the Color Swatch Name dialog box, then click OK, or click the Paint Bucket tool and then click an empty section on the Swatches panel. You will be prompted to name the color before you click the Swatches panel. The foreground color on the Tools panel is the color that will be added to the Swatches panel.

4. Click the **Brush tool** , then define a brush that is 28 pixels with a soft edge (0% hardness).

 Throughout this chapter, verify that your Brush tool is set to 100% Opacity and 100% Flow.
5. Create a new layer named **Top Blue 28px**.
6. Click the **Paths panel menu button** , then click **Stroke Path**.
7. Click the **Tool list arrow** in the Stroke Path dialog box, click **Brush**, then click **OK**.
8. Deactivate Path 2, then compare your result to Figure 31.

 The Stroke Path command strokes the path with the tool you select. It uses the tool's current settings for size, hardness, opacity, and so on, when creating the stroke.

(continued)

TIP For all the figures in this lesson, the path is deactivated so that you can better see the artwork. To avoid repetition, we won't continue to instruct you to deactivate your path when comparing it to a figure, though you can feel free to.

9. Create a new layer named **Top Border**.

10. Click **Path 1** to activate it, then click the **Stroke path with brush button** on the Paths panel.

 Like the Stroke Path command, the **Stroke path with brush button** strokes the path with the Brush tool using its current settings.

11. Compare your canvas to Figure 32.

 Had the two paths been combined as one path, we could have created this artwork with one stroke instead of two. However, it is necessary for the final artwork that we are able to access these two paths independently from one another.

12. Create a clipped Hue/Saturation adjustment layer named **Colorize** for the Top Border layer.

13. On the Properties panel, click the **Colorize check box**.

14. Set the Hue value to **0**, the Saturation value to **25**, the Lightness value to **0**, then compare your result to Figure 33.

(continued)

Figure 32 *Path 1 stroked with Top Blue*

Image courtesy of Chris Botello. Source Adobe® Photoshop®, 2013.

Figure 33 *Path 1 colorized*

Image courtesy of Chris Botello. Source Adobe® Photoshop®, 2013.

Figure 34 *Paths 1 and 2 stroked with White 19 pixels*

Image courtesy of Chris Botello. Source Adobe® Photoshop®, 2013.

15. Change the size on the Brush tool to **19 pixels**, then change the foreground color to white.
16. Create a new layer named **White 19px**.
17. Click **Path 1**, then click the **Stroke path with brush button** on the Paths panel.
18. Click **Path 2**, click the **Stroke path with brush button**, then compare your artwork to Figure 34.
19. Create a new layer group of the artwork named **Tubes**.

TIP Don't include the Background layer in the group.

20. Save your work.

AUTHOR'S NOTE

This is the point at which most books on Photoshop stop, with the neon "tubes" against a black background. It's a cool effect, but there's so much more you can do to enhance the effect by creating a reflection of the neon graphics, which is what we'll do in the next lesson.

Design a drop shadow for neon effects

1. Create a new foreground color that is **129R/156G/182B**, then save it in the Swatches panel as **Drop Blue**.

2. Increase the Brush tool size to **50 pixels**.

3. Hide the Tubes layer group.

4. Target the **Background layer**, then create a new layer named **Drop Blue 1 (50px)**.

5. Verify that Path 2 is active, click the **Path Selection tool** , click the letter **O**, then [Shift]-click the letter **P** so that your selection resembles Figure 35.

6. Click the **Paths panel menu button** , then click **Stroke Subpaths**.

7. Click **OK**, then compare your result to Figure 36.

(continued)

Figure 35 *Selecting only the O and P paths*

Image courtesy of Chris Botello. Source Adobe® Photoshop®, 2013.

Figure 36 *Stroking the subpaths*

Image courtesy of Chris Botello. Source Adobe® Photoshop®, 2013.

Creating Special Effects

Figure 37 *Selecting only the E and N paths*

Figure 38 *Stroking the subpaths*

Lesson 4 Create Neon Effects

8. Select the paths for the letter **E** and **N** so that your selection resembles Figure 37.

9. Create a new layer on the Layers panel, then name it **Drop Blue 2**.

10. Stroke the subpaths, then compare your results to Figure 38.

 The first two and the last two letters are on different layers.

11. Show the Tubes layer group, then target the **Drop Blue 1 (50px) layer**.

12. Click the **Filter menu**, point to **Other**, then click **Offset**.

13. Type **13** in the Horizontal text box, type **8** in the Vertical text box, then click **OK**.

14. Target the **Drop Blue 2 layer**, then return to the Offset dialog box.

(continued)

15. Type **-13** in the Horizontal text box, type **8** in the Vertical text box, then click **OK**.

16. Change the Opacity for both the Drop Blue layers to **50%**, then compare your artwork to Figure 39.

17. Target the **Background layer**, then create a new layer named **Drop Red 64px**.

18. Create a new foreground color that is **178R/39G/27B**, then save it in the Swatches panel as **Drop Red**.

19. Increase the Brush tool size to **64 pixels**, click **Path 1**, then stroke the path.

20. Set the layer's Opacity to **50%**, then compare your results to Figure 40.

21. Save your work.

Figure 39 *Final drop shadow effect*

Image courtesy of Chris Botello. Source Adobe® Photoshop®, 2013.

Figure 40 *Adding the red drop shadow*

Image courtesy of Chris Botello. Source Adobe® Photoshop®, 2013.

AUTHOR'S NOTE

If you compare Figure 40 to Figure 34, you'll see that the drop shadow behind the text and the glow behind the border goes a long way in enhancing the effect, mostly by creating a sense of depth. However, you must ask yourself, what is the neon shining against? What is the background that is reflecting that drop shadow? It's a key question when creating a neon effect, because you can use a background as a reflective surface to really make the neon glow.

Figure 41 *Fill Path dialog box*

Fill Path

Contents
Use: Foreground Color ▼

Custom Pattern: [] ▼

OK
Cancel

Blending
Mode: Normal ▼
Opacity: 100 %
☐ Preserve Transparency

Rendering
Feather Radius: 32 pixels
☑ Anti-alias

Figure 42 *Adding the reflective background surface*

Lesson 4 Create Neon Effects

Design a reflective background surface for a neon effect

1. Target the **Background layer**, then create a new layer named **Top Blue Fill**.
2. Change the foreground color to **Top Blue**, then click **Path 4** to activate it.
3. Click the **Paths panel menu button** ▾≣, then click **Fill Path**.
4. Enter the settings shown in Figure 41, then click **OK**.
5. Deactivate the path, change the Opacity on the layer to **25%**, then compare your artwork to Figure 42.

 Some neon signs are set within a metal box, and the neon light reflects off that surface. The fill that we added in Figure 42 represents that surface, and it is very effective in creating context for the drop shadow behind the neon text. The drop shadow now has a background to reflect off, and that gives us the opportunity to reflect even more dramatic colors off that surface.

(continued)

6. Create a new layer above the Top Blue Fill layer, then name the new layer **Drop Red 150px**.

7. Change the foreground color to **Drop Red**, then increase the Brush tool's size to **150 pixels**.

8. Stroke Path 1, change the layer's opacity to **33%**, then compare your result to Figure 43.

9. Create a new layer above Drop Red 150px, then name the new layer **Top Blue 150px**.

10. Change the foreground color to Top Blue, click **Path 2** to activate it, then stroke the path.

(continued)

Figure 43 *Adding the large glow behind the neon border*

Image courtesy of Chris Botello. Source Adobe® Photoshop®, 2013.

Figure 44 *Adding the large glow behind the neon text*

Image courtesy of Chris Botello. Source Adobe® Photoshop®, 2013.

11. Set the Opacity on the layer to **55%**, change the blending mode to **Hard Light**, then compare your results to Figure 44.

12. Save your work.

Finish the illustration

1. Merge the Drop Blue 1 (50px) and Drop Blue 2 layers.

2. Rename the merged layer **Drop Blue (50px)**, then click the **Add layer mask button** on the Layers panel.

3. Set the foreground color to black.

4. Expand the Tubes layer group, then load the selection of the Top Blue 28px layer (the blue neon type).

5. Click the **Select menu**, point to **Modify**, then click **Expand**.

6. Type **2** in the Expand By text box, then click **OK**.

(continued)

7. Feather the selection 4 pixels.

 Your canvas should resemble Figure 45.

8. Click the **layer mask thumbnail** on the Drop Blue (50px) layer, then fill the selection with black.

9. Deselect, then compare your artwork to Figure 46.

 If you undo, redo the move, you'll see that this move is both subtle and important. Prior to this move, the shadow appeared to be emanating from the tubes themselves. With the move, the drop shadow no longer abuts the neon tubes, and by creating this separation, the neon tubes are now clearly *in front* of the drop shadow, and the drop shadow itself is now a reflection *against the back surface*.

10. Collapse the Tubes layer group, target the **Tubes layer**, then create a new layer named **Black Tubes**.

11. Change the Size of the Brush tool to **18 px**, then change the Hardness value to **80%**.

 (continued)

Figure 45 *Selecting the neon text*

Image courtesy of Chris Botello. Source Adobe® Photoshop®, 2013.

Figure 46 *Masking pixels behind the tubes*

Image courtesy of Chris Botello. Source Adobe® Photoshop®, 2013.

Creating Special Effects

Figure 47 *Stroking the path to create the "black" tubes*

Image courtesy of Chris Botello. Source Adobe® Photoshop®, 2013.

Figure 48 *Adding a highlight*

Image courtesy of Chris Botello. Source Adobe® Photoshop®, 2013.

Lesson 4 Create Neon Effects

12. Display the Color panel, click the **Color panel menu button** , click **Grayscale Slider**, then specify a foreground color that is **94% Black**.

13. Click **Path 3** to activate it, stroke the path, then compare your canvas to Figure 47.

14. Change the foreground color to **88% Black**.

15. Change the Size on the Brush tool to **10 px**, then change the Hardness value to **0%**.

16. Stroke Path 3 again, deactivate the path, then compare your artwork to Figure 48.

 The second stroke plays the role of a subtle highlight; we used a 0% Hardness value so that its edge would be soft, like a highlight. Note that when we created the first black stroke, we used a high Hardness value. The neon effect is created by using very soft edges of color; the soft edges create the effect that they glow. Because we want these black tubes to *not* glow, we used a harder edge.

17. Drag the **Black Tubes layer** below the Tubes layer group on the Layers panel.

(continued)

18. Reduce the Opacity on the Black Tubes layer to **35%**, then compare your artwork to Figure 49.

You can think of the black tubes as adding a "recognizable reality" to the artwork. They are especially effective above the letter N, *behind* the N, and between the P and E. However, there's a problem that I saw immediately when I first designed this. Note the relationship between the black tubes and the type's drop shadow. Because the black tubes artwork is at 35% opacity, we see the drop shadow behind it. As noted above, we want the drop shadow to be a reflection off the back surface. This means that the drop shadow must be behind the neon tubes. I call this a "visual logic" problem. Visually, it doesn't make sense. Don't make the mistake of thinking that it's so subtle it's not important. Visual logic problems, even when subtle, can do great damage to an illustration.

(continued)

Figure 49 *Viewing the black tubes art*

Image courtesy of Chris Botello. Source Adobe® Photoshop®, 2013.

Figure 50 *Final artwork*

Image courtesy of Chris Botello. Source Adobe® Photoshop®, 2013.

19. Undo your last move so that the Black Tubes artwork is at 100% Opacity, then [Ctrl]-click (Win) or ⌘-click (Mac) the **layer thumbnail** to load a selection.

20. Click the **layer mask thumbnail** on the Drop Blue (50px) layer, fill the selection with black, then deselect.

21. Change the Opacity on the Black Tubes layer back to **35%**, then compare your final artwork to Figure 50.

 The Black Tubes layer is now masked over the neon letters and the black tubes. If you look at the black tube between the *O* and the *P*, you can really see how important it is to the overall effect that the black tube is in front of the neon drop shadow.

22. Save your work, then close Neon.psd.

AUTHOR'S NOTE

From a design perspective, the black tubes really pay off. They add complexity to the illustration because their texture is completely different from every other element in the illustration. By contrast, the black tubes' dullness and hardness only serve to make the neon that much more vibrant and glowing. As a designer, I always keep an eye out for these extra elements or extra details that I can use to enrich an illustration.

Create a
RIPPED EFFECT

What You'll Do

Source Adobe® Photoshop®, 2013. Getty Images, Ken Weingart

Rips are your friends; rips are your buddies. Rip effects—as though an image has been torn, leaving a rough edge—are an old standby when creating a concept. That's because they are so versatile. For any kind of conflict—war, homicide, law and order, love triangle—a ripped effect gets the message across. But rips can also be fun. They can be used for a cool before-and-after effect. For example, if you had a picture of your house in summer and another in winter when the house is covered with snow, you could put the two together side by side, then mask around the ripped edge so that the summer view on the left half "rips" to show the winter view on the right.

In this lesson, we're going to design the most complex type of ripped edge: one with texture in the ripped edge. It involves some foresight when scanning the original, and some tricky layer mask moves. One last word on ripped effects though: they're a bit overused, and because of that, they can be a bit cliché. Just be aware of that, but don't be put off. For the right concept and with the right artwork, a ripped effect can be just the right trick to make the whole thing work.

Figure 51 *Isolating the ripped edges*

Image courtesy of Chris Botello. Source Adobe® Photoshop®, 2013.

Prepare a layer mask for a ripped effect

1. Open AP 9-6.psd, then save it as **Ripped Original**.

 This file is a scan of a manila folder that has been torn in half. Using a magic marker, I first filled in the length of the folder with black ink. I tore the folder down the middle of the black ink, creating two torn edges. I then scanned each half against a black background, which produced the file at hand.

2. Press and hold [**Ctrl**][**L**] (Win) or ⌘ [**L**] (Mac), drag the **black triangle** to the right until the first Input Levels text box reads **60**, then click **OK.**

 Your artwork should resemble Figure 51.

3. Click the **Filter menu**, point to **Sharpen**, then click **Smart Sharpen**.

 The Smart Sharpen dialog box is an upgrade of the Unsharp Mask dialog box. In addition to providing a large preview window, it offers the ability to control how specific areas of the image (such as highlights, shadows, and so on) are sharpened and the ability to choose different algorithms for sharpening the image.

4. Note that the Remove setting is set to Gaussian Blur.

 The Remove option determines which algorithm will be used to sharpen the image. You can choose among three: Gaussian Blur is the same algorithm that the Unsharp Mask filter uses; Lens Blur is designed to sharpen fine detail; Motion Blur is designed to sharpen areas of an image that are blurry because the subject moved or was moving when the image was captured.

 (continued)

5. Click the **Remove list arrow**, then click **Lens Blur**.

 We want to sharpen the fine detail in the grains of paper in the ripped edge.

6. Set the Amount value to **30**, then verify that the Radius value is set to **1.0**.

7. Click the **More Accurate check box**, if necessary, so that your Smart Sharpen dialog box resembles Figure 52.

8. Click **OK**.

9. Click the **Select menu**, click **Load Selection**, click the **Channel list arrow**, click **Top Rip**, then click **OK**.

 Top Rip is a selection that I made with the Magic Wand tool by clicking the black areas then inverting the selection. I then spent about 10 minutes tweaking the selection to exclude stray black pixels.

10. Click the **Edit menu**, then click **Copy**.

11. Open AP 9-7.psd, then save it as **Ripped**.

12. Duplicate the Background layer, rename it **Solarize**, then drag it to the top of the Layers panel.

13. Click the **Layer menu**, point to **New Adjustment Layer**, then click **Hue/ Saturation**.

14. Click the **Use Previous Layer to Create Clipping Mask check box**, name the layer **Blue**, then click **OK**.

15. On the Properties panel, click the **Colorize check box**, drag the **Hue slider** to **200**, drag the **Saturation slider** to **35**, then compare your artwork to Figure 53.

(continued)

Figure 52 *Smart Sharpen dialog box*

Source Adobe® Photoshop®, 2013.

Figure 53 *Applying a Hue/Saturation adjustment layer*

Source Adobe® Photoshop®, 2013. Getty Images, Ken Weingart

Creating Special Effects

Figure 54 *Positioning the top rip*

Figure 55 *Positioning the bottom rip*

On the comedy circuit, if an act is risque or uses foul language, the comic is said to "work blue" or to use "blue material." Sometimes, the act itself is called "a blue act." Because this illustration is about an artist whose work is controversial, the Hue/Saturation move is a nice metaphor.

16. Click the **Edit menu**, click **Paste**, then position the top rip as shown in Figure 54.

17. Return to the Ripped Original document, load the selection called Bottom Rip, copy it, then paste it in the Ripped document as shown in Figure 55.

18. Merge the two ripped layers, then name the new layer **Rips**.

19. Click the **Magic Wand tool** , set the Tolerance value to **4**, then verify that the Anti-alias check box is not checked and that the **Contiguous check box** is checked.

20. Click the canvas in the area above the top rip, then [**Shift**]-click the area below the bottom rip.

(continued)

21. Expand the selection by 1 pixel, then compare your selection to Figure 56.

22. Target the **Solarize layer**, click the **Add layer mask button** [image] on the Layers panel, then compare your result to Figure 57.

23. Paint white in the Solarize layer mask to hide any red pixels that are showing through the ripped texture.

24. Target the **Rips layer**, press [**Ctrl**][**U**] (Win) or [⌘] [**U**] (Mac) to open the Hue/Saturation dialog box, drag the **Saturation slider** to 0, then click **OK**.

 Photos are printed on white paper. We don't want the yellowish cast to suggest that we used a manila folder to create the rip.

25. [**Ctrl**]-click (Win) or [⌘]-click (Mac) the **Rips layer thumbnail** to load it as a selection.

(continued)

Figure 56 *Selecting with the Magic Wand tool*

Source Adobe® Photoshop®, 2013. Getty Images, Ken Weingart

Figure 57 *Adding a layer mask to the Solarize layer*

Source Adobe® Photoshop®, 2013. Getty Images, Ken Weingart

Creating Special Effects

Figure 58 *Completed artwork*

Source Adobe® Photoshop®, 2013. Getty Images, Ken Weingart

26. Expand the selection by 1 pixel, then feather the selection by 1 pixel.

27. [**Ctrl**]-click (Win) or ⌘-click (Mac) the **Create a new layer button** 🔲 on the Layers panel.

 A new layer is added *below* the Rips layer.

28. Name the new layer **Rips Shadow**, fill the selection with black, then deselect all.

29. Add a layer mask to the Rips Shadow layer, then completely mask out the shadow along the top edge of the top rip and along the bottom edge of the bottom rip.

30. Reduce the Opacity of the Rips Shadow layer to **70%**, then compare your results to Figure 58.

31. Save your work, close Ripped.psd, save the Ripped Original document, then close it as well.

AUTHOR'S NOTE

A key factor in this artwork is the texture of the rip. You will often see this effect done with the quickie method of having a hard edge with no texture or with a white-filled ripped edge. The paper texture within the ripped edge is very satisfying and a fine example of how some effects just demand scanned artwork. The Smart Sharpen filter played an important role in exaggerating the ripped paper detail. Remember that a sharpening filter is always more noticeable on your monitor screen than it is when printed. Our use of hard-edged selections (not anti-aliased) was important for maintaining the hard edge of the rip. Of course, you see this where the rip meets the red, but take a moment to notice the effect where the rip meets the image—it's very realistic. Remember to keep a copy of these two rips in your collection of artwork—you can use them over and over again.

Create Monotones
AND DUOTONES

What You'll Do

Source Adobe® Photoshop®, 2013. Getty Images, Barbara Maurer

With blending modes and color overlays, the Layers panel offers a number of options for creating effects that look like colorized black-and-white images. As a result, over the last decade or so, many designers have steadily moved away from creating monotones and duotones. It's not so much that they've fallen out of fashion as that everybody's sort of forgotten about them.

Don't let that be you. Monotones, duotones, and tritones are very practical and important components in a designer's bag of tricks. From a design point of view, if you are laying out a page that has a number of color images, you can use duotones to "push back" or "mute" some images—which allows you to emphasize the full-color images.

When you are working on a two-color job, usually Black and a PMS color, that's when duotones really come into play. In Duotone mode, you can apply the PMS color to the images in the piece, which can be very effective. I can't tell you how many times I see two-color jobs in which the designer uses the PMS color only in the type elements and runs black-and-white images throughout. That's a designer that has forgotten about Duotone mode, and the design suffers. One more thing: if you get a chance to do a three-color job (Black and 2 PMS inks), then take some time to experiment with tritones (in Duotone mode). With three colors, you can create some really cool color effects.

Figure 59 *Duotone Options dialog box*

Source Adobe® Photoshop®, 2013.

Figure 60 *Monotone image*

Source Adobe® Photoshop®, 2013. Getty Images, Barbara Maurer

Create a monotone

1. Open AP 9-8.psd, then save it as **Monotone**.

 To access the Monotone, Duotone, or Tritone modes, you must first convert an image to Grayscale mode.

2. Click the **Image menu**, point to **Mode**, then click **Duotone**.

3. Click the **Type list arrow**, then click **Monotone**.

4. Click the **color square** next to Ink 1 in the Duotone Options dialog box, then click **Color Libraries** in the Color Picker (Ink 1 Color) dialog box.

5. Click the **Book list arrow**, then click **PANTONE®️ solid coated**.

6. Use the triangles to scroll to Pantone 293 C, click **Pantone 293 C**, then click **OK**.

 Your Duotone Options dialog box should resemble Figure 59. Photoshop automatically names the ink with the standard PANTONE naming convention.

7. Click **OK**, then compare your canvas to Figure 60.

 A monotone image is the same thing as a grayscale image. Both refer to a single-channel image that will be printed with a single ink, and both have 256 colors available per pixel. The term *monotone* is used to distinguish an image that prints with an ink other than black, usually a PANTONE ink.

8. Save your work and then close Monotone.psd.

Create a duotone

1. Open AP 9-9.psd, then save it as **Duotone**.

2. Click the **Image menu**, point to **Mode**, then click **Duotone**.

3. In the Duotone Options dialog box, click the **Type list arrow**, then click **Duotone**.

4. Click the **color square** next to Ink 1 in the Duotone Options dialog box, then change its color to **Pantone 355 C**.

5. Click the **color square** next to Ink 2, click **Color Libraries** in the Color Picker dialog box, then click **Picker** in the Color Libraries dialog box.

6. Choose **Black—0R/0G/0B**—then click **OK**.

 If "Black" is not automatically supplied next to Ink 2, type it in so that your Duotone Options dialog box resembles Figure 61.

 TIP When typing the name of an ink, it is standard to capitalize the first letter of the four process inks.

7. Click **OK**, then compare your duotone to Figure 62.

 In a layout application such as InDesign, this image would be separated onto two inking "plates"—the Black process ink plate and a plate for PANTONE 355 C. When printed, the image is printed using those two inks only. This is why duotones are often referred to as *two-color images*.

8. Save your work.

Figure 61 *Duotone Options dialog box*

Source Adobe® Photoshop®, 2013.

Figure 62 *Duotone image, Black and PANTONE 355 C*

Source Adobe® Photoshop®, 2013. Getty Images, Barbara Maurer

Creating Special Effects

Figure 63 *Duotone, Black and PANTONE 485 C*

Source Adobe® Photoshop®, 2013. Getty Images, Barbara Maurer

Figure 64 *Duotone Curve dialog box*

Source Adobe® Photoshop®, 2013.

Edit a duotone

1. Click the **Image menu**, point to **Mode**, then click **Duotone**.

 To edit a duotone, you must do so in the Duotone Options dialog box.

2. Click the **PANTONE 355 C color box**.

3. Scroll to and click **PANTONE 485 C**, then click **OK**.

4. Click **OK** again, then compare your canvas to Figure 63.

 In addition to changing the colors in a duotone, you can also manipulate the relationships between the two inks and control how each is distributed across the grayscale.

5. Click the **Image menu**, point to **Mode**, then click **Duotone**.

6. Click the diagonal line in the box next to the PANTONE 485 C ink to open the Duotone Curve dialog box.

 At this point, the distribution of the two inks across the grayscale is identical. Wherever you would find a certain value of black ink, you'd also find the same value of PANTONE 485 C ink.

7. Type **90** in the 100% text box, then compare your Duotone Curve dialog box to Figure 64.

(continued)

The Duotone Curve dialog box is specified in ink printing percentages. 0% ink is no ink and represents the highlight areas of an image. 100% ink is full ink coverage and represents the shadow areas of an image.

Note the gradient at the bottom of the grid; it moves from highlight to shadow, left to right. This means that the lower-left corner represents the highlight areas of the image, and the upper-right corner represents the shadows. Lowering the value for any point on the curve means the point prints with less ink.

For example, because we typed 90 in the 100% text box, this means that a 90% dot of PANTONE 485 C will be used to print in the shadow areas. Because we haven't changed the curve on the Black ink, a 100% dot of black will print in this same area.

8. Type **20** in the 50% text box, click **OK**, click **OK** to close the Duotone Options dialog box, then compare your artwork to Figure 65.

9. Display the Info panel, click the **Tracks actual color values button** (eyedropper) in the Info panel, then click **Actual Color**.

(continued)

Figure 65 *Duotone, Black and PANTONE 485 C*

Source Adobe® Photoshop®, 2013. Getty Images, Barbara Maurer

Creating Special Effects

Figure 66 *Duotone, Black and PANTONE 485 C*

Source Adobe® Photoshop®, 2013. Getty Images, Barbara Maurer

10. Sample different areas of the image to see the distribution of PANTONE 485 C throughout the image and in relation to Black.

 At these settings, PANTONE 485 C will print heavily in the shadow areas only. If you sample the shadow areas, such as the boy's hair or coat, you will see a high percentage of PANTONE 485 C (identified as *1* in the Info panel) along with Black (*2*). If you sample light areas, such as the face, you will see that the PANTONE 485 C values are drastically lower than the Black values in the same area.

11. Click the **Image menu**, point to **Mode**, then click **Duotone**.

12. Click the **duotone curve** beside PANTONE 485C.

13. Type **50** in the 50% text box, then click **OK**.

14. Click the **duotone curve** beside the Black ink.

15. Type **20** in the 40% text box, type **60** in the 80% text box, then click **OK**.

16. Click **OK** to close the Duotone Options dialog box, then compare your artwork to Figure 66.

 If you sample the image, you will see that the Black ink values in the face are reduced and the PANTONE 485 C inks are increased.

17. Save the file, then close Duotone.psd.

Create a High Dynamic
RANGE (HDR) COMPOSITE

What You'll Do

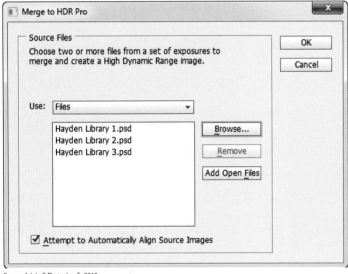

Source Adobe® Photoshop®, 2013.

In this lesson, you will use the Merge to HDR Pro utility to create an HDR composite.

High Dynamic Range merged photography (HDR) is a great option for creating dramatic, highly detailed images and special effects. The basic concept of HDR is that you create one composite image from many source files—usually a minimum of three. Let's say you photograph the same image three times—once at normal exposure, once underexposed and once overexposed. Each image has captured different ranges of detail from your subject. The underexposed image has captured subtle highlights, but no shadow detail. The overexposed image captures all the shadow detail, but with blown-out highlights. And the normal exposure captures the midrange.

In Photoshop, import those three source files into the Merge to HDR Pro utility. Automatically, it will create a composite image of the three, merging the tonal ranges from each to produce a composite image with a greater range of detail throughout the image than your camera could ever capture in a single image.

The Merge to HDR Pro dialog box offers a number of control settings that you can use to modify the initial merge. Among many options, you can use these controls to perfect a photorealistic result, or you can create high-contrast surrealistic effects.

Clearly, the Merge to HDR Pro utility is a photographer's dream, but if you use Photoshop more as a graphic design package, the HDR utility is very useful for you both as a powerful special effects generator and as a color manipulation device, working hand-in-hand with curves and levels.

Figure 67 *Three source files at different exposures*

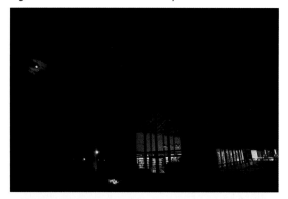

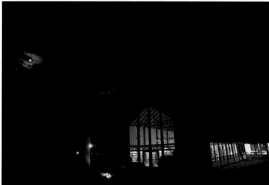

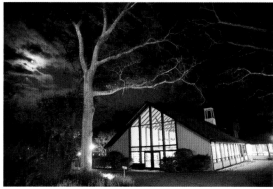

Image © Scott Barnhill Photography

Analyze source files for an HDR merge

1. Open Three Source Files.psd, which is shown in Figure 67.

2. Zoom in on the first (top-left) image.

 This image is the most underexposed, and therefore the darkest. Only the lightest areas of the scene have been captured, and they've been captured with crisp, clean detail. Note the inside of the library. There's a full range of detail from shadow to highlight, and the detail is so crisp that you can see each individual book. Other very bright areas—the moon and the light beside the tree—have also been captured. Note that none of the highlights are glaring—none are blown out. Other than that, the other areas of the image are so underexposed that they're black.

3. Zoom in on the second (top-right) image.

 This image is also underexposed, but if you compare this image to the first, you can see clearly that the photographer has allowed in enough light that many more areas of the image are visible. You can see substantially more sky, and the entire tree in the foreground is visible. More detail of the building can be seen, the shrubs in the foreground and in front of the building are suddenly visible, and the white bell tower on the building's roof has emerged from the shadows. The library interior is overexposed and many areas are blown out to white.

 (continued)

4. Zoom in on the third (bottom) image.

The third image is at the complete opposite extreme. It is way overexposed. You can see this in the highlight areas. The interior of the library, the light behind the tree, and the sky around the moon are all blown out. On the other hand, all of the detail hidden in shadows in the other two images is exposed in this image. The sky, the trees behind the building, the branches above the building, and all the foliage in the foreground is visible.

5. Look at the three images, and try to see how together, the three images show a full range of detail in the shadows, in the middle range, and in the highlights.

6. Keep the file open.

Use the Merge to HDR Pro utility

1. Click the **File menu**, point to **Automate**, then click **Merge to HDR Pro**.

The Merge to HDR Pro dialog box opens, as shown in Figure 68.

2. Click **Browse**.

3. Navigate to the drive and folder where your Chapter 9 Data Files are stored.

(continued)

Figure 68 *Merge to HDR Pro dialog box*

Source Adobe® Photoshop®, 2013.

Creating Special Effects

Figure 69 *Three source files imported*

Source Adobe® Photoshop®, 2013.

4. Select the three files **Hayden Library 1**, **Hayden Library 2**, and **Hayden Library 3**, then click **OK** (Win) or **Open** (Mac).

 Your dialog box should resemble Figure 69. Note that the Attempt to Automatically Align Source Images check box is checked. Remember that HDR images are composites of multiple images. If any subject in your image moved between shots, or if the photographer moved slightly, Photoshop will use built-in algorithms to attempt to automatically align the source images.

5. Click **OK**.

 Photoshop immediately begins the process of creating the composite image. When the processing is finished, the image will appear in a large Merge to HDR Pro dialog box.

TIP If you see a warning dialog box about using Camera Raw, click OK. Photoshop is suggesting that you create the HDR merge with Camera Raw files instead of Photoshop PSD files. See the Author's Note called *About HDR and Camera Raw* below.

(continued)

AUTHOR'S NOTE

About HDR and Camera Raw

When downloading images from your digital camera, you can open the JPEG versions in Photoshop, or you can open the raw data files in Camera Raw. The raw data files give you access to the actual data captured when you snapped the photo, and the Camera Raw interface allows you to manipulate that data through a number of presets. When creating HDR files, you want to work with and retain as much of the original data as possible, so it's best that you use raw data files as your source files. Note however, that you shouldn't make any adjustments to the source files in the Camera Raw interface, because those settings are all automatically nullified as part of the Merge to HDR Pro process.

6. Compare the composite image in your Merge to HDR Pro dialog box to Figure 70.

The merged composite image shows a stunning range of detail throughout. Note that the three source files are shown at the bottom of the dialog box. Consider your analysis of them when you look at the composite. The composite shows detail in the shadow areas in the sky. Note that you can identify the color of the leaves in the trees *behind* the library. It shows detail in the shrubbery and in the exterior of the building. And the highlight areas within the illuminated library interior and around the moon are not glaring or blown out. The detail throughout is so enhanced that the overall result is more a special effect than a realistic representation of reality. Because everything is so very visible in the shadows, in the midrange, and in the highlights, the overall image seems to flatten out onto one plane. The result is pleasing—some would say beautiful— and somewhat surreal.

(continued)

Figure 70 *Composite HDR image*

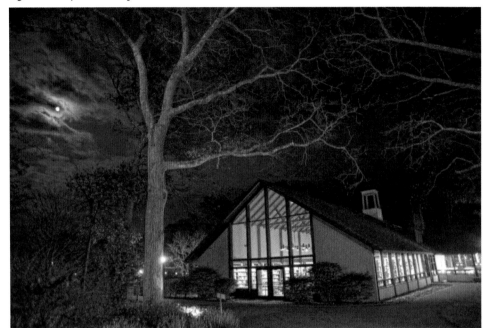

Image © Scott Barnhill Photography

Creating Special Effects

About Bit Depth

Bit depth is a term used to indicate the amount of computer memory allocated to each pixel in a Photoshop file. The bit depth for a given file is indicated, and can be specified using the Mode command on the Image menu.

If an image is a 1-bit image, that would mean that only one byte of computer memory is allocated per pixel. Since a byte represents two things —on/off, black/white, pos/neg, etc.—a pixel in a 1-bit image could be either black or white. In a 2-bit image, pixels could be one of four colors: 2 x 2=4.

As you know, in a grayscale image, each pixel can be one of 256 colors, or shades of gray. 2^8=256. Thus, in a grayscale image, the bit depth is 8 bits. Each pixel is allocated 8 bits of computer memory, allowing it to be one of 256 colors.

An RGB image equires 8 bits per pixel per channel – that is, for one pixel, 8 bits in the red channel, 8 bits in the green channel, and 8 bits in the blue channel. Don't be confused and call that a 24-bit image. It's still an 8-bit image, 8 bits per pixel per channel. This is often noted as 8 bpc (bits per channel). Remember, that the higher the bit depth per pixel, the greater the file size. That's why when you convert a grayscale image (one channel) to RGB mode (three channels) the file size triples.

By determining the number of different shades a pixel can be, bit depth determines the extent to which a range of detail can be captured in a digital file. When creating HDR composites, 8 bits per pixel per channel does not provide enough potential shades per pixel per channel to capture the broad tonal range accessed from the source files. To put it a different way, HDR composites contain a tonal range that far exceeds the range that an 8-bpc file can store.

Photoshop offers 16-bit and 32- bit options in the Mode menu. The Merge to HDR Pro dialog box allows you to work in 16-bit and 32-bit mode. You will find that 16 bit is broad enough to capture a satisfying tonal range in an HDR composite without creating an enormous file size. Nevertheless, only a 32-184 bpc file can store all the HDR image data.

7. If the Mode is not already set to 16 Bit, click the **Mode list arrow**, then choose **16 Bit**. See the Author's Note called *About Bit Depth* on this page.

8. Click the **Preset list arrow**, then click **Monochromatic artistic**.

 The initial result of the HDR merge is just that: an initial result. You can move the controls in 16-Bit mode to manipulate the composite to your liking. Rather than moving the sliders immediately, you might find it helpful to use the built-in presets as a starting point.

 (continued)

9. Click the **Preset list arrow**, then click **Surrealistic**.

10. Drag the **Exposure slider** all the way to the left.

11. Drag the **Gamma slider** all the way to the right, then compare your composite to Figure 71.

12. Click the **Preset list arrow**, then click **Default**.

 The Default setting restores the composite to that which was generated originally.

13. Click the **Preset list arrow**, then click **Photorealistic**.

(continued)

Figure 71 *Surrealistic composite*

Image © Scott Barnhill Photography

Creating Special Effects

Figure 72 *Settings for a custom photorealistic merge*

Preset: Custom

☑ Remove ghosts

Mode: 16 Bit Local Adaptation

Edge Glow

Radius: 86 px

Strength: 1.48

☐ Edge Smoothness

Tone and Detail

Gamma: 1.20

Exposure: 0.20

Detail: 50 %

Advanced Curve

Shadow: -50 %

Highlight: -50 %

Vibrance: 30 %

Saturation: 10 %

Source Adobe® Photoshop®, 2013.

14. Enter the settings shown in Figure 72.

Click the Remove ghosts check box as the last move you make. When you do, note its effect on the moon in the upper-left area of the image.

15. Click **OK** to execute the HDR merge.

Photoshop processes the HDR merge and creates a new Photoshop file for the image.

16. Save the file as **HDR Merge**.

17. Compare the composite to the images in Three Source Files.psd.

When you compare the four images, you can really see that the composite image has utilized the best detail from the three source images.

18. Close Three Source Files.psd.

19. In HDR Merge.psd, add a new Levels adjustment layer, then drag the **black triangle** under the histogram right until the readout is **25**.

(continued)

Lesson 7 Create a High Dynamic Range (HDR) Composite

20. Compare your results to Figure 73.

Remember that the Merge to HDR Pro composite is not necessarily a final result. You can apply adjustment layers to the composite to produce your final result.

21. Save your work, then close HDR Merge.psd.

Figure 73 *Final HDR image*

Image © Scott Barnhill Photography

Creating Special Effects

1. Open AP 9-10.psd, then save it as **Color Mezzotint**.
2. Target the Silo Layer, then apply the Mezzotint filter with fine dots.
3. Zoom in on an area of the silo so that you can see white pixels easily.
4. Click the Magic Wand tool, set its Tolerance value to 4, verify that neither the Anti-alias nor the Contiguous check boxes are checked, then click a white area to select all the white pixels on the layer.
5. Inverse the selection to select all the black pixels on the layer, copy, then paste.
6. Name the new layer **Black Only**, then zoom out to view the entire face.
7. Set the Silo layer's blending mode to Overlay.
8. Show the Gradient layer at the top of the Layers panel, then target it.
9. Clip the Gradient layer into the Black Only layer.
10. With the Gradient layer still targeted, click the Layers panel menu button then click Merge Down.
11. Zoom in so that you are viewing the face at 100%.
12. Change the blending mode to Overlay.
13. Change the blending mode to Soft Light.
14. Change the blending mode to Hard Light.
15. Change the blending mode to Vivid Light.
16. Change the blending mode to Linear Light.
17. Change the blending mode to Pin Light.
18. Change the blending mode to Hard Mix, change the zoom level to 50% to see the entire face then compare your result to Figure 75.
19. Save your work, then close Color Mezzotint.psd.

Figure 75 *Completed Project Builder 1*

Source Adobe® Photoshop®, 2013. Getty Images, Photodisc

1. Open AP 9-11.psd, then save it as **Single Rip**. (*Hint*: A single rip effect is very different from the rip effect created in Lesson 4 of this chapter. In that project, the photo had two ripped edges, as though a strip had been torn from the image. With a single rip, the image is ripped along a single edge.)
2. Load the Rip layer as a selection, then save the selection as **Rip Right**.
3. Deselect, then click the Rip Right channel to view it.
4. Make everything to the right of the rip white, so that the entire right half of the channel is completely white.
5. Click the RGB channel, then click the Background layer.
6. Click the Image menu, then click Canvas Size.
7. Change the width measurement to 7.52 inches, click the square to the left of the center square, then click OK.
8. Target the Rip layer, load the Rip Right selection, click the Edit menu, then click Copy Merged.
9. Click Paste, then name the new merged layer **Right Half**.
10. Load the Rip Right selection again, target the Solarize layer, then click the Add layer mask button on the Layers panel.
11. Invert the layer mask.
12. Drag the Rip layer below the Solarize layer, then hide the Rip layer.
13. Click the Move tool, then drag the artwork on the Right Half layer all the way to the right edge of the canvas.
14. Target the Rip layer, make it visible, then load it as a selection.
15. Contract the selection by 2 pixels.
16. Press and hold [Alt] (Win) or [option] (Mac), then click the Add layer mask button. (*Hint*: With this keyboard command, the layer mask is added with the selected pixels being masked.)

17. Click the Brush tool, then use a hard brush to mask out the remaining right edge of the rip.
18. Click the Pencil tool, then set the size to 3 pixels.
19. Painting in the layer mask, hide additional areas of the white edge and also show more of the white edge so that it is not so even down the left half.
20. Add a Drop Shadow layer style to the Right Half layer, then compare your artwork to Figure 68.
21. Save your work, then close the Single Rip document.

Figure 76 *Completed Project Builder 2*

Source Adobe® Photoshop®, 2013. Getty Images, Ken Weingart

1. Open the three files: Pool1.psd, Pool2.psd, and Pool3.psd.
2. Assess the three images in terms of lighting, various exposures, etc.
3. Click the File menu, point to Automate, then click Merge to HDR Pro.
4. Click Browse.
5. Navigate to the drive and folder where your Chapter 9 Data Files are stored.
6. Select the three files Pool1.psd, Pool2.psd, and Pool3.psd, then click Open.
7. Click OK. Photoshop begins the process of creating the composite image.
8. If the Mode is not already set to 16 Bit, click the Mode list arrow, then choose 16 Bit.
9. Click the Preset list arrow, then sample the effects available with different presets.
10. Click the Preset list arrow, then click Photorealistic.
11. Experiment with the various sliders to produce a photorealistic result that you like.
12. Click OK to execute the HDR merge.
13. Save the resulting file as **Pool HDR Merge**.
14. Compare the composite to the three open source files.
15. Close the three open source files.
16. In the Pool HDR Merge.psd file, add any adjustment layers to produce the result you'd like.
17. Compare your results to Figure 77.
18. Save your work, then close Pool HDR Merge.psd.

Figure 77 *One result of the HDR merge*

Source Adobe® Photoshop®, 2013. Image © Scott Barnhill Photography

jay van solt
peter rajter
selena york

FAST COMPANY

they drive by night

will fine
jay van solt
peter rajter
selena york

FAST COMPANY

they drive by night

will fine
jay van solt
peter rajter
selena york

FAST COMPANY

they drive by night

will fine
jay van solt
peter rajter
selena york

FAST COMPANY

will fine
jay van solt
peter rajter
selena york

FAST COMPANY

CHAPTER 10

WORKING WITH
BLENDING MODES

1. Color balance a photo montage.

2. Add depth and dimension to a photo montage.

3. Use the Luminosity and Hard Light blending modes.

4. Use blending modes in calculations.

5. Use the Overlay and Screen blending modes.

6. Use the Multiply, Color, and Soft Light blending modes.

7. Combine blending modes with color fills.

8. Work with textures.

Color Balance a PHOTO MONTAGE

What You'll Do

Source Adobe® Photoshop®, 2013. African American female: Erin Patrice O'Brien/Getty Images, White male brown hair: Michael Sharkey/Getty Images, Afro American male: Ryan McVay/Jupiter Images, White male-side view: Shannon Fagan/Getty Images

Whenever you are creating a montage with different images, color becomes an important consideration, especially if the images are from different sources and different photographers. Even if all the component images are themselves color balanced and color corrected, when juxtaposed in a montage, variations in tonal range and color cast are evident immediately. If your goal is to create a montage with all the images having consistent color, then you'll need to adjust levels and color balance to achieve that goal.

In this lesson, you'll do just that. You'll be supplied with four images from an online stock photography service. Each is from a different studio and a different photographer. You'll be surprised at how very different they are in terms of color and tone, and you'll be pleasantly surprised at how effective you can be in making that color and tone consistent between the four.

Figure 1 *Comparing four component images*

Source Adobe® Photoshop®, 2013. African American female: Erin Patrice O'Brien/Getty Images, White male brown hair: Michael Sharkey/Getty Images, Afro American male: Ryan McVay/Jupiter Images, White male-side view: Shannon Fagan/Getty Images

AUTHOR'S NOTE

Light source is a critical component when creating a montage. If the models in a montage were in the same room, then they'd be subject to the same lighting conditions. As a designer, however, when compositing with "found imagery" consider yourself lucky if all the images share a consistent light source. It's not usually the case. This is why most professional studios will schedule a special photo shoot with all the models literally in the same room to be photographed. If you can begin a project with all the photography having the same light source and the same color tones, you are really starting off on the proverbial right foot.

Compare images in a montage for lighting and color

1. Open the following four files: North.psd, South.psd, East.psd and West.psd.

 The four images will be used together as a composite image. Each was found on an online stock photography website, and each was taken by a different photographer. I did some minor retouching on all four (removed blemishes, whitened eyes, and so on), but I did not manipulate levels, curves, or color balance in any way.

2. Close the four images.

3. Open AP 10-1.psd, then save it as **Fast Company Composite**.

 Throughout this chapter, I will refer to each image as North, South, East, and West.

4. Assess the color in the images of all four characters.

 When the images are juxtaposed, it becomes clear immediately how different they are on so many visual levels. The goal of this lesson is to manipulate the images so that they appear consistent, as though the four models were photographed together.

5. Identify the direction of the light source on each of the four images in Figure 1.

 In terms of light source, this montage isn't perfect, but it's not so bad either. North and West share the same source, from the right. East is well lit from the right, but you can see an intense highlight coming from the left and shining above where his ear would be if it were visible. This makes

 (continued)

Lesson 1 Color Balance a Photo Montage

ADVANCED PHOTOSHOP 10-3

East consistent with South, as the light source for South clearly comes from a left angle. Overall, the composite works well with its two light sources, one from the left, the other from the right.

6. Compare the four images in terms of color.

 This is where all four diverge from one another. If you compare North and West, North's flesh shows warm reds, and yellows, whereas West's is cold, dark, and blue. South is cold too, but in a different way. South is bright—but not warm. He looks like he's in a hospital under fluorescent light. And then there's East, whose color is warm and peachy, completely different from the other three.

Adjust levels in a montage

1. Target the **Background layer**, then press [**Ctrl**] [**I**] (Win) or ⌘ [**I**] (Mac) to invert it so that it is black, then compare your screen to Figure 2.

 Before addressing color, you first need to address the shadow-to-highlight range for each of the component images in a montage. Consistent shadow qualities will be critical. Positioning the images against a black background is very useful to see if the shadows are weak or strong.

2. Show the History panel, then click the **Create new snapshot button** 📷 on the panel.

3. Assess the images in terms of shadow quality and contrast.

 Of the four, only East appears to have satisfactory contrast. West is so flat that it was noticeable against the white background. The black background reveals that North and South both need a contrast bump and that North has weak shadows.

 (continued)

Figure 2 *Changing the background to black*

Source Adobe® Photoshop®, 2013. African American female: Erin Patrice O'Brien/Getty Images, White male brown hair: Michael Sharkey/Getty Images, Afro American male: Ryan McVay/Jupiter Images, White male-side view: Shannon Fagan/Getty Images

Figure 3 *Adjusted levels on West and North*

Source Adobe® Photoshop®, 2013. African American female: Erin Patrice O'Brien/Getty Images, White male brown hair: Michael Sharkey/Getty Images, Afro American male: Ryan McVay/Jupiter Images, White male-side view: Shannon Fagan/Getty Images

This is especially evident where her hair meets the black background. The shadow behind her neck is weak also.

4. Make the **North Curves layer** visible, then double-click the **layer thumbnail** to see the adjustments made on the Properties panel.

 The histogram shows that the shadows in the original were weak. I darkened those shadows, but not so much that I lost the highlight and the detail in her hair. I did not move the highlights much at all, because I'd already assessed that the light on her face was the most intense of the four images. I tweaked it for contrast only.

5. Make the **West Curves layer** visible, then double-click the **layer thumbnail** to see the adjustments.

 West required a dramatic adjustment, which was expected given that the original was so flat. Note how little pixel detail was available in the original's upper highlight range, and note how far I moved the black triangle to darken the shadows.

6. Drag the **black triangle** all the way to the left and note the effect on West.

 The image is flat because the shadows in the original were weak. This is especially evident in his forehead and in his hair, which is bluish gray rather than black. Even his forehead is grayish.

7. Click the **Edit menu**, then click **Undo Modify Curves Layer**.

8. Compare your artwork to Figure 3, then toggle the West Curves layer on and off to see the dramatic change.

(continued)

Note how much more *shape* his face has with the contrast bump, how much more prominent his cheekbones become, for example. The hair at the top of his head is black, not gray. Note too how the contrast move "warmed up" his flesh tone. Finally, note how flat South now appears compared to West and North.

TIP Throughout this chapter, when you are instructed to toggle a layer on and off to see a change, be sure to toggle the layer on when you are done viewing.

9. Make the **East Curves layer** visible.

 As good as East looked at the beginning, the contrast bump removed a dull gray cast overall and brightened him even more.

10. Make the **South Curves layer** visible, compare your screen to Figure 4, then toggle the South Curves layer on and off to see the change.

 With the adjustment, it becomes apparent that the right side of his face and the shadow on his shoulder were especially weak.

11. Save your work.

12. Click **Snapshot 1** on the History panel to see the canvas before the layer adjustments.

13. Click the **Edit menu**, then click **Undo State Change**.

14. Click the **Create new snapshot button** on the History panel.

Figure 4 *Adjusted levels overall*

Source Adobe® Photoshop®, 2013. African American female: Erin Patrice O'Brien/Getty Images, White male brown hair: Michael Sharkey/Getty Images, Afro American male: Ryan McVay/Jupiter Images, White male-side view: Shannon Fagan/Getty Images

Figure 5 *Warming up West*

Source Adobe® Photoshop®, 2013. African American female: Erin Patrice O'Brien/Getty Images, White male brown hair: Michael Sharkey/Getty Images, Afro American male: Ryan McVay/Jupiter Images, White male-side view: Shannon Fagan/Getty Images

Work with Color Balance adjustment layers

1. Target the **West Curves layer**, press and hold [**Alt**] (Win) or [**option**] (Mac), click the **Create new fill or adjustment layer button** ⬤ on the Layers panel, then click **Color Balance**.

2. Type **West Color Balance** in the Name text box, click the **Use Previous Layer to Create Clipping Mask check box** to activate it, if necessary, then click **OK**.

TIP Use these steps when making color balance adjustment layers for the remainder of this chapter.

We want to move the color in West so it is more like North—warm and appealing. When adjusting color, "warm" always signifies yellow, magenta, and red, while "cold" signifies blue, cyan, and green.

3. Drag the **top slider** to **+15** and note the effect on West.

Don't rush through these moves. Take time to experiment with the slider—push it to the extremes, see what happens. After you've experimented, be sure to input the specified value.

4. Drag the **middle slider** to **-5**, drag the **bottom slider** to **-20**, then compare your result to Figure 5.

(continued)

5. Using the default layer mask on the West Color Balance layer, mask out the color adjustment so that it doesn't affect his eyes.

 We don't want the whites of his eyes to turn yellow.

6. Target the **North Curves layer**, then create a Color Balance adjustment layer named **North Color Balance**.

 North needs to cool off a bit to fall more into line with West and eventually with South, so we want to reduce the warm red and yellow tone from the face.

7. Drag the **top slider** to **-10**, drag the **bottom slider** to **+5**, then compare your result to Figure 6.

 TIP Feel free to toggle the adjustment layer on and off to see the change.

 With this simple move, note how similar the color is between North and West—it's as though they were photographed together under the same lighting conditions.

8. Target the **South Curves layer**, then add a Color Balance adjustment layer named **South Color Balance**.

9. Drag the **top slider** to **+15**, then drag the **bottom slider** to **-20**.

 To move this away from the cold blue, we've made these two dramatic moves—one toward red, the other toward yellow.

 (continued)

Figure 6 *Cooling off North*

Source Adobe® Photoshop®, 2013. African American female: Erin Patrice O'Brien/Getty Images, White male brown hair: Michael Sharkey/Getty Images, Afro American male: Ryan McVay/Jupiter Images, White male-side view: Shannon Fagan/Getty Images

Working with Blending Modes

Figure 7 *Warming up South*

Source Adobe® Photoshop®, 2013. African American female: Erin Patrice O'Brien/Getty Images, White male brown hair: Michael Sharkey/Getty Images, Afro American male: Ryan McVay/Jupiter Images, White male-side view: Shannon Fagan/Getty Images

10. Compare your result to Figure 7.

 If you toggle the adjustment layer on and off you can really see how blue—actually, how purple—South was originally.

11. Target the **East Curves layer**.

 East is going to need more than just a Color Balance adjustment. East's tonal range is entirely different from the other three—where they are moderately lit with a full range from shadow to highlight, East is lit very brightly— so much so that there are no shadows on him. To be more consistent with the others, East's brightness must be reduced.

12. Add a new Curves adjustment layer named **Darken East**.

13. Add a point to the curve, type **76** in the Input text box, then type **66** in the Output text box.

 The image is darkened. However, we don't want it to go too flat, so we'll return the highlights to where they were originally.

14. Add a second point to the upper half of the curve, type **191** in the Input text box, then type **191** in the Output text box.

 This was a move in the right direction, but the tricky thing about East is that when you darken the artwork, it gets more intensely red. Therefore, this move needed to be slight. However, the intense red is a tip-off for the next move. If an image's color is in the right range but is too intense, that tells you to reduce saturation.

15. Add a new Hue/Saturation adjustment layer.

 (continued)

16. Drag the **Saturation slider** to **-15**, then compare your result to Figure 8.

17. Add a new Color Balance adjustment layer named **East Color Balance**.

 We're still fighting the red cast, so we'll use the Color Balance adjustment to cool him down.

18. Drag the **top slider** to **-10**, drag the **middle slider** to **+5**, then drag the **bottom slider** to **+5**.

 This was a good move, but after all this, he's *still* too bright.

19. Add a new Curves adjustment layer named **Darken East More**.

 (continued)

Figure 8 *Reducing the saturation on East*

Source Adobe® Photoshop®, 2013. African American female: Erin Patrice O'Brien/Getty Images, White male brown hair: Michael Sharkey/Getty Images, Afro American male: Ryan McVay/Jupiter Images, White male-side view: Shannon Fagan/Getty Images

Figure 9 *Reducing East's brightness again*

Source Adobe® Photoshop®, 2013. African American female: Erin Patrice O'Brien/Getty Images, White male brown hair: Michael Sharkey/Getty Images, Afro American male: Ryan McVay/Jupiter Images, White male-side view: Shannon Fagan/Getty Images

20. Click to add a point to the curve, type **128** in the Input text box, type **111** in the Output text box, move the shadow point so that its Input value is 12, then compare your result to Figure 9.

 This is the first time that we've used dual Curves adjustment layers, but this is a very common technique. Could we have gone back to adjust the first curves adjustment? Sure. But this type of work is all about building and moving *forward*, and not so much about going back. The first Curves adjustment was one of the steps that got us to where we were when we realized we wanted to darken the image again. So we moved forward; we added another Curves adjustment layer and made the move.

21. Save your work, then click the **Create new snapshot button**.

22. Click **Snapshot 2** on the History panel to see the artwork before all of the color adjustments you made.

23. Toggle between Snapshot 2 and Snapshot 3.

24. Verify that the artwork is at Snapshot 3 before moving forward.

Add Depth and Dimension
TO A PHOTO MONTAGE

What You'll Do

Source Adobe® Photoshop®, 2013. African American female: Erin Patrice O'Brien/Getty Images, White male brown hair: Michael Sharkey/Getty Images, Afro American male: Ryan McVay/ Jupiter Images, White male-side view: Shannon Fagan/Getty Images

In this lesson, you'll focus on another important challenge: creating the *spatial relationship* between the individual images. In this challenge, you'll face head on the one word that haunts every photo montage: *flat*.

When you layer individual pieces of art, that's what they are: flat. The challenge is to create depth and dimension, to bring some components forward and push others back. In doing so, you create the all-important spatial relationship between the components. And the big irony is, with photo montage, the techniques you use to make it "real" are dramatic shadows, artistic touches, and wild effects that never have and never will exist in the real world.

Figure 10 *Artwork against a white background*

Source Adobe® Photoshop®, 2013. African American female: Erin Patrice O'Brien/Getty Images, White male brown hair: Michael Sharkey/Getty Images, Afro American male: Ryan McVay/Jupiter Images, White male-side view: Shannon Fagan/Getty Images

Paint depth between layered artwork

1. Toggle East's layer mask on and off, and note that the layer mask makes it appear as though East's chest is darkened as it fades into the background.

2. Target the **Background layer**, invert it, then compare your canvas to Figure 10.

 With the black background inverted to white, East's chest is now lightened as it fades into the background.

3. Note the relationship between South and West.

 Though the background is now white, the suggestion of space between them continues to exist. White or black, the eye continues to perceive the negative space between them as distance.

4. Undo the invert so that the background is black once again.

5. Note the relationship between South and East.

 We must create the suggestion of distance between South and East, and to do that, we must create negative space.

 (continued)

6. On the Layers panel, make the **East Shadow layer** visible, then compare your canvas to Figure 11.

 The darkening of the East artwork creates the distance between South and East. To achieve that darkening, I created an empty layer, painted black in the layer, then clipped the layer into the East layer so that the black paint didn't affect any of the other artwork.

7. Make the **South Shadow layer** visible, then compare your artwork to Figure 12.

 Just like with a light source, shadows in a montage must also have a visual logic. The shadow over the left ear of South is from the same direction as the shadow cast over East. South's face is now "emerging" from a shadow.

 (continued)

Figure 11 *Shadow on East*

Source Adobe® Photoshop®, 2013. African American female: Erin Patrice O'Brien/ Getty Images, White male brown hair: Michael Sharkey/Getty Images, Afro American male: Ryan McVay/Jupiter Images, White male-side view: Shannon Fagan/Getty Images

Figure 12 *Shadow on South*

Source Adobe® Photoshop®, 2013. African American female: Erin Patrice O'Brien/ Getty Images, White male brown hair: Michael Sharkey/Getty Images, Afro American male: Ryan McVay/Jupiter Images, White male-side view: Shannon Fagan/Getty Images

Working with Blending Modes

Figure 13 *Shadow on North*

Source Adobe® Photoshop®, 2013. African American female: Erin Patrice O'Brien/ Getty Images, White male brown hair: Michael Sharkey/Getty Images, Afro American male: Ryan McVay/Jupiter Images, White male-side view: Shannon Fagan/Getty Images

Figure 14 *Shadow on West*

Source Adobe® Photoshop®, 2013. African American female: Erin Patrice O'Brien/ Getty Images, White male brown hair: Michael Sharkey/Getty Images, Afro American male: Ryan McVay/Jupiter Images, White male-side view: Shannon Fagan/Getty Images

8. Make the **North Shadow layer** visible, then compare your artwork to Figure 13.

 The North Shadow is important to create distance between the two front images and the North artwork.

9. Make the **West Shadow layer** visible, then compare your artwork to Figure 14.

10. On the History panel, create a new snapshot.

11. Toggle between Snapshot 3 and Snapshot 4 to see the artwork before and after the shadowing.

 Note how much more "space" now exists between the characters.

12. Save your work, then close Fast Company Composite.psd.

Use the Luminosity and
HARD LIGHT BLENDING MODES

What You'll Do

Source Adobe® Photoshop®, 2013. African American female: Erin Patrice O'Brien/Getty Images, White male brown hair: Michael Sharkey/Getty Images, Afro American male: Ryan McVay/ Jupiter Images, White male-side view: Shannon Fagan/Getty Images

Hard Light is a popular blending mode, one that you'll use often and to great effect. Whenever you apply the Hard Light mode, the color of artwork on the Hard Light-layer is intensified, as though it were shining a "hard light" on the layers beneath.

The Hard Light blending mode can be unpredictable because the resulting effect changes dramatically depending on the color of those layers beneath. However, when you use Hard Light against a black background, you can be sure of two things: middle and dark areas will go black, and brighter colors will become more intense.

The Luminosity blending mode uses a simpler algorithm to create its effect. When you set a layer to Luminosity, it reads only the brightness values of the layer, then applies those values to the artwork beneath the layer. Simple though it may be, it provides interesting results.

Working with Blending Modes

Figure 15 *Clouds filter*

Source Adobe® Photoshop®, 2013. African American female: Erin Patrice O'Brien/Getty Images, White male brown hair: Michael Sharkey/Getty Images, Afro American male: Ryan McVay/Jupiter Images, White male-side view: Shannon Fagan/Getty Images

Use the Luminosity blending mode

1. Open AP 10-2.psd, then save it as **Fast Company Overlay**.

 The montage artwork in this file is a copy of the artwork you worked on in Lessons 1 and 2. The only changes that have been made are that North, South, East, and West have been grouped individually, and each has been sharpened slightly with the Unsharp Mask filter.

2. Target the **Background layer**, create a new layer above it, then name the new layer **Clouds**.

 Whenever I'm creating layered artwork, I am leery about working with a flat color background. With this file, I want to create a texture to use with the black background, just to have some sort of detail rather than a flat black background.

3. Press [D] to access default foreground and background colors, then change your foreground color to **0R/162G/238B**.

4. Switch the foreground and background colors so that white is the foreground color.

5. Click the **Filter menu**, point to **Render**, click **Clouds**, then compare your result to Figure 15.

 The Clouds filter works with any foreground and background color. It uses the foreground to create the clouds and the background to create the "sky" background. Clouds is a random filter—every time you apply it, it renders a unique result. Therefore, your clouds will not exactly match Figure 15.

(continued)

6. Press and hold [**Shift**][**Alt**] (Win) or [**Shift**] [**option**] (Mac), click the **Filter menu**, point to **Render**, then click **Clouds**.

 This keyboard combination causes the filter to render clouds with higher contrast.

7. Change the blending mode to **Luminosity**, then compare your canvas to Figure 16.

 To best understand the result—and how the Luminosity blending mode works—think of the black background artwork and the sky artwork as working together to produce this new background image. The Luminosity blending mode takes all the brightness values—and only the brightness values—from the pixels on the Clouds layer and applies those values to the brightness values of the pixels on the black Background layer.

 (continued)

Figure 16 *Clouds with the Luminosity blending mode against black*

Source Adobe® Photoshop®, 2013. African American female: Erin Patrice O'Brien/Getty Images, White male brown hair: Michael Sharkey/Getty Images, Afro American male: Ryan McVay/Jupiter Images, White male-side view: Shannon Fagan/Getty Images

Working with Blending Modes

Figure 17 *Inverted clouds artwork against black*

Source Adobe® Photoshop®, 2013. African American female: Erin Patrice O'Brien/Getty Images, White male brown hair: Michael Sharkey/Getty Images, Afro American male: Ryan McVay/Jupiter Images, White male-side view: Shannon Fagan/Getty Images

8. Reduce the Opacity of the Clouds layer to **10%**.

9. Invert the Clouds artwork.

 In its original state, the Clouds layer was bright overall, with the bright blue "sky" and the even brighter clouds. Inverting the layer creates artwork with more contrast. The white clouds are now black, and black will have no effect on the background when set to Luminosity. Therefore, those areas remain black and the Background layer is now brightened only by the "sky" component of the artwork. Thus, the effect has more contrast.

10. Change the blending mode to **Hard Light**, then compare your result to Figure 17.

 Not only do the clouds create a more complex background, they also make the layer masks on the models work better. Now, it appears that the models are emerging from clouds of smoke rather than just fading into a flat black background.

11. Save your work and keep the Fast Company Overlay document open.

Analyze the Hard Light blending mode

1. Open AP 10-3.psd, then save it as **Hard Light Analysis**.

 When working with blending modes, it's a big plus if you have an intellectual grasp of how they work—an understanding of the mathematical process that produces the effect they create. Some modes, like Luminosity and Multiply, are fairly easy to understand. Hard Light is a bit more complex, but we're going to use this quick lesson to give you a better understanding of how Hard Light works.

2. Target the **Bottom Vegas layer**, then change its blending mode to Hard Light.

3. Double-click the **layer thumbnail** on the Test Levels layer, drag the **black triangle** to 128, then compare your result to Figure 18.

 The result is identical. The change you made to the Levels adjustment yields the same result as applying Hard Light to the same image against a black background.

4. Undo your last step.

5. Invert the background, then note the change to the Bottom Vegas artwork now that it is hard lit against the white background.

 (continued)

Figure 18 *Duplicating a Hard Light effect against a black background*

Source Adobe® Photoshop®, 2013. Getty Images, Neil Emmerson

Figure 19 *Duplicating a Hard Light effect against a white background*

Effect created with a
Layers adjustment

Effect created with
Hard Light blending
mode against a
white background

Source Adobe® Photoshop®, 2013. Getty Images, Neil Emmerson

6. Double-click the **layer thumbnail** on the Test Levels layer, drag the **white triangle** to **128**, then compare your result to Figure 19.

The move of the white triangle to 128 yields the same result as applying Hard Light to the bottom image against a white background.

(continued)

7. Fill the Background layer with yellow, then compare your result to Figure 20.

Because the layer is set to Normal, the artwork on the Top Vegas layer does not interact with the Background layer, regardless of the color of the background or the moves you make adjusting levels. On the Bottom Vegas layer, the algorithm that defines the Hard Light blending mode causes the artwork to be affected differently by different background colors.

8. Save your work, then close Hard Light Analysis.psd.

Figure 20 *Viewing the inability to duplicate a Hard Light effect against a colored background*

Effect created with a Layers adjustment unaffected by yellow background

Effect created with Hard Light blending mode changes against a different background

Source Adobe® Photoshop®, 2013. Getty Images, Neil Emmerson

Working with Blending Modes

Figure 21 *Hard lighting the Highway art*

Source Adobe® Photoshop®, 2013. Getty Images, Robert Warren

Figure 22 *Hard lighting the Vegas art*

Source Adobe® Photoshop®, 2013. Highway: Robert Warren/Getty Images, Vegas: Neil Emmerson/Getty Images

Apply Hard Light to background images

1. Return to the Fast Company Overlay document.
2. Hide the Clouds layer, then hide the four group layers.
3. Show and target the **Highway layer**, change its blending mode to Hard Light, then compare your result to Figure 21.

 If you toggle the move, note how the midrange tones become black with the Hard Light mode and how only the bright colors are preserved.
4. Activate the layer mask thumbnail on the Highway layer.
5. Show and target the **Vegas layer**, change its blending mode to Hard Light, activate its layer mask, then compare your results to Figure 22.
6. Reduce the Opacity on the Vegas layer to **50%**.
7. Save your work.

Use Blending Modes
IN CALCULATIONS

What You'll Do

Source Adobe® Photoshop®, 2013.

Calculations have long been a feature of Photoshop, and they are the precursor to the blending modes listed on the Layers panel. In the early days of Photoshop, calculations were *the* advanced feature of the application, the exclusive province of the power user.

Like the blending modes, calculations are algorithms that can be applied when blending one or more images to create special effects. Before there was a Layers panel, you used calculations to blend one file with another, with the result being a new document, channel or selection. In that situation, each file was functioning like a layer does in present-day Photoshop, and each calculation was functioning like a blending mode.

With the advent of layers and blending modes, calculations have become really obscure. However, they remain a very powerful feature, and learning how to use them can really strengthen your intellectual understanding of layer masks, channels, and blending modes.

Working with Blending Modes

Figure 23 *Clouds overlapping the Highway and Vegas artwork*

Source Adobe® Photoshop®, 2013. Highway: Robert Warren/Getty Images, Vegas: Neil Emmerson/Getty Images

Create a layer mask using calculations

1. Make the **Clouds layer** visible, drag it above the Vegas layer, then compare your artwork to Figure 23.

 We want to create a layer mask for the Clouds layer so that it doesn't show in the areas occupied by the Highway and Vegas artwork. There are many ways to achieve this, but we're going to use this as an excuse to use the Calculations command.

2. Verify that you can see the Vegas, Highway, and Clouds layers on the Layers panel.

3. Click the **Image menu**, then click **Calculations**.

TIP Move the Calculations dialog box so that you can see the Layers panel if necessary.

(continued)

Lesson 4 Use Blending Modes in Calculations

4. Enter the settings shown in Figure 24.

Here's how to read the information in this dialog box. It says that the file for Source 1 and Source 2 is the same: Fast Company Overlay.psd. In the Source 1 section, it says that we're going to use the Vegas layer's layer mask as Source 1. For Source 2, we're going to use the Highway layer's layer mask. The Blending section determines the calculation—the blending mode that will be used to apply Source 1 to Source 2. We've specified the Add blending mode, and the result of the calculation will be a new channel in the Fast Company Overlay document.

(continued)

Figure 24 *Calculations dialog box*

Source Adobe® Photoshop®, 2013.

Working with Blending Modes

Figure 25 *New channel resulting from the calculation*

Source Adobe® Photoshop®, 2013. Getty Images, Robert Warren

Figure 26 *Clouds layer with new layer mask*

Source Adobe® Photoshop®, 2013.

5. Click **OK**, open the Channels panel then compare your canvas to Figure 25.

TIP Your canvas automatically changes to show the new channel.

The Add blending mode does exactly that: it takes the two layer masks, then adds the grayscale values of the pixels in the first with those in the second. The result of the calculation is the new channel. Remember that a black pixel's grayscale value is 0, so any lighter pixel that overlaps a black pixel and is added to that pixel is unchanged, because any number + zero isn't changed.

6. Invert the new channel, click the **RGB channel**, then target the **Clouds layer**.

7. [**Ctrl**] (Win) or ⌘ (Mac)-click the **new Alpha 1 channel thumbnail** to load it as a selection.

8. Click the **Add layer mask button** 🔲 on the Layers panel, compare your Layers panel to Figure 26, then save.

The Clouds layer now has a layer mask that is black in the areas where it overlaps the Highway and Vegas artwork.

This exercise is based in reality. It's often the case that you'll want to create a layer mask that is the combination of one or more other masks, and this calculation is a quick method for making it happen.

Use the Overlay and
SCREEN BLENDING MODES

What You'll Do

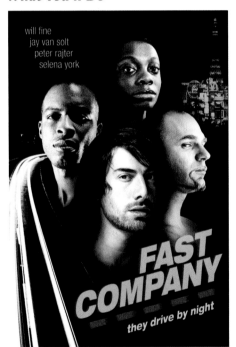

Source Adobe® Photoshop®, 2013. African American female: Erin Patrice O'Brien/ Getty Images, White male brown hair: Michael Sharkey/Getty Images, Afro American male: Ryan McVay/Jupiter Images, White male-side view: Shannon Fagan/Getty Images, Vegas: Neil Emmerson/Getty Images, Highway: Robert Warren/Getty Images

In this chapter, you're going to work with the Overlay mode to overlay images for special effect.

From a practical standpoint, Overlay is important because it makes a neutral gray transparent. Thus, as we've done in earlier lessons, you can add noise to a gray layer, add a lens flare to a gray layer, or add a texture to a gray layer, then make the gray invisible, leaving only the noise, flare, or texture visible against the layers beneath.

Overlay is just as important and useful from the artistic perspective. When you overlay color over an image or when you overlay a copy of an image over itself, the Overlay mode is an intensifier. Shadows get darker, highlights get lighter, and color becomes more intense and vivid. Vivid color—remember that phrase when you think of the Overlay mode.

Screen mode is a lightener—whenever you apply the Screen mode, the active layer lightens the artwork on the canvas. Screen is biased towards light and white.

Highlights play the important role in Screen mode—it's the highlights in the active layer that brighten the artwork.

The most important thing to remember about the Screen mode is that black pixels become transparent when screened. If you had white type on a black layer, then screened the layer, only the white type would be visible. This makes the Screen mode the exact opposite of the Multiply mode.

Figure 27 *Overlaying the artwork over itself*

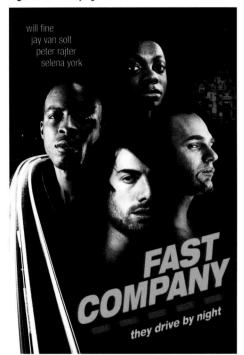

Source Adobe® Photoshop®, 2013. African American female: Erin Patrice O'Brien/
Getty Images, White male brown hair: Michael Sharkey/Getty Images, Afro
American male: Ryan McVay/Jupiter Images, White male-side view: Shannon
Fagan/Getty Images, Vegas: Neil Emmerson/Getty Images, Highway: Robert
Warren/Getty Images

Figure 28 *Reducing the darkening effect of the Overlay blending mode*

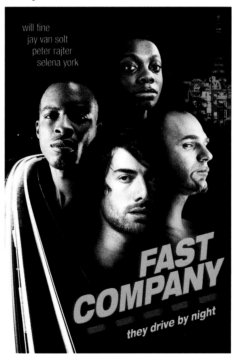

Source Adobe® Photoshop®, 2013. African American female: Erin Patrice O'Brien/
Getty Images, White male brown hair: Michael Sharkey/Getty Images, Afro
American male: Ryan McVay/Jupiter Images, White male-side view: Shannon
Fagan/Getty Images, Vegas: Neil Emmerson/Getty Images, Highway: Robert
Warren/Getty Images

Use the Overlay blending mode with a montage

1. Make the **North**, **South**, **East**, and **West** groups visible.

2. Make the **Type group** visible.

3. Target the **South Group**, click the **Create new fill or adjustment layer button** 🔘 on the Layers panel, then click **Hue/Saturation**.

4. Make no adjustments in the Properties panel.

5. Apply the **Overlay** blending mode to the Hue/ Saturation adjustment layer.

 Note that the Overlay blending mode doesn't affect any of the type elements because they are all above the Hue/Saturation adjustment layer.

6. Compare your artwork to Figure 27.

 The Overlay blending mode has made all the colors more vivid and intense, which works well especially for the models. However, the shadows are now too dark. Rather than mask the Overlay blending mode from the shadows, we can adjust the Overlay blending mode itself.

7. On the Properties panel, drag the **Lightness slider** to **+30**, then compare your result to Figure 28.

 Adjusting the brightness allows you to control the Overlay blending mode. Toggle it on and off and you'll see that the blending mode still makes the colors more vivid, but the effect on the shadows is no longer so overwhelming.

 (continued)

8. Click the **Create new fill or adjustment layer button** on the Layers panel, then click **Solid Color**.

9. Type **248**, **208**, and **24** in the R, G, and B text boxes, then click **OK**.

 This color is the same yellow used in the title artwork.

10. Name the new layer **Yellow Overlay**, set its blending mode to **Overlay**, set the opacity to **30%**, then compare your result to Figure 29.

Figure 29 *Overlaying a yellow fill*

will fine
jay van solt
peter rajter
selena york

FAST COMPANY

they drive by night

Source Adobe® Photoshop®, 2013. African American female: Erin Patrice O'Brien/Getty Images, White male brown hair: Michael Sharkey/Getty Images, Afro American male: Ryan McVay/Jupiter Images, White male-side view: Shannon Fagan/Getty Images, Vegas: Neil Emmerson/Getty Images, Highway: Robert Warren/Getty Images

AUTHOR'S NOTE

If you toggle the Color Overlay layer on and off, you can see that, even without the yellow overlay, all of the artwork is unified in look and feel, and it all works together as one piece. With that in mind, it's interesting to see how the yellow overlay takes that even further. It pulls it all together, the models, the highway, the city, and the title treatment. No one element pulls your focus or stands apart from the rest.

Working with Blending Modes

Figure 30 *Colorizing the screened artwork*

will fine
jay van solt
peter rajter
selena york

FAST COMPANY

they drive by night

Source Adobe® Photoshop®, 2013. African American female: Erin Patrice O'Brien/Getty Images, White male brown hair: Michael Sharkey/Getty Images, Afro American male: Ryan McVay/Jupiter Images, White male-side view: Shannon Fagan/Getty Images, Vegas: Neil Emmerson/Getty Images, Highway: Robert Warren/Getty Images

Use the Screen blending mode with a montage

1. Hide the Yellow Overlay layer, target the **Hue/Saturation 1 adjustment layer**, click the **Create new fill or adjustment layer button** on the Layers panel, then click **Hue/Saturation**.

2. Name the new adjustment layer **Screen**.

3. Change the Screen adjustment layer's blending mode to **Screen**.

4. Click **Colorize check box** to activate it, drag the **Saturation slider** to **50**, then drag the **Lightness slide**r to **-50**.

5. Compare your result to Figure 30.

6. Toggle the Screen adjustment layer on and off to see its effect.

7. Save your work, then close Fast Company Overlay.psd.

Use the Multiply, Color, and
SOFT LIGHT BLENDING MODES

What You'll Do

Source Adobe® Photoshop®, 2013. African American female: Erin Patrice O'Brien/ Getty Images, White male brown hair: Michael Sharkey/Getty Images, Afro American male: Ryan McVay/Jupiter Images, White male-side view: Shannon Fagan/Getty Images, Vegas: Neil Emmerson/Getty Images, Highway: Robert Warren/Getty Images

There are two important rules to remember about the Multiply mode: first, anything multiplied with black becomes black; and second, when multiplied, white pixels disappear. Multiply is the opposite of the Screen blending mode.

When you multiply color artwork, the artwork retains its color, but it becomes transparent. You can think of multiplying color artwork like working with colored markers. The color is transparent, and it colors the artwork beneath it. Multiplied artwork always darkens the artwork beneath it.

The Color blending mode applies the hue and saturation values of the pixels on the active layer to the pixels on the underlying image.

Color mode does not affect the lightness value of underlying pixels; therefore, it doesn't change the shadow-to-highlight range of the underlying artwork.

It only makes sense that the Soft Light mode is a reduced version of the Hard Light mode, right? Strangely enough, that's not the case. Soft Light and Hard Light usually create dramatically different effects, which doesn't make sense, given their names. Actually, Soft Light is much more like the Overlay mode than the Hard Light mode. Like Overlay, Soft Light makes 50% gray pixels disappear and makes brighter areas brighter and darker areas darker. The difference is that Soft Light has a more subtle effect than Overlay.

Figure 31 *Multiplying the Green channel art*

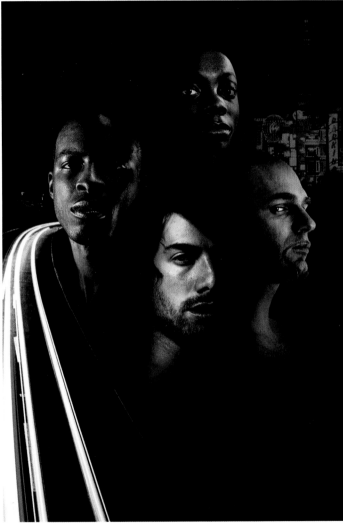

Use the Multiply blending mode

1. Open AP 10-4.psd, then save it as **Fast Company Multiply**.
2. On the Channels panel duplicate the Green channel, then click the **Green copy channel** to view it.
3. Select all the artwork on the Green copy channel, click the **Edit menu**, then click **Copy**.
4. Click the **RGB thumbnail** on the Channels panel.
5. On the Layers panel target the **Montage layer group**, paste the copy, then name the new layer **Green Multiply**.
6. Change the blending mode to **Multiply**.
7. Load the saved selection Montage Only, then click the **Add layer mask button** .
8. Compare your result to Figure 31.
9. Create a new empty layer immediately below the Green Multiply layer, then name it **White Back**.
10. Load the Montage Only selection again, click the **Select menu**, point to **Modify**, then click **Contract**.
11. Type **2** in the Contract By text box, click **OK**, then fill the selection with white.

 This is a great trick for working with multiplied artwork. If you position a flat fill color behind the artwork, you can manipulate the fill color to control the color and the opacity of the multiplied effect.

(continued)

12. Deselect, then reduce the Opacity on the White Back layer to **80%**.

13. Target the **Green Multiply layer**, then add a Levels adjustment layer named **Brighter Whites**.

TIP Be sure to click the Use Previous Layer to Create Clipping Mask check box. We want the Levels move to affect only the montage art.

14. Drag the **black triangle** to **12**, then drag the **white triangle** to **206**.

15. Click the **Desat adjustment layer**, click the **Create new fill or adjustment layer button** on the Layers panel, then click **Solid Color**.

16. Type **17R/26G/93B**, then click **OK**.

17. Change the blending mode to **Color**, make the Type layer group visible, then compare your result to Figure 32.

 The Color blending mode applies the hue and saturation values of the solid fill color to the artwork beneath. The Color blending mode does not affect the artwork's Lightness value.

 (continued)

Figure 32 *Color fill with the Color blending mode*

will fine
jay van solt
peter rajter
selena york

Source Adobe® Photoshop®, 2013. African American female: Erin Patrice O'Brien/Getty Images, White male brown hair: Michael Sharkey/Getty Images, Afro American male: Ryan McVay/Jupiter Images, White male-side view: Shannon Fagan/Getty Images, Vegas: Neil Emmerson/Getty Images, Highway: Robert Warren/Getty Images

Working with Blending Modes

Figure 33 *Final artwork*

will fine
jay van solt
peter rajter
selena york

FAST COMPANY

Source Adobe® Photoshop®, 2013. African American female: Erin Patrice O'Brien/Getty Images, White male brown hair: Michael Sharkey/Getty Images, Afro American male: Ryan McVay/Jupiter Images, White male-side view: Shannon Fagan/Getty Images, Vegas: Neil Emmerson/Getty Images, Highway: Robert Warren/Getty Images

18. Make the Highway Abstract layer visible, reduce its Opacity to **70%**, then drag it below the Type layer group.

19. Change its blending mode to **Soft Light**, then activate its layer mask.

20. Expand the Background layer group, reduce the Opacity of the Vegas layer to **40%**, then reduce the Opacity of the Highway layer to **50%**.

21. Verify that you are viewing the artwork at 50%.

22. Press [**F**] two times to view the artwork against a black background and without panels in view.

23. Compare your results to Figure 33.

24. Press [**F**] to return to Standard Screen Mode, save your work, then close Fast Company Multiply.psd.

Combine Blending
MODES WITH COLOR FILLS

What You'll Do

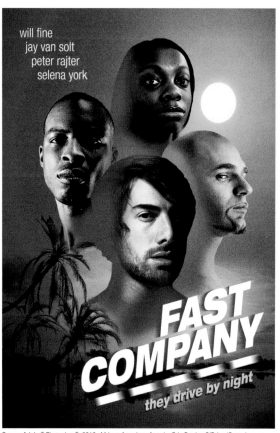

will fine
jay van solt
peter rajter
selena york

FAST
COMPANY
they drive by night

Source Adobe® Photoshop®, 2013. African American female: Erin Patrice O'Brien/Getty Images,
White male brown hair: Michael Sharkey/Getty Images, Afro American male: Ryan McVay/Jupiter
Images, White male-side view: Shannon Fagan/Getty Images

So far, you've seen how adjustment layers and blending modes can create two dramatically different results with the same artwork.

In this lesson, you're going to produce a third result. You'll learn how to use a layer with a gradient and a blending mode to unify a piece that contains multiple images and to create a mood.

Using a simple gradient fill designed to resemble a sunset, watch how we employ blending modes, along with some crafty clipping, to create the most visually powerful and cohesive version of the poster yet.

Figure 34 *Clipping Sunset into South Shadow*

Sunset artwork
clipped with a
layer mask

Figure 35 *Clipping Sunset into all four shadows*

Use blending modes with color fills

1. Open AP 10-5.psd, then save it as **Fast Company Sunset**.

2. Target the **Sunset layer**, select all, copy, then hide the Sunset layer.

 The "sunset" artwork is a radial gradient I created in Photoshop. Sometimes you don't need to rely on photography - you can just make your own artwork.

3. Expand the South layer group.

4. Target the **South Shadow layer**.

5. Press and hold [**Ctrl**] (Win) or ⌘ (Mac), then click its **layer thumbnail** to load it as a selection.

6. Click the **Edit menu**, point to **Paste Special**, then click **Paste Into**.

7. Clip the new layer into the South Shadow layer.

8. Compare your canvas and your Layers panel to Figure 34, then collapse the South layer group.

9. Using the same steps you used in Steps 5, 6, 7, and 8, paste and clip the sunset artwork into the West Shadow, East Shadow, and North Shadow layers so that your canvas resembles Figure 35.

TIP Be sure that you *target* each shadow layer then load it as a selection before applying the Paste Into command.

(continued)

10. Make the **Sunset layer** visible, then compare your canvas to Figure 36.

11. On the Channels panel, duplicate the **Red channel** by dragging it down to the **Create a new channel button** 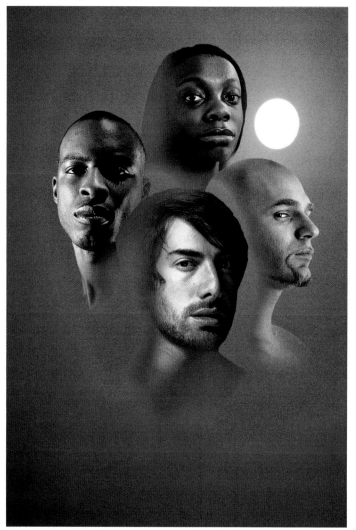 select all, copy the channel artwork, then click the **RGB channel thumbnail**.

12. On the Layers panel target the **South group**, paste, then name the new layer **Red Channel**.

13. Change the blending mode on the Red Channel layer to **Multiply**.

14. Create a new empty layer above the Red Channel layer, name it **Overlay**, then fill it with **255R/181G/7B**.

15. Change the blending mode to **Overlay**.

16. Target the **Red Channel layer**, then create a new Levels adjustment layer.

TIP Be sure to click the Use Previous Layer to Create Clipping Mask check box.

17. Drag the **black triangle** to **53**, then drag the **white triangle** to **227**.

 At this point, the artwork is too hot. Much of that has to do with the way the Overlay layer is interacting with the Red Channel layer.

(continued)

Figure 36 *Viewing the shadows against the Sunset layer artwork*

Working with Blending Modes

Figure 37 *Final artwork*

will fine
jay van solt
peter rajter
selena york

FAST COMPANY

they drive by night

Source Adobe® Photoshop®, 2013. African American female: Erin Patrice O'Brien/Getty Images, White male brown hair: Michael Sharkey/Getty Images, Afro American male: Ryan McVay/Jupiter Images, White male-side view: Shannon Fagan/Getty Images

18. Drag the **Overlay layer** below the Red Channel layer.

19. Make the **Everglades layer** visible, then activate its layer mask.

20. Drag the **Everglades layer** below the North Group layer.

 The color of the Everglades artwork changes because of the yellow Overlay layer.

21. Change the blending mode of the Everglades layer to **Hard Light**.

22. Make the **Type group layer** visible.

23. Verify that you are viewing the artwork at 50%.

24. Press [**F**] two times to view the artwork against a black background.

25. Compare your results to Figure 37.

26. Press [**F**] to return to Standard Screen Mode.

27. Save your work, then close Fast Company Sunset.psd.

Work with TEXTURES

What You'll Do

will fine
jay van solt
peter rajter
selena york

FAST COMPANY
they drive by night

Source Adobe® Photoshop®, 2013. African American female: Erin Patrice O'Brien/Getty Images, White male brown hair: Michael Sharkey/Getty Images, Afro American male: Ryan McVay/Jupiter Images, White male-side view: Shannon Fagan/Getty Images

In the quest to unify artwork in a montage, textures can be your secret weapon. When the art allows for it and you can apply a texture—scratches, grain, creases, grit, raindrops, and so on—it is remarkable how powerful a force a texture can be in bringing the disparate elements together as a whole, as one complete thought.

When designers talk about textures, they're not talking about filters. They're talking about homemade, handmade artwork that is scanned in and incorporated into a piece via a blending mode. You'll find that most designers have their own secret stash of textures, which they often guard like a treasure.

In my own work, I've scanned in such unexpected items as a white bath towel, sandpaper, a big piece of tin foil, and a rubber mouse pad. You never know what will work, nor do you know how it will work. The best part is that it's unique. It's your own artwork and a great way of incorporating handmade art into a digital environment.

Working with Blending Modes

Figure 38 *Darkening the raindrops texture file*

will fine
jay van solt
peter rajter
selena york

FAST COMPANY

Source Adobe® Photoshop®, 2013. African American female: Erin Patrice O'Brien/Getty Images, White male brown hair: Michael Sharkey/Getty Images, Afro American male: Ryan McVay/Jupiter Images, White male-side view: Shannon Fagan/Getty Images, Vegas: Neil Emmerson/Getty Images, Highway: Robert Warren/Getty Images

Use raindrops as a texture

1. Open AP 10-6.psd, then save it as **Multiply Raindrops**.

2. Open the file named Raindrops.psd.

3. Select all, copy, then close the file.

4. Target the **Highway Abstract layer**, paste, then name the new layer **Raindrops**.

5. Change the blending mode to **Screen**, then reduce the opacity to **30%**.

 Overall, the texture file looks like it will create an interesting effect. However, its middle tones are flattening out the artwork. Since we know that with the Screen mode, black becomes transparent, darkening the image will make it more transparent.

6. Create a new group folder to hold the Raindrops layer.

7. Name the group folder **Texture**, then change the folder's blending mode to **Normal**.

8. Create an unclipped Levels adjustment layer above the Raindrops layer, drag the **black triangle** to 128, then compare your result to Figure 38.

 The left side now looks really good. However, the right side no longer looks like raindrops; it looks more like a bunch of white dots.

9. Add a layer mask to the Raindrops layer, then fill it with a gradient that goes from white on the left to black on the right.

(continued)

10. Press [**Ctrl**][**J**] (Win) or ⌘ [**J**] (Mac) to duplicate the Raindrops layer.

11. Target just the **Raindrops copy layer**, click the **Edit menu**, point to **Transform**, then click **Rotate 180°**.

12. Reduce the Opacity of the Raindrops copy layer to **20%**.

13. Reduce the Opacity of the Texture layer group to 50%.

14. Press [**F**] two times to view the artwork against a black background.

15. Compare your results to Figure 39.

16. Press [**F**] to return to Standard Screen Mode, save your work, then close Multiply Raindrops.psd.

Figure 39 *Final artwork*

Source Adobe® Photoshop®, 2013. African American female: Erin Patrice O'Brien/Getty Images, White male brown hair: Michael Sharkey/Getty Images, Afro American male: Ryan McVay/Jupiter Images, White male-side view: Shannon Fagan/Getty Images, Vegas: Neil Emmerson/Getty Images, Highway: Robert Warren/Getty Images

Working with Blending Modes

Figure 40 *Scratch texture multiplied over artwork*

will fine
jay van solt
peter rajter
selena york

FAST COMPANY

they drive by night

Use scratches as a texture

1. Open AP 10-7.psd, then save it as **Sunset Scratches**.
2. Open Scratches on White.psd.
3. Select all, copy, then close the file.
4. Target the **Overlay group layer**, paste, then name the new layer **Scratches**.
5. Change the blending mode to **Multiply**, then reduce the Opacity to **60%**.
6. Verify that you are viewing the artwork at 50%.
7. Press [**F**] two times to view the artwork against a black background.
8. Compare your results to Figure 40.
9. Save your work, then close Sunset Scratches.psd.

1. Open AP 10-8.psd, then save it as **Complex Sepia.**
2. Duplicate the Green channel, select all, copy it, paste it above the Type group, then name it **Green 1.**
3. Open Grit.psd, select all, copy, paste it beneath the Green 1 layer, then name it **Grit**.
4. Reduce the Opacity on the Green 1 layer to 30%.
5. Duplicate the Green 1 layer, then rename it **Green 2**.
6. Drag the Green 2 layer above the Color Overlay layer, then increase its Opacity to 75%.
7. Change its blending mode to Luminosity.
8. Duplicate the Green 2 layer, then name it **Green 3**.
9. Load the Montage Only channel as a selection, then click the Add layer mask button on the Layers panel.
10. Change its blending mode to Soft Light.
11. Make the Creases layer visible, change its blending mode to Screen, reduce its Opacity to 50%, then activate its layer mask.
12. Duplicate the Color Overlay layer, then drag the copy to the top of the Layers panel.
13. Reduce its Opacity to 10%, then compare your artwork to Figure 41.
14. Save your work, close Grit.psd, then close Complex Sepia.psd.

Figure 41 *Completed Project Builder 1*

Source Adobe® Photoshop®, 2013. African American female: Erin Patrice O'Brien/Getty Images, White male brown hair: Michael Sharkey/Getty Images, Afro American male: Ryan McVay/Jupiter Images, White male-side view: Shannon Fagan/Getty Images, Vegas: Neil Emmerson/Getty Images, Highway: Robert Warren/Getty Images

1. Open AP 10-9.psd, then save it as **Sunset Brushes**.
2. Open Brush Texture.psd.
3. Select all, copy, then close the file.
4. Target the Type group layer, paste, then name the new layer **Brushes**.
5. Add a clipped Levels adjustment layer, drag the black triangle to 46, then drag the white triangle to 179.
6. Target the Brushes layer, apply the Invert command, then set its blending mode to Multiply.
7. Make the Scratches layer visible.
8. Evaluate how the brushes and scratches textures are interacting with the models' faces, the title treatment, the stars' names, etc.
9. Decide what areas—if any—of the scratches or brushes texture need to be reduced or masked out, then do so.
10. Compare your results to Figure 42.
11. Save your work, then close Sunset Brushes.psd.

Figure 42 *Completed Project Builder 2*

Source Adobe® Photoshop®, 2013. African American female: Erin Patrice O'Brien/Getty Images, White male brown hair: Michael Sharkey/Getty Images, Afro American male: Ryan McVay/Jupiter Images, White male-side view: Shannon Fagan/Getty Images

Working with Blending Modes

will fine
jay van solt
peter rajter
selena york

FAST
COMPANY
they drive by night

will fine
jay van solt
peter rajter
selena york

FAST
COMPANY
they drive by night

will fine
jay van solt
peter rajter
selena york

FAST
COMPANY
drive by night

will fine
jay van solt
peter rajter
selena york

FAST
COMPANY
y drive by night

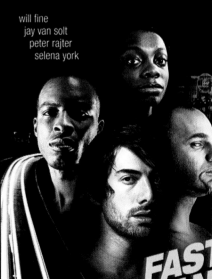

will fine
jay van solt
peter rajter
selena york

FAST
COMPANY
y drive by night

ADVANCED ADOBE PHOTOSHOP CS6			
Chapter	Data File Supplied*	Lessons in which Student Creates a File	Solution File Name
Chapter 1	AP 1-1.psd		HAWAII
	AP 1-2.psd		Puppet Warp
	AP 1-3.psd		Hawaii Noise
	AP 1-4.psd		Puppet Pencil
Chapter 2	AP 2-1.ai		[none]
	AP 2-2.psd		Paste From Illustrator
	AP 2-3.ai		Export Illustrator Layers
	AP 2-4.psd		Top 20
	AP 2-5.psd		Pink Lady
	AP 2-6.psd		Luck Be A Lady
Chapter 3	AP 3-1.psd		Levels of Gray
	AP 3-2.psd		Levels Intro
	AP 3-3.psd		Shadow & Highlight Points
	AP 3-4.psd		Crayons
	AP 3-5.psd		Sweater
	AP 3-6.psd		Color Woman
	AP 3-7.psd		Green Drink

DATA FILES LIST

(CONTINUED)

ADVANCED ADOBE PHOTOSHOP CS6			
Chapter	**Data File Supplied***	**Lessons in which Student Creates a File**	**Solution File Name**
Chapter 4	AP 4-1.psd		Sunset Swans
	AP 4-2.psd		Analyze Curves
	AP 4-3.psd		Analyze Channels
	AP 4-4.psd		Outback
	AP 4-5.psd		Red Scarf
	AP 4-6.psd		Sailboat
	AP 4-7.psd		Old Car
	AP 4-8.psd		Curves Review
	AP 4-9.psd		Half and Half

ADVANCED ADOBE PHOTOSHOP CS6			
Chapter	Data File Supplied*	Lessons in which Student Creates a File	Solution File Name
Chapter 5	AP 5-1.psd		Chisel Text
		Lesson 1; Create a Texture	Texture
	AP 5-2.ai		Round Corners
	AP 5-3.psd		Plastic
	AP 5-4.psd		Inner Shadow
	AP 5-5.ai		[none]
	AP 5-6.psd		Indent
	AP 5-7.psd		Jazz 2096
	AP 5-8.psd		Chisel Type Images
	AP 5-9.psd		Plastic Type Images
	AP 5-10.psd		Inset Type Images
	AP 5-11.psd		[none]
	AP 5-12.psd		Eroded Text
	AP 5-13.psd		Carved Wood
	AP 5-14.psd		White Mischief
Chapter 6	AP 6-1.psd		Black Knight Poster
	Actress.psd Damsel.psd		Actress Damsel Merge
	AP 6-2.psd		Project Builder 1
	AP 6-3.psd		Project Builder 2

ADVANCED ADOBE PHOTOSHOP CS6			
Chapter	**Data File Supplied***	**Lessons in which Student Creates a File**	**Solution File Name**
Chapter 7	AP 7-1.psd		Freckles Resize
	AP 7-2.psd		14 × 48 Billboard
	AP 7-3.psd		Invert Align
	AP 7-4.psd		Overlay Tricks
	AP 7-5.psd		Simple Grayscale
	AP 7-6.psd		LAB Grayscale
	AP 7-7.psd		BW Adjustment
	AP 7-8.psd		Unsharp Mask
	AP 7-9.psd		Grain
	Bricks Flowers Marble Rice Paper Water Wood Woodchip Paper	Lesson 6: Automate Workflow	Automation Folder containing TIFF, JPEG and PSD versions of supplied files
	AP 7-10.psd		Project Builder 1
	AP 7-11.psd		Extension Billboard

ADVANCED ADOBE PHOTOSHOP CS6			
Chapter	Data File Supplied*	Lessons in which Student Creates a File	Solution File Name
Chapter 8	AP 8-1.psd		Bright Eyes
	AP 8-2.psd		Smooth Lines
	AP 8-3.psd		Fix Teeth
	AP 8-4.psd		Smart Sampling
	AP 8-5.psd		Healing Brush
	AP 8-6.psd		Bali Seaweed Farmer
	AP 8-7.psd		Bali Beach Girl
	AP 8-8.psd		Umbrella
	AP 8-9.psd		Spot Healing Brush
	AP 8-10.psd		Overlay Retouching
			Overlay Retouching Color
	AP 8-11.psd		Red Boy
	AP 8-12.psd		Teeth Project

ADVANCED ADOBE PHOTOSHOP CS6			
Chapter	Data File Supplied*	Lessons in which Student Creates a File	Solution File Name
Chapter 9	AP 9-1.psd		Smart Filters
	AP 9-2.psd		Solarize
	AP 9-3.psd		Mezzotint
	AP 9-4.psd		Halftone
			Halftone Variation
	AP 9-5.psd		Neon
	AP 9-6.psd		Ripped Original
	AP 9-7.psd		Ripped
	AP 9-8.psd		Monotone
	AP 9-9.psd		Duotone
		Lesson 7: Use the Merge to HDR Pro Utility	HDR Merge
	AP 9-10.psd		Color Mezzotint
		Project Builder 2	Pool HDR Merge

ADVANCED ADOBE PHOTOSHOP CS6			
Chapter	Data File Supplied*	Lessons in which Student Creates a File	Solution File Name
Chapter 10	AP 10-1.psd		Fast Company Composite
	AP 10-2.psd		Fast Company Overlay
	AP 10-3.psd		Hard Light Analysis
	AP 10-4.psd		Fast Company Multiply
	AP 10-5.psd		Fast Company Sunset
	AP 10-6.psd		Multiply Raindrops
	AP 10-7.psd		Sunset Scratches
	AP 10-8.psd		Complex Sepia
	AP 10-9.psd		Sunset Brushes

*See Support Files List at end of table for a list of files students open to place into the final solution files.

Chapter	Support Files Supplied
Chapter 1	Couple, Flower, Hula, Ukulele, Volcano, Waterfall
Chapter 2	
Chapter 3	
Chapter 4	
Chapter 5	
Chapter 6	Actress, Author Merge, Billing, Big Knight, Castle, Damsel, King, Moon, Small Knight, Smoke, Stars, Sword, Title
Chapter 7	20×3, King Hi-Res
Chapter 8	
Chapter 9	Hayden Library 1, Hayden Library 2, Hayden Library 3, Pool 1, Pool 2, Pool 3, Three Source Files
Chapter 10	Brush Texture, East, Grit, North, Raindrops, Scratches on White, South, West